FRAGONARD
in the Universe of Painting

Dore Ashton

SMITHSONIAN INSTITUTION PRESS
WASHINGTON, D.C.
LONDON

LIBRARY OF CONGRESS CATALOGING-IN-PUBLICATION DATA

Ashton, Dore.
Fragonard in the universe of painting.

Bibliography: p.
Includes index.
1. Fragonard, Jean Honoré, 1732–1806—
Criticism and interpretation. 2. Painting, French.
3. Painting, Modern—17th–18th centuries—France.
I. Title.
ND553.F7A88 1988 759.4 87-43110
ISBN 0-87474-208-0

British Library Cataloguing-in-Publication Data is available.

The paper used in this publication meets the
minimum requirements of the American National
Standard for Permanence of Paper for Printed
Library Materials Z39.48—1984.

Photographs have been supplied by the owners of
the works of art. In addition, the following pho-
tographers are acknowledged: Bulloz, Paris: figs.
52,53; M. de Lorenzo, Nice: fig. 18; Jacques
Mayer, Grasse: fig. 68; and Sydney W. Newbery,
London: figs. 58, 59, 61.

Contents

Acknowledgments

ABOVE ALL I thank two old friends whose wisdom I deeply appreciate: Barbara Burn, who, as always, was encouraging, and Professor Fred Licht, whose superbly imaginative approach to art history has always inspired me. Many other friends have encouraged and assisted me, and I thank them all warmly: Aki Nanjo, Ronald Christ, Silvia Tennenbaum, Hedda Sterne, Professor Rudolf Arnheim, Jetske Sybesma-Ironside, Gregory Kolovakos, Bernice Davidson, Helen R. Lane, Paul Rotterdam, Katharine Ray, Kathy Kuhtz, and Virginia Wageman. Among museum scholars who have been exceptionally kind I thank above all Edgar Munhall of the Frick Collection, and also George Szabo of the Robert Lehman Collection at the Metropolitan Museum of Art and Anselmo Carini of the Art Institute of Chicago. Eugene Victor Thaw also deserves my special thanks for sharing his thoughts and his wonderful collection. In Europe, I thank especially Marianne Roland-Michel; Professor Michel Gallet; Catherine Legrand, conservator at the Musée des Beaux-Arts in Besançon; Ariane Lebas and Ariane Lasson of the Musée Fragonard in Grasse; M. Jean-François Mejanes of the Louvre; Pierre Rosenberg, chief curator of painting at the Louvre; and Denise Rousseau, in France. In Spain, my thanks go to Victoria Combalia and Daniel Giralt-Miracle for their generous efforts on my behalf. I also thank Marina Svietlana Yunkers, Dr. Evan M. Maurer of the University of Michigan Art Museum, Karin Breuer at the Achenbach Foundation for Graphic Arts, Janice Driesbach of the Crocker Art Museum, Herbert Bott of the Cooper Union Library for his great assistance and Sandra Ferguson for her typing services. At Smithsonian Institution Press, I am grateful to Felix Lowe, the director, and Daniel Goodwin, Michelle Smith, and Alan Carter. I thank my two daughters, Sasha and Marina, for their indulgence, and my husband, Matti Megged, for his help in every way.

Foreword

*La peinture a pour ainsi dire son soleil qui n'est pas
celui de l'univers.*

—Diderot

OR A LONG TIME I possessed what seemed an irreversible distaste for eighteenth-century painting. Each time I walked through museums I hastened my pace in the eighteenth-century rooms, as did so many other writers on modern art. Still, as the years passed, I noticed that I was often arrested by a painter whom many considered the most eighteenth-century painter of all, Jean-Honoré Fragonard. Fragonard's singularity—at least in his major works and in many of his casual drawings—has rarely found enthusiasts in our century. Most writers have not been able to help applying the old Tainean formula of race, moment, and milieu, coming out with an exemplar of the Rococo instead of an individual of markedly independent temperament. Since Fragonard was not given to writing theory and since he kept no journal and wrote no illuminating letters, the writers on him have been forced to fall back on art-historical conjecture that frequently has arrived at fanciful conclusions. There are less than a dozen notations of things Fragonard is supposed to have said. Of these, I am quite willing to believe at least one of them and to believe that he said it on more than one occasion: "I would paint with my ass." He was a born painter, for certain, and temperamentally allied with all born painters in history.

For the most part I believe that are-historical method has gone, like one of Fragonard's swings, high into a fictive bank of clouds, obscuring, or at least neglecting, one of the most difficult issues: how a painter relates to the universe of painting. The Rococo age has been the subject of many attempts at definition and has never found a satisfying exposition. Fragonard, one of its most interesting painters, has been caught in its foggy depths. Mostly he has been seen only as a representative Rococo artist (or rather, late Rococo, if we go by decades rather than style). Most commentators have been content to follow the brothers Goncourt, who called him the poet of the *ars amatorio,* and have often fallen into such

conventional interpretations as the Goncourts': "Fragonard was a master of a dream world. His painting is a dream—the dream of a man asleep in a box at the opera."

In many of Fragonard's paintings, this is surely so. But his masterworks are far more than the vagaries of an opera-goer's slumber. Even if there is a light, dreamlike character in certain of Fragonard's works, why couldn't the modern world, so steeped in the lore of dreams, appreciate him? How could we, in literary history, understand such dream artists as Gerard de Nerval, Fragonard's great admirer, and Charles Baudelaire, and yet not find ourselves in Fragonard? I am inclined to believe that the failure can be attributed to the current obsession with paradigms and social history and to the increasing tendency to base all interpretation on theory.

In this book, I do not advance a theory so much as a point of view. I have not undertaken an analysis with the precision of the art historian armed with a scientific method. I have not tried to find unacknowledged masterpieces. I have deliberately limited my attention to works that can be seen in public collections, for the most part, and that have a sure provenience. There are new books, published in 1988, by Jean-Pierre Cuzin and Pierre Rosenberg that provide detailed histories of individual works and extensive illustrations for readers who wish more ample documentary information. My own undertaking has been to cast a light on one aspect of interpretation that I feel has found few defenders and that is essential for an understanding of Fragonard's major work.

Introduction:
The Painter's Dream of Light

EAN-HONORÉ FRAGONARD wrote no letters of interest to the history of art, left no lectures for us to discuss—as did several artists of his generation who addressed the Academy— and was almost never quoted in the numerous memoirs of the busy eighteenth-century *amateurs*. He seems to have avoided the salons of his day, some of which were of signal importance to the careers of artists. A few of his contemporaries described him as even-tempered and full of bonhomie; others wrote of his impetuous character, which led to disagreements, and worse, with patrons and busybodies in the art world. The unusual lack of documentation in a period when writing things down seemed to be *de rigueur* for everyone with even a modicum of education has led to rather wide-ranging speculation about Fragonard, some of it quite fantastic. There is, however, one explicit document, dated and convincing. But that document itself has led to countless unwarranted assumptions concerning the nature of Fragonard's temperament and the most significant aspects of his work.

The document relates to *The Swing* (colorplate 1), a small painting in the Wallace Collection in London—a popular work so nearly fulfilling the received idea of eighteenth-century Rococo and so closely identified with the definition of mid-to-late-eighteenth-century mores as licentious that even the most perspicacious commentators are content to read the painting at face value, that is to say, iconographically. The reporter in this document is the playwright and man of letters Charles Collé, an adept in the art of Salon gossip, a hireling of the court— where he often produced on demand playlets for the private theaters of noblemen—a frequenter of actresses, and, in his other life of letters, a provider of salacious dramas for the private theater of Mlle Marie-Madeleine Guimard, who would figure significantly in Fragonard's life.[1] Collé, then, was no stranger to the spirit of libertinage. At Mlle Guimard's private performances the titles included his

Vérité dans le vin and *Mlle Engueule* and others too scandalous for memorialists to mention by name. Collé recorded in his journal an "encounter" on October 2, 1767, with the painter Gabriel-François Doyen, no doubt in one of the Salons. Doyen was, as Collé conscientiously mentions, the star of the recent Salon where he exhibited *Sainte Geneviève Putting an End to Pestilence,* a painting commissioned for the Church of Saint Roch. On his return to Paris from his stint in Rome in 1756, Doyen had quickly found his footing in high circles, which were impressed with his penchant for painting grand machines. His commissions emanated from both court and church. One can imagine the two worldly acquaintances moving to the corner of a drawing room after a performance at the Opéra, where Doyen regales Collé with the following anecdote:

> "Would you believe," Doyen said to me, "that a few days after the exhibition at the Salon of my painting [of Sainte Geneviève], a gentleman of the Court sent for me to commission a painting I'm going to describe to you. This Lord was at his villa with his mistress when I presented myself to find out what he wanted from me. He began by covering me with flattery and praise and finished by declaring that he was dying to have me paint, in my style, the painting he would describe to me. "I would like," he continued, "that you paint Madame (pointing to his mistress) on a swing which a bishop is setting in motion. You will place me in a position in which I can see the legs of this lovely child, and I would be even more pleased if you felt like embellishing the picture still further." . . .
>
> "I admit," Doyen told me, "that this proposition that I never would have expected, given the nature of the painting that had prompted it, confounded and stunned me for a moment. I pulled myself together enough to say to him almost immediately, 'Ah, Monsieur, one should add to the basic idea of your painting by making the slippers of Madame fly into the air and be caught by cupids.' But since I was far from wanting to treat such a subject, so different from the genre in which I work, I directed this Lord to M. Fagonat [*sic*] who took it on and is now making this singular work."[2]

This document is brimming with information to be interpreted. It gives the initial program of the painting. It suggests how the art world functioned. It hints at the collusion of the nobility and the church. It speaks of Fragonard's still modest reputation at the time, since it is apparent in the misspelling of his name that Collé was not an intimate of the painter. But it does not illuminate the painting itself, merely the occasion for it. It shows that the nobleman, now thought to have been the Baron de Saint-Julien, receiver general to the French clergy, had been impressed by the talk about Doyen during the Salon and wanted an important painter, a star, to bring his caprice into being. He wanted a boudoir painting not only to pay tribute to his mistress, but also to titillate his friends. It was the custom. In fact, many highly placed patrons, including the king's mistress, commissioned these conversation-piece paintings and even sculptures, which they often made more tantalizing by shielding them from imprudent eyes with colored satins.

In Collé's account we get, in a condensed form, a considerable insight into the social history of art. Doyen, the rising young official painter, is summoned by a nobleman, and he wastes no time answering the call. Judging by his account to Collé, Doyen may well have been more shocked by the explicit order of the patron, who gave the entire program of the painting—since instruction was already considered in bad taste—than by the subject itself, which, as he quite well knew, was by that time fairly conventional. Artists in the mid-eighteenth century often bridled when given explicit instructions by patrons. The Marquis de Marigny, Charles-Nicolas Cochin, and other notables in the art world of Louis XV issued frequent admonitions to *amateurs* and courtiers not to interfere, not to suggest subjects, and above all not to fetter the imaginations of their artists. Probably at the very moment Fragonard was working on the small masterpiece in 1768, Diderot was writing to the sculptor Etienne-Maurice Falconet, whose statue of Cupid was included in Fragonard's painting: "It is just that we allow our artists their fantasy and that Mme Geoffrin wants to make them go with hers."[3] He added that François Boucher wanted "to extract himself from her despotism."

In recounting the story to Collé, who was known for his risqué humor, Doyen almost certainly only pretended to be shocked by the motif. The two probably had a good laugh at Saint-Julien's expense, especially when Doyen added his own salacious bit. All the same, he refused, since, as he explains, he had already established his genre and, he might have added, his clientele, and he would not have risked offending the clergy. Knowing about Fragonard's recent work of an intimate order, he sent the nobleman packing.

No doubt Fragonard was glad enough to oblige. He needed money, and he had enough humor to see possibilities. Having once been refused, Saint-Julien may have modified his request, or Fragonard, with his independent impulses, may have decided just what he would paint and how he would handle things. The theme of the swing had a venerable history in images dating from ancient times, but it was especially alluring for eighteenth-century artists, who, as Donald Posner has written, saw it as representing "love and the rising tide of passion."[4] The theme had been artfully announced by Jean-Antoine Watteau, who was well aware of the erotic connotations of swinging, and had been liberally exploited by lesser painters before Fragonard. It was quite easy for Fragonard to assemble his story from established sources, such as, for instance, the Cupid of Falconet, whose fingers are to its lips suggesting the clandestine exchange between the girl and her uxorious lover. Fragonard easily adapted the language of statuary, wielded so poetically by Watteau and practiced by countless painters thereafter. Fragonard had had many occasions to utilize the statuary language during his apprentice years with François Boucher. If he wanted to suggest certain themes, he had only to pick his statue as he might pick a color from his palette. In *The Swing* he also includes the statue of two Cupids riding a dolphin—an allusion to the dolphin that conventionally drew Venus's chariot through the water—which had been a stock adornment in Bou-

cher, as in the Metropolitan Museum's *Shepherd's Idyll,* where Boucher places the figures high on a plinth, or the Columbus Museum's *Earth: Vertumnus and Pomona,* where the statue of Cupid and the dolphin glimmer in a bluish rear ground. Boucher liked this emblematic statue and used it often. Fragonard also seemed to like it and used it again in the Frick panel *The Pursuit* (colorplate 7). The shorthand of statuary, then, takes care of the general theme in *The Swing.* It does not make the painting an allegory; it is more like a title. The allegorical is diminished merely by the fact that in this painting, all, absolutely all, goes back to the center. Moreover, it probably amused Fragonard to quote his friends and contemporaries. Using these easily readable statues and adding the flying satin slipper and naked foot, which, as Posner has noted, also had a long history of erotic connotations,[5] Fragonard composed the story no doubt as the patron had wished it.

As for style, the painting neatly accommodates the received idea of late Rococo with exaggerated diagonals, elaborate ornamental flourishes, artificiality in the representation of nature, and repetition of extravagant curves that evoke shell patterns. Fragonard falls back on his training and his memory for the composition, in which two pronounced diagonal movements cross and, in their curvilinear irregularities, spiral as well. The frayed ropes of the swing are spirals, as are the background trees. Fragonard was not a simplicist, however, and he enjoyed making subtle transitions from one form to another, as when the billowing skirts of the swinging girl become the first curves in a sequence of spiraling foliage behind, or as when he grounds his composition with a few firm horizontals—the plinths of the statues and the faintly perceived lattice behind—in order to make the flying figure more pronounced. The painting is full of complicated rhymes: the tilt of the girl's straw hat rhymes with the positions of her arm grasping the rope; the soaring slipper with the ebullience of roses; the curve of the ropes circling the trees with the curve of the corkscrew branch that closes the circle of the central event.

The question is, then, what is the event that lifts this painting out of the commonplace of its period? What is the meaning of this painting, if by meaning we refer to what Jean-Paul Sartre meant when he cryptically observed that the *Mona Lisa* doesn't mean anything, but that it has meaning. Beyond the immediate occasion, beyond the badinage, beyond the implications of the story, and beyond even the stylistic conventions lie Fragonard's most profound intuitions and a central metaphor. In all of his drawings and most of his paintings there is always some event that is so moving to him that it is cast in the highest light, sometimes so high that the light obliterates the lineaments of form. Where others would cast their secrets in shadows, Fragonard swathes them in light. The most mysterious passages in Fragonard are the most effulgent. Light as it passes over palpable surfaces excited him. The space that such overwhelming lightness produces is still more mysterious, and it was Fragonard's love of endlessly variable spaces in nature that, once bestirred, as it was during a summer in the wild precincts of Tivoli, set the key for everything after, even his genre paintings.

The Swing is more than a period piece. In it Fragonard found a central metaphor that lingered in his life's work in its profoundly poetic way. The circular figure of the swinging girl is immured in a light invented by the painter to underscore his metaphorical meaning—a light that originates in the center of his canvas on her flowing satin dress and remains there, discrete from the whole; this light is to the luxurious garden as is a rose. In the slow blue mists with their flickering green accents, this girl is an opening, an initiation of ravishing color within a circular dream. She becomes that flower, as Mallarmé so unforgettably put it, that is absent from all bouquets.

Like all artists trained at the Academy, Fragonard emerged from his student years with a complete repertoire of classical allusions. He was, as Jacques-Louis David later said, a connoisseur of the history of art. Endowed with an exceptional visual intelligence and a prodigious memory, Fragonard studied the myriad ways his predecessors and even his contemporaries had found to use the myths and historical events to which their audience could respond. The subjects or themes of his works were sometimes drawn from his own classical repertory and sometimes from contemporary literature or theater. He was a good storyteller, and he did not hesitate to use familiar sources to enhance his subject. But there are always two subjects in most significant paintings, as so many painters in history have remarked. What Fragonard had in common with his predecessors was a sense of the innate potential of his medium. His subject was as much that, and the magic of light, as it was Venus or Minerva or courtly or bourgeois love.

To recognize the iconography of Fragonard's individual works is to know only one part of their meanings. Consider, for instance, one of his more obvious allusions to the classical past in *The Embrace* (fig. 1), a drawing at the Albertina. This brown wash drawing with black chalk has interesting iconographical implications. It is described in the Albertina catalog as an allegory illustrating a verse from Horace: *"Spirat adhuc Amor vivuntque calores Aeoliae puellae"* (Still love aspires and the impatient burnings of the Aeolian girls still live).[6] Erwin Panofsky in his essay *"Et in Arcadia Ego:* Poussin and the Elegaic Tradition" includes the drawing in the tradition established by Jacobo Sannazaro in his poem *Arcadia*.[7] First published in Venice in 1502, the Sannazaro poem was based on both Italian and classical sources, according to Panofsky, including Petrarch and Boccaccio on the one hand and Virgil, Polybius, Catullus, and Longinus on the other. Panofsky traces the first use of the motif *Et in Arcadia Ego* to a painting by Guercino in 1623, lodged in the Galleria Corsini. This painting was certainly familiar to Fragonard, who studied in Rome, as were Nicolas Poussin's two famous renditions. In Fragonard's Albertina drawing, the lovers embracing in the broken sarcophagus, the stone lying on the ground with an inscription, and the angel with the nuptial torch were all established references. In terms of its iconography and its visual sources, however, there is much about the drawing that is open to interpretation. Fragonard was familiar with Virgil, since Virgil was a required subject in the curricu-

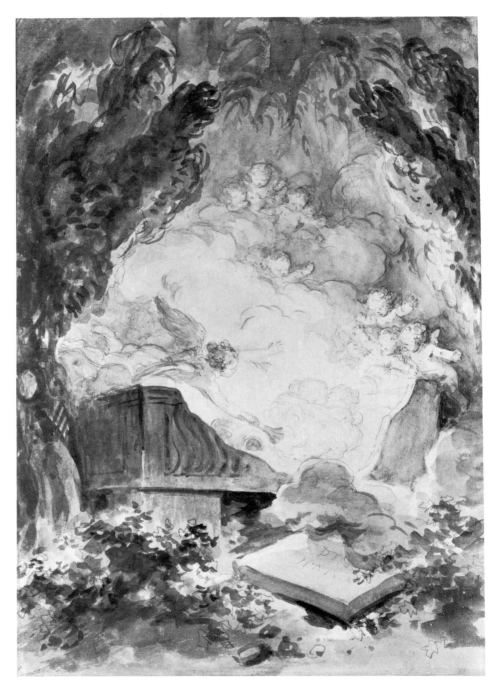

FIGURE 1. *The Embrace*. Graphische Sammlung Albertina, Vienna.

lum of the Academy. By the time he made this drawing, which appears to have been done after his second journey to Rome, judging by its free wash style, he was at work on his remarkable illustrations of Ariosto and probably also Boccaccio, whose tales were recast by La Fontaine and illustrated by Fragonard. There were ample sources from which Fragonard could have chosen to make this drawing.

But even if all the antecedents were traced and all the iconographical details pinned down, the drawing would still not yield its full meaning, for Fragonard has endowed this carefully constructed drawing, with its pronounced sequence of triangles and its triangular frame of foliage, with a mystery. The most significant detail is not the faint inscription on the lozenge of stone but the great blaze of light that almost conceals the embracing lovers as it flows upward. This central beacon, made more intense by the framing washes of dark sepia on either side, is the most emotionally charged detail in the drawing. If Fragonard's meaning is "Even in Death there may be Arcady," as Panofsky suggests, it is purveyed through Fragonard's climax of supernatural light. Here, as in *The Swing*, Fragonard makes use of a conventional theme, but he turns it to his own account, changing the metaphor with pictorial means. It is important to know his sources and to confirm the sense of historical continuity painters can purvey, but it is not enough to talk only of influences and sources. There is something singular about the *sensibility* at work here—to use a term current in Fragonard's time—and that sensibility must be studied within the works to discern other meanings. In his own time some of Fragonard's fellow artists recognized his special sensibility and its superiority; Gabriel de Saint-Aubin noted of a Fragonard drawing in an auction catalog that it displays "*la touche la plus spirituelle.*"

Fragonard shared the tastes and tendencies of his period and bowed to certain professional necessities, but he almost always approached his work from a distinctive position, visible not only in acknowledged major works but also in many of his incidental activities. Among his most engaging works were a small number of original etchings, including a suite of four *Bacchanalia* done after bas-reliefs that had been unearthed at Herculaneum. Fragonard, like other art students of his generation, had had to follow the Academy practice by which antiquities, particularly sculptures, were endlessly copied. Often these copies became the basis for engravings that embellished the many travel guides of the eighteenth century. With the increasing archaeological finds in the mid-eighteenth century came a host of earnest connoisseurs who wished to keep up by means of the illustrations provided by an army of engravers who did a flourishing business. Not many painters undertook to make original prints, and Fragonard himself is known to have made only some two dozen with his own hand. If a painter produced a print, it was probably in the hope of a quick sale. Most often he farmed out the work to professional engravers, although there was a small market for prints by the artist's own hand that remained steadily lively. Possibly it was for this market of specialized connois-

seurs that Fragonard undertook the four prints in the *Bacchanalia* group, but they may have been done for his own pleasure. They have the savor.

His choice of nymphs and fauns as subject matter was not unusual, for the period was well supplied with them. Their erotic associations alone warranted their popularity, but in the light-handed *Bacchanalia* etchings, Fragonard does not capitalize on the *amateur*'s love of amiably disguised prurience. These disporting nymphs and fauns are depicted in carefree moments, demonstrating affectionate relationships within a family circle. Fragonard envisioned these scenes with intense delight, frankly announcing their source as ancient bas-reliefs, but illuminating them with the flickering light of a bower—a reedy, protected retreat. More than a century later Mallarmé would dream his way to an identical place. Fragonard had anticipated the metaphors that breathe through Mallarmé's *L'Après-Midi d'un faune*. He was dreaming, as the brothers Goncourt recognized, but not from an opera box, as they thought. Rather, Fragonard's reveries take place on the lower levels of the forest and marsh floor, where reeds embrace the mythical family.

In *The Satyr Family* (fig. 2), the first of the four plates in the *Bacchanalia* group, Fragonard shows two fauns with clasped hands crossed and a nymph delicately stepping over to seat herself on their hands. He composes his figures in an oval contained within a rectangle, forming a cameo framed by rich vegetation and a hint of cultivation in the sheaf of bound reeds. Fragonard plays with illusion by depicting the three figures in a warm, high light, as if the sun had burrowed its way into the tableau, obliterating pronounced shadow and bringing to the relief scene a soft impression in depth. In the delicate system of lights and in the minute

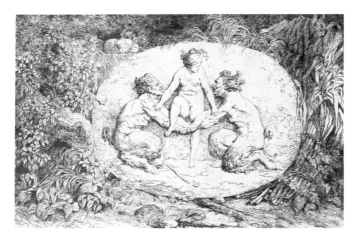

FIGURE 2. *Bacchanalia: The Satyr Family*. The Cleveland Museum of Art, Dudley P. Allen Fund.

breaks in the line delimiting the nymph's shoulder and the back of the satyr, Fragonard anticipates his later works in which critics have found proto-Impressionist tendencies. It is not difficult to imagine the imaginer of these scenes wondering, like Mallarmé's faun, if it were, after all, only a dream.

The *Bacchanalia* etchings were completed in 1763 after drawings Fragonard had made in Italy. It is possible that soon after his return to Paris Fragonard had considered trying to make his commercial way by means of prints. But it seems unlikely. The taste among the usual buyers of prints was often for heavily worked engravings. The handbook for all artists embarking on printmaking was at that time Cochin's translation of Abraham Bosse, in which Bosse summarized the definition of the print as "a manner of painting or drawing with hatching."[8] Prints on the mass market tended to be reproductions or at least full-dress scenes with more hatching and heavier working of the plate. Only the eminently cultivated connoisseur, schooled in etching by seventeenth-century Italians such as Salvator Rosa (who had himself done several etchings of fauns that might have been studied by Fragonard) or the Dutch school, most eminently Rembrandt, would have rallied to Fragonard's slight etchings. Moreover, they were not numerous enough to make for a living. True, there were distinguished collectors of Giambattista Tiepolo's etchings who would have appreciated Fragonard's bow to the Italian's light touch, but these were specialized *amateurs*. On the whole, prints after antique subjects were mainly treasured for their veracity and not for their fantasy. Fragonard's liberties would not necessarily have been appreciated by the scholarly collectors of prints after the antique. Such collectors were, on the whole, more like the Comte de Caylus, who in 1759 wrote to the Italian scholar Paolo Maria Paciaudi that he did not want a certain statue of a Bacchus: "It is beautiful, it is authentic, it is well observed. And yet, I don't want it. I am not making a collection of statues; I am making a course in antiquity."[9]

Fragonard, who was certainly a master of "hatching" and who had mastered engraving techniques while still a student, chose instead to make his four plates with the finest of needles and the lightest of values and, almost unprecedented, with a free system of dots—mere points on the white ground—that suggest both the rounded forms of his figures and the surrounding air. The audacity of his technique was apposite to his theme, and the value derives from his willingness to step out of convention even while seeming to adhere to it, a trait that brought him considerable grief later in his career. Nonetheless, these prints have shown their persistent appeal. Édouard Manet's illustrations for Mallarmé in the full Impressionist graphic idiom are greatly akin to Fragonard's. (It is quite possible that Manet had seen them, for they were reprinted extensively in the mid-nineteenth century.) Fragonard's interpretation of the ancient dream remains alive. His choice of both motif and technique reflects the persistence of his own dream of light, of surfaces reflecting in the light of his own, a painter's, universe.

The Painter as Puzzle

F ALL THE reliably attributed works of Fragonard are considered, his oeuvre seems immensely varied, often perplexingly diverse. The erotic works for which he was so long considered, often condescendingly, as a late Rococo specialist, are actually only a small part of a large oeuvre. His shifts both in subjects and in approach were frequent. He was at times attracted to certain unusual motifs, such as bulls in their stables (fig. 3), while on the other hand, he seemed to be repelled by certain standard themes of his time. After winning acclaim at the Academy in 1765, for example, he would produce almost no religious or mythological works in the grand manner. As a draftsman he was agile and prolific. He could build solid figures with as much structural geometry as any Poussinist could wish. But he could also produce quick sketches, particularly of landscape, and his atmospheric lightness has no precedent in the history of art. His drawings often attest to an inherent structural genius, using the word genius in its late-seventeenth- and eighteenth-century meaning, as derived from the Latin *ingenium* for "a predisposition." Not even the sweep of his often Baroque fantasy in so many drawings can distract from the solidity of his underlying structures. What Goethe said of Diderot's *Le Neveu de Rameau* (*Rameau's Nephew*), which he had just translated, could be said of Fragonard's oeuvre: "Those who think they see the fits and starts, the incoherence of a conversation, are much mistaken: it has of conversation only the vivacity. Everything is held together . . . by a chain of steel which is hidden from our eyes by a wreath."[1] For all the fits and starts in Fragonard's career, and for all the confounding (and seemingly gratuitous) trails into unexpected territory in his evolution, there are constants all along the way. He struggled toward his vision. It is obvious that he combed through the history of art as a connoisseur, but it is also obvious that his temperament was easily swayed by chance encounters, events in his daily life, talk he overheard, conversations with other artists, and the striking changes taking place in the art world during the second half of his century.

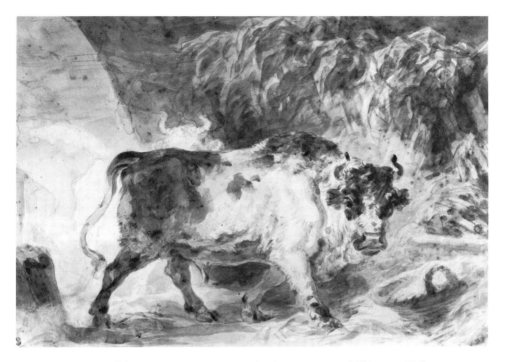

FIGURE 3. *A Bull of the Roman Campagna.* The Art Institute of Chicago, Helen Regenstein Collection, 1962.116. © 1987 The Art Institute of Chicago. All rights reserved.

There has been much speculation about Fragonard's place in that world. By all accounts he was an alert participant in the increasing volume of art business. Like his peers, he was on the lookout for commissions and patrons, and he was always in need of money despite his having reached the position of academician. Yet for reasons that have never been satisfactorily explained, Fragonard, after his stunning success at the Salon, turned away from official career-building. He showed only once after his initial Salon debut and thereafter resolutely shunned the Salon to the consternation of his sponsors. To fully comprehend his moves in the art world would require some insight into his personality. There are, unfortunately, all too few solid indications, yet those few are helpful, for they suggest that he was at once a steady, dedicated artist and a mercurial personality. Physically he was diminutive—less than five feet, if official documents are accurate—but he took up a lot of space in his epoch. He was a celebrity for a considerable part of his life. His character tended toward cheerfulness, but he was capable of deep anger. His personal habits showed independence, even bohemian traits. If we work our way back from late testimonials, it can be taken for granted that he had certain eccentricities throughout his adult life. According to one account of his old age, he

appeared in public carelessly clad in an old knee-length cloak "with no buckles, straps, or buttons; when he got down to work he clasped it to his waist with whatever was to hand—a bit of string, a scrap of material."[2] This man had once been on the way to official glory but had sidestepped.

It may well have been Fragonard's innate sense of independence and his conscious desire to freely pursue his own interests that motivated his distancing from official circles. His earliest associations while he was an apprentice in Boucher's studio were in a milieu in which the visual arts were important enough to warrant discussion even among the loftiest intellectuals. His emergence as a young painter in command of his means at mid-century coincided with the infusion of art patronage that Louis XV inadvertently abetted by installing Mme de Pompadour as his mistress. At the same time, there was a powerful drive among the bourgeoisie to claim the privileges of the nobility. Nothing achieved this so well as patronage of the visual arts. In other words, at the very moment when Fragonard was beckoned to the official establishment, opportunities of another order began to flourish. There were alternative paths to success, if not glory.

This was the period in which the philosophes had gained entrée to all privileged circles and exercised considerable influence. They enormously stimulated discussion and initiated ongoing disputes that entertained and sometimes outraged their listeners. Of course artists had not awaited the appearance of the luminaries in the intellectual world in order to debate. They had a long tradition of their own and took it for granted that strong differences of opinion would arise. Contention was endemic to their daily lives. They had a kind of understanding that bridged periods, a language of their own that excluded even the philosophes, who all too often misunderstood the nature of artistic, visual intelligence. Yet, despite the cleavage separating visual and intellectual discourse, the philosophes had made inroads.

Voltaire, above all, had set the tone of discussion, even artistic discussion, by insisting that the *esprit critique* was the only possible attitude in the modern age. Skepticism was the only decent response to all dogmatic claims, whether in the theory of art or in politics. Nearly a century later the power of Voltaire's thought was sarcastically remarked by Stendhal, who wrote in *Le Rouge et le noir:* "Since Voltaire, since the government with two chambers, which is basically nothing but *mistrust* and *private judgment,* and gives the spirit of the people the bad habit of being *skeptical,* the church of France seems to have understood that books are its real enemies."[3] As a natural accompaniment of the general attitude of criticism or skepticism here was the enhanced sense of personal independence—the right, seized by each person endowed with intelligence, to examine many positions and to make his individual choice. The painters who were Fragonard's tutors—those who had made their names during the previous two decades—were notable for their new spirit of independence. The lore of the period is full of references to their temperamental behavior and displays of defiance. Maurice-Quentin de La Tour is

described by the Goncourt brothers as a typical representative of the eighteenth century who had "returned from London with the independent spirit of a free citizen; he was untutored at court, churlish toward influential persons, insolent to the rich, a character from Duclos embodied in a Danubian peasant."[4] Even Marigny handled him with kid gloves. La Tour was often quoted as saying, "My talent belongs to me." In the studios at the Louvre, where Fragonard had gained entry in his thirtieth year, his neighbors included La Tour and other such well-established artists as Jean-Baptiste-Siméon Chardin and John-Baptiste Greuze (another temperamental artist with a stubborn pride that often, as his neighbor Claude-Joseph Vernet pointed out to him, defeated his own ambitions).[5] Fragonard's sense of independence could only have been reinforced in such a milieu.

The critical spirit in the universe of the painters and sculptors had long been at work and was made more keen by the newly installed philosophes. By the time Fragonard came on the scene, everything was discussed, and there were armed camps that fought theoretical battles that ranged from the sublime to the ridiculous. It is likely that he was sufficiently exposed to the critical spirit among his peers to be able to take it all with a smile and go his own way. The century-old battles between the Rubenists and Poussinists still alive during Fragonard's student years, though outfitted with a new vocabulary, seemed to him and his fellow students somewhat silly. Fragonard's easy circulation among various modes of representation attests to his sophisticated stance vis à vis the old arguments. Perhaps the intellectual history of the period had no direct impact on the way Fragonard thought, but indirectly he must have absorbed the new passion to mistrust, to be skeptical about systems. "The taste for systems," d'Alembert had written in his preliminary discourse for the *Encyclopédie,* "a taste more appropriate for flattering the imagination than for enlightening the reason is today almost completely banished from sound treatises."[6] In the wild paradoxes of the century, the very systems the philosophes construed were constantly under attack by the authors themselves. They established the necessity of structures of thought but denied fixed systems. In this essential activity, they did affect the way art was apprehended, and, above all, the way it was taught. Fragonard was a beneficiary of the liberality of thought, the dynamic processes that were the hallmark of enlightenment.

During his lifetime Fragonard's work was assessed by other artists as "intelligent" and his nature was described as "ardent." The intelligence acknowledged by artists always presupposed an immanent history of their art that laymen sometimes suppose to be technical and therefore not lofty. Shoptalk is not exalted enough to be a mark of intelligence. From the mid-century on, the tug of war between critics, who included *amateurs* and men of letters as well as officials of the Academy, and practicing artists became exacerbated. Despite the high-minded approval of the arts on the part of the intellectuals of the *Encyclopédie,* there was always a lingering contempt for the handworkers whose educations were wanting.

The Baron de Grimm, who considered painting and sculpture important enough to engage Diderot to write on the Salons for his bulletins to the mighty of Europe, in an unguarded moment was capable of reporting of Carle Van Loo that "it was pathetic to hear him talk about painting . . . he could neither read nor write."[7] The feeling was mutual. The engraver Charles-Nicolas Cochin, perpetual secretary of the Academy, considered that literary men knew "next to nothing" about artists and art and ought not to set themselves up as public critics.[8] The hostility was so marked that the celebrated *salonniste* Mme Geoffrin was obliged to separate the two factions.[9] Toward 1750, she initiated the practice of holding one salon on Mondays for artists and *amateurs* and another on Wednesdays for philosophes and other littérateurs. Even so, her meddling in artists' lives, as beneficial as it might be economically, caused many to avoid her altogether. She had her regulars, however, and they were distinguished enough. They included Vernet, Boucher, Joseph-Marie Vien, Carle Van Loo, Louis-Jean-François Lagrenée, Greuze, Hubert Robert, the Comte de Caylus, and Cochin among others. Fragonard, who certainly would have been welcome, appears never to have taken up the habit of salon attendance. When he was in Boucher's shop, though, and later when he was under Van Loo's wing at the École Royale des Élèves Protégés, he heard about the evenings at Mme Geoffrin's and perhaps even heard Boucher grumble about her mild tyranny. In any case, much that transpired in the art world was discussed and initiated in the neutral territory of the salon, and Mme Geoffrin herself, who was a bourgeois and therefore never received by court circles, served as a kind of culture broker. Fragonard's absence from her salon, given that his close friends, including the Abbé de Saint Non and the painter Hubert Robert, were devoted attendants, is puzzling and suggests that he almost certainly made a decision to keep his distance equally from court and salon circles. All the same, the kind of exchanges that took place in Mme Geoffrin's salon created the ambience within which Fragonard worked.

The memoirs that report snatches of conversations at Mme Geoffrin's often include topics of conversation. For instance, the Comte de Caylus, a fervent admirer of the ancients and a scholar of their procedures, would expose his theory of ancient wax painting to the critique of the artists present, some of whom maintained a lively interest in the lost techniques. If Marigny were there, the issue of who would get one of the coveted studios in the Louvre might be raised, or the artists would regale him with their problems in dealing with the bureaucracy in his arts administration. If some of the wealthy dilettanti were present, Mme Geoffrin might try to arrange for some struggling young artist to be there and would tactfully exact a sale. If some ambitious tax farmer wished to buy his way into the cultured circles, Mme Geoffrin would allow him to consult her experts, sometimes on the spot, about some object or painting he was considering acquiring. Then, as now, it was not unusual for a dealer to let a potential buyer take a work home on

approval, and quite often these uneasy collectors wanted to make sure of its monetary value.[10]

Not all the objects or paintings that turned up on those Mondays were objects of speculation. An account by Henri, Comte de Beauregard, who was a fourteen-year-old painter visiting Paris in 1768, suggests the atmosphere and range of conversation. After dinner, at which it was customary for the guests to keep conversations on the light side (Mme Geoffrin was firm about that, as she was about eliminating totally all heated argument), the young count reports:

> Each one had brought something: Vernet a picture newly arrived from Italy, which they believe was a Correggio; M. de La Rochefoucauld a little picture painted in cameo upon marble and encrusted by a process of which no one knew the secret; M. Mariette a portfolio full of his most beautiful prints; M. Cochin some designs in pen and ink; and I, my pictures.[11]

This precocious painter happened to be there on one of the more civilized evenings. Sometimes when there were more painters present, among them Hubert Robert, known for his high spirits, the talk was more vigorous and beyond Mme Geoffrin's limits. Then the artists would betake themselves to the cafés and cabarets where they reverted to their more irreverent selves.

Few of the connoisseurs could really understand that these painters were talking about weighty matters that had profound philosophical implications when they exclaimed, as did Greuze: "It is incomprehensible to me that a man could, with the aid of merely a few powdered minerals, so animate a canvas, and, indeed, in pagan times I should have feared the fate of Prometheus."[12] The teachings of Shaftesbury, who said that the intuitive artist becomes "a second maker, a just Prometheus under Jove,"[13] modified by later French treatises, peer out of this sentence. The Goncourts had used Greuze's statement to deride his dreadful hubris, but they did not imagine that not only Greuze but most painters of sensibility during the eighteenth century questioned again and again the nature of the artistic transformation of matter and the meanings and sources of creativity. When Chardin says: "But who told you one paints with colors? One uses the colors but one paints with feelings," the simplicity of the statement covered a vast and lifelong speculation about the meaning of painting.[14] This statement has often been cited and too often put forward as evidence of the influence of Jean-Jacques Rousseau and Denis Diderot and the idea of sensibility as the overweening aesthetic of the time.

When Chardin repeated this characterization of painting, even the Goncourts took it as a sign of his good and modest character and missed the great ambition implicit in it. Chardin was quoted by several contemporaries as saying, "Painting is an island whose shore I have skirted."[15] Here, in the midst of the eighteenth-century celebration of reason and disciplined thinking is the undercur-

rent that would feed into the nineteenth century and the Romantic movement and even into the twentieth century, when the painters, also at mid-century, questioned and probed their relationship to their art and its often baffling history. Chardin's keen sense of the mysteries implicit in the transformations wrought in matter by the intuition, skill, and knowledge of the painter was influential during his lifetime and no doubt made its mark on Fragonard. Although almost all commentators have assumed that the young Fragonard assigned to Chardin's tutelage was impatient and unresponsive to Chardin's procedures, it is more appropriate to assume that Chardin's doubt, like Cézanne's doubt, as Picasso saw it, made a deep impression. Further, Chardin's visual intelligence and his ability to talk about his art (on which Diderot feasted so liberally) helped Fragonard to make his choices and confirmed him in his instinctive need to find the means to express the effects of color and light as they affected his feelings. In such a fluctuating moment in art history and with so much bewildering discussion, a young artist could take heart listening to the wise and eloquent discussion of painting available through Chardin, for whom the old universe with its reliable rules and methods was also no longer dependable. The empiricism that was moving into every field of endeavor during the eighteenth century had altered the universe of painting.

CHAPTER 2

The Painter's Apprentice

THROUGH THE volatile and expostulatory writings of Denis Diderot—the one philosophe whose imagination, once aroused, could attune itself finely to the pictorial arts—we are offered glimpses of the preoccupations of artists during the period when Fragonard was completing his training. Diderot had the merit of listening. In many of his more specific statements and his more acute judgments, we can hear Chardin, who, as Diderot said, "spoke marvelously" about painting. Or we hear the sculptor Falconet, who was Diderot's friend and tutor in sculpture. From the beginning of his belated career as art critic, Diderot noticed in the new talents brought forward by the greatly enlarged art world their free choices among the various established genres. He understood quickly that this moment—he began writing on art in 1759—was marked by a profusion of directions, and he defended artists whose "genres" were traditionally ranked low. He was particularly sensitive to the implications of the abandonment of the strict categories that had been imposed on painters in France for more than a century. He himself, together with his colleagues on the *Encyclopédie,* had contributed to the new, more relaxed attitudes. In his entry on eclecticism, published in volume 5 (1755), he opens:

> The eclectic is a philosopher who, trampling underfoot prejudice, tradition, venerability, universal assent, authority—in a word everything that overawes the crowd—dares to think for himself, to ascend to the clearest general principles, to examine them, discuss them, to admit nothing save on the testimony of his own reason and experience, and from all the philosophies he has analyzed without favor or partiality, to make one for himself, individual and personal, belonging to him.

It is not difficult to translate this manifesto into the art of painting. A young artist being trained, as was Fragonard, at the time Diderot published this entry, was only too ready to accept the general message. When Fragonard's own eclecticism

throughout his career is examined, it is obvious that the principles so much discussed at the time and succinctly enunciated by Diderot were congenial to his character and zestfully pursued.

Fragonard happened to be thrust into the world at a time when momentous changes were under way. This is no mere truism. The contemporaries in Fragonard's moment were strangely aware of what was so often called in contemporary writings a "fermentation of the mind." The active nature of fermentation was sensed by many and the spirit of change was regarded as the most characteristic signal of the time. Of course, every period regards itself in the light of change, but precisely at mid-century in France, the momentousness of widespread alterations in the status quo became obvious to many. The new awareness was very well articulated by Diderot's associate, the vivid Jean le Rond d'Alembert, in his essay *Éléments de philosophie,* published in 1759:

> If one examines carefully the mid-point of the century in which we live, the
> events which excite us or at any rate occupy our minds, our customs, our
> achievements, and even our diversions, it is difficult not to see that in some re-
> spects a very remarkable change in our ideas is taking place, a change whose
> rapidity seems to promise an even greater transformation to come. Time alone
> will tell what will be the goal, the nature, and the limits of this revolution.[1]

What d'Alembert was sensing in the world of philosophy, a kind of "effervescence," as he said, was equally true in the world of visual art. There was heightened activity in every aspect of the arts, a palpable sense of excitement, and Fragonard's quick temperament and his emotional readiness must have made him responsive. Although most art historians seem to believe that Fragonard was not intellectually inclined, he clearly responded to certain works of literature and probably followed, as did his peers, the growing and rather unruly literature of art criticism. In addition, this was a period of endless discussion. A visit to a café sufficed to arm a young painter with a host of novel propositions, many of them filtering down from the high circles of the philosophes. It is certain that the intuitions inspiring d'Alembert's statement were shared by the gifted artists of this era.

By the time Fragonard became an acknowledged young master, he had already had a varied experience of the world. The equipment he brought with him had been acquired from many sources and milieux, starting with the family circle in Grasse. Although the impact of his father's fortunes may have affected Fragonard, there is little hope of finding specific clues. We can only amass as many biographical details as possible and hope to illuminate, at least a little, the formation of his character.

There is very little precise information about Fragonard's father, François. Sources even disagree on the nature of his profession. He was most probably a shopkeeper in Grasse, a lofty old walled city that overlooked a rich plain. Described as a *gantier-parfumeur,* he was a member of the local guild, which listed

five categories. He was in the lowest. The popularity of scented leather goods was waning by the time the painter was born, and lesser members of the profession who were not able to convert quickly to the production of perfume alone were in straitened circumstances. Everything suggests that Fragonard's father was inept at business and given to extravagant dreams of future riches. His opportunity arrived in 1738 when his own father handed over a part of his inheritance, which Fragonard *père* may have invested in a scheme to outfit Paris with 123 fire hydrants, conceived by the royal superintendent of fire brigades. The scheme failed and François Fragonard, possibly in 1743, set out for Paris to try to recoup. Apparently he failed again, and, according to Wildenstein, took a position as clerk to a haberdasher.[2] Lacking any revealing documents, there has been much guesswork about Fragonard's family and its social position. Was Fragonard's father the black sheep of a prosperous bourgeois family, or was he simply a *petit-bourgeois* businessman who got caught in an irreversible economic malaise?

Whatever the case, the society to which the Fragonard family belonged was somewhat distinct from other provincial societies in eighteenth-century France. Grasse had had a long tradition of industry in which the titled nobility had little part. One historian has written:

> Social promotion is founded on enrichment through work. Nobility is considered as the desired end of generations of businessmen. . . . The essence of social power is thus confined to an oligarchy comprising either the ennobled families of rich businessmen and lawyers, or of families of the upper bourgeoisie of the same origin. . . . At the dawn of the revolution, then, there exists no opposition between the aristocracy and the bourgeoisie: the first is the happy issue of the second.[3]

Fragonard's father, then, had slipped down the social scale, but his family was nonetheless a part of the Grassois bourgeoisie that had, for more than a century, enjoyed relative prosperity. They admired music, literature, and the visual arts as insignia of their position.

The Fragonard family, once installed in Paris, had to struggle. Jean-Honoré was placed with a notary as a messenger boy and apprentice clerk when he was around fourteen or fifteen. As Jean-Jacques Lévêque has pointed out, his title was indicative of the kind of experience this extremely observant boy would have.[4] A messenger boy in France of the period was called a *saute ruisseau*—literally, a jumper of gutters—and there were plenty of foul gutters to jump. Paris was in an industrious moment of tearing down, building, expanding streets, and trying to clean up the fetid mess around increasingly populated areas. The city as it looked to the provincials who increasingly sought the pleasures, profits, and relative freedom of the big city, was described by Restif de La Bretonne, almost an exact contemporary of Fragonard, in his epistolary novel *Le Paysan et la paysanne pervertis:*

> Paris is an absolutely new world for provincials. It resembles our small coun-
> try towns even less than the latter resemble our villages. Just picture to your-
> self a vast collection of irregular buildings, some forming beautiful streets,
> whilst others have the most disagreeable aspect and give off the foulest stinks.
> There is one street, in a deserted quarter, which is forty feet wide, yet not
> three carriages pass through it a day. On the other hand, the rue de la Hu-
> chette, one of the most frequented of thoroughfares, is only five feet wide, so
> that at every moment one risks being crushed by the throng.[5]

As for the throng:

> Back home we find apathy, nonchalance, a relish for life, and at the same time
> the tranquility of acceptance. But here one finds bustle and activity and con-
> centration on business. . . . Nobody has any time to pay attention to his
> neighbor.[6]

The fifteen-year-old Fragonard wandering the thronged streets of the Châtelet
district probably noted his environs with a similar eye and an equally sensitive
nose. The smells were certainly a problem, as documents of the period attest. The
banks of the Seine were active ports where refuse abounded, fish rotted, and
women cooked masses of tripe, whose odor blighted the nearby streets. The police
were constantly issuing orders to householders to wash their stoops twice a day,
but little could be done about the muck in the gutters. Merchants of vegetables
were warned not to leave the stalks and leaves of artichokes in the streets or on the
square, but this seemed to be the least of evils. As for the sights, the painter Étienne
Jeaurat was busy documenting the life of the people in paintings that show both his
acquaintance with William Hogarth and his interest, parallel with Restif's, in the
many layers of Parisian society. Restif deftly describes the harassed lives of prosti-
tutes who were often rounded up by the police in the Saint Honoré quarter: "As I
watched I noticed a crowd of people; it was ten girls and four old women, escorted
by the foot patrol. The young ones were frantic; they were scantily clothed and
disheveled. I was revolted by the shameful behavior of the commissioner, who did
not permit—did not command—the wretched girls to dress."[7]

Jeaurat, a history painter whose character as a bon vivant drew Diderot's
disdain, left a number of precise images of the street life of Paris, one of which
shows a cartload of prostitutes being conducted to prison. Diderot was forced to
admire the painting, recalling some years later that there were two girls, one of
whom seemed desolate and the other who defiantly made the sign of the horns to
the commissioner.[8] The other painting he remembered is the companion piece,
shown in the Salon of 1757, in which Jeaurat offers a view of a street performance
from which historians of culture have been able to glean a great deal of informa-
tion. Students of Fragonard can deduce from it the kind of theatrical street life he
observed from his youth, which would later be transformed in some of his greatest
paintings.[9]

Fragonard was one of many artists who showed strong interest in urban life

around the middle of the eighteenth century. Numerous ditties and songs of the time have been recorded, and popular culture was a lucrative subject for artists. Christophe Huet's 1753 series representing the cries of Paris's vinegar and aubergine sellers would find a rich market when reproduced in porcelain by the factories in Meissen; effigies of street entertainers, such as the hurdy-gurdy players, were legion. Add to this store of imagery the impressions Fragonard had of his notary's well-heeled clients—their new apartments in the Marais district or their elegant shops—and Fragonard's initial formation as an impressionable youth can be imagined.

According to tradition, Fragonard's sojourn with the notary was relatively brief. The employer is said to have noticed the talent of his charge and counseled his mother to apprentice him instead to an artist. Her decision to do so indicates her ambition and also her familiarity with the artistic hierarchy, drawn perhaps from her concourse with cultured members of Grasse society. She brought young Fragonard, probably in 1748, to the most famous, rich, and sought-after painter active in Paris, François Boucher.

Fragonard was presented to Boucher at a time when the artist was beginning his extensive work for Mme de Pompadour. Commissions were already inundating him, and despite his boundless energy, even Boucher could not keep up. He had scarcely the time to take a raw youth under his wing, and he advised Mme Fragonard to take her son to Jean-Baptiste-Siméon Chardin. Tradition has it that Chardin set the boy to preparing his palette and making copies of prints after his own paintings. Wildenstein and almost all other writers on Fragonard accept the theory that Fragonard's vivid temperament rebelled at Chardin's laborious methods of teaching and that he quickly found the means of returning to Boucher. It is equally possible that Chardin was known for his skill at teaching the rudiments of good studio procedures and that Fragonard, who after all had had no training at all, needed these months to acquire the basic technical information of his craft.

Setting a palette in the eighteenth century was still a complicated ceremony. The colors needed to be ground, and the right recipe for their mixture had to be learned. The student had to become familiar with the way that different pigments responded to oil and turpentine and to learn the nuances of proper proportioning. Fragonard learned from Chardin's immense expertise, as did Diderot, that an artist had to be something of a chemist and something of a magician. For, as Diderot discovered with a certain wonderment, the painter's palette is made with bits of earth, essences of plants, powdered stones, oxidized substances, and metallic limestone that he must transform. Once the colors are established, based on the artist's observation of relationships of tone in nature, he can translate these rudimentary substances into painted images.

Diderot's response to "the harmony of colors and their reflections" was initiated by Chardin himself,[10] who was admired by connoisseurs for his ability to talk about painting with precision. Diderot wrote an appreciation of *The Olive*

Jar, in which Chardin's approach is admirably assimilated. In it we read what Chardin viewed as the essential means and ends of painting. One understands nothing of this magic, Diderot begins, with his usual conversational exclamation: "These are thick coats of color, applied one over the other, in which the effect transpires from the ground to the surface. At times one would say that it is a mist that one has blown on the canvas; elsewhere, a light spray that one has thrown on it. . . . You come closer, everything becomes foggy, flattens and disappears. Distance yourself and everything composes itself, reproduces itself."[11] When Chardin condensed his methods for the sake of his student and, according to tradition, told him, "You seek, you scrape, you rub, you glaze, and when you have got hold of something that pleases, the picture is finished,"[12] he passed on a method that Fragonard would later use, albeit quite differently. Above all, Fragonard remembered the sound methods of glazing, which he would use sparingly but crucially in his mature works. As he was augmenting his studies with Chardin by copying masterpieces in churches and private collections (to which he probably gained access through Chardin), these lessons were important.

Even Chardin's contemporaries were aware of his originality and understood, vaguely, that this repetition of certain still lifes was not mechanical; what he valued in painting went beyond the motif. His old friend Cochin saw his "natural simplicity" as a distinct quality and interpreted his preference for still life, correctly, as a means of revealing insights about light and form.[13] It was about the time Fragonard was admitted to the studio that Chardin was rededicating himself to still-life motifs. He would later himself seek to express values similar to those of Chardin in his landscapes. Fragonard's exposure at an early age to the kind of immanent ideal of painting that Chardin proffered was an important experience and probably, in later years, assumed more importance than is usually granted by critics. In addition to teaching the youth the secrets of painterly cuisine, Chardin was able to turn his attention to the self-sufficient beauty of light and color for which the objects he himself painted were both pretext and meaning. Even more important perhaps is the fact that it was probably Chardin who revealed to the apprentice Fragonard the genius of the long-dead Watteau. Knowing Chardin's intelligent connoisseurship, it may be assumed that he taught Fragonard, who would soon return to be accepted in Boucher's studio, that the value of Watteau's drawings and paintings went far beyond their subjects.

Boucher himself was a Watteau admirer and knew the work intimately.[14] He had participated in his youth in the etching of Watteau's complete oeuvre. He knew the Pierre Crozat collection well and arranged to have his students copy some of the choice paintings, among them Rembrandt's *Danae* and *The Sweeper.* Fragonard copied them both, together with two early Watteau paintings. The Crozat collection had 19,000 drawings and numerous paintings, including those by Rembrandt, Veronese, and Titian. Boucher himself collected wisely; he owned, among others, 137 works by Tiepolo, probably prints and drawings. If Fragonard entered

Boucher's studio when he was sixteen, such early exposure to old masters (the two that Boucher admired above all were Rembrandt and Rubens) affected his course of studies and was as important to his formation as Boucher's instruction, which was not dependent on theory but rather "brush in hand."

At the time Fragonard entered Boucher's studio, Boucher was at the height of his popularity. All the same, he could not have avoided being aware of a new policy, initiated by Lenormand de Tournehem, Pompadour's uncle, who had become minister of public buildings. His policy was frankly designed to force artists to return to the sober grand style of history painting. During the Régence the taste for heroic mythology had waned, giving way to scenes of the love of the gods or to *fêtes galantes*. If painters did attempt to work in the grand style with historical subjects, they often turned to Correggio as a model rather than the previously admired Raphael, and they gave their subjects a lighter treatment—the very treatment that Boucher epitomized.

But in the late 1740s there was already a voluble faction among art-world notables that condemned the frivolity of Régence painting. The rapidly growing influence of the theorists, with their conviction that only an artist well educated in the humanities and sciences could possibly be a great artist, was reflected in official policy when Tournehem attempted to pressure artists by cutting the prices of portraits and augmenting those of history paintings. He equipped the Academy library with books on theory, and, most importantly, established the École Royale des Élèves Protégés in 1748 in order to force-feed painters and sculptors with a lofty humanist education. Boucher, whom the man of letters Jean-François Marmontel mocked for his coarse diction, lack of formal education, and plebian tastes, was not to be intimidated. Marmontel, in his *Mémoires,* wrote that Boucher "had imaginative fire but little truth, and less nobility. He saw the Graces in evil places and painted Venus and the Virgin as footlight nymphs. His language as well as his pictures reflected the manners of his models and his workshop."[15]

Boucher had sufficient support in high places to withstand such sniping. He waged his war on the theoreticians through his students, whom he warned away from exaggerated reverence for old masters. His parting advice to Fragonard, when the young painter was about to leave for Italy, was *"si tu prends ces gens là [Michelangelo et Raphael] au serieux tu es garçon foutu!"* (If you take Michelangelo and Raphael seriously, you are a damned fool!)[16] To another student Boucher was less than honest when he told him: *"Pour ma part j'ai jadis fait cadeau a Sa Majesté de trois années du séjour italien qu'il m'avit octroyé, puisqu'au bout d'un an j'étais de retour à Paris où, m'abandonnant aux leçons de la nature, je fis de rapide progrès."* (For my part, I made a gift to His Majesty of three years of an Italian sojourn that he granted me, since at the end of a year, I returned to Paris where I abandoned myself to the lessons of nature and made rapid progress.)[17] In fact, Boucher did not return after a year, but the rest of the statement reflects his stubborn resistance and his point of view. For him, nature and not the Italian

masters was a primary source. While his mature style was certainly remote from natural verisimilitude, his drawings, especially of animals, often bespeak a close observation of nature. The apprentice Fragonard must often have heard Boucher mock intellectuals and admonish his pupils to stick close to nature even though he himself had little opportunity to sketch from life. He was frantically busy with the kind of commissioned paintings the intellectuals were beginning to find too frivolous and with work both for the manufactures of Beauvais and Gobelins and for the theater.

Amid all this activity, in which Fragonard probably assisted during his later years in Boucher's studio, the painter found time to spend with his students. There are testimonies, as Lévêque has pointed out, to the exceptional atmosphere of the atelier: "One can see the master taking his chocolate in the morning with a circle of students around him submitting their works. Between sips of the exquisite brew, which he was passionately fond of, he corrected with a quick, mischievous brush works which multiplied his pastoral and vulgar vision of mythology."[18] In the long-simmering argument between those defending the ancient and those advocating the modern, Boucher clearly stood with the moderns. The largest part of his oeuvre was produced on demand, and much of it was intended to be decorative.

Unlike some of his more testy colleagues, Boucher seemed almost never to have taken offense when someone proposed to supply a rather detailed program for a work. Mme de Pompadour, with whom he had an easy relationship, often came to him for specific required works, such as overdoors for one of her many residences, or, as some writers suggest, intimate paintings to stimulate the king. Boucher complied without compunction, and he was training his young apprentices similarly to make their way in the grand world of commissions and to know their business from every point of view. Fragonard watched as Boucher worked on two easel paintings ordered by Pompadour, *The Toilet of Venus* (Metropolitan Museum of Art, New York) and *The Bath of Venus* (National Gallery of Art, Washington, D.C.). Both were motifs that would assume importance for Fragonard once he embarked on his own career as a decorative painter. He learned from Boucher that a successful painter must be able to navigate in all waters.

Boucher's urbanity, which was a point of pride for him, was not perhaps on the scale of Rubens, who put himself at the service of the state in more ways than painting alone, but it seemed to suffice for the rapidly changing life in Paris. Class distinctions, which at one time kept men either in court or in the city but never both, were being blurred at a rapid pace in mid-century. A painter such as Boucher could frequent Versailles, Mme Geoffrin, and even actresses without real social stigma. In fact, Boucher and many others profited from the new manners by receiving both noble and bourgeois patrons in the studios. There are many memoirs by titled ladies as well as rich bourgeois describing visits to painters' studios. Then, as now, people believed there was an advantage, either economic or social, in penetrating the artist's studio and then dining over the quaint details. The

acquisition of creative people for one's salon was *bon ton.* During a visit to Paris of Louis XV, the indefatigable English visitor Horace Walpole remarked, "Every woman here has two authors planted in her house and heaven knows how carefully she waters them!"[19]

Boucher's involvement in theatrical decor was more than a matter of business. He was an aficionado. One of his best friends was the entrepreneur Jean Monnet, whose off-color wit was said to have enlivened Boucher's studio during evening leisure hours.[20] The Goncourts, who understood the importance of theater decor in Boucher's oeuvre, went to the trouble of consulting archives to establish that he worked on scenery at the Opéra in 1737, 1738, and 1739 and "again for a fee of 5,000 livres, from August 1744 to July 1748."[21] If Fragonard entered Boucher's studio early in 1748, he would still have seen the elaborate backdrops and props Boucher designed. French theater had already been in the process of transformation for two decades and was known throughout Europe for its extensive stage decor and magnificent machinery. Fragonard had the occasion to share evenings with Monnet. The Goncourts wrote:

> When Monnet, who was his friend, wished to revive the Opéra Comique and to assure his venture a brilliant debut, at the Foire Saint-Laurent in June 1743, with a parody of *Les Indes galantes,* it was Boucher whom he commissioned to design the highly successful scenery. For the theater built by Monnet in thirty-seven days for the Foire Saint-Laurent of 1752, Boucher designed almost the entire auditorium, the ceiling, the ornamentation, and the scenery, and he supervised all the painting. And at the Foire Saint-Germain, in 1754, it was again the talent and brush of Boucher that all Paris came to applaud in the decor for Noverre's ballet *Les Fêtes chinoises.*[22]

The theaters at the fairs had become so successful that the repertory of the Théâtre Français had to be revamped in order to compete. French society, which by Fragonard's time included people of all classes and professions, rushed to the unpredictable displays at the fair theaters. The wily promoters of alternative theaters sought to refresh theatrical tradition by healthy doses of vulgarity and popular idiom, much as Picasso, Cocteau, Milhaud, and Stravinsky later did in the twentieth century. Popular art forms abounded in mid-eighteenth-century Paris. The marionettes that became a passion at the time could be seen in performances that mixed many idioms and included specialties from tightrope walking to declaiming parodic verse.

Boucher's taste for the fairs was transmitted to Fragonard, who never forgot his first impressions and later incorporated strolling players and marionette theaters in his greatest works. Like his master Boucher, he enjoyed milling with the fair crowds, which included many students like himself as well as members of all other classes. Mixing with the people was in fashion, and many well-fed members of Parisian society prided themselves on their ability to get to know the lower orders. Restif, above all, boasted of his ability to talk to all sorts of people and to

know and understand their customs. However, when they were en masse, he tended to regard them as rabble, as did even his most liberal contemporaries. Perhaps Boucher shared that ambivalence, but it is likely that Fragonard was relatively dispassionate and could relate easily to people, as many of his drawings testify.

During an apprenticeship it was often necessary for a young artist to find a source of income. Fragonard had the advantage of working in a studio with older students who had begun to find ways to enter professional life. They ranged from designing endpapers and colophons for publishers to copying masterworks for private collections. One of Fragonard's friends at the studio was Pierre-Antoine Baudouin, nine years older and a favorite of Boucher, whose daughter Baudouin would later marry. Baudouin was already established as a painter of small erotic paintings suitable for the boudoirs of the rich. Many of his exquisite gouaches have served historians of manners well, for Baudouin was explicit in his descriptions of both the behavior of his upper-class subjects and their environment. Another future son-in-law, Jean-Baptiste Deshays, was only three years older than Fragonard but was already admired for his bold brushwork and sparkling colors, from which Fragonard may have learned. Unlike Baudouin, however, Deshays bowed to the growing demand for grand-manner history painting and would later be praised by Diderot for his austerity, which would not have appealed to Fragonard.

In Boucher's studio Fragonard developed certain interests that would last throughout his working life. Apart from the value of concourse with all kinds of people moving through Boucher's studio, there were other lessons. It is known, for instance, that Boucher endeavored to inspire his pupils with the poetry of Tasso and Ariosto, who were being revived at the time, partly through the enthusiasm of Voltaire. Boucher took particular interest in his students' careers and would have emphasized the importance of literary epics as sources for painting subjects. He himself had based his reception painting at the Academy on the theme of *Rinaldo and Armida*.

Although many art historians have insisted that Fragonard never read and could only have learned about the Italian poets through dramatizations at the theater, his frequent recourse to the Italian poets and above all his remarkable Ariosto drawings prove his genuine interest and an exceptional understanding, undoubtedly initiated while he was a student. Boucher's insistence that his students familiarize themselves with the great Italian tradition had another purpose as well. He knew that the tastes of the Academy had not changed much since his own presentation, and when he decided it was time for his students to try for the Prix de Rome he knew how to prepare them.

Rigors of the Academy in Paris

*A*LL WAS NOT silks, satins, chocolate, and the collections of precious stones, blue butterflies, and shells at Boucher's studio. Boucher was well aware of the situation at the Academy and of the demands for the grand manner. He was a friend of the influential Charles-Nicolas Cochin and a frequenter of Mme Geoffrin's salons, and he could guide Fragonard with confidence. When the young painter expressed doubts about competing for the Rome prize because of his lack of academic training, Boucher insisted: Do it. After all, he was Boucher's student. It was not only Boucher's vast prestige that permitted him to be so confident. Boucher, despite his own decorative style, was privy to Mme de Pompadour's decisions and may even have influenced them. There was a distinct and generally accepted cleavage between what was considered good for the state and what was considered good for its managers. Pompadour had sent her favorite young brother on the grand tour of Italy with Cochin as his guide. In 1751, when her uncle Tournehem died, she immediately made her brother, Abel Poisson, later the Marquis de Marigny, the chief arts administrator. Cochin's influence was enhanced when Marigny appointed him secretary at the Academy and used him as a liaison between the court and the artists of the Academy. Both Cochin and Marigny had returned from Italy with a great admiration for the grand machines of generations of Italian painters. They were intent on eliciting from French painters a renewal of interest in history painting. Neither of them saw any conflict between a private art, such as that produced by Boucher for Pompadour and Marigny himself, and a public art designed to broadcast the prestige of Louis XV.

The young artists in Boucher's studio did not have to rely on the grand tour to familiarize themselves with Italian painting. Paris was full of examples, and Fragonard knew them well. The Palais-Royal, to which even tourists had access, housed the collection of the regent who had sent Crozat to Italy to negotiate the

sale of the collection of Queen Christina of Sweden. This colorful monarch spent her last days in self-elected exile in Rome, where she augmented an already brilliant collection—official loot from Prague—with contemporary Italians of the late seventeenth century. Fragonard and his classmates could study with little effort some 25 paintings by Annibale Carracci, 2 by Caravaggio, 15 by Guido Reni, 8 by Domenichino, 21 by Titian, and 19 by Veronese. Louis XV's collection was also accessible to Fragonard thanks to Boucher's influence. In fact, early in 1752 while Fragonard was at work on his competition piece for the Prix de Rome, Pompadour persuaded the king to install 113 paintings from his collection of 1,228 in the Luxembourg palace, which was open to the public twice a week. Young painters could see works by Raphael, Correggio, Andrea del Sarto, Caravaggio, Titian, and Veronese, among others.

The subject for the Prix de Rome competition was established by Cochin, who chose a dramatic moment from the Old Testament, the story of Jéroboam in 1 Kings. A renegade king, Jéroboam had set up a golden calf and was burning incense and making an offering when a man of God appeared: "And he cried against the altar by the word of the Lord . . . and he gave a sign the same day, saying . . . the altar shall be rent and the ashes that are upon it shall be poured out." Fragonard's rendition of the story (fig. 4), which gained him the Prix de Rome as Boucher had expected, is couched in the conventions of the Italian High Baroque. In at least a formal sense the formulas of the Baroque masters were to remain congenial to Fragonard. "It was striking," René Huyghe has written, "when one compared his compositions, always to find large Rubensian diagonals which gave his paintings their general armature."[1]

For the composition of his competition painting, Fragonard adhered to the rules. Each figure group is a triangle within the greater triangle, with the golden calf at its crest. The scene is staged on a platform with *repoussoir* figures in the foreground and grand Roman columns opening out through an arch to the rear. A pastiche of the styles of many painters, Fragonard's work nevertheless shows the prowess of the twenty year old, not only in its firmly modeled figures and its bravura brushwork but also in the solution of the problem of pictorial unity. To that end he brings together two moments of the text, the gesture of Jéroboam and the shocked cry of the man of God. He combines this with his giving the sign.

In Fragonard's manner of treatment, it is clear that his taste tends toward the Venetian, particularly Veronese, and his contemporary Giambattista Tiepolo. (Could Boucher have conveyed to his pupil Cochin's enthusiasm for Piazzetta and Tiepolo at the conclusion of his trip in 1751?) The Venetian influence is evident in the man of God with his elegant robes and his beautifully painted white and gold turban. This figure heralds many of Fragonard's future paintings, with the intense light—white and in high relief—emphasizing the drama, which is paramount for him. The man of God's face also derives from Rembrandt's studies of old men.

FIGURE 4. *Jéroboam Sacrificing to the Idols*. École des Beaux-Arts, Paris.

Fragonard was later to show an intense interest in his heads of prophets, and chiaroscuro was important to him, as it was to the Italians Guercino and Luca Giordano, whom he would later admire in Italy.

Fragonard won the grand prize in 1752, but it was almost a year later, in May 1753, before he was admitted to the École Royale des Élèves Protégés. During the months he waited he may have continued in Boucher's studio, assisting him with commissions. It is possible that Fragonard undertook some commissions on his own, for his professionalism, even at such an early age, was already marked. He could work in several manners, retrieve various techniques and compositions from considerable experience in copying old masters, and adapt himself to the demands of the market. He nevertheless recognized that by modern standards he was ill-equipped for a successful career. It was no longer considered adequate for a painter to learn his métier in a working atelier. The whole point of the school that had been inaugurated four years before was to elevate the tastes and academic knowledge of young artists and bring them into direct contact with those who were energetically propounding theories. Fragonard willingly submitted to the program at the

school, even signing a petition later begging for an extension of his sojourn because of the excellence of the instruction of its director, Carle Van Loo.

Van Loo continued to uphold, at least some of the time, the official doctrines that had reigned for more than a century. The attitude of Antoine Coypel, an earlier director at the Academy, had remained intact when Van Loo took over the École. In a lecture of 1729 Coypel had set out his position (although he and his successors did not always adhere to their own rules):

> The most perfect type of painting is that which, molded in the artist's mind and imagination and wrought with his hand, is able to represent the figures of things and all the objects of nature. The hand, however, is what contributes least to the excellence of this art: the hand should obey the mind and is, so to speak, its slave.[2]

In order to bring the minds of the gifted protégés of the state up to an appropriate level, the routine at the school included strictly enforced attendance at classes in which students were lectured on history, which included the Bible, ancient Greek and Roman history, geography, mythology, history of costumes, and literature—mostly Homer, Ovid, Herodotus, and Virgil. Students were also required to copy from plaster casts of ancient sculptures, to which they had easy access since the school was located in an annex of the Louvre. To these academic exercises were added sessions with live models. Students were also expected to make the rounds of various collections for the purpose of copying the old masters.

All of this activity took care of the official position and its enforcement. But much else happened at the Academy. In spite of its carefully determined routine, the school was singularly open to many points of view, including many inimical to the Comte de Caylus, the aging *amateur* who had once known Watteau and whose views were diffidently accepted by the director, Carle Van Loo. It may well have been at the École where Fragonard was first exposed to the strong differences of opinion then reigning in the art world and where he learned to defend himself from the demands of so many voices.

The old Comte de Caylus was only one of the many, but he was still making his presence felt while Fragonard was in residence at the École. His was one of the many hectoring voices that began to invade the lives of painters, often raising their hackles. Marmontel, who in this instance is to be believed, condemned "the kind of domination over artists that he had usurped, which he abused, favoring medio-cre talents that paid him court and repressing those who, more proud of their talent, did not rush to solicit his support."[3] Fragonard could witness firsthand the effect of the count's imperious attitude; for unaccountably, Van Loo was painfully in awe of his dicta. Caylus was not the only one attempting to legislate what artists did. Criticism from outside official institutions began to flourish precisely during Fragonard's student years. The early significant attempt on the part of *amateurs* and lesser figures to redirect French painting was made by La Font de Saint-Yenne in his 1747 attack, *Réflexions sur quelques causes de l'état présent de la peinture en*

France (*Reflections on Certain Causes of the Present State of Painting in France*), a state that he found painfully wanting in dignity and grandeur.[4]

When the many assaults issued in the mid-eighteenth century on the taste for intimate and sometimes licentious painting are studied—ranging from the august pronouncements of Caylus to the pamphlets of minor scriveners who had suddenly found an outlet for their meager talents—the message is consistently the same: Go back to the days of Jean-Baptiste Colbert and Louis XIV, when grandeur ennobled the art of painting. Fragonard, as a pupil of Boucher and one well-attuned to Boucher's style, would have had to listen for the voices—and there were many among the *amateurs* and older painters—that defended the liberties of the artists and the value of their intuitions. Extending the arguments of the previous century between the Rubenists and Poussinists, these opponents of Caylus's classicizing stance prolonged the influence of the previous century's outstanding aesthetician (and Rubenist) Roger de Piles.

The surest signs of the serious effects of the rising tide of conflicting theories is in the way artists responded after 1750. Either they submitted to the prompting of what they considered the more cultivated *amateurs,* as did Fragonard's beloved mentor Van Loo, or they resisted, sometimes to the detriment of their official careers. The case of Van Loo is of particular interest, because he felt an affinity with his young colleague Fragonard, who, like himself, came up through the studio system and was relatively untutored in the things of the mind that so preoccupied Caylus.

Van Loo came of a family of professional artists who had come from Holland in the seventeenth century. He was orphaned early and brought up and trained by his older brother, Jean-Baptiste. He spent his childhood in Rome, where his brother saw to it that he had lessons with both a painter and a sculptor, and at fourteen he returned to Paris. By the age of nineteen he had won the grand prize that took him back to Italy in 1727, where he remained until 1734. Van Loo's success brought him a commission for a ceiling in San Isidoro in Rome. He was soon called to the court of Turin, where he flourished, working for the king of Sardinia and his courtiers. The court in Turin was extremely animated, and not the least of its courtly pleasures was the opera, to which Van Loo was strongly attracted. He soon met the daughter of the king's first physician. She was one of the rising stars in the opera. He courted her and won her hand. This marriage was natural enough for a young man who had spent most of his life in Italy, but when he brought her back to Paris in 1734, Mme Van Loo quickly became a source of immense admiration. Years later a young visitor exclaimed, "It was she who made Italian music known and loved in France," and spoke with great enthusiasm of "the little concerts to which only persons of distinction were admitted."[5] By all accounts Mme Van Loo was a charming and cultivated singer whose meridional warmth was much appreciated. She was the first of several women in the performing arts who would have a strong influence on Fragonard.

By the time Van Loo returned to France he had established a firm reputation. Within three years he won the attention of the court and was at work—along with Boucher, Charles Natoire, and Pierre-Charles Trémolières—decorating the Hôtel de Soubise, a masterpiece of Rococo decor. From then on he produced an oeuvre ranging from paintings for churches to genre scenes and allegories. He was immensely versatile and an indisputable success. Voltaire compared him to Raphael, while Grimm called him the greatest painter in Europe. Yet this highly competent artist stood in dread of falling short of the lofty demands of the learned *amateurs*. The Comte de Caylus had free access to Van Loo's studio and never hesitated to offer severe criticism of work in progress. By the time Fragonard was in residence, Van Loo had embarked on his classicizing new style. "He was," writes Marie-Catherine Sahut, "the first interpreter—before Vien, Doyen, and Deshays—of the battle led by the 'theoreticians' to revive history painting in France," and he led the reaction "against the affectations of the Rococo."[6] When Caylus made his critiques, Van Loo often fell into despair. He would paint out, scrape, and sometimes even destroy his work. When he called in his embarrassed students to ask their opinions, he would fly into a rage if they were frank, then apologize and give them a few sous to attend the theater. When Mme Geoffrin commissioned two paintings from him, suggesting both the theme and the way of handling it, he suffered her presence and bowed to her counsels. Diderot was one of several contemporaries who remarked on Van Loo's strange lack of assurance, despite his great fame, and in a swipe at Mme Geoffrin, reported that she presided over these works and that each day "there were scenes to make you die of laughing."[7] Such scenes, with Caylus, Mme Geoffrin, and the painter-critic Michel-François Dandré-Bardon, took place during the years of Fragonard's residence at the École and were the direct consequence of the official campaign to restore sobriety to painting.

Yet there was another side to Van Loo, a confident side that showed he could brush in a genre scene with skill and even inspiration in his more relaxed moments. He was, in certain moods, still an artist who could experience what the previous century had called "enthusiasm." That all was not so simple in his switch to the new austere style is apparent in the report of Christian de Mannlich, whose visits to the old painter occurred between 1762 and 1765. He found Van Loo "an artist in all the rigor of that term," who in his dedication sealed himself away in his studio and could tell even an archbishop to go to the devil. This old painter told the young German visitor: "Do not try to imitate Raphael. You will become cold as ice."[8] It was this attitude, harking back to Van Loo's Rococo youth, that no doubt made him a liberal teacher, appreciative of the individual traits of his students. His personal conflicts would only have made him more sympathetic to Fragonard and the other students.

These conflicts may well have extended into Van Loo's private life, for he was evidently by nature a convivial man. Ensconced in a comfortable apartment in the Louvre, he took pleasure in offering his charges the lavish hospitality of the south,

often inviting them to share evenings with his cultivated friends and patrons during which Mme Van Loo gave her little concerts. His own love of the theater and opera was communicated to his students. Fragonard was reported to have been a special favorite of Mme Van Loo, and it is safe to assume that he often participated in the musical life of the house. He was, in fact, in residence during the great debate, between 1752 and 1754, in which partisans of Italian opera, who defended Pergolesi's *La serva padrona,* attacked defenders of French opera. Jean-Jacques Rousseau led the Italian partisans, declaring in 1753 that "French songs were but a continuous barking intolerable to any unbiased ear," and he was seconded by a chorus of influential philosophes.[9] Students in Van Loo's charge were accustomed to hearing the impassioned arguments in his home, and they were encouraged to attend the opera as often as possible—not only the opera, but all the other theaters that flourished at the time and were, as Restif wrote, within the means of students:

> The best performance at the Opéra, where daily expenses amount to 800 livres, can be seen for 40 sous. At another theater, the Théâtre Français, which is more interesting and down-to-earth, one can get a seat for as little as 20 sous. It is the same at the Théâtre des Italiens, where they present fine plays and light music, which drives all Paris crazy with delight.[10]

Odd that Restif saw the Théâtre Français as "down-to-earth." Rousseau had seen it as pretentious, trying to mimic the grand style of the great tragedies of the seventeenth century. He dismissed it all as "scholarly nonsense."[11]

The spirited debates about the merits of Italian and French opera were matched by debates about individual singers, dancers, and actors. Paris was the most volatile of all European capitals, always on the lookout for new sensations and always critical. Such dancers as Marie Camargo, who revolutionized the ballet by performing leaps and wearing a tutu (which she invented) and shoes without high heels, became legends. Their private lives were never very private, and they provided endless salon topics. Casanova, who visited Paris as a professional musician and who was accustomed to the ample intrigues and gossip of Venice, was impressed by mid-century Paris, by the partisanship of its theatergoers and the foyers of its theaters, which were, as he wrote, "bazaars where lovers practiced their talents."[12] He also noted, with satisfaction, the current craze for the imported *furlana,* a Venetian dance of flirtation performed with tambourine, castanets, and mandolin.

This artistically booming Paris was the background for Fragonard's intense studies at the École where the daily routine was severely regimented. From seven thirty to nine o'clock the antiquary Dandré-Bardon made his charges read the Catholic theologian Jacques-Bénigne Bossuet and the great authors of antiquity. Then they went to draw in the Galerie d'Apollon. After lunch Van Loo corrected their drawings, and on fine days they were sent around Paris in a carriage to visit the châteaux where the best paintings in the royal collection were to be found. At five o'clock they returned for a life class. After the evening meal, they were often

expected to read from Homer, Virgil, and Ovid. In spite of this full schedule, most of the students found time to ramble around Paris and have an occasional romantic fling. The street life was rich in texture, particularly around the Louvre, where cafés and theaters were within walking distance.

If we take into account that Fragonard spent his twenty-first to twenty-fourth years at the École and that earlier he had spent several years in the heart of an immensely active art world under the tutelage of one of the best-known painters in the world, it is not hard to imagine the variety of experiences that he, with a temperament that was always described by contemporaries as "ardent," was able to encompass in those years. It was in this period of his life that he responded to certain experiences, such as music and theater, with emotional attachment that would have considerable meaning for the works of his maturity.

CHAPTER 4

Life at the Academy in Rome

N September 17, 1756, Fragonard received notice from Marigny that he was to proceed to Rome, leaving on October 20 together with three others. They were accompanied by Mme Van Loo, who entertained them in Turin before they reached the Academy in Rome in December. There is no way of knowing with what trepidation the twenty-four-year-old painter approached this fateful experience, although his petition to be allowed to remain longer in Paris suggests that he was somewhat reluctant to confront such a sharp break in his routine. Perhaps he had a premonition of the spiritual disarray awaiting him. He could not have imagined it would be in Italy that he would find his great release, his heightened moment of self-recognition—but in a way quite different from what the authorities at the Academy might have expected. It was soon evident that the mixture of diffidence and rebellion in Fragonard's temperament would bring him into conflict with the prevailing expectations.

His erratic course during his first year at the Academy, fortunately documented in the communications of the director, Charles Natoire, to Marigny, offers clues to the puzzle of his lifelong eclecticism. His epiphany during the summer of 1760, which would finally elicit the character of expression he had fruitlessly sought before and would mark his life's work, is crucial to the understanding of Fragonard's special vision and the distinct quality of his contribution. When Fragonard arrived at the Academy in Rome to take up residence in the Palazzo Mancini on the Corso, he had already spent about eight years absorbing the often contradictory advice tendered by his teachers. Most of what he had learned was based on copying and analyzing old masters and ancient casts. In addition, he had been exposed to a cargo of theories that, like most theories in the eighteenth century, were often self-contradictory and dramatically assertive. The students of his generation had been subjected to a barrage of learned advice from all quarters of the art world, as well as to the restive response of older artists to the new

45

conservatism. Pressures mounted, as did the varying possibilities for careers. The undeniable force of new ideas gathered considerable prestige, even among artists, when the first volumes of Diderot's *Encyclopédie* began appearing in 1751 and continued to be issued all during Fragonard's years at the École Royale des Élèves Protégés. The *amateurs* who functioned within the establishment were impressed by the authors of the *Encyclopédie* and redoubled their own efforts to put painting and sculpture in the proper light of the new learning.

Fragonard and the community of painters no doubt had private sessions in which they derided the intellectualism that threatened their particular knowledge. Yet the younger artists could not help being intimidated, at least in their moments of self-doubt. Even in the prevailing attitude toward Italy, which among the older painters such as Natoire and Boucher still amounted to a light-hearted appreciation of its warmth and color, there had been a gradual change. A long tradition of respect for the greatness of Italy—its antiquities and monuments and remarkable collection of works visible in public places—existed in France. But by mid-century the interest had become pedantically scientific. Gentlemen travelers now tended to seek out the treasures of Herculaneum and ancient Rome with an eye to cataloging, measuring, and recording, where once they were content to let their imaginations play. All of this was keenly felt by the young painters and their mentors. Fragonard's two teachers, Boucher and Van Loo, both of whom had had their time in Italy, contributed to Fragonard's malaise, since they were by 1756 at quite opposite ends of the spectrum of theories, with Van Loo giving way to the strict antiquarian Caylus and Boucher staunchly resisting. Yet Van Loo, for all his own uncertainty, was a different man in the studio with his younger colleagues, whom he urged to be attentive to the building up of colors, the shifting planes that art confers on objects. This is not merely a technical instruction, for it focuses on the apprehension of light and space. Judging from Fragonard's later conquest of the inner language of his own space, these sessions with Van Loo were helpful.

For all his studio experience, Fragonard had to submit yet again to a course of instruction at the Academy in Rome—a course he seems to have been ambivalent about. He arrived, after all, with Boucher's admonition in mind: If you take Michelangelo and Raphael seriously, you are lost. (One can imagine what Boucher might have said about taking the theoreticians seriously.) Boucher was not alone in trying to guard the students from an over-earnest, theoretical approach to painting in which only the old masters and ancients counted. The Abbé Gougenot, for instance, personally escorted Jean-Baptiste Greuze to Rome in order to protect him from the over-intellectual ardors of the Academy. Even Diderot, in one of his more engaging self-contradictions, would later deplore the flattening of learned styles and the loss of verve and poetry as the *esprit philosphique* spread. Yet, the entry in the *Encyclopédie* under the French Academy takes an utterly traditional view of the function of training in Rome. It doesn't advance much from Charles Montesquieu's 1728 opinions on the importance of ancient statuary: "These

statues cannot be sufficiently looked at, for it is from them that the moderns have built up their systems of proportions, and it is they which have practically given us the arts."[1] D'Alembert and Diderot in the *Encyclopédie* also laud the ancient statues that, "by the exact proportion and the elegant variety of their forms, served as models for the artists of the recent periods and must serve as models for all those of all centuries!" In addition, they proposed the same hackneyed recipe for improvement that had been parroted throughout the century by travelers: "This is where the works of artists like Michelangelo, Vignola, Domenichino, Raphael, and those of the ancient Greeks give silent lessons much superior to those which could be given by our greatest modern masters."[2]

Fragonard arrived in Rome with strong feelings but no clear objective in which to invest them. He was greeted by the director, Natoire, a man of the generation of 1700 who seems to have had a genial personality that made it difficult for him to meet the stringent requirements of the Paris administration. Although he consistently misspelled Fragonard's name in his frequent reports to Marigny, Natoire was basically sympathetic to Fragonard's personality and even indulgent. Natoire's reports to Marigny are among the very few documents about Fragonard, and despite their often stilted diction and patent attempts to please Marigny, they tell a great deal about Fragonard's initial difficulties in accommodating the demands put upon him. Natoire, following his own youthful course in Rome, set his students to copying Pietro da Cortona, Guido Reni, and the Carracci. He complained in the fall of 1757 that he could not send on the first copies because of the "weakness of their talent" and the students' inability to settle down.[3] Nine months later, Marigny criticized the male life study by Fragonard sent by Natoire, which "would have been more satisfactory if we had not been aware of the striking gifts he had already manifested in Paris." The following month Natoire answered Marigny, saying: "Fragonard, with his gifts, has an astonishing facility to change his stance from one moment to the next, which makes him work in an uneven way. These young minds are not easy to guide. I will try always to bring out their best without cramping them too much because you have to give talent a little freedom."

Still, the rigid studio routine of copying and making repeated academies from hired models prevailed. In October Marigny criticized Fragonard, and indirectly Natoire, for having made a male nude that was "too labored, too finished, his color lacks freshness . . . he should take courage and get back the old fire and that happy felicity he once had." To this Natoire, who had previously remarked that Fragonard had too *much* fire and too little patience, now answered that Marigny needn't fear that Fragonard will cool the fire that his talent naturally gave him: "It is true that sometimes it happens that from his wish to surpass himself he finds himself over his head, but I think that this one will easily recover that which nature has given him and I see, now and then, things which give me great hope." The vacillating course of instructions and criticisms reflected in these exchanges could only have exacerbated Fragonard's uneasiness during the first two years of his stay.

In a less reliable document, but one perhaps based on fact, Alexandre Lenoir quotes Fragonard on his first exposure to Italy:

> The energy of Michelangelo terrified me. I experienced an emotion which I was incapable of expressing; on seeing the beauties of Raphael, I was moved to tears, and the pencil fell from my hand; in the end, I remained for some months in a state of indolence which I lacked the strength to overcome, until I concentrated upon the study of such pictures as permitted the hope that I might one day rival them; it was then that Barocci, Pietro da Cortona, Solimena, and Tiepolo attracted my attention.[4]

The power centralized in the hand of Marigny and his lieutenants in arts administration certainly contributed to the problems of the young men who were probably thoroughly weary with being students by the time they had "settled down" at the Academy.

How imperious the men in charge in Paris were can be seen in a letter about Fragonard's companion, the irrepressible Hubert Robert. In this case, Marigny sent a criticism by Cochin "in which he advised the student to paint landscapes directly after nature rather than work in his studio, using more drawings of the Roman countryside as the basis for his canvases."[5] Robert was further counseled to improve his command of perspective and to perfect the figures in his paintings, which he could easily do by working from the model. Cochin added that "although it would require much application to remedy these faults, the student's great promise justified the effort." As it turned out, this advice was all to the good and justified Natoire in sending his students out on sketching trips—something he himself liked and had done in his own Academy years. Judging from a dated Fragonard drawing of 1758 of a ruin in the Coliseum (fig. 6), Natoire had encouraged these sorties to picturesque Roman sites but kept a wary eye to Paris. Marigny's approval spurred Natoire to release both Fragonard and Robert from onerous studio routines, allowing them to wander both in Rome and the campagna, where their affinities became apparent. Robert was a year younger, but he had been in Rome since 1754 and probably introduced Fragonard to its charms, both artistic and otherwise.

For all the stern commands from Paris and Marigny's and Cochin's attempts to make the Academy in Rome a kind of replica of the one in Paris, the situation in Rome was entirely different. These men were a little too old (twenty-three and twenty-four) to hold to a schoolroom environment, and in Rome there had always been a tradition of moving out into the city both for sketching motifs and for copying. No one could regiment Fragonard and Robert (who was a high-spirited daredevil, always taking on bets) once they stepped out onto the Corso in Rome. The long hand of Paris could not reach them there.

The Academy in Rome was situated in the very heart of one of the most international communities of Europe. Each day the Corso was thronged not only with the people of Rome attending to business but countless travelers, many from

England, on the grand tour, as well as clergymen either visiting or stationed in Rome. France especially had spawned numerous abbés whose sole religious duty was to collect taxes from their fiefs and cultivate their tastes for literature and art with the proceeds. Goethe, on his own grand tour in Rome twenty years later, spoke deprecatingly of these little abbés with their pretensions to culture.[6] Yet, it was from the more affluent clergy that many of the students could earn money on the side. The students were not averse to serving as their ciceroni or making copies of antiquities for them. Not far from the French Academy on the Corso was the Italian Academy of San Luca, with which the French had cordial relations. There was considerable concourse among students and faculty. The cafés on the side streets were generally well supplied with artists and students taking coffee and exchanging gossip at all hours of the day. The rigid routines of the French Academy in Paris could never have survived in Rome where, even then, *dolce far niente* was more than a proverb; it was a point of view. In these far more casual circumstances, Fragonard could indulge his taste for observing, and he could also participate, as art students in Rome were known to do, in an active night life of considerable gaiety in the rather numerous Roman celebrations of saints and, of course, the fabled Roman carnival (several previous students who had pressed their advantages too far had been expelled).

There are many sketches of residents at the academies in Rome depicting them studiously setting up their drawing boards in churches, above all Saint Peter's, and arduously copying dimly perceived works of other centuries. There are few firsthand accounts of the hours in between or of life after hours, but from anecdotes about Hubert Robert's exploits, such as his bet that he could traverse the dangerous ledge of Saint Peter's (which he apparently won), it can be assumed that he and his companion Frago, as the painter was known, made full use of the effervescent atmosphere of Rome.

Fragonard had arrived in Rome during December, a time of year when the life of Rome was heightened by numerous spectacles, many of them on the streets and, most particularly, on the Corso. Aside from the astoundingly colorful religious pageants both at Saint Peter's and in the many other churches punctuating any stroll in Rome, it was the custom to open all the theaters for the season on December 26. The theater season and its social festivities stretched out to the great theatrical events that made up the long carnival season in the spring. With his love of costumes and his interest in observing lively gestures, Fragonard was certainly among the worst of the offenders who Natoire said could not settle down. Rome had the full range of theater, as did Paris, and in addition, had many concerts. Only a year after Fragonard's arrival, the celebrated author Carlo Goldoni was called to Rome, where he lodged with one of the maligned abbés, fought with conservative actors from Naples who had not accepted his reforms (he had banished masks from his plays), and generally animated the discussion of modern theater among the cognoscenti. Goldoni complained in his memoirs of the power of the parterre,

traditionally reserved for the lesser clergy, students, and professionals of the middle classes: "The parterre in Rome is terrible," he wrote in 1758. "The abbés decide everything in a brilliant and vigorous manner . . . the whistles, the cries, the laughter, the echoing invective on every side."[7] The bluff Robert and the smiling Frago, whose interest in theater had been inspired years before, were undoubtedly among the whistlers.

Goldoni stayed long enough to experience the wild antics of the people of Rome during the eight days of carnival, which he said was "brilliant and magnificent."[8] He admired especially the exceptional number of accomplished street musicians and the Holy Week church music. As for the public spectacle, Goldoni, with his vested interest, was delighted. Like most notables, he had managed to get himself lodging on the Corso itself and witnessed the sale of places at windows and on balconies for the great parade of carriages and masked, costumed people who, as he noted, formed a crowd that abolished class distinctions.

Twenty years later, Goethe would document his own observations of the Roman carnival in considerable detail. Nothing had changed. The Corso, home of the Academy, was still the center stage. "The Roman carnival is not really a festival given *for* the people," he wrote, "but one the people give themselves."[9] He explained that, unlike religious festivals, there were no fireworks or illuminations of costumed processions: "All that happens is that, at a given signal, everyone has leave to be as mad and foolish as he likes, and almost everything except fisticuffs and stabbing is permissible." With guidebook precision, Goethe opened his description of the Roman carnival with a description of the Corso that serves very well to set the scene of Fragonard's daily life in Rome:

> Like many other long streets in Italian towns, it takes its name from the horse races with which each evening of the carnival concludes. . . . The Corso runs in a straight line from the Piazza del Popolo to the Piazza Venezia. It is approximately 3,500 paces long and lined with high, and for the most part, magnificent buildings. The width bears no proportion to its length or to the height of the buildings. The pavements on both sides take up from six to eight feet, leaving a space between which in most places is not more than twelve or fourteen paces wide, barely sufficient for three carriages to drive abreast.

There was nothing unique about the carnival, Goethe observed, since it was only a continuation of the pleasure drives that took place every Sunday and on feast days. (That makes it frequent, indeed, as anyone who has ever worked in present-day Rome knows all too well. It is a city with more feast days, almost, than working days.) The procession of carriages was orderly until the evening bells were rung, when all semblance of order disappeared.

As for the look of the throng: "There is nothing unfamiliar about seeing figures in fancy dress or masks out in the streets under the clear sky. They can be seen every day of the year . . . there seems to be carnival all year round." Showing a slight distaste, Goethe described the men of the lower classes in their more ribald

guises, such as a Pulcinella "with a large horn dangling from colored strings around his thighs. As he talks to women he manages to intimate with a slight, impudent movement the figure of the ancient God of Gardens—and in holy Rome!—but his frivolity excites more amusement than indignation." In considerable detail Goethe described the behavior and costumes of the crowd, noting that strangers had to resign themselves to being made fun of: "The foreign painters, especially those who, because they are studying landscape and architecture, have to sit and draw in public and are therefore a familiar sight to the Romans, often encounter caricatures of themselves running about in the carnival crowd in long frock-coats carrying enormous portfolios and gigantic pencils." Goethe noticed also the beautiful women and recorded the Roman practice, still apparent today, of loud comments, such as *"O, quanto é bella!"* He described the upper classes, with their confetti of sugar-coated almonds, and moved on to detail another kind of entertainment, not far from the French Academy, which may well have remained vivid in Fragonard's memory:

> The so-called *Capitano* of the Italian theater, in Spanish dress, with feathered hat and large gloves, steps forward from a crowd of maskers on a stand and begins telling the story of his great deeds by land and sea in stentorian tones. Before long he is challenged by a Pulcinella who, after pretending to accept everything in good faith, casts doubt and aspersions on the hero's tale and interrupts his rodomontade with puns and mock platitudes.

After a meticulous description of the race of the *barberi,* much like the visual record later by the painter Théodore Géricault, Goethe told how everyone unmasked and hurried to the theater after the final race. The theaters were the same as in Goldoni's description: "The Aliberti and the Argentina give *opera seria* with ballets between the acts; the Valle and the Capranica comedies and tragedies with comic operas as intermezzi. The Pace does the same, though its standards are lower; and there are many other minor kinds of performance, down to puppet shows and tightrope dancers. . . . The Romans have a passion for the stage."[10]

For art students, particularly those who were described by contemporaries as "ardent" and fun-loving, as both Robert and Fragonard were, these torrential festivities (as Goethe called them) were as instructive as they were exciting. The pagan overtone that Goethe found uncomfortable merely bolstered the young artists' interest in the antique past. Of all his many drawings after antique sculpture and reliefs, Fragonard's record of the robustly pagan anti-Christian deities is the most loving. Satyrs and Venuses never failed to rouse his interest, as in *Satyr Pressing Grapes beside a Tiger* (fig. 5). Then there were the traditional Italian declaimers, often reciting endless portions of Tasso and Ariosto by heart, significantly clad in Spanish dress, a costume Fragonard would relish depicting in his fantasy portraits ten years later.

These were events for a temperament that resisted the increasingly pedantic interest in the past, sponsored not only by the officials and *amateurs* back home

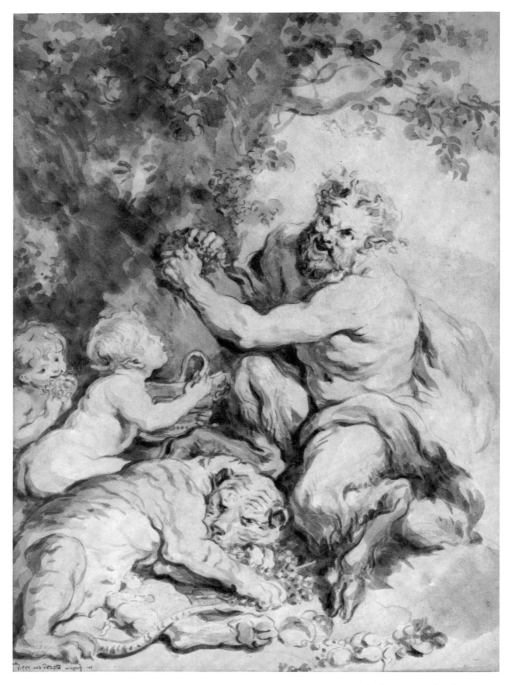

FIGURE 5. *Satyr Pressing Grapes beside a Tiger.* The Art Institute of Chicago, gift of Mr. and Mrs. Robert J. Hamman in honor of Suzanne Folds McCullagh, 1982.500. © 1987 The Art Institute of Chicago.

but also by the presence in Rome since 1755 of Johann Joachim Winckelmann, whose small book *Gedanken über die Nachahmung der gniechischen Werke in der Malerei und Bildhauerkunst* (*Thoughts on the Imitation of Greek Works in Painting and Sculpture*), published in 1755, was an international best seller. Winckelmann and his compliant disciple, the painter Anton Raffael Mengs, were almost instant celebrities in Rome and had powerful patronage. Winckelmann's importance, even during Fragonard's sojourn, was known to all art students. His challenge, as Lorenz Eitner has remarked, was drawn from intuition and vast reading rather than direct observation, and it had the intensity of daydream: "It was this wishful ideality which gave to his first book its special force, lifted it above the plodding antiquarianism of the scholars, and brought it to the attention of educated laymen throughout Europe."[11] Winckelmann was another of the little abbés, but his eloquence was instantly felt. To the endless nagging of Caylus and Cochin and Marigny, who pushed the students toward a sobriety that was often tempermentally foreign to them, was added the new vogue in Rome for Winckelmann's rather tendentious voice, which stated categorically in his 1755 booklet that "there is but one way for the moderns to become great, and perhaps unequalled; I mean, by imitating the ancients."[12] For Fragonard, who would soon find his way in a directly opposing direction, the gathering chorus of Winckelmann admirers, who agreed that there was something "superior to Nature—ideal beauties, brain-born images,"[13] could only have compounded his problem during the first two years of his Roman adventure.

Those first two years in Rome were crucial for Fragonard. Yet, except for the rather circumspect letters of Natoire and the brief quotation in which Fragonard admits paralysis in the face of Rome's great Renaissance treasures, there is little to suggest precisely how he found his way to his personal enlightenment. By all accounts Fragonard arrived in Italy during a period of immense activity—heated public discussions of artistic theory and ever-growing commerce both in antiquities and works by contemporary artists. An artist with strong feelings would be bound to resist the constant proselytizing from one side or the other. Already in Paris Fragonard moved in circles where pressure was mounting. The Italian courtier and writer Francesco Algarotti, who frequented Parisian salons, would write in 1756: "The philosophical spirit which has made such progress in our time and has penetrated all domains of knowledge, has in a certain manner become the censor of the fine arts."[14] Fragonard's strong instinct for artistic freedom and his probable sympathy for the basic tenets of this "philosophical spirit," particularly its rejection of bombastic historical (above all, religious) themes, no doubt brought daily conflict as he undertook his assigned tasks.

The one acceptable route for all parties was to use Rome and environs as a starting point. To the antiquarian minds in Paris, the recording of ancient Rome was a responsibility. To the abbés and connoisseurs, it was a gentleman's pleasure. Fortunately for Fragonard and his companion Robert, there were two personali-

ties in Rome who could both instruct and inspire and whose careers were well under way by the time the young French painters appeared in Rome. The first, with whom they would of necessity come into contact since he was a regular instructor at the Academy, was Giovanni Paolo Panini, who taught perspective to the French Academy students. Panini had a flourishing business in producing views of antique Rome. His composite renderings of famous sites, with columns, sculptures, and artifacts bought together, found a market not only among the nobility of Europe but among the increasing body of tourists, who achieved the double goal of acquiring souvenirs and acquiring social distinction through collecting. When Fragonard arrived, Panini had just been commissioned by the Duc de Choiseul, ambassador to Rome, "to paint an imaginary palatial gallery stocked with the greatest treasures of Ancient Rome" (now in the Staatsgalerie, Stuttgart). Panini's role with the students of the French Academy included teaching them the ropes with the new clientele. Through his connections in all the circles of Rome—and they were many and complex—he could pass on little commissions, such as being ciceroni for important visitors, recording a specific site or artifact for an *amateur,* or even copying one of his own compositions for potential sale.

The other important figure with whom the young French painters came into contact was Giovanni Battista Piranesi, who, though only twelve years older than Fragonard, was one of the most significant artists working in Rome and enjoyed an international reputation.[15] Sometime around 1746 Piranesi had established his printing presses opposite the Palazzo Mancini on the Corso, and his workshop was known as a place where artists frequently met and talked. Even when he removed his shop to Trinità da Monte, it remained a gathering place for young artists.

It is known that Hubert Robert spent time with Piranesi and even went on sketching trips with him. It is possible that Fragonard too was personally acquainted with the great figure. In any case, he would have known Piranesi's engravings firsthand since the Academy acquired them for use in teaching. The effects of having personal concourse with so volatile and eccentric an artist whose interests were broad and who bristled with opinions and theories are incalculable. Conversance with Piranesi's much-discussed publications—the *Antichità romane,* available even before Fragonard and Robert left Paris, and the *Carceri*—was widespread among students. Through his publications Piranesi challenged other antiquarians, offering unexpected viewpoints and in general maintaining an eccentric position. Students who had discussions with him knew how complicated this artist was. He who had spoken in 1743 so poetically of *queste parlante ruini*—these speaking ruins—took issue with the conventional notions of the painters of ruins and went far beyond them in his speculations on the role of nature. In 1765 in his *Parere su l'architectture* Piranesi quoted Ovid's last book of *Metamorphoses* on a plate inscribed with nature as "the great renewer" that "makes form from form." This odd note in eighteenth-century discourse is seen by certain art historians as a proto-Romantic avatar, and certainly Piranesi's random thoughts far outshine

those of his contemporaries and carry prophetic overtones. The question of nature and, above all, ruins in nature was much discussed by mid-century. Algarotti thought the philosophes had laid the groundwork, and he was probably right. Anyone who assesses mid-century attitudes toward nature will be struck by the chaotic body of thoughts that occur with lightning rapidity and that are often contradicted from one sentence to another. The speculative tone is their most notable feature. For artists pondering the importance of ruins, the choice of intellectual perspectives was widening almost beyond endurance.

The encyclopedists, above all the Baron d'Holbach, were generally believers in scientific definitions of nature and, as d'Holbach would later write, saw nature as "the great total that results from the assemblage of different matters, their differing combinations, and their differing movements that we see in the universe."[16] Man, he said, "is found in nature and is a part of it; he acts according to laws that are appropriate to him, and he receives, in a manner more or less marked, the action and impulsion of beings that act on him, after laws appropriate to their essence . . . but his actions are always composed of his own energy, and of that of the beings that act on him."[17] He was a monist.

Diderot, however, who had to wrestle with the existence of art that so often seemed to flout the laws of nature, had recourse to the idea of genius in whom the energy of nature is liberated. The existence of inflexible laws could not be tolerated in an aesthetic as complicated and variable as Diderot's and, for that matter, many others after the mid-century. As Jacques Chouillet has pointed out: "From 1757 to 1763 throughout Europe and particularly in the *Conjectures on Original Composition* by Edward Young, the idea according to which it is genius that creates the rules of art and not the rules that create genius was affirmed."[18] Diderot mused frequently on the role of nature and merged a lyrical vision of time and history with a basic belief in the ineluctability of matter itself. Nothing better illustrates the force of the new aesthetic attitudes derived from the contemplation of ruins than his response in the Salon of 1767 to the work of Hubert Robert:

> The ideas which the ruins arouse in me are large. Everything is obliterated, everything perishes, everything passes, there is only the world that remains, there is only time that lasts. How old this world is! I walk between two eternities. In one direction where I cast my eyes, the objects that surround me announce an end and prepare me to resign to that which awaits me. What is my ephemeral existence in comparison with that of this rock that sinks, that valley that grows hollow, that forest that quivers, these suspended masses above my head that shudder.[19]

From around the time Fragonard began to seek his own way, the concept of nature was rapidly changing. Academicians still spoke of imitating nature in the Aristotelian tradition, but nature by 1750 had been transformed into an integral part of the whole universe, or rather, nature *was* the universe and all it contained. Probably because of the radical shift in the view of nature, those who were busily

rendering views of Roman ruins and of the campagna to sell to English tourists and others had begun to include picturesque landscapes, often directly observed, in their drawings and prints.

Fortunately for Fragonard and Robert, drawings were not only a method of learning but, by the time they were active in Rome, constituted a handy source of income. The trafficking in drawings—not only presentation drawings but sketches in situ as well—was already a tradition in the days of Claude Lorrain and Poussin, and in Boucher's youthful days a major artist could appoint his household comfortably from the proceeds of his drawings alone. When Natoire released his charges to the city and its environs, he was not only retrieving the practices of his own youth at the Academy but he was also fulfilling the new demand for the casual view—the "natural"—with all its unpredictability.

For all the change in the concept of the natural, no one yet believed that the routines of the students at the Academy should be altered in any way. They would still draw the *Gladiator* and the *Laocoön*, according to Nicolas-Bernard Lépicié in 1749, "and the other remains of antiquity from which the constant study had formed Raphael, the Domenichinos, and the Carracci."[20] The Palazzo Mancini was very well stocked with casts:

> As the visitor climbed up the staircase to the first floor, he saw the *Farnese Hercules* in a well-lit niche to his left; a little farther up, along rather a dark corridor, was the *Farnese Flora;* flanking the door in the first room were the *Lion* and the *Boar;* beyond, could be seen *Paetus and Arria,* and next to the Niobe clutching her young daughter from the *Niobe* group . . . in one large room were the *Dancing Faun,* the *Commodus as Hercules,* the *Antinous,* the *Germanicus,* the *Cincinnatus,* the children of *Niobe* . . . and everywhere, elegantly placed, were plaster versions of those statues whose proportions had been measured and whose features had been analyzed by artists and scholars from all over Europe: the *Laocoön,* the *Dying Gladiator,* the *Spinario,* the *Hermaphrodite.*[21]

With surprising tenacity the idea of copying ancient statues, usually Roman copies after the Greek, remained unshakable in academies right up to the twentieth century, when Willem de Kooning could still describe the gallery of plaster copies that he had to draw in the Academy.

By the time of Fragonard's Roman training, there were more than enough books to consult, such as Bernard de Montfaucon's *Antiquité expliquée* (*Antiquity Explained*), first published in 1719. In addition, the Academy itself housed casts of certain of the most frequently mentioned sculptures. Fragonard did not relish detailed drawings after the muscle-bound, heavy Hercules in the Academy's collection or the even more weighty *Gladiator* in the Campidoglio museum. We know these onerous copying jobs did not appeal to him since the types of the Roman heroes never again appear in his work. However, he might have enjoyed working after the cast of the dancing faun—that enchanting plebian boy with his cymbals—

or the plaster of the boy removing a thorn, or the boy binding his sandal, or the many versions all over Rome of the crouching Venus in the Villa Medici—for these gestures enter his subsequent works. Later, when he would use the language of statues in an allegorical way, these early studies contributed, but unexpectedly so. A certain excitement was still possible for the students. The Scottish archaeologist and dealer Gavin Hamilton was still finding extraordinary works at Hadrian's Villa (which since the 1700s had been a focus of excavation), and works from the south, particularly Naples, were flowing into the Roman market. If the students were expected to render the expressions on the faces of the *Laocoön* (the great vogue for *têtes d'expression* was in full force), they were also expected to see the historical connection in High Renaissance and Baroque paintings all over Rome. Ancient painting, on the other hand, was beginning to be reassessed. Ever since the seventeenth century, for instance, artists had known the Vatican fresco known as *The Aldobrandini Wedding* from a Roman villa. It had been admired for its friezelike simplicity long before the neoclassic theorists addressed it. Fragonard, like the others, knew it and probably appreciated the graceful drawing, the elegant rendering of simple Roman draped clothing, and the femininity of the figures. Yet there was more to be gleaned from this fresco, which was indelibly fixed in the memories of generations of painters. The simple juxtapositions of ocher, rose, browns, and blue-grays occur in later Fragonard works, as does the sensuous contraposto of the beautiful serving girl. (Did Matisse remember her in his sculpture *La Serpentine?*)

There is every reason to believe that Fragonard was actively seeking precedents for his own need to lighten his palette and seek painterly approaches to light on form. He himself mentioned his discovery of Tiepolo, the contemporary whose reputation was international and who was still working in Italy at the time. Piranesi had studied with Tiepolo and talked about him in Rome. Travelers came through the Academy with accounts of his wondrous decor for the Ca Rezzonico in Venice, finished in 1758. Still, students were not expected to be overzealous in their interest in Tiepolo if they could hark back to the past. If Fragonard was attentive, it had to be with a sidelong glance, and the implicit lessons would have to be stored for later. Tiepolo could never match the ancients in the eyes of the authorities who, although they coveted his works for themselves, felt that artists at the Academy ought to follow more hallowed models.

CHAPTER 5

Nature as Art, Art as Artifice

*T*HE PROBLEM OF fashion in the arts has a long history. Dante lamented the short artistic life of poets and painters in his century and Diderot concurred, writing several centuries later in *Le Neveu de Rameau* that "no one, not even a pretty woman who wakes up to find a pimple on her nose feels so vexed as an author who threatens to survive his own reputation." Casanova, writing about Paris, remarked that the "divinities worshiped here, though no altars are raised to them, are novelty and fashion."[1] Demands for change—cloaked in lofty rhetoric but derived from eternal human restlessness and surfeit— multiplied in Fragonard's day. The reasons are complex. One was certainly the fact that there was a war going on. The Seven Years' War, which ended in 1763, may not have affected social life in the metropole as obviously as some historians suggest, but it certainly altered the way the visual arts were commanded and consumed. The crown had little money to indulge in artistic patronage, while on the other hand the bourgeoisie was expanding and eager to make its impact on the art world. Collectors increasingly ignored attempts by the officials to manufacture canons of taste, finding the variety in the art forms flourishing at mid-century far more satisfying than the limited modes decreed by the ambitious art managers of the state.

The keen appetite for change worked in Fragonard's favor. His own proclivities were, fortunately, beginning to find favor with the *amateurs* who still flocked to Italy, even during the war. These *amateurs* came with new perspectives. Even the terminology of art appreciation was new. Received ideas of nobility in drawing and composition had been drastically altered by the new emphasis on the word "natural." Suddenly, everything that was good was declared natural and everything that was natural was declared good. Even so unnatural a way of composing as the upstart Greuze's newly acclaimed rural bourgeois scenes was declared good because the "sentiment" expressed was considered "natural." More directly, when

Claude-Henri Wâtelet wrote the *Encyclopédie* entry on drawing, he spoke of nature, "that inexhaustible source of variety," and said that no matter how imaginative an artist was, he would only repeat himself if he did not have constant recourse to nature. Since what was natural was good, then the sketch, which was to prove Fragonard's psychological salvation during the exceptional summer of 1760, was gaining in importance. Views of nature were already in vogue among tourists by the mid-eighteenth century, sought as souvenirs of the grand tour, and so there was a flourishing industry in Rome. Either as a result of this redoubled enthusiasm for landscape or as one of the causes, the sketch began to be seen as more valuable than it had for decades. Its necessary incompleteness was once again a virtue. By the time Diderot brought his lively pen to bear on the subject of the sketch, a considerable literature already existed. His remarks in the Salon of 1765 reflect the opinions that had prevailed among connoisseurs for more than twenty years but were constantly gaining in currency:

> Sketches have a fire that the painting doesn't have. It is the moment of heat of the artist, pure verve, without any mixture of cuisine [*apprêt*] that reflection impresses on everything; it is the soul of the painter that freely expands on the canvas. The more the expression in the arts is vague, the more the imagination is at ease.[2]

The taste for the sketch after nature did not ultimately displace the accepted belief in the hierarchy in genres. Any *amateur* professing great love for the unfinished sketch or for the pure landscape painting would have hastened to add that, of course, it could never be as noble as history painting. In practice, however, the hegemony of the Academy with its hierarchy of genres had been slipping for years. No true connoisseur would have dismissed Chardin, although he worked in an inferior genre. The change in taste was a fact, and it made Fragonard's choices somewhat less difficult in Rome. He could bypass the sentimental classicizing of his most celebrated Italian contemporary, Pompeo Batoni, by working toward distinction as a landscape artist.

By 1758 Fragonard was finding his way, taking himself in hand and setting off on his own course, indicated by one of his few dated drawings, *View of the Hermit's Courtyard in the Coliseum* (fig. 6). He and Hubert Robert had betaken themselves to the Coliseum, where the ruins of ancient Rome had supplied standard motifs to generations of academicians. There is, however, something quite distinct about Fragonard's approach, even in this early and somewhat tentative essay. It abounds in "naturalness." Fragonard deliberately chose a nonheroic vantage point. There are no towering masses, no remnants of ancient grandeur here. Rather, he and his sketching companion take a modest corner known as the hermit's courtyard and, in bringing it close to the picture plane, render its details with meticulous care—a ladder, an overturned basket, planks of rotting wood, and weeds. Instead of an evocation of the grandeur of vanished, ancient Rome,

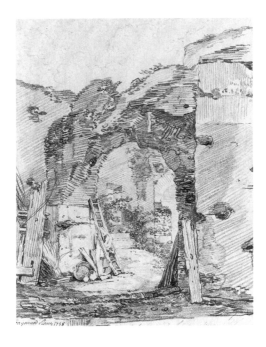

FIGURE 6. *View of the Hermit's Courtyard in the Coliseum.* Private collection.

this becomes a contemporary inhabited corner of the modern, dilapidated city.

It is true that Dutch seventeenth-century artists and some other artists in Rome at the same time had specialized in such homely realism, but for Fragonard it was probably not their precedent that inspired his approach but rather a liberty that came to him, that was seized *sur le motif*. He used the standard vocabulary of the draftsman—hatching laid on broadly for light areas or closely for dark ones—but already his idiosyncrasies were being formed, as can be seen in his special affinity for light that almost obliterates the solid masonry. Also, a lifelong practice was already present: that of finding an almost perfect center to establish a middle ground with a vertical placed firmly as a point of reference. Light radiates from the center, although complex elements such as the sequence of diagonals in ladder and boards modify this simple expedient.

Although this drawing is still a student's exercise, it shows Fragonard's instinctive craving for light and a certain ease that, judging by Natoire's reports, Fragonard could not find in more ambitious subjects. He needed to move away from the conflicting demands of various parties in the art establishment—demands for morality, imitative precision, historic fantasy, or even imagination—and find his own way to artistic freedom. He was beginning to understand the basic paradox in the life of the painter, that a painter must be responsible for the choice of what to paint, while understanding that the activity of painting is, in itself, in its very procedures, another language—another subject that must somehow be harnessed to the final legibility of the work.

As the growing popular interest in a broader field of possible subjects para-doxically brought forth an increasingly restrictive commentary, artists of marked talent were tempted to flee from the fray and concede to their innate proclivities. That flight, begun in the mid-eighteenth century, would culminate in the nine-teenth century in the art-for-art's-sake movement—a defensive movement spawned by the increasingly imperious (if well meant) demands of Davidian mor-alizers on the one hand and socialist moralizers on the other. The need to spring free expressed itself in Fragonard early in his career, and it was landscape painting that would release him. His works all through his career testify to an instinctive resistance to being categorized.

In January 1759 Natoire wrote a letter to Marigny assuring him that he had let his charges loose in the landscape. This was in direct response to one of the many demands emanating from the circle of *amateurs* whose new power, evidenced in the striking increase in written commentary, infiltrated official policy. Their swings from one idea to another can be observed already in 1744, when the influen-tial connoisseur Jean-Pierre Mariette complained that artists were neglecting land-scape:

> Our best masters rarely devote themselves to this kind of study: they regard
> the pieces of Landscape that they deign to chance to spend a few moments on,
> as an amusement or a distraction: it is uncommon to see such things from
> their hands despite the beauties that are appreciated in them, and the unani-
> mous approval that such productions generally earn.[3]

By 1759 the situation had changed, and it was possible for Natoire, who himself was an enthusiastic landscape sketcher, to direct his charges to develop their abilities by drawing *sur le motif,* with full approval from Paris.

Fragonard was the most significant beneficiary of the new policy, since Hu-bert Robert had already acquired powerful patrons who wanted his landscapes and were prepared to pay well for them. Neither of the two painters had come completely unprepared, for even in Paris there had been some attention given to the art of landscape drawing. Fragonard's rummaging for picturesque corners in the Roman campagna and his sketching in the neglected gardens of the once princely palazzos of Rome and its suburbs had to some degree been initiated during his early student years. Stored in his visual memory, and retrieved when he was fully ready, were certain drawings by Watteau, Jacob van Ruisdael, and Rembrandt, who had served his master Boucher as models.

Fragonard's intimate concourse with Boucher extended beyond his student years and into the period when Boucher was both evolving a new approach to theater decor and assisting his close friend Claude-Henri Wâtelet in designing his new château and gardens at Moulin Joli à Colombes, begun in 1754. Boucher brought to this adventure his enthusiasm for the ruins wrought by nature when it was allowed to flourish without restraint. He had conceived this taste during the

1730s, when he sketched the disarray of the Prince de Guise's neglected garden. The prince's estate at Arcueil had been renowned since the days of Ronsard for its fountains and complicated waterplays and the remains of an ancient aqueduct. Encouraged by Jean-Baptiste Oudry, whose special preserve it was, Boucher spent many afternoons at Arcueil with his sketch pad. When Wâtelet began to think about his own plans, Boucher had much to contribute to the romantic scheme.

The taste for picturesque ruins that had been gaining ground for several decades was given a forceful thrust by a new literature of theoretical writing that emanated from England and was adapted in France by a new generation of architects seeking to advance beyond the powerful, formal designs of André Le Nôtre. The artful construction of the artless, seemingly wild garden, complete with its carefully constructed ruins, was not only in vogue when Boucher worked with Wâtelet but was soon given a mighty impetus by the publication in 1761 of Rousseau's *La Nouvelle Héloïse,* in which the heroine strives to have nature make her garden natural but "under my direction." The ambitions of the new garden enthusiasts had their diverse sources, but it was perhaps also a function of contemporary circumstance reaching back to the disastrous end of Louis XIV's regime, as William Howard Adams has suggested:

> The growing bankruptcy of the government during the decade before the King's death in 1715 can be followed in the records of the declining expenditure on the royal gardens. For example, the annual cost of maintaining Marly's terraces and gardens was nearly 100,000 livres in 1698. By 1712 the yearly expenditures had fallen to less than 5,000. What this meant to the precise, architectonic lines dictated by rules designed to control not only space but time as well, where trees were not to exceed a predetermined height by natural growth, can only be imagined. The Sun King's gardens, like his wars, were eventually reckoned in terms of the national debt. Liberated by the declining fortunes of the state, nature itself quickly reached out for a new freedom, enclosing avenues and filling in the open garden rooms of the Tuileries and the Luxembourg, embracing the classical statues, balustrades, and urns. Nature's metamorphosis transformed the old geometry into a poetically overgrown, seedy, Italianate landscape.[4]

What the fortunes of war had wrought—or at least partly—was turned to good account by French artists beginning with Watteau. When Wâtelet set out to produce a "natural" garden at Moulin Joli, Boucher's memory of Watteau was stirred. Wâtelet, who was very popular among the artists, had extravagant ambitions. His generation had been exposed to the first impact of Rousseau and Voltaire, and he was influenced by both. He had also become sympathetic to the utopian, bucolic views of the Physiocrats. It is quite possible that Fragonard encountered Wâtelet during that time in Boucher's studio; in any case, he knew of Wâtelet's bizarre plan, as did all of the art world in 1754, to join two islands in the Seine by a pontoon

bridge, to be accomplished quickly and very soon to be a rendezvous for encyclo-pedists and artists. Wâtelet's fantasy was too much for some visitors, though. His views were mocked by Horace Walpole, who on a visit to Moulin Joli wrote in his journal that Wâtelet's approach was simply to find a wilderness "full of willows, cram it full of small elms and poplar pines, strip them in cradles and cut them into paths and have all the rest as rough as you found it."[5] On another occasion Walpole's sarcasm extended even to the behavior of Wâtelet's numerous guests: "How sociable to shake hands over a brook from two miniature mountain tops! Only such an amiable nation could have had the idea."[6]

Making an artificial confection of the natural, with all the paradoxical over-tones that this implies, was not without precedent in France, however, and the history of landscape gardening is closely enough woven with that of the visual arts to provide a background for the formation of a painter such as Fragonard, for whom those wild gardens were primary materials. Ever since the sixteenth cen-tury, gardens had been the collective product of architects, artists, poets, and at times even composers. Once the idea of the garden as a capriccio was imported from Italy, it gained distinctive features in the court of France. During the seven-teenth century there had been intense interest in the great tradition of outdoor festivals staged by artists. Those artists who doubled as theater designers were in great demand for the construction of glades, grottoes, and calculated vistas. By the mid-eighteenth century landscape gardening had been indelibly marked by the flourishing and widely varied theater in France. Designers saw landscape in epi-sodic terms, as in the opera, and spoke to their patrons of the shifting of "scenes." No one would have undertaken a new garden design without employing a painter who would provide a satisfying illusion that the architect could follow. The picto-rial aspect of gardening was as important in the gardens—which were often con-ceived as outdoor theaters, at least metaphorically—as it was in the theater. Bou-cher's stage sets were admired for their allusion to picturesque views and, in turn, were the basis for the production of new picturesque views in private gardens. The Abbé Gougenot praised his sets in 1748 for their "happy mixture of views of Rome and Tivoli with those of Sceaux and Arcueil."[7] In Fragonard's tenure as student it was taken for granted that he would be familiar with the intricate relationships among theater, landscape gardening, and painting and that this knowledge would stand him in good stead when he arrived in Rome.

Once in Rome, art students encountered the local tradition that had influ-enced many of France's planners and in which there was a strong literary incre-ment. The legendary Society of Arcadia—a loose association originally sponsored by the eccentric Queen Christina of Sweden—was still active, if somewhat de-based, in Fragonard's time. The society had originally been named for Sannazaro's poem *Arcadia,* which opens with the celebrated lines:

More often than not, the high and spreading trees
brought forth by nature on the shaggy mountains
are wont to bring greater pleasure to those who view them
than the cultivated trees pruned and thinned
by cunning hands in ornamental gardens.[8]

The society that took shape shortly after Queen Christina's death in 1689 was founded to exterminate bad taste and to restore what the poets saw as the simple pastoral values once described by Virgil. The first meetings were held in October 1690 in Queen Christina's gardens at the Palazzo Riario, lush with jasmine, ilex, lemon, and orange trees. Later, in 1727, the king of Portugal donated a villa near the Palazzo Riario in Trastevere, where Francesco de Sanctis, the architect of the Spanish steps, designed a Parnassian wood with a fountain shaded by cypress trees and an open-air theater.

The garden was well known to art students, even in Fragonard's time. Tourists also made their way to the ceremonies of the Arcadians, which had taken on a slightly ridiculous cast by the time Goethe visited in 1786. In his journal Goethe mentions the poetic origins and serious critical function the society had in literary history, serving to restore a deteriorating situation in seventeenth-century poetry, in which "faulty images and tropes" and "the habitual use of incongruous metonymies and metaphors" had led poets astray.[9] In the secluded gardens where the artistic rebels met, "close to nature and breathing the fresh air, they could divine the primordial spirit of poetry."[10]

Certainly these romantic, secluded corners of Rome stirred Fragonard and brought him closer to understanding his own nature. If we look for courses of his imaginative impulses once he was freed from academic routine, Rome itself looms large. Perhaps his memory and early associations were stimulated by his encounter with the gardens of Rome. To this day the city is adorned with cypresses, willows, poplars, umbrella pines, lemon trees, and laurels, which could easily have recalled to Fragonard his childhood in Grasse. On the heights—the Janiculum—there are cedar trees, all sorts of firs, and elaborate pergolas with profusions of flowers, above all roses. The flora of Grasse is identical to that in the vicinity of Rome; in the hill towns such as Castelgandolfo and Frascati, the narrow streets are cooled by towering trees, and hidden gardens conceal elaborately shaped trellises with their roses and peonies. The vegetables are the same as those in southern France and so are the cheeses. Still more evocative of Fragonard's childhood paths is the town of Tivoli and its neighboring hamlets, built on a hill and overlooking fertile valleys and slopes of ancient olive groves, and skirting a deep and dramatic gorge with a great cascade, caves, and powerful rock formations. The countryside near Grasse is also punctuated with brooks, waterfalls, and ancient grottoes, with intermittent vistas of great fields of mimosa and laurel and large olive groves. Fragonard, born with a strong visual character, surely carried these images in his

mind and also in his body as he learned to move through the irregular streets and fields of Grasse with their unexpected turnings, their sudden broad vistas, their curves, drops, and rises. He must have registered permanently their look and feel as well as certain necessary movements. Once Fragonard was dispatched from the Academy in Paris into the sunlight of Rome, his earliest and most enduring experiences flooded back. (Even if, as scholars now believe, Fragonard left Grasse as early as his sixth year, an impressionable child would have retained significant traces of his early formation.)

Fragonard's last year at the Academy in Rome brought him to the most dramatic and decisive moment in his artistic life. During that year he met a sympathetic patron who seemed to understand him, the Abbé de Saint-Non, whose family connections had brought him a sinecure of 8,000 francs a year as the abbé *commendataire* of Pothières, near Langre.[11] Born in 1727, he was of the generation that had been influenced by those connoisseurs who had first shown their serious intentions in the circle of Watteau's patron, Pierre Crozat. Saint-Non took their advice seriously, and when the Comte de Caylus insisted that an *amateur* had to know how to draw, "since drawing was the alphabet of all knowledge in the arts," Saint-Non studied drawing and engraving.[12] When he was twenty-three he traveled in Holland where he found and acquired a number of original prints by Rembrandt. On his return to Paris he sought out and befriended young artists, and in 1759 he set out for his grand tour of Italy, bringing with him the young painter Hughes Taraval, who had just completed his stint in the École Royale des Élèves Protégés. Saint-Non's patronage was of the most enlightened kind. He was singularly free of prejudices and unwilling to limit himself to one doctrine or another, even though the old Comte de Caylus had been his mentor. When the time came, the count armed Saint-Non with the proper introductions for Italy, and while Saint-Non never accepted the stern views of the antiquarian and managed somehow not to be inhibited by Caylus's seething hatred for the encyclopedists, the two remained on good terms.

Good connections were necessary to the serious *amateur* who needed entrée to private collections. Caylus sent Saint-Non to the best of sources: the scholar, priest, and art dealer Paolo Maria Paciaudi, who knew everyone in the art world of Italy. Paciaudi reported that Saint-Non was both very cultured and very amiable.[13] As Paciaudi was a friend and advisor to Stainville, later the Duc de Choiseul, who was Hubert Robert's patron, it was probably through him that Saint-Non found his next protégé. Once in Rome, where he arrived in November 1759, Saint-Non planned a travel itinerary that would take him and Hubert Robert the following April to Naples. There they drew from newly unearthed antiquities at Herculaneum, read Virgil aloud, and probably met the considerable colony of *amateurs* who were always buzzing around the treasures of the king of Naples. When they returned to Rome in May, Saint-Non arranged to rent from the Duc de Modena the utterly neglected Villa d'Este in Tivoli for the summer. This time it was Fra-

gonard's turn, perhaps because Robert, who was already a much sought-after painter of views, was too busy filling commissions to take a whole summer off.

The eloquent record of this extraordinarily inspiring summer lies in the works themselves—not only the numerous drawings done in situ, but in references to the experience that recur throughout the rest of Fragonard's oeuvre. There are also hints about the success of the sojourn in Saint-Non's letters. He took a liking to Fragonard shortly after his arrival, having told Natoire that he would take the young painter with him to Venice the previous March—a trip that seems to have been deferred. During the summer Saint-Non wrote to his brother in the conventional language (how they loved to describe artists as "fiery" and "ardent"), praising Fragonard who, he said, was "entirely of fire" and reporting that "his drawings are numerous, one follows another; they enchant me. I find in them a sort of witchcraft."[14] In August Natoire dutifully reported to Marigny that the abbé "is enjoying himself greatly and is very busy. Our young artist is doing admirable studies which cannot but be useful to him and do him great credit. He has a very telling gift for his kind of landscape and successfully introduces pastoral scenes into his compositions."[15] For Saint-Non, the summer would also serve to establish definitely an ambition that he seemed to have harbored earlier. As Elizabeth Mongan has pointed out, "The cultivated, intelligent Saint Non was doubtless just beginning to meditate on what was to be his life's work: the publication in beautiful folio volumes, of all that was picturesque in Italy."[16]

Exhilaration at Tivoli

*A*T TIVOLI, Fragonard immersed himself, paced the gardens, scanned the plain from the lofty balustrade, descended the stairs with their sequence of fountains plunging from basin to basin, sought out the niches with waters so profuse in this unique garden. He built an inner palace, proportioned to the musical sequences of Tivoli, above the Villa d'Este gardens where everything imagined by its ingenious original sixteenth-century architect, Pirro Ligorio, was animated by the unpredictable sound and shape of water and by the alternation of eccentric and formal vistas. Perhaps the magnificent avenue of one hundred fountains was not functioning in this greatly neglected estate when Fragonard was there, but the beautiful *girandole* fountain—the fountain of the dragons—was at play, at least occasionally, as we know from eighteenth-century drawings. He climbed the footpaths of the Villa Gregoriana and saw, felt, the great ravine below him, surveyed the opposite hill with its olive groves and a few villas, while below the river glinted and vineyards flourished. He circled the terrain, seeking every possible view of the fabled temple of the Sibyl of the first century B.C., with its eighteen Corinthian columns and delicate proportions—a monument generations of artists before him had recorded, but few with the natural sense of its original place that Fragonard would stress in his drawings. He walked the medieval streets of the town, with its narrowed lanes offering shaped glimpses of sky, or framed views of the distant campagna, and listened to the rush of sound from nearby cascades. In Fragonard's reveries—his inner trove—these sense impressions became immensely heightened and would remain touchstones throughout his life. They assumed a reality, a tangibility, that must have overwhelmed him. In his drawing in the Coliseum, only his will to record and his faint initiation into the pleasure of light on the softened surfaces of ancient stones are visible. In the drawings that so bewitched the Abbé de Saint-Non, however, the rush of excitement is unmistakable, as is a rather sudden acquisition of precisely

the right technical approach. Fragonard, actually installed in the heart of a paradise of light and shadow, was struck with wonder. The assiduous work, free from all academic routines, had an immediate effect.

To imagine the exhilaration of an artist who craved freedom, one has only to imagine the effects of years of tuition. For nearly a century the art of drawing had been discussed, codified, and written about as though it were something that could be learned only from the past. By copying in the churches of Rome, young artists were meant to learn the techniques of the seventeenth century—techniques that had been learned in academies. There were formulas for composition and formulas for rendering various objects. Generations of artists had developed conventions for the shapes of flowers, leaves, bushes, and sculptures. Their drawings and the prints made after them were stacked up in academies and used for drills—an artist looking at Rome looked through the eyes of others. Then, there was the drawing from ancient sculpture, or rather, casts. This procedure, in the dimly lit stone halls of Roman palazzi, was meant to develop both figure type and the method of working with a range of values. Everything was static, and light could be measured, doled out, imitated as if it were constant. The tactics of earlier draftsmen were automatically assumed. A standard vocabulary was considered necessary for the student, who would learn his ABC's, as Caylus put it. By the time Fragonard came to Rome, an artist who aspired to any rank in the art world had been drilled and lectured for years. Almost any task he would undertake had been analyzed. Even landscape was encompassed in the lectures at the Academy, which had been founded in the mid-seventeenth century. Jean-Baptiste Oudry quoted his teacher Nicolas Largillière: "Each object stands against the sky as a colored mass, or as a dark mass when it is not illuminated by the sun. Only when so illuminated do the gleams of light playing upon it stand out bright against the sky, a brightness always shot with color."[1] His contemporary Antoine Coypel lectured students at the Academy on the true function of line, which

> lies in bringing out the principal parts of the picture through the principal masses, in avoiding anything dry, sharp, hard or abrupt. Contours with angles in them make for paltriness or harshness. The undulating form is the form that resembles flame, that quickens contours, swells them out to the full and gives them elegance and truthfulness. This is what we may call the spirit of the contour and in this we cannot do better than to imitate Correggio.[2]

These two conflicting counsels, reflecting the previous century's dispute between the Poussinists and the Rubenists, were still being purveyed to students of Fragonard's generation, along with a lot else of a pedantic order.

After learning how to compose, how to rationalize masses and individual details, how to start, proceed, and finish—all from previous models—it was both a profound shock and an unparalleled delight for Fragonard to treat himself to the contemplation of the myriad vistas of Tivoli. He studied the changing light on the great cypress trees at all hours and noticed, as we see in countless drawings, how

irrational and capricious the living sun could be as it threw itself brightly into a dark wood, picked out a resplendent path on a single tree trunk, or became entrapped in a thicket to which, it would seem, no light could ever find its wavering way. Seated below the Villa d'Este, looking up the alley of cypresses to the culmination of a flight of steps, Fragonard understood that the rules for contour and mass could never match his pulsating vision of light, a vision that unmistakably rose from the same sources in emotional identification that later motivated the Impressionists. (He would certainly have understood Cézanne, who drew day after day from the same motif on the banks of a river and explained that he need only turn his head a fraction of a inch and everything changed.) The necessary scanning, the repeated study, and the need to invent forms constantly in order to match his emotional experiences must have chastened Fragonard even as it enlightened him.

In *The Giant Cypresses at the Villa d'Este* (fig. 7), which is on good antique laid paper with a fine linear grain, Fragonard set out his thoughts—as drawings were then so aptly called—using mainly a stick of red chalk. Eschewing the tricks of Boucher, he sat himself down on the rotunda of cypresses, still there today, and looked directly up the alley to the palazzo in which the terraced arches rise to the perfect horizontal that closes off the middle ground. The ancient cypresses are not only Fragonard's motif but also epitomize his expressive description of the quality of towering. With a boldness few artists could muster in rendering this favorite motif, Fragonard brings the crowns of his cypresses almost to the top of the page. He builds their leafy masses with singularly inventive ways of wielding his sanguine stick. He uses the rhythmic diagonal strokes that were commonly employed to suggest darker or light broad areas, but he broadens out and diminishes with gradations he had never before tried. The density of the cypress foliage is rendered in almost painterly surfaces, large and delineated only by occasional accents of zigzags or mere dots. Instinctively, Fragonard balanced the luxurious curves by using the serried lines of the paper as counterweights and by holding to an almost classical allocation of receding planes. The firm intuition of space Fragonard could always count on guided his hand in a natural way toward the virtual horizontal and vertical planes that are hidden even in the most tangled and uproarious growth of nature. A small quick sketch in the Fogg notebook, *Sketch of a Park with Tall Trees* (fig. 8), describes Fragonard's initial response to a view of towering trees. His hand impulsively blocks the crown of the tallest trees in almost geometrical sequence, stressing its prominence in his mind's eye by giving a heavier weight to the stick and reminding himself of the disposition of light by means of the blocklike wall of shade separating the two stands of trees. His eye steps, rather than glides upward, not as in the artifices of Tiepolo for depicting soaring and flying heights but with fidelity to a particular vision that Fragonard had when directly recording his impression in a "first thought."

The Fogg sketch tells of an instinctive sense of form—a way of envisioning—

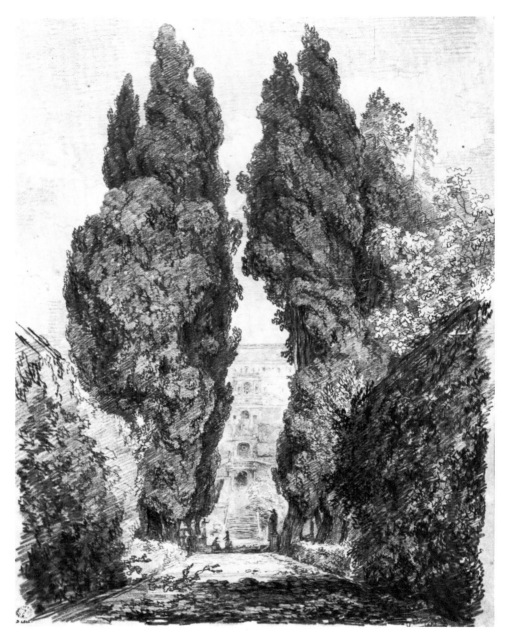

FIGURE 7. *The Giant Cypresses at the Villa d'Este.* Musée des Beaux-Arts, Besançon.

FIGURE 8. *Sketch of a Park with Tall Trees.* Fogg Art Museum, Harvard University, Cambridge, purchase, Louise Haskell Daly Fund.

that would inform all of his future works. Even in this quick *aperçu,* Fragonard's hand seeks the points of reference in space and accents them slightly with short, geometric angles, as in the left rear tree, where the sharp triangular stop in the contour establishes a diagonal plane to the right-hand contour of the tree in front—the largest tree, whose repeat in the triangular cut is deftly established by a bit more pressure on the point of his chalk. The assurance Fragonard displays here, by locating his forms in a space so meagerly indicated, is stunning. The lessons he had taken from Rembrandt in his student years began to function actively in his work.

Fragonard can now be seen for the first time as the connoisseur David admired so much. Few of his contemporaries understood so well the cursive function of Rembrandt's drawings. Few could read Rembrandt's extravagant lines that so often flung themselves into surrounding space and no longer functioned merely as the boundaries of forms in space. But Fragonard understood, as his own renderings of out-of-door spaces and his later illustrations for Ariosto emphatically prove, and had recourse to sophisticated, abstracting, draftsman's means. If we look forward from Fragonard, we can find a similar tactic in Cézanne's drawings, particularly his late drawings of the Bibémus quarry.

It is not a fault to interpret Fragonard with a modern's eye and to see in his

work the germ of Cézanne. There is a history of art that cannot be measured in a linear way. It is a history of dialogues between artists of different times and different places. For them, the conversation has no calendar date. If in Fragonard's drawings we see the rectitude of which Ingres spoke, the "probity," and the light that so agonized Cézanne, this is not merely using modern canons to interpret an art locked into its century. There are countless eighteenth-century drawings of tall trees, but the habits of the period mark them. Whereas with Fragonard, the finished sanguine drawings of the Villa d'Este and environs—if the staffage figures are ignored—presage future sketching traditions.

What Fragonard established for himself once and for all in the Tivoli drawings was the importance of his most cherished subject—light and its velleities as they determine form. The draftsman's problems—where to put one's stroke so that it serves at once to place the form in space and describe its individual characteristics; how to determine where, exactly, the objects before one rest; how to begin; how to leave out; how to adjust the nearest and the farthest; in short, what exactly *are* forms in space—these were questions with which Fragonard grappled from the moment he was released from academic routine, and they were brilliantly confronted at Tivoli. The great vertical drawing in Besançon known as *The Giant Cypresses at the Villa d'Este* (fig. 7) shows nature (the foliage on the cypresses) carefully studied and barely altered. Yet this is no topographic souvenir, for Fragonard took a view already conceived by two other artists. The first was Watteau, whose painting of Montmorency, the garden of his patron Crozat, is in the Museum of Fine Arts, Boston. Watteau sketched a center vertical axis, exactly as did Fragonard, which is closed off by the architectural detail in the distance. The alley of trees is similarly rendered, emphasizing their loftiness and their massive shadows. Yet Watteau's subject, as mysterious as it is, is not as architectonic as Fragonard's, whose drawing of the enormous trees emphasizes their massive structure. Watteau uses a series of established signs to delineate the nature of his feathery trees, while Fragonard invents each curve, each straight line, anew. The other artist whose sensibility informs this drawing is the architect Ligorio, who planned this superb vista. Yet Ligorio worked in the era of grandees of the Church whose pride was to import living poets and musicians to animate their gardens. The scene, then, was set for a spectacle, whose boundaries were all thirty-four thousand square meters of the garden with its twenty stairways, 240 sprays, 240 waterfalls, twenty thousand flower vases, fifteen thousand ornamental trees and shrubs, and uncountable other features.[3] Fragonard, sitting with his drawing board in one of the principal viewing points designated by Ligorio, faced the task of eliminating or lessening the importance of details. He does not widen the alley in order to exaggerate the recession to the palace in the rear, nor does he place figures in the foreground to establish a *repoussoir*. He devotes himself rather to expressing his elation as he shapes the imposing masses of the trees and the light that draws their irregular contours. The eye goes immediately to the light, exactly centered as

it is in so many of his drawings and far from the Rococo conventions of always beckoning the viewer into a painting or drawing on a diagonal course.

In the complex composition of *View of the Escalier de la gerbe* (fig. 9), we sense, still more, Fragonard's passionate search for a means to communicate the light that all but obliterates form. Fragonard in his usual way divides the page along a specific vertical axis, exactly centered (the hedge in the middle ground), and it is there, in a complicated sequence from ground to sky, that the light forms a vessel from which all else radiates. Fragonard took pleasure in establishing his deepest color on the right, going off the page. (The gradations in pressure on his hatching always suggest the different shades of green, so carefully juxtaposed by the masterful architects of those old gardens.) This in turn sets up the stairway as it mounts to the standing sculpture, a dark silhouette against light sky. It is not this sculpture, echoing the shafts of the four cypresses, that Fragonard wished to stress but rather its companion statue emblazoned in light. The four cypresses with their arrowlike thrust into the sky are rhymed with the sky by means of the repetition of diagonal hatches, and they serve Fragonard well as a counterweight to the catherine wheel of light in the heart of his sketch.

Again and again in these sketches and finished drawings from the sojourn in Tivoli we see Fragonard abandoning the conventions he had so assiduously stud-

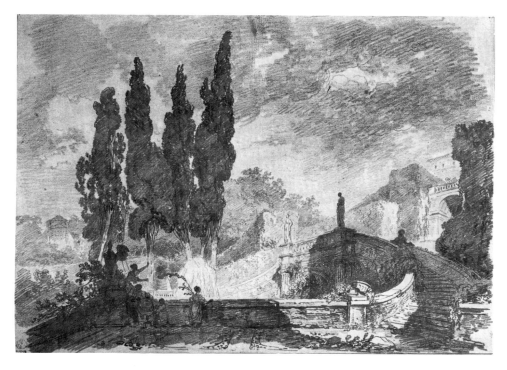

FIGURE 9. *View of the Escalier de la gerbe.* Musée des Beaux-Arts, Besançon.

ied, resisting the recommended point of view and the impulse to draw a capriccio after Panini or any number of contemporaries who were expected to improve on the given view of antique sites. One day Fragonard sat down before the tangle of overgrowth that had overtaken Hadrian's Villa in Tivoli and, on a double page of his sketch pad, did a head-on version of a shell-like structure—the remains of the Serapeum—with a great central arch (fig. 10). Its crown of shrubs is offered with a strong emphasis on verisimilitude, and the brickwork is carefully recorded. Far less inventive here than he is in the Villa d'Este drawings, Fragonard nonetheless approaches his subject with a lack of posturing rare for the period. The site is directly observed, and yet it is not addressed to the scholarly *amateurs* who liked their antiquities rendered in what they considered scientifically exact details.

From the heat of that summer Fragonard would take away indelible memories, and certain of his most exalted works depend on the emotional pitch reached during his days at Tivoli. It was not only towering trees and sun-blanched statuary that caught his avid eye that summer. He rambled through many dramatic landscapes with his sketch pad, and many peaceable farms. Nothing is known about the arrangements at the villa. Who cooked their dinners? Who did the marketing? Where did the wine and cheese come from? Fragonard had spent more than six years protected by the state, in situations in which there were servants and meals,

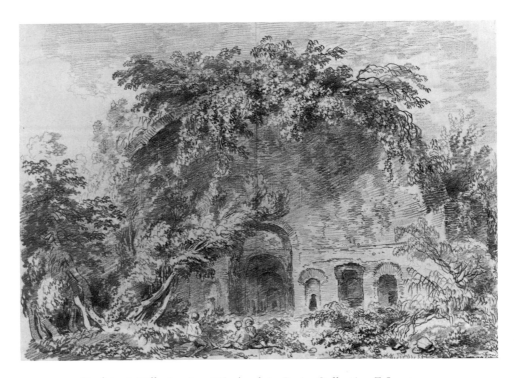

FIGURE 10. *Hadrian's Villa.* Institut Néerlandais, Paris, Collection F. Lugt.

and in cities where an art student could repair to a café for a roll and coffee. In Tivoli, no doubt, Saint-Non acquired the services of local women to cook, clean, and market. The laundry was usually done by local women. There was probably a family of caretakers on the grounds, for even if the current owner was not attentive to the disintegrating villa and its neglected grounds, he would have followed the custom of protecting his property from vandals.

Living for once in an unregimented and relatively countrified environment and having, as is apparent from his work, a natural sympathy for working people, Fragonard watched and listened and sketched the attitudes of the women at work. If he went into town for a glass of wine, he met the people who had made the wine or the cheese on his table. The doll-like figures of Boucher's pastoral paintings have disappeared in Fragonard's works, replaced with frank and directly observed portraits of the people he encountered in the environment of Tivoli. Many of the abandoned and ruined properties of the past had been appropriated by local families, whom Fragonard evidently got to know. Where a cellar or ground floor was inhabited by peasants, there were always their animals as well, and these too were seen by Fragonard directly, not mediated by the eyes of previous artists. In the town, which was largely a legacy of the middle ages, the ground floor of buildings was usually reserved for domestic animals—the working burros and mules, the chickens, cows, and bulls. With whole days free, Fragonard could wander and observe, making quick sketches that would serve him for years to come. The conventional obligation of a painter to notice and characterize the seasons, the times of day, the way the light changes morning, noon, and night became second nature here. If we are told that the Abbé de Saint-Non read poetry aloud in the evenings or that there were musicales, we can be sure that other more simple pleasures were also abundant during that prolonged sojourn.

Fragonard's interest in pastoral motifs may well have been intensified by the fashions that prevailed among the rich making the grand tour, as Wildenstein hints.[4] In *The Storm* (Art Institute of Chicago), a drawing dated 1759 in the manner of Castiglione, an Italian epigone of the Dutch landscapists, Fragonard effectively showed that he could depict flocks of sheep, haywains, and even the lowering weather. Wildenstein suggests that his sketches of peasants at their tasks during the summer in Tivoli may have started out as preparations for the fulfillment of commercial demands,[5] but the wellsprings of empathy that had been primed that summer certainly converted them.

Even when Fragonard adopts a motif that had long been commercially acceptable—the washerwomen, which for various reasons attracted customers— he focuses on features that the scenes at Tivoli had revealed to him. His excitement moves from light to light, form to form, as they announce themselves in the environment, always changing and yet sustaining a rhythm that Fragonard made his own. When he descended from the villa, he would sometimes seat himself near the rapids to study foliage and water. A drawing of the wild waterfalls at Tivoli,

covering two pages in his sketch pad (Institut Néerlandais, Paris), shows him studying the shapes of the cascades as the light moves on the surfaces and equating these shapes with the wild foliage framing them. The rhythmic sequence is almost oriental, yet we see instantly that it is a very careful and closely observed portrait of rocks, foliage, sky, and water.

In another, more finished drawing in the Louvre that was probably the preparatory study for *The Waterfalls at Tivoli* (fig. 11), also in the Louvre, Fragonard chose an extraordinary vantage point in order to describe his immense excitement about the falling water. The keyhole formed by the overbridge is, as usual, exactly centered, and the composition is built with rectangular masonry as a scaffolding for the excited movements of the natural elements. In the drawing, Fragonard introduces a figure in the routine way, merely to intimate scale. In the painting, however, which is not dated but is thought to have been done immediately upon his return to Paris the following year (though why not in Rome, or even that summer in Tivoli?), the figures multiply and assume other functions. Fragonard could forget neither his encounters nor his delight in the way his subjects belong to their landscape.

What is this painting about? It is first and foremost about that central cascade of water, which becomes, through the power of the sun, a cascade of light. By introducing his studies of laundresses, Fragonard is able to celebrate the effects of light again, particularly as it falls on the laundry on the line or being washed below in an old stone sarcophagus. Laundry—its smell in the sun, its sumptuous wet folds—is a lure for Fragonard's brush. He was to do many other scenes of laundresses, undoubtedly because of his pleasure in light on drapery in the outdoors. And drapery is like cascades. This painting, with its wonderful steps in vertical space, its great sense of movement, shows Fragonard fusing several methods, such as the technique of working from dark to light used by the Baroque painters and the impasto accents (on figures and laundry) of his Venetian contemporaries, whose work he had surely seen in collectors' homes in Rome. But it also shows his growing obsession with a kind of light that is both metaphorically central to his reveries and charged with the kind of poetic function that is exclusive to the painter's means and cannot be otherwise translated.

The implicit lyricism in this painting is quite different from that of slightly older contemporaries, such as the British painter Richard Wilson or the French landscapist Claude-Joseph Vernet. Both of these painters offered panoramic visions of Tivoli, stressing the grandeur of the view and using the conventions of small figures on the foreplane as *repoussoirs,* much as Claude had done in the seventeenth century. The traces of the rhetorical notion of the sublime are strong in Wilson's *The Cascatelle* in the Dulwich Picture Gallery, London, and especially so in Vernet's spectacular *A View of the Waterfalls at Tivoli* in the Cleveland Museum of Art. Fragonard's view, on the other hand, eschews rhetoric, and the solidly constructed scene is in no way heightened. This, one feels immediately, is what he

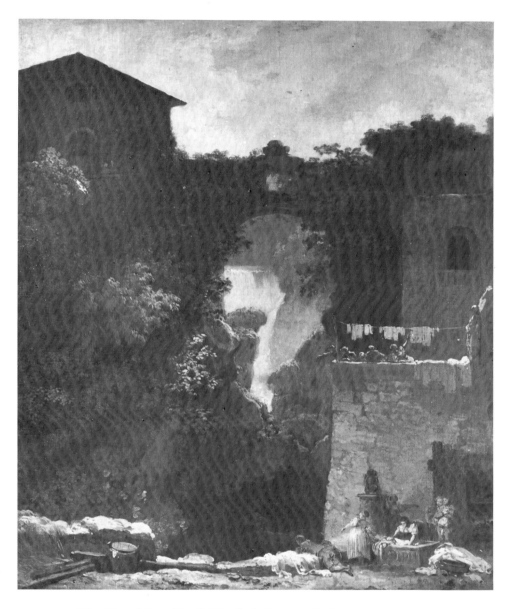

FIGURE 11. *The Waterfalls at Tivoli.* Musée du Louvre, Paris.

saw and how he saw, and the beauty and majesty are rendered without idealiza-
tion.

If the metaphorical dimension grows in the later work, its elements were
gathered during that summer when Fragonard peered into every corner of Tivoli.
No doubt the series of interiors of ruined palazzi spring from his jaunts in the
countryside. *The Italian Family* (colorplate 2), at the Metropolitan Museum of
Art, New York, may well have been painted during the Tivoli stay. The setting is
clearly a palatial basement, where Fragonard may have dropped in for a glass of
water or been brought by one of the workers at the Villa d'Este. The composition is
academic enough, spawned by countless copies of Italian Baroque compositions,
but the light is Fragonard's as is the peculiarity that the major figure—the woman
holding a child—is exactly centered and in a dazzling blaze of white and gold,
which is strangely echoed in the doorway behind her, as if in a mirror.

Although there is anecdotal detail (figures whose eyes meet, whose bodily
gestures suggest a moment of communication, and animals that are seen in felici-
tous harmony), this painting is essentially about the drama of chiaroscuro, remem-
bered no doubt from Rembrandt, but in its distribution of white to gray values and

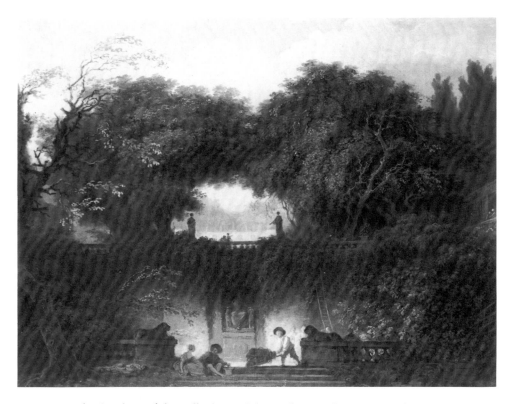

FIGURE 12. *The Gardens of the Villa d'Este.* The Wallace Collection, London.

its gold accents, strangely reversed. The keyhole of light that the doorway and the woman with the child produce comes from an irresistible impulse on Fragonard's part.

In a landscape from the Villa d'Este in the Wallace Collection (fig. 12), the niche with a statue below the balustrade becomes a part of the keyhole image above. But here the exactly centered circle of light produced by overarching shrubs becomes the central focus of the painting. This landscape, thought to have been painted soon after Fragonard's return to Paris, is more easily associated with the fantasies about the good life familiar to views of Boucher and is like a theater set. Yet certain Fragonard characteristics lift it into another range of feeling.

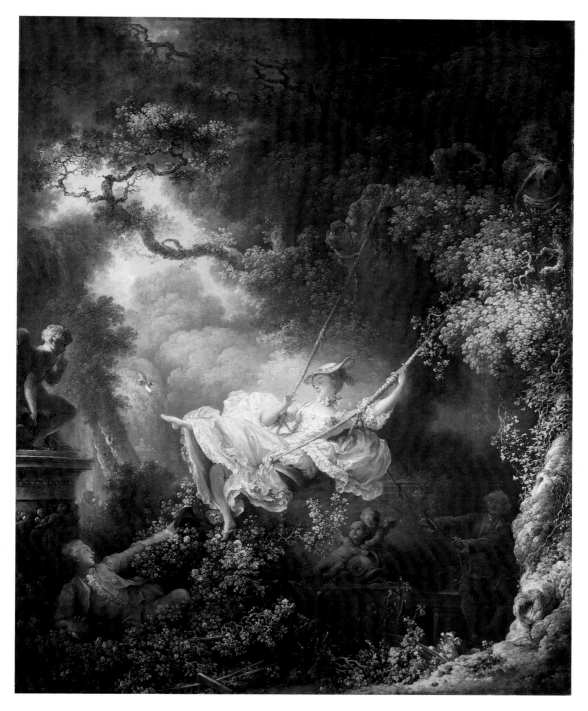

COLORPLATE 1. *The Swing*. The Wallace Collection, London.

COLORPLATE 2. *The Italian Family.* The Metropolitan Museum of Art, New York, Harris Brisbane Dick Fund, 1946.

COLORPLATE 3. *The Abbé de Saint-Non in Spanish Costume.* Museo de Arte Cataluña, Barcelona.

COLORPLATE 4. *Music: Portrait of M. de La Bretèche*. Musée du Louvre, Paris.

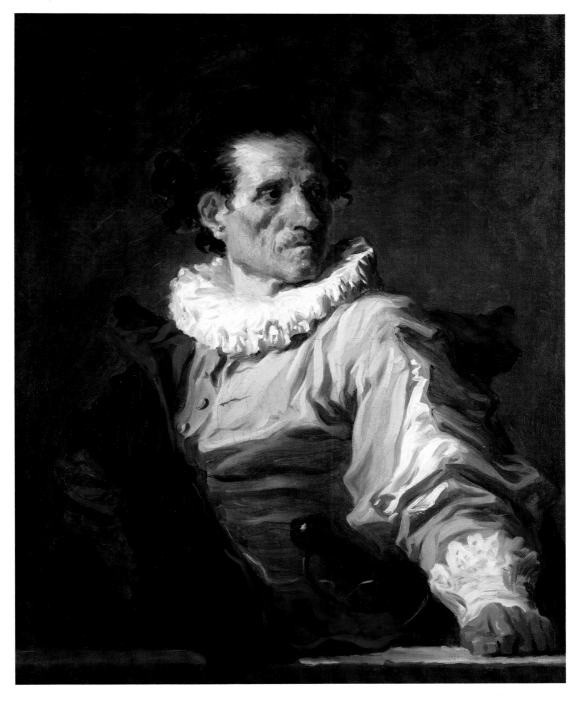

COLORPLATE 5. *The Warrior*. Sterling and Francine Clark Art Institute, Williamstown.

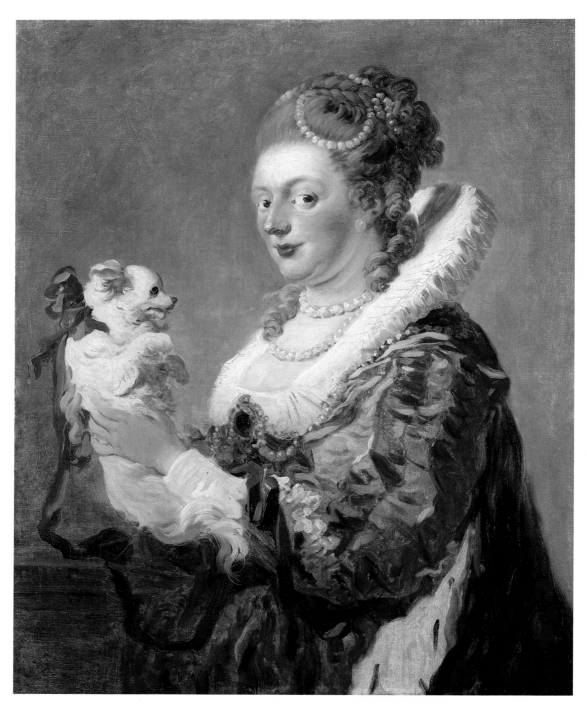

COLORPLATE 6. *Portrait of a Lady with a Dog.* The Metropolitan Museum of Art, New York, Fletcher Fund, 1937.

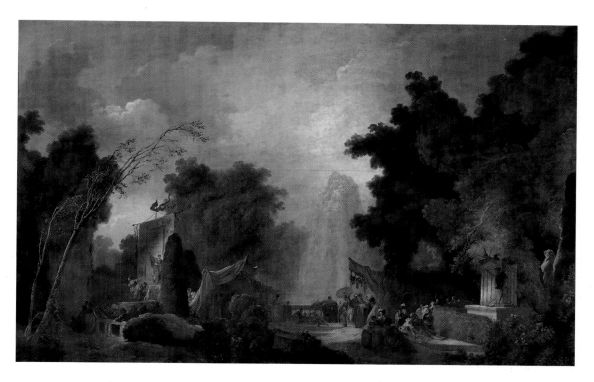

COLORPLATE 9. *The Fête at Saint-Cloud.* Banque de France, Paris.

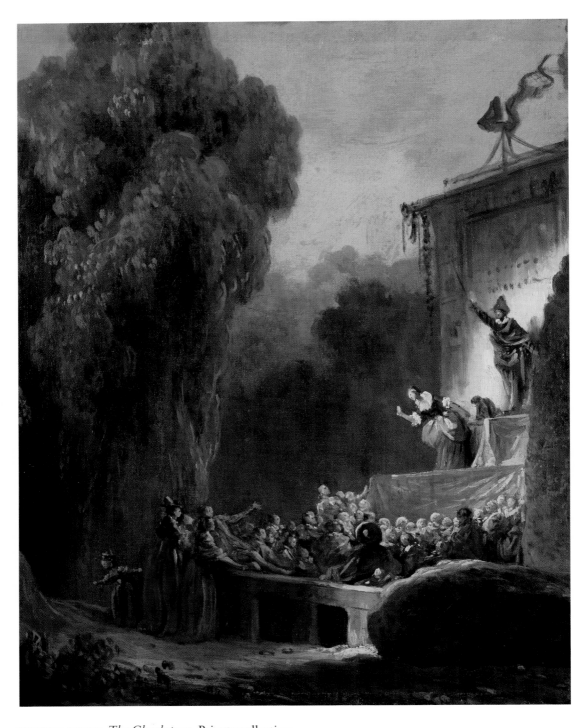

COLORPLATE 10. *The Charlatans*. Private collection.

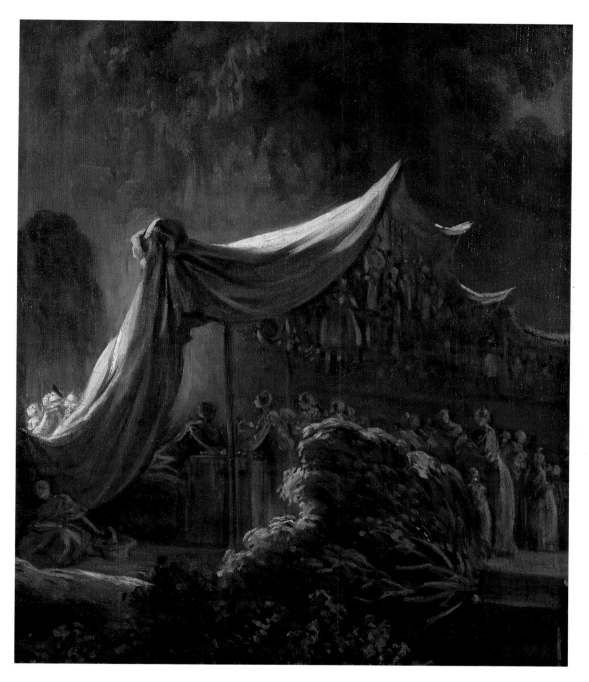

COLORPLATE II. *The Toy Seller.* Private collection.

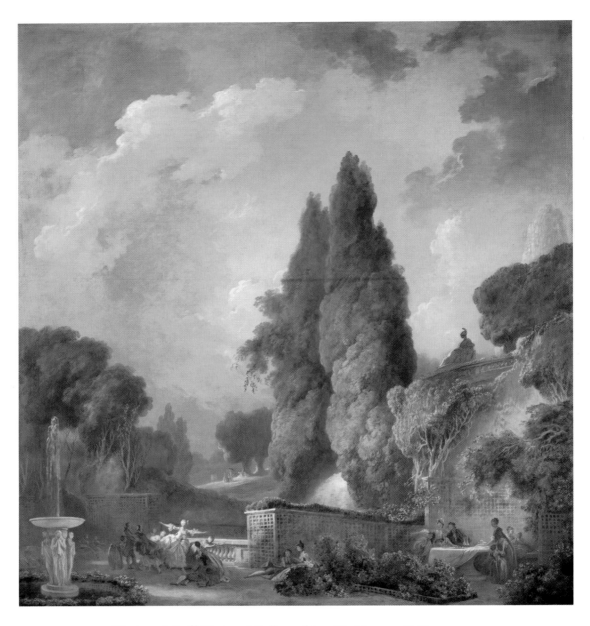

COLORPLATE 12. *Blindman's Buff*. National Gallery of Art, Washington, D.C.,
Samuel H. Kress Collection.

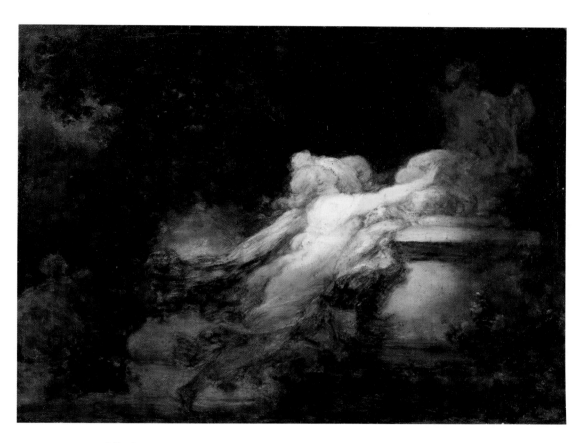

COLORPLATE 13. *The Invocation to Love*. Musée du Louvre, Paris.

COLORPLATE 14. *Joash and Joad*. Collection of Mr. and Mrs. Eugene Victor Thaw, New York.

Completing the Grand Aesthetic Tour

*T*HERE WERE to be few more dramatic and lastingly significant experiences for Fragonard in Italy than his sojourn in Tivoli. In the fall he returned to the Academy in Rome, and although he had been slated to leave for France, he requested an extension of his stay. If Saint-Non had already laid out his grandiose plan for publishing sketches of Italian views and masterpieces, Fragonard's last months as a pensioner at the Academy were probably devoted to the project. Many of his sketches in the palazzi of Rome were later engraved for Saint-Non's album. Among them were the Rubens in the Palazzo Colonna, Poussin in the Chigi, Caravaggio in the Borghese, Pietro da Cortona in the Pamphili, Salvator Rosa in the Colonna, and Annibale Carracci in the Farnese. Cortona and the Carracci were standard fare for students, and Fragonard had probably already copied them early in his Roman sojourn. The Carracci were especially recommended, and since Annibale's greatest extravaganza was in Rome at the Farnese, generations of students had copied their teeming surfaces and tortuous spaces. Cochin in his *Voyage d'Italie* declared that the complete art of painting is wholly owed to the Carracci: "The love of the grand had almost always led Raphael to suppress those beautiful details of reality that nature reveals. . . . The Carracci, after having studied the antique and the principal masters of their time, understood that nature was the true object of imitation and that the suppositions of a beauty that would be superior to it were chimerical."[1]

Fragonard's approach to the Carracci in the engravings in Saint-Non's album suggests that he shared Cochin's view. In general, the works in the album reflect a rather free and highly selective approach—one that would have been developed only during the last year of Fragonard's stay. There is some question as to whether Fragonard was completing his education or embarking on his professional career during those last months in Italy. When Natoire informed Marigny that Saint-Non was sending Fragonard to Naples in March 1761, he thought of it clearly as an

educational jaunt. But Fragonard, it seems, was dispatched by the abbé together with a mysterious figure who was a regular at the table of the Academy, the painter Ango,[2] whose Neapolitan sketches were also designated for Saint-Non's album. Jean-Robert Ango (whose birth date and origins are unknown) was, according to Marianne Roland-Michel and Jean Cailleux, a close friend of both Fragonard and Robert. He survived in Rome as a professional copyist and was described by a friend as "simple, wise, and true."[3] It seems likely that both Ango and Fragonard were sent to Naples for the specific purpose of recording major monuments and paintings for this album.

No memoirs, no letters, no documents of any kind other than the drawings themselves tell us what Fragonard saw in Naples and what interested him. "Naples is a paradise; everyone lives in a state of intoxicated self-forgetfulness, myself included," wrote an enchanted Goethe.[4] The teeming vivacity of the city was certainly part of the value for Fragonard in this first visit to Naples, and its paradiselike ambiance was not forgotten. Most of the time, however, the two artists were hard at work visiting the lofty palaces overlooking sweeping views of the sea. They had access to the palatial collections through Saint-Non's connections, and they were expected to copy artifacts brought up from excavations of Herculaneum. Examining the hoard of coins, vases, and bas-reliefs in Naples, Fragonard added to his repertory of fauns and nymphs.

The paintings installed in great profusion in the churches of Naples were for Fragonard at least as interesting as the antiquities. He was attracted to Francesco Solimena, who was nearly a contemporary (he died in 1747) and whose personality had impressed scores of travelers in earlier decades. Already in 1715 Caylus had admired both Solimena and Jusepe de Ribera. Montesquieu visited Naples in 1729 and found that "their churches are infinitely rich in bad taste" but exempted Luca Giordano and Solimena, following, as Anthony Blunt has said, "what was becoming conventional taste among French travelers."[5] On his 1749 trip, Cochin also admired Solimena, in whose frescoes he found "little truth but much art."[6] It would have been difficult for Fragonard to resist the appeal given this sustained chorus of praise for Solimena, who was best known for his rage to cover all the walls of Naples, saying, "I never draw on paper: too many walls are there calling my brush."[7]

More likely, Fragonard was impressed by the fact that this was the achievement of an artist of his own period. More than Solimena, Fragonard admired Luca Giordano, known as "Luca *fa presto*," whose approach to surface and composition he filed away in his memory for future use. To some degree, Fragonard's attention to Giordano must have been heightened by his knowledge that, in advanced circles in Rome, Giordano was now anathema, thanks to the astonishing power of Winckelmann. In his *Essay on the Beautiful in Art,* published two years after Fragonard's visit to Naples, Winckelmann summed up his attitude to the whole crew of Neapolitan artists: "The lover of art can be assured that if it were not

necessary to know the style of certain masters, the paintings of Luca Giordano, Preti, Solimena, and altogether all Neapolitan painters, are hardly worth the time to examine them: this can be said of the modern Venetian painters, especially of Piazzetta."[8] Winckelmann's contempt for these Neapolitans has been brought up to date by Michael Levey, who has written of Giordano: "The lack of intellectual power his work displays—its sheer brilliant brainlessness—is itself admirable and perhaps the necessary concomitant of such tireless productivity."[9] Yet for Fragonard the existence of these lusty, bravura Neapolitan painters represented a certain freedom that was not available in the works of the mighty figures of the Renaissance. The *fa presto* brushwork that Fragonard had already admired in Dutch and Flemish masters was epitomized in Giordano's showmanship. His *Madonna of the Rosary* in the Church of Santo Spirito was more or less a standard object of admiration and had been singled out by travelers for several decades. The Abbé de Saint-Non probably was no exception to the rule and encouraged Fragonard's interest in the late Baroque swift brushwork.

Soon after his return from Naples, Fragonard packed up for his final trip through Italy, this time as a companion as well as an employee of the Abbé de Saint-Non. Their leisurely excursion to the principal centers of Italy was the final stage in Fragonard's education as a connoisseur. He was no longer a raw youth—he was twenty-eight years old—and he had won the friendship of an exceptionally cultured man whose quest for knowledge in the visual arts was inexhaustible. The abbé was a liberal-minded man whose interest in the views of others had brought him into contact with many significant figures of the eighteenth century. He knew personally many of his fellow *amateurs,* many of the energetic thinkers who enlivened the second half of the century in both Italy and France. His great virtue was that he was not committed to one view or another and moved easily among various opposing milieux that interested themselves in art. The abbé deeply respected the cultivated eye of his traveling companion, and he seemed to allow Fragonard to choose his own subjects for copying. The catholicity of Saint-Non's taste—one of the hallmarks of a new breed of connoisseur in the late eighteenth century—gave Fragonard considerable latitude. Fragonard's friendship with the abbé must be taken as a measure of the abbé's seriousness as a connoisseur and his keen intelligence. He would hardly have tolerated a mere copyist on so prolonged a journey. In the absence of information on Fragonard's personal life, the fact that he remained friends with Saint-Non throughout their lives suggests a great deal.

In most texts on Fragonard the voyage back to Paris is usually dispensed of quickly with a list of the places the two men visited. But the itinerary was of importance for Fragonard. They went to Parma, Siena, Florence, Bologna, Mantua, Vicenza, Padua, Venice, and Genoa, with countless halts between. Judging by the number of his drawings, we can assume Fragonard spent much time recording masterpieces in Bologna, but the visits to Parma and Venice were the crucial experiences on the journey. They offered emotional sources that would stand

Fragonard in good stead for the rest of his life. After so many studies of the work of
Annibale Carracci in the Farnese Gallery, Fragonard was finally to see the great
Duomo in the Cathedral of Parma that established the original tradition that the
Carracci had extended in Rome. Correggio's frescoes in the Duomo, above all the
magnificent ascent of figures in the cupola swirling into a soft light that com-
pounds the illusion of an opening into the heavens themselves, are painted with
such brio that it is easy to understand why Fragonard was excited.

Here one can only speculate—but speculate we must, for there was more
than one reason that Correggio appealed not only to Fragonard but to others in the
eighteenth century, such as the royal families who collected Correggio's mytho-
logic subjects rendered with a strong erotic intonation. It is not impossible that
Fragonard came to Parma armed with considerable information about Correggio.
He had early on become a passionate devotee of the poetry of Correggio's neighbor
and contemporary Ludovico Ariosto. Perhaps Saint-Non had spoken to him of
Voltaire, whom he wholly admired and who was credited with the boom in theatri-
cal and painted visions based on the poems of Ariosto. Saint-Non was learned and
would have known the complicated intellectual foundation for the Ariosto vogue.
The eighteenth century, in one of its many moods, was attracted to the Platonic
undercurrent in Correggio's period that saw poetry as furor. They studied the
theological shifts in the sixteenth century that demanded a more direct art, "one
that spoke to the heart," as aestheticians in Correggio's time often wrote. The
parallels between the painter and poet were made already in their own period and
noted again in both the seventeenth and eighteenth centuries. Eugenio Riccomini
has summed them up deftly:

> Both Ariosto in his poem and Correggio in his cupola attempted a "genre"
> without precedent . . . this "genre," unlike lyrical poetry, presupposed the
> presence of a public and its participation. We see in Ariosto, almost at the
> closing of each canto, an invitation to the listeners, and in Correggio . . . the
> glances and gestures are also a direct invitation to the viewer. Such theatrical
> devices are accompanied by an almost spontaneous, natural, and incompara-
> ble facility in exposition and illustration. . . . They also share the intimate
> structure of their statements, inclined to reject every prearranged symmetry,
> every calculated pause in the flow of the narrative or in the depiction.[10]

For Fragonard, who would later often group his figures as though they were on
stage and who liberally made use of the stage aside (particularly in his more playful
compositions), an encounter with the art of Correggio would have been more than
routine. A visit to the province of Ariosto held special meaning for him. His
comprehension of the poet was not superficial, as he would prove in later years,
and his conception of art, or of being an artist, was informed by his ruminations
about the poet. In a splendid drawing of Ariosto (fig. 13), possibly meant to be the
frontispiece for the illustrated edition of *Orlando Furioso* that was never pub-
lished, Fragonard shows reverence and his own credo, portraying the poet com-

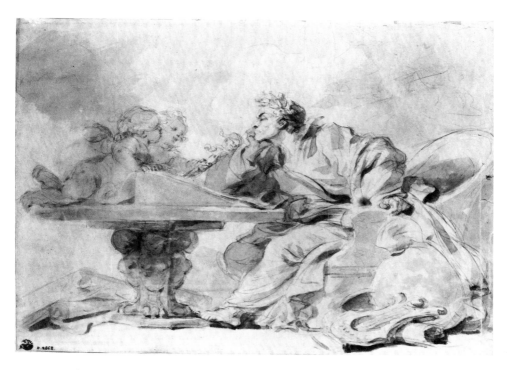

FIGURE 13. *Ariosto Inspired by Love and Folly.* Musée des Beaux-Arts, Besançon.

posing at his desk under the tutelage of Love and Folly—two deities Fragonard could well understand.

Fragonard's visit to Venice and environs had still another significance. During the second half of the eighteenth century Venice was immensely attractive to visitors, especially artists, not only because of its physical wonders but also because of its exceptionally lively artistic milieu. As Antonio Maria Zanetti observed, "In Venice one saw as many styles as there were painters."[11] France had had a long flirtation with Venice. The concourse of French and Venetian artists was known to all art students who were trained to revere Watteau. His patron, Crozat, had made a special point of introducing visitors such as the much-honored Sebastiano Ricci to the young Watteau. Through Crozat, the celebrated Rosalba Carriera, who visited Paris in 1720, made a sketch of Watteau, and he of her. Fragonard's master, Boucher, carried on the tradition. Defenders of colorism in art had always repaired to Venice to praise its great tradition. Even Cochin, who seems to have wavered in his allegiances, had sung the praises of Tiepolo and Giovanni Battista Piazzetta during his visit to Italy with Marigny. Certain older figures in the highly diversified art scene in Venice were still alive; others had died only shortly before (Carriera in 1757 and Piazzetta in 1754), and their epigones were still supplying imitations to tourists at the time of Fragonard's visit.

What the Venetian *vedutists* such as Francesco Guardi and Canaletto represented to visitors such as Saint-Non and Fragonard was a thoroughly secular art with no ambition toward history painting and no taste for the *grand goût*. Tiepolo, on the other hand, was seen as an original who could take on large spaces and transform them without becoming unnecessarily grandiloquent and heavy. His great decorative cycles were more or less complete by 1750, with the exception of Ca Rezzonico, completed only in 1758. Already in Boucher's student years, Tiepolo was celebrated for his ineffable lightness and extraordinarily inventive design. The elder Tiepolo was often in Venice between 1753 and 1762, when he was called to Madrid, but there is no mention of an encounter in Fragonard's history. Still, the two travelers would have heard plenty about him. Saint-Non had installed them in rooms facing the Grand Canal and each day hired a gondola to take them to churches, palaces, and private dealers. The most important of these was the notorious English consul Joseph Smith, whose apartments were filled with contemporary paintings by, above all, Guardi, Canaletto, and Pietro Longhi, whom his English visitors coveted. Smith had a reputation for buying cheap and selling dear, but all the same he was respected by artists for his sure taste. Fragonard made drawings in Smith's apartment and probably enjoyed badinage with the clever, if sharp and aging, Mr. Smith, whose knowledge of artists was extensive. It was there in Smith's apartments that Fragonard saw Tiepolo's small paint sketches and finished drawings, which proved to be so important in his evolution as an artist.

The light values in Tiepolo's drawings and prints were already familiar to Fragonard, but nothing could have prepared him for his encounter with the ceiling at Ca Rezzonico, its dazzling banks of clouds and sky, its airborne deities. Even its smaller details were of great importance to Fragonard, such as the serious studies of the heads of old men and women. In the Palazzo Labia, Fragonard studied Tiepolo's treatment of the Anthony and Cleopatra story and copied freely, and with obvious relish, for Saint-Non's album (fig. 14). Here was a painter whose touch and whose obsession with light corresponded to Fragonard's deepest instincts and feelings. Fragonard could profitably study the unique methods Tiepolo employed to heighten the splendors of sky and cloud and robe and flesh, rendered with the surest and lightest of touches. At the Villa Valmarana near Vicenza, one of the side trips the two artists made for Saint-Non's project, Fragonard drew from Tiepolo's version of the Orlando theme in his illustrations for Torquato Tasso's *Gerusalemme Liberata* (*Jerusalem Delivered*). Tiepolo's preparatory drawings for his exquisite cycle were bold washes that may have suggested to Fragonard his own course when he later undertook his Ariosto drawings.

Judging by the large number of copies he completed—of the many Tintorettos in San Marco, of Titians and Veroneses—it would appear that Fragonard worked demonically all during the Venetian visit. Commentators have noticed

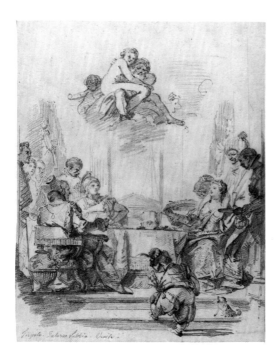

FIGURE 14. *The Banquet of Anthony and Cleopatra* (after Tiepolo). The Norton Simon Foundation, Pasadena.

that there are no drawings by Fragonard of the city itself, usually a lure for visiting artists. No doubt the exigencies of Saint-Non's project prevented idle sketching. There were, however, late afternoon and evening hours when the two zealots could hardly have avoided the usual pleasures of Venice. Theatricality was endemic. Not only were the pink and white palaces and thronged waterways and bridges of Venice dramatized by painters and poets, but the theater itself spilled into the streets. Numerous eyewitness accounts describe the constant street performances.

The piazza San Marco itself during that period was filled with *ciarlotani* whose stands alternated with cafés and were often embellished with painted backdrops. Seven years before, Tiepolo had painted a scene where the performing charlatan is realistically described in a crowd of carnivalesque spectators, a scene that, with its companion piece showing a lively minuet performed by a well-dressed couple amid a crowd of amused spectators, Fragonard might have seen in one of the private collections he visited. At any given time in Venice, not only during the carnival, there were strolling musicians, tellers of tales, acrobats, and small troupes performing commedia dell'arte favorites, enlivening the city everywhere. Then there were the *gondolieri,* who were famous for their chanted verses, often based on Tasso and Ariosto, as were the themes of the numerous marionette performances. Men and women strolled around in masks all year round, and the

Ridotto, a notorious public gambling house, was one of the liveliest scenes in Europe. The daily life in Venice, recorded so richly by Domenico Tiepolo and Pietro Longhi, was unlike that of any other city in Europe.

A man as avid for visual pleasure as Fragonard would have had his fill in Venice. Not only was the city itself fabled, but its theater—with which Fragonard was already acquainted since it had been brought to France during the Regency— was still flourishing. Goldoni's reforms may have banished masks from the stage elsewhere, but in Venice they persisted. Fragonard's early encounters at the fairs in Paris were pale in comparison with the reality of Venice. Goethe's description a few years later shows Venice seething with activities for which the basis was always the common people. "The crowd becomes part of the theater," he wrote, and

> during the daytime, squares, canals, gondolas, and palazzi are full of life as
> the buyer and seller, the beggar and the boatman, the housewife and the law-
> yer offer something for sale, sing and gamble, shout and swear. In the eve-
> ning, these same people go to theater to behold their actual life, presented
> with great economy as make-believe interwoven with fairy stories and re-
> moved from reality masks, yet, in its characters and manners, the life they
> know. . . . Indeed, I never saw more natural acting than these masked
> players.[12]

Casanova fills out the account by telling about the *filosofi* or *contastori*—those exuberant improvisers of verse who could be encountered even in the meanest canals of Venice.[13] In the theaters there were still improvisations, although the form had long since faded elsewhere. Casanova was also impressed by the *gondolieri* who sang the verses of Tasso and Ariosto to each other from shore to shore. (As might be expected, he preferred Ariosto.)

The floating architectural prodigies and oriental exoticism of Venice were not the significant experiences for Fragonard, as they were for so many others. What was important to him, as can be adduced from his allusions in his works, were his direct experience of Tiepolo, whose satyrs and nymphs were far removed from antiquity, and his immersion in a living theater. Venice provided the grand finale of his formative years. After a brief visit to Genoa, where Fragonard seemed to relax, drawing only a few landscapes, he and Saint-Non set out for Paris, which, like Fragonard, was marking a great and difficult event—the winding down of the Seven Years' War.

CHAPTER 8

Home to Paris

WHEN FRAGONARD got back to Paris in late September 1761, the Duc de Choiseul was hard at work picking up the pieces of a disastrous war. Despite his clever maneuvering, the Seven Years' War could not be seen as anything other than an expensive and humiliating defeat. In 1763, when he finally arranged the treaty known as the Peace of Paris, all of France was aware that the colonial empire of France in North America was irrevocably lost. The art world to which Fragonard returned, however, had not been unduly disturbed. Many of the wealthy financiers and lesser bourgeois businessmen who had penetrated the circle of collectors while Fragonard was still an apprentice were still able to wield ample means. If the royal commissions had been considerably reduced by the war, private commissions were rapidly increasing, as was intense trading in works of art. The number of auctions of both private collections and collections formed by dealers increased steadily until by the 1770s there were some thirty to forty a year. The economic effects of the war were far less apparent than the psychological effects—the humiliation that would goad Marigny and Cochin, his willing lieutenant, in the battle against demoralization. Much of the patriotic rhetoric issuing from Marigny's office in the 1760s can be attributed to his need to cancel the memory of France's defeat.

Fragonard, then, returned to a city that had been stirred by a public event of serious implications—a city that was eager for distraction in the form of real or apparent change. What he did when he first returned is not at all clear. Perhaps he himself was not sure of his course. He had to install himself somewhere, pick up his relationships within the confines of the art world, make his presence known to those in power—academicians, dealers, and patrons—and above all, find ways of earning money. For an artist protected by Boucher, regarded highly by Cochin, and who had won the Prix de Rome, the prospects were good. Fragonard returned to his old haunts; he was visited by and made visits to his former acquaintances

among the *amateurs,* particularly the academicians. He picked up his old compan-
ionship with Boucher's son-in-law Baudouin and was seen about town with him.
He saw Saint-Non, whose whole family took a special interest in him. No doubt he
became acquainted with some of the abbé's intellectual friends such as d'Alembert
and Diderot.

The means by which an artist of Fragonard's background could make money
had expanded during the five years he was away. There were more and more
people of relatively modest means interested in acquiring art for their walls, and
they willingly snapped up editions of engravings after works by the best-known
artists. Although still not widely known, Fragonard could find print dealers will-
ing to issue editions; even before he had returned, an edition of views of Naples and
Rome by him and Hubert Robert had already been marketed. Besides the print
dealers who were also editors, there were booksellers who functioned as pub-
lishers and who were in need of endpapers or title pages, or sometimes illustra-
tions. Fragonard made contact with publishers early in his career, and his interest
in book illustration was sustained throughout his life. Slightly more profitable
than prints for an artist were original drawings, which were very much in vogue by
the 1760s. A young artist with the facility so evident in Fragonard's Italian works
could establish a market among the new collectors who followed Crozat's
generation—a more diverse group that included people from the merchant class,
the minor nobility, bureaucrats of Louis XV's regime, and the clergy. There were
patrons with grander ambitions and purses who would commission paintings
from the rising contemporary generation, sometimes even assigning the subject.
These included many agents for clients in Sweden, Prussia, Austria, and Russia.
And of course there was royal patronage. Filtered through Marigny's office, it
extended to commissions for the flourishing tapestry factories as well as for works
for various royal lodgings and palaces. Courtiers could be counted upon to ape the
king, whose tastes were still dominated by Mme de Pompadour. Although no
longer his mistress in fact, she was still mistress in title.

Despite Fragonard's good position, his protectors, and his knowledge of
Paris, he was functioning, like everyone else in the arts, in a pervasively political
atmosphere. A young artist had to know his way around, and there were innumer-
able hazards. For example, an artist trying to build a career needed to be aware of
the many internecine quarrels that could taint his relationships. If he frequented
Diderot, he had to hide the fact from the old Comte de Caylus, whose scorn for the
philosophe sometimes reached fanatical levels. If he was doing business with a
collector of risqué tastes, he had to be sure that the more straitlaced collectors were
not offended. If he decided that the church would be his main source of income, he
would do well, like Doyen, to avoid the patronage of the various secular sources in
whom the church saw potential political enemies and economic rivals.

Although we have little direct knowledge of Fragonard's personality, certain
of the legends are revealing. He was at once rebellious and timid as an artist,

basically agreeable but at the same time short-tempered on occasion. Small of stature but well made, with even features, a high forehead, intelligent and lively eyes, Fragonard seems to have pleased many people. Making his way through the increasingly complicated art world was probably relatively easy for him. Yet he wavered.

His activities during his first few years back in Paris are hard to trace, but it seems likely that he had just as hard a time settling down as he had in Rome. If we seek reasons for his initial restlessness, many can be conjectured. He had just had the most intensely satisfying months in his life as an artist. He finally, after many false starts, found what was essential to his temperament: inspiration. But it was inspiration that derived from the campagna of Italy and not the salons or lecture halls of the Academy.

He arrived in Paris exactly at the moment—one of those inexplicable moments when everyone agrees that something is different or changed in their milieu—when such inspiration was regarded by many as passé. Paris had moved on, and the newest preoccupations ran directly counter to Fragonard's. Everything associated with the Italian Baroque that Fragonard instinctively admired was now regarded with less than enthusiasm by many *amateurs,* although not all. The light style that had seemed so apposite before the mid-century now no longer fulfilled the needs of a greatly sobered educated class.

What Fragonard faced must have been all too clear when he returned, for it was just after the 1761 Salon in which an event of capital importance had taken place. The newly fashionable censure of frivolity, *petit goût,* and Pompadour, fueled by the newly fashionable pamphlets written by newly established art critics, had found its expression through the idolization of Jean-Baptiste Greuze, the uncontested star of that year's Salon. It is quite possible that this overwhelming event distracted Fragonard. He had already found committed and stable patrons quite ready to sustain him in his preferred style, but he had not yet found renown. If the subjects he preferred were no longer in fashion, he was bound to know some conflict or confusion. Subjects in the eighteenth century were of great importance to most connoisseurs, only a few of whom had the prescience to recognize Fragonard's painterly secrets. What is broadly called a shift in taste was taking place with such rapidity that Fragonard would be forced to reckon with it.

The title of Greuze's painting in the 1761 Salon, before which throngs gathered daily during the exhibition, was *The Village Bride.* Greuze depicted the moment when the old father presents the dowry agreement to his future son-in-law. The painting, for which Greuze had made meticulous studies, had been commissioned by Marigny, who was listed as its owner at the time it was shown in the Salon. What excited his viewers was neither Greuze's painterly facility, which had been noticed and praised several years before, nor his ability to establish character through portraiture, which also was well known to cognoscenti, but rather his decision to present a real-life scene as though it were a momentous scene

in a history painting. The lengthy commentaries on the painting at the time were almost all couched in terms of the story he was telling through the characters grouped in a modest country home. Writers took pleasure in describing the demure daughter, or the demeanor of the father (he had to be patriarchal and "good"), or the jealousy of the sister who stares with a dubious expression at the son-in-law, or the wistfulness of the servants. The painting was described exactly as if it were a scene in a bourgeois drama—the new genre in Parisian theater that was gaining powerful adherents.

The significance of Greuze's victory in 1761 was, then, its value as the herald of a conscious change in taste. Fragonard, who had known Greuze in Rome where their sojourns overlapped for a few months, confronted an art-world event that had implications for him and all the other painters of his generation determined to build a career. While he was excited about peasant life and was probably painting the Italian interiors redolent with animals, laundry steam, babies, and straw, Greuze was presenting a middle-class rural family in a grave and moralistic tone. If Fragonard wanted to keep up with French fashion or to be counted in what was then the avant-garde, he would have to change *his* tone.

Fragonard's temperament, which sheltered a romantic approach to both painting and life, put him at a distinct disadvantage in 1761. Painters may have talked about painting and its immanent problems, but patrons and the public had been swept up in an excess of enthusiasm for the new anecdotal approach given currency largely through the efforts of the philosophes. Already in 1756, the wise Italian connoisseur Francesco Algarotti noted that "the philosophical spirit which has made such progress in our times and has penetrated all domains of knowledge has in a certain manner become the censor of the fine arts."[1] That philosophical spirit was abroad in various undertakings and was full of contradictions, especially in the realm of the visual arts.

Fragonard's return to Paris occurred in a moment when both Rousseau and Diderot were hectoring the public with immensely successful lessons in manners. Just a few weeks before Greuze came forward with his rural encomium of virtue, showing the *bon gens* who were so different from the city dwellers (the painting was an implicit censure of urban life), Diderot himself had attempted to reform the theater with his play *Le Père de famille* (*The Father*), a domestic bourgeois drama written in opposition to the convention-ridden neoclassical drama then in vogue. Although the play failed, the ideas were avidly discussed. Greuze's painting, with its stentorian gestures and its grouping of characters in what is more like a stage set than a realistic interior, directly reflects the experience of theatergoers who were watching the rapid dissolution of the monopoly of the classic Théâtre Français with its fixed habits and rules. Diderot and Rousseau led the attack, and Greuze, who at the time was an intimate friend of Diderot, was certainly sympathetic and quickly seized upon the implications of the new theories for his own painted dramas. Diderot, as Peter Brooks has written, "wished to introduce into drama the

emotional immediacy of the novel, its complex plotting and elaborately realized setting; and he saw drama as directly moral in its aim, concerned with the recognition of virtue, and based on a new relation of sentimental identification between spectator and character."[2] This reckoning of Diderot's intentions could easily be applied to the way Greuze's painting was received by reviewers of the 1761 Salon, and by Diderot himself, who wrote an excessively detailed analysis of the plot, setting, and characters in the painting as if it were theater. "Clearly," Brooks goes on, "Diderot's urging of a *genre serieux* that would not be a tragi-comedy but a new middle ground for serious treatment of private lives and their dilemmas— and that would depend for effect less on observing defined categories of the *vraisemblable* than on creating an illusion of lived experience—his arguments for an emotional rhetoric that would infuse sublimity into the ordinary, and for action and pantomime, in large measure announce melodrama."[3]

Here again the parallel with Greuze is exact. After the resounding success of *The Village Bride,* Greuze went on to darken his domestic dramas and to reach pure melodrama in later works. This transposition of noble sentiment from history paintings in the old genre to serious domestic tragedies found a broad public. The engravings that were instantly issued in very large editions sold out. People continued to buy Greuze's subjects, and even when he turned outright sentimental, as he did with his painting of a child weeping for her dead bird, high-minded intellectuals were among his many admirers. Among the philosophes, Greuze was a major figure during the 1760s. When in 1765 d'Alembert helped install his friend Julie de Lespinasse in new lodgings where she commenced a brilliant *salonniste* career, he saw to it that the walls were adorned with Greuze prints: *The Paralytic, The Village Bride,* and *Young Girl Mourning Her Dead Bird* shared the honors of the main salon with two prints after paintings by Van Loo.[4]

Rousseau contributed immeasurably to the swelling bourgeois sentimentality when he published in 1761, the same year as Greuze's Salon success, his novel *La Nouvelle Héloïse,* which, as Robert Darnton has noted, was a response to a new rhetorical situation: "Reader and writer communed across the printed page, each of them assuming the ideal form envisioned in the text. . . . The Rousseauistic readers fell in love, married, and raised children by steeping themselves in print. . . . The Rousseauistic readers of prerevolutionary France threw themselves into texts with a passion."[5] And so it was with the Rousseauistic viewers of paintings, who took a stern view of the frivolities of the court but an indulgent view of the sentimentalities of bourgeois life. Moreover, Rousseau's admonitions, with their critique of sharp Voltairean reason, made subtle inroads. When a reader of *La Nouvelle Héloïse* came across a sentence such as, "*la froide raison n'a jamais rien fait d'illustre*" (cold reason has never done anything outstanding), he knew very well with whom Rousseau was quarreling.

The 1760s were heavily marked by the printed word, and not only the works of Rousseau and Diderot. There were other currents. Samuel Richardson's *Pamela*

was avidly consumed even in upper-class French drawing rooms, as were the strange novels of Laurence Sterne—the other valence in eighteenth-century literature. No assessment of the intellectual history of the second half of the eighteenth century is adequate without a careful consideration of the presence of Sterne. The novelist Milan Kundera, answering fashionable critics whose focus in the 1980s is "on speaking ill of the eighteenth century," reminds them that it was a century not only of Rousseau, Voltaire, and Holbach but (and perhaps above all) the age of Fielding, Sterne, Goethe, and Laclos.[6] He thinks that perhaps indirectly a grand dialogue took shape between the novel and philosophy:

> Eighteenth-century rationalism is based on Leibniz's famous declaration: *nihil est sine ratione*—there is nothing without its reason. Against that reduction of the world to the causal succession of events, Sterne's novel asserts by its very form that poetry lies not in the action but there where action stops, where the bridge between a cause and an effect is ruptured and thought wanders off in sweet, lazy liberty. The poetry of existence, says Sterne's novel, lies in digression. It lies in the incalculable. It lies opposite causality. It is *sine ratione,* without reason. It lies opposite Leibniz's statement.[7]

This view was more congenial to Fragonard's character, but he would not fight his way back to it for a few years.

There were other avenues of censure in the sixties. The *petit goût* still supported by Mme de Pompadour was coming in for severe chastisement from many quarters. The style of Louis XV's court did not please the philosophes, who were eager to scourge its decadence by heavy doses of ancient wisdom. Almost all the philosophes were behind the resurrection of the Greek philosophers, most particularly Plato and Socrates and, of course, the poet Homer. Around 1756 the Comte de Caylus already noticed that translations of Homer were "raining down from every side," and he thought it wouldn't hurt for the French to occupy themselves a bit with this great man.[8] Several years later Diderot compared Homer to the former divinity Ovid as a source for painters: "Ovid in the *Metamorphoses* will furnish painting bizarre subjects but Homer will provide grand subjects."[9] In his review of the 1761 Salon, he commented on Charles-Michel Challe's painting of Socrates, noting that "here reigns a simplicity, a tranquility that is not of our time. One would say that it is a copy after an antique bas-relief." As Jean Seznec has revealed in his close study of Diderot and the question of antiquity, Diderot and his *Encyclopédie* colleagues were construing an attitude that would pave the way for the full neoclassic vogue of the following decade.[10]

Diderot's attempts to influence painters (he fancied himself a rich source for subjects) were based on a rather faulty knowledge of antique works of art conveyed by numerous folios of prints lavishly published at the time. His friend Falconet was exasperated with Diderot's pretensions. He defended himself as an artist against the tendency of the literati "to perpetually compare books with paintings with ridiculous sophism." He scolded Diderot for his dependence on

these often inferior and inaccurate reproductions of supposed works of Greek art, stating, "I only believe in masterpieces *when I see them*." Of course Falconet's response was more vigorous since he recognized in Diderot's somewhat maundering proselytizing the old quarrel of the ancients versus the moderns and he had to defend his position as a contemporary artist.

How right Falconet was can be judged by a painting by Joseph-Marie Vien that was greatly admired in the Salon of 1763. Even though the painting had been suggested to Vien by Diderot's archenemy Caylus, Diderot was rapturous. Vien worked from an engraving issued in 1762 after a Roman painting that had been excavated in 1759 at Grangnano, near Naples. The subject, *The Selling of Cupids,* is handled with a literal earnestness that drains the painting of the charm of the Roman original. The print from which Vien worked had misled and constrained him, but the painting was welcomed nonetheless by those who wanted to reassert the superiority of the ancient painters over the moderns. Fragonard, with his highly intelligent painter's eye, could hardly have been cheered by the reception of this painting with its dry, parrotlike approach. Years later he must have been enraged when Vien was chosen to replace him in Mme Du Barry's new palace.

Strangely enough, the philosophes, who hated antiquarians like Caylus for their pedantry and their passion for classifying and labeling, did not see the contradiction in their predilection for such antique parodies. The philosophes had long made the antiquarians the butt of their jokes and denunciations. When the historian Edward Gibbon visited various philosophes in 1763, he was shocked at their attitude toward the *erudits,* the antiquarian scholars: "I was provoked to hear from M. d'Alembert that the exercise of memory, the sole merit [of the *erudits*], had been superseded by the nobler faculties of imagination and judgment."[11] Gibbon quoted quite accurately. In the *Encyclopédie,* the entry under erudition reads: "*Le goût des ouvrages du bel esprit et l'étude des sciences exactes a succédé chez nous au goût de nos pères pour les matières d'erudition*" (The taste for works of imagination, and the study of exact sciences has replaced, in our time, the taste of our fathers for matters of erudition).

Fragonard's immediate problem when he returned was to make a presentation to the Academy in order to gain associate status. No matter how much he and the other painters might have wished to function without official confirmation, the Academy was still a powerful source of patronage, and all of Fragonard's admirers among the cognoscenti would certainly have urged him on. From the moment he set foot in Paris, this obligation hung over him. Fragonard was already searching for an appropriate subject late in 1761 and would continue, rather unhappily, for many months before he settled on the Greek legend of Corésus and Callirrhoé. It is not surprising that a painter who had won so much praise for his Prix de Rome painting would try to win his entry to the Academy with a history painting. That tradition, despite the rumbling of shifting taste, was still unquestioned for academic aspirations. Fragonard had to tear himself away from his

recent exhilaration in the Italian campagna and address himself to the task of finding an appropriate vehicle to display his mastery of the grand manner. He had to be a *serious* painter, as the times demanded.

The engraver Jean-Pierre Mariette, one of the *amateurs* of the Academy, visited Fragonard during the artist's preparations for the important event and reported, shortly after Fragonard's success, that the winning painting had been painted with difficulty. He wrote that "diffidence, which is the dominant quality of this artist, restrains his hand and, never content with what he has done, he rubs out and goes back on himself, a method which is harmful to talent and could spoil the chances of this young painter."[12] This testimony might indicate Fragonard's inner resistance to the required grand manner or his deep need to wrench meaning from this obligatory exercise. There are small sketches attesting to his search for an appropriate tone, and several oil sketches indicate how often he changed his approach and how hard he found it to settle on a scheme.

Fragonard was eager to find a story that had not been worked to death by other painters. His decision to work with Pausanias's legend of thwarted love and suicide gave him a chance to invent his own visual drama, since very few painters before him had dealt specifically with the theme. Assiduous searches by iconographers have revealed only a single drawing by Natoire on the Corésus and Callirrhoé theme. Since Fragonard had been in Natoire's company for almost five years in Rome, he might have heard the story or seen Natoire's rendition. The story had many elements to inflame Fragonard's imagination: Corésus is a priest in the Calydonian sanctuary of Dionysus who falls in love with Callirrhoé. She spurns him cruelly, and he enlists Dionysus's aid. The god sends a plague of madness on the Caledonians, which only the sacrifice of Callirrhoé will assuage. When Callirrhoé is brought to the sacrificial altar, Corésus, in a moment of passion, stabs himself to spare her. She, filled with pity and remorse, kills herself in turn. With such a sequence of melodramatic climaxes, Fragonard had something to work with—something that had been exploited previously only in theaters, twice in drama and once years earlier in an opera.

In Fragonard's mind the motif of sacrifice was associated with the grand manner. At first, in his earliest sketches for *Corésus,* he seemed to cast himself back to his earlier success, the *Jéroboam Sacrificing to the Idols* (fig. 4). The same smoking incense and flickering light appear in the early sketches, the platform with its *repoussoir* figure, the high priest with his exaggerated expressive face and his highlighted white garments, the sumptuous scarlets and blues of the other costumes, the studies of the heads of old men, the presence of a statue, and the massive classical columns—all recall the *Jéroboam* picture. This first version, modified by Fragonard's memory of Correggio and Luca Giordano (the softened and lightened values of the central group were perhaps suggested by his study of Correggio), was offered on March 30, 1765, at the Academy, where Fragonard was unanimously accepted by a significant group that included his old teacher Van Loo; the *amateurs*

Mariette and Bergeret de Grancourt; the engraver and adviser to Marigny, Cochin; the painters Chardin, Vien, Jean Restout, François-Hubert Drouais, and Baudouin; and the engraver and diarist Jean-Jacques Wille. The enthusiasm at the session cheered Cochin, who had long appreciated Fragonard's work and invested considerable hope that he might be the history painter so desperately needed by the new era. He immediately asked Marigny to buy the painting and to order a pendant to be used at the Gobelins factory. Another request that revealed Cochin's plans for Fragonard's future was that Marigny grant him one of the coveted studios at the Louvre—a crowning sign of royal favor that gave any painter a decided advantage on the market. Two days after Cochin's request, Marigny complied. Fragonard, it seemed, was launched on a distinguished official career. (The promised money, however, had to be pried loose after numerous requests by Cochin, and it was eight years until the final payment.)

Between March 30 and August 25, when Fragonard showed the final version at the Salon, he worked incessantly, searching for a more satisfying interpretation of his theme. No doubt he consulted his erudite friends among the *amateurs* and his friend the Abbé de Saint-Non. His "diffidence," as Mariette had remarked, would not have been based on his skills as a painter, for he had long since secured them.[13] Rather, he wrestled with the issue of literary interpretation. When he arrived at his final decision, the character of the painting had radically changed (fig. 15). The figure of Corésus is no longer a bearded patriarch but a young man whose features, as many critics noticed, were somewhat androgynous. His head is cast back as though he is in a trance; the expression is more inward; and the fainting girl, in a similarly high light, becomes, in her oblivious state, a part of his inner drama. Fragonard had also altered his composition radically. The Baroque diagonal that dominated the first version is banished in favor of strong parallel planes and alternating lights, which accent pictorial rather than literary episodes.

The final version, firmly composed and masterfully painted, was discussed at length by numerous commentators, all of whom treated the painting as though it were a play, discussing the merits of the climactic scene, the nature of the characters, and the more abstruse meanings of the legend. From Fragonard's own period to the present, critics of this painting have sought the sources of his unusual approach to the theme and have tried to resolve the mystery of his decisions between the first sketch and the final version, always in terms of the iconography and almost always looking for his inspiration in the theater of his time. Since nothing is known of Fragonard's thought processes, speculation has run free. Sensible speculation is certainly in order. This painting was to be the last major work of its genre in Fragonard's career. His struggle with it, as evidenced by so many preparatory painted sketches, may have brought him to a crisis.

It is obvious that the theater had long been a part of his life. The visual spectacle of the contemporary theater was in the eighteenth century intimately linked with the spectacle within painting, particularly history painting. Painters,

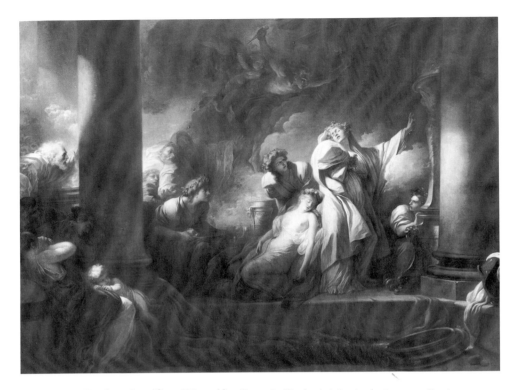

FIGURE 15. *Corésus Sacrifices Himself to Save Callirrhoé.* Musée du Louvre, Paris.

including his teachers Boucher and Van Loo, had worked in the theater; several of Fragonard's comrades had moved into theater design, and one became an actor. Almost all the painters of his generation were in the habit of attending the theater and dropping into the cafés around the Palais-Royal or on the Left Bank in which actors, poets, playwrights, and gossip columnists mingled. It was always amusing to be around after an opening night to hear the postmortems (an old tradition going back to the 1740s, when even the famous Voltaire would steal into the Café Procope in disguise to suffer the insults and hear the critiques of his latest play). At the same time Fragonard was working on his painting, there were vivid controversies and broad discussions of theory aired first in the cafés and then in the columns of the newspapers.

The classical French theater was edging toward melodrama. The thirst for novel effects was growing, and connoisseurs were discussing the deleterious results of more and more elaborate stage machinery. Spectacular effects and extravagantly horrifying actions, such as self-sacrifice on the stage, were deplored by the more classicizing cognoscenti, who focused on the Comédie Française. On the other hand, a demand for psychological rather than stylized effects was expressed

not only in the standard drama criticism of the day but also in discussions among the literati, particularly the philosophes.

If Fragonard turned to his literary friends for assistance with his problem, he probably turned first to his intimate friend the Abbé Saint-Non, who, in turn, was a friend to most of the original encyclopedists. He was well enough known to them to be discussed in their correspondence, as when d'Alembert wrote to Voltaire that the abbé had gone to Rome "to see the masterpieces of art, hear good music, and know the buffoons of every type that that country contains."[14] As an artistic gadfly, Saint-Non was invaluable to his friends among the painters. When Voltaire's *Olympie* was performed in Paris in 1764, Saint-Non was privy to heated discussions of the staging. The play, as Beth S. Wright has pointed out, may have suggested Fragonard's treatment of the climax in his painting.[15] The theme is the suicide of Olympia, who stabs herself and leaps into her mother's funeral pyre for shame at loving the assassin of her father. Wright notes that the play was criticized by Bachaumont for its spectacular and costly stage effects—a measure of the new tendency to melodrama. Voltaire's purpose in the play was thought to be to condemn religious fanaticism. Since the barbarous execution in 1762 of Jean Calas, a Calvinist wrongfully charged with murder, was still very much on the minds of Parisians when the play was performed, it seems likely that the subject was of particular interest to the people of Paris, who would know how to read the parallels.

Speculation about Fragonard's views of his subject matter must take into account the overwrought atmosphere of the period and the basic fact that France was a police state in which all expression of overt opinion was risky. If Fragonard's painting (like Voltaire's play) was an indictment of religious fanaticism, as Seznec has said,[16] then Fragonard's attitudes can be guessed at and his later withdrawal from history painting perhaps accounted for. Despite the lively life of the arts during the latter half of Louis XV's regime, there were plenty of hazards, even for painters. The philosophes were always in danger of imprisonment at the merest whim of the crown. There grew up an elaborate Aesopian code in which, for instance, the words exchanged in the Café Procope during the 1760s were carefully guarded. The soul was known as "Margot," liberty as "Jeanneton," and God as "M. de l'Être." Marmontel, the poet friend of Saint-Non and Marigny, reported an anecdote in which he and a friend were talking at the Procope and were overheard by someone who interrupted to ask, "Monsieur, may I venture to ask who is this M. de l'Être who behaves so badly and with whom you are so dissatisfied? To which his friend replied, "He is a police spy, Monsieur."[17]

Perhaps Fragonard's version of the suicidal drama of the Corésus story was modified by his participation in philosophical discussions and by his reflection on the implications of his theme. But there is another aspect to be considered, and that is his need to fulfill the intimations of freedom he had experienced in his last

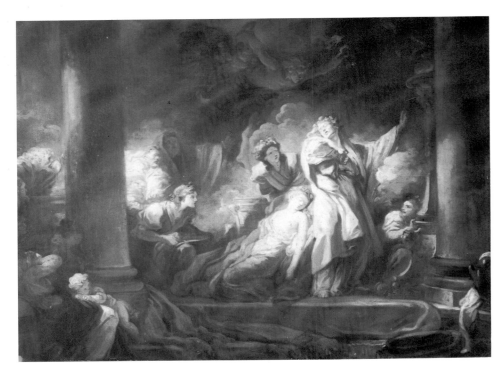

FIGURE 16. *Corésus Sacrifices Himself to Save Callirrhoé.* Academia de Bellas Artes San Fernando, Madrid.

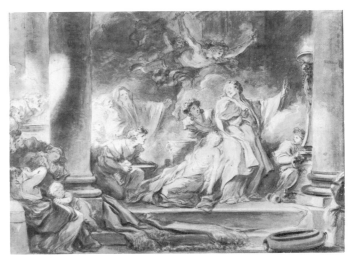

FIGURE 17. *Corésus Sacrifices Himself to Save Callirrhoé.*
The Pierpont Morgan Library, New York.

FIGURE 18. *Head of an Old Man.* Musée des Beaux-Arts Jules Chéret, Nice.

months in Italy. Viewed from this far less literary point of view, the movements
Fragonard undertook in his long preparation for the history painting can be seen as
a struggle to maintain the excitement of freeing his brush. The vivacious oil sketch
in Madrid (fig. 16)—probably his final essay before undertaking the large presen-
tation canvas—indicates Fragonard's full creative power, for he had both invented
a composition that would have satisfied any Poussinist and used the range of his
colors to make a dramatic pictorial impact. The drama here lies in the firm organi-
zation of light and dark, which Fragonard aligns on several parallel planes. It lies in
a discovery he had made in Italy—that he could suggest mystery by casting a
saturated light on his subjects, thereby reversing the usual formula of the *clair-
obscur*. The memories of other painters are almost effaced, although the avenging
angel that swoops over the scene could have been recorded in Fragonard's vast
mental notebook in Venice, where he saw Tintoretto. The Madrid oil sketch is
almost identical to a drawing in the Pierpont Morgan Library (fig. 17) that Eunice
Williams believes to be either a record after the final painting or a commissioned
copy.[18] In this black chalk and brown wash drawing, Fragonard is explicit about
his interest in the mysterious effects of greatly intensified light. At the left there is a
telling detail: he casts the profile of a bearded elder against one of the lightest areas

in the painting, much as Tiepolo had done in his wash drawings for large mural commissions. Light, then, is a protagonist in the pictorial drama that in many ways stays within the canon of late Italian Baroque but yet announces Fragonard's own idiosyncratic way of organizing dramatic effect.

During the period when Fragonard was casting about for his final version, he probably began working on the numerous studies of heads of old men, many of which found a ready market. The motif was almost certainly a reminiscence from his student years, when he had been set to study Rembrandt's prints. Later he carefully studied features of the old men in Tiepolo's work. But when he painted *Head of an Old Man* (fig. 18), Fragonard already had moved toward his freedom. The technique of fluttering strokes, rapidly brushed and built over transparent glazes, with a network of violet lines working against a gray-toned ground would later become his hallmark. In the Nice head, the structured strokes of rose, ocher, and yellow move beyond the outlines of the head, giving volume just as they do in the final painted sketch and even the final large version of *Corésus and Callirrhoé*. In these essays with his brush, Fragonard shows a strong drive to express his motif through the activity of the paint itself. *Corésus,* with its stage and its exaggerated lighting, suggests a derivation from opera, but in its details Fragonard is seen moving beyond the motif to what Baudelaire, influenced by Diderot, called the "magic" of painting. The whole prolonged dialogue with the métier throughout the struggle with this obligatory work shows Fragonard moving from a *première pensée* that was essentially a routine rhetorical exercise to a seminal engagement with immanent painterly means.

CHAPTER 9

Portraits of Fantasy

ITH HIS *Corésas and Callirrhoé* Fragonard acquitted himself superbly of his initial obligation at the Academy. His dramatic large-scale painting was the cynosure of the Salon of 1765. There were a few critical cavils among the cognoscenti, but the general public was fully satisified. Fragonard's success brought connoisseurs to his door (which was soon to be a door in the Louvre), and his name quickly became known outside the inner circles. In the normal course of events, his next step would have been to make his final offering to the Academy and be accepted as a full member, but he never took that step. He quickly disappointed his ambitious sponsors by showing no major work in the next Salon, only a few drawings, the head of an old man, and group of putti described with memorable sarcasm by Diderot:"*C'est une belle et grande omelette d'enfants dans le ciel. . . . M. Fragonard, cela est diablement fade. Belle omelette, bien douillette, bien jaune et point brûlée.*" (It is a large and pretty omelette of infants in the sky. . . . M. Fragonard, this is damnably insipid. Pretty omelette, well puffed-out, properly yellow, and not burned.)[1] On that occasion, the newspaper *Mercure de France* reported that "out of his sense of delicacy" Fragonard had removed two large paintings[2]—a clear indication that his activity as a purveyor of erotic paintings was underway and that such activity was looked upon as ignoble by the authorities he needed to impress in the Salon setting. He may have already made the decision not to try to impress them.

Several plausible reasons for this reluctance can be inferred. The most likely was economic need, for the state was notoriously slow in honoring its commitments. Cochin had to appeal again and again for payments, and almost a full year later, in April 1766, he wrote again to Marigny to say that Fragonard was in great need of assistance. The alacrity with which Fragonard took on the commission for *The Swing* (colorplate 1) some months later might confirm this financial distress. But it might also be seen as yet another indication of Fragonard's decision to free

himself from the duties of being a painting courtier. From hints scattered in mem-
oirs of the period, it seems that Fragonard had little patience with the round of
obligations taken on by academicians. He didn't like the salons of the wealthy
amateurs, and he was not eager to listen to the lectures or the gossip at meetings at
the Academy. What he liked was to dine out with fellow artists or sympathetic
amateurs and professionals, such as the dealer and printer Gabriel Huquier, for
whom he dashed off sketches at the dinner table, making private jokes with his
pen. He also liked to pass time with his friend Baudouin, who shared his own
interests and who worked for an upper-middle-class market that was, to say the
least, free from academic prejudices.

During the years after their return from Italy, Fragonard's friendship with
Saint-Non remained firm. The abbé's enthusiasm for Fragonard's "fire" had not
diminished, and he enlisted his entire family in support of his protégé. His brother-
in-law, Bergeret de Grancourt, had already started collecting drawings and small
paintings before the famous Salon. Saint-Non's brother, M. de la Bretèche, who
had recently built one of the many new houses on the rue de Faubourg Saint
Honoré, near the Champs Elysées, was also interested in cabinet paintings and
drawings for his new mansion. In addition, Fragonard was gaining ground among
the tax farmers, who were getting richer and richer during the late 1760s and were
increasingly eager to function as patrons of the arts. All of these possibilities made
Fragonard's economic prospects seem more secure, and they made it possible for
him to avoid further obligations to the Academy.

There were other less obvious advantages for Fragonard in choosing a path
that led away from the official arena. His deepest need was to grope his way back
to the freedom he had known in Tivoli. The psychological release of that extraor-
dinary summer must have been immense. The use of the word freedom here is not
misplaced. He had found a freedom that he had never known before, and he
shared with his epoch a profound respect for its importance. The years leading up
to the Revolution were fraught with expressions of discontent brought on by the
constraints imposed by the state. They began with the despotic principle of the
king's privilege to issue *lettres de cachet,* and filtered down, through direct or
indirect censorship, to the arts, and still further into every aspect of daily life.
Voluble protests against the arbitrary were evident even before Louis XV's death.
The diction of the literati had highlighted the word "freedom." Even the word
"rights" was well installed in literature by mid-century. A whole industry of pam-
phleteering and illegal writing flourished in Paris, reflecting dissatisfaction with
the status quo and asserting demands that would later be codified into revolution-
ary slogans demanding liberty.

The abstract idea of freedom would become, for an artist of Fragonard's
temperament, quite concrete. He had experienced it for himself and in his own
medium during that summer in Tivoli. To relinquish that peculiar satisfaction to
the demands of any institution would not be possible. Fragonard could make a

living by working with what amused him, using his considerable skills to delight connoisseurs. At the same time, he could actively seek larger opportunities to realize again in his work the feelings he had once known.

Fragonard's tactic was to be available to diverse potential clients: dealers who had a market for certain subjects, *amateurs* who had a taste for risqué drawings and small paintings, and book publishers who needed illustrations. It was far more likely that Fragonard could find ways to move, in his idiosyncratic fashion, to satisfy his own needs in these smaller modes than in working toward official approval. During the years immediately following his success at the Salon, he produced numerous small works of striking variety. They included the heads of old men (that Wildenstein believes were requested by dealers), robust studies of bulls, scenes of peasant life, and anecdotal erotic paintings and drawings. In many of these small works Fragonard can be seen advancing bold approaches. The small study entitled *The White Bull* (fig. 19), in the Louvre, is an unusually realistic description of the character of a bull, both in physical structure and in attitude.

Another of the Louvre's treasures, *Women Bathing* (fig. 20), usually dated in the decade of the 1760s, seems at first in its imaginary motif to have been an exercise in the style of his master Boucher. Yet for all its stylized details, such as the

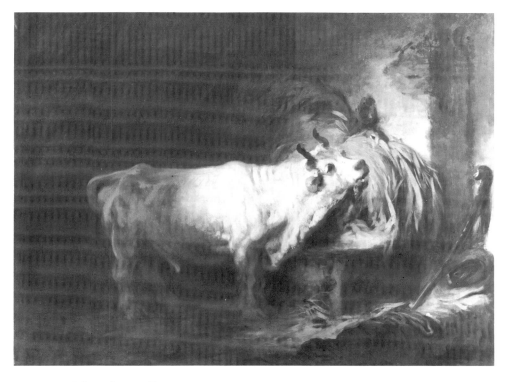

FIGURE 19. *The White Bull*. Musée du Louvre, Paris.

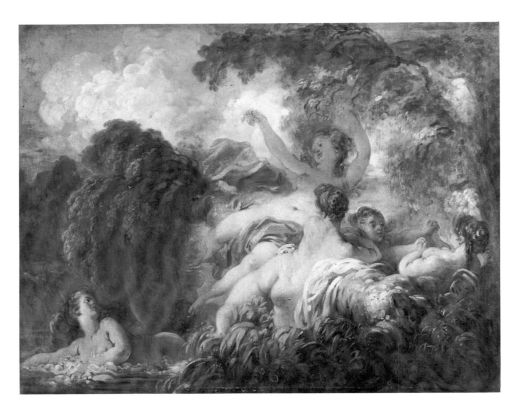

FIGURE 20. *Women Bathing.* Musée du Louvre, Paris.

shrubbery in the background, Fragonard treated this theme with considerable originality. He made no attempt to disguise a frankly sensuous motif by giving its figures mythological identities. While he may have been inspired by Rubens's nereids in the Medici series (with which he had long been familiar), or perhaps by Veronese, or by Titian's incomparable *Europa,* Fragonard's approach to his subject was original in that it was completely free of pretext. He was obviously excited by the central group, the propinquity of flesh to flesh, the graded sequence of highlights, and above all the sense of floating that the aquatic setting inspires. The rhythms of light accents in this painting are established by the most summary of brushstrokes, leading to many comparisons with the way the Impressionists handled paint.

In springing free of traditional anecdote, Fragonard could indulge his compelling desire to paint from his sensibility alone, using the language of his brush in an unrestricted way. Even though the subject of *Women Bathing*—young female nudes disporting—as well as the erotic motifs of a number of other small oil sketches of the period, such as *The Stolen Chemise* (fig. 21), show Fragonard's willingness to cater to a specific clientele, he used the occasion to press for his

freedom from grandiloquence. Fragonard's approach to erotic motifs was as direct as that of painters of the nineteenth century and had none of the coquetry that flourished among other students of Boucher. This can be seen in his works in an even lighter vein, such as the wash drawings illustrating scenes of the intimate life of working girls (fig. 22). Using a lightly laden brush, he captures the warmth of the atmosphere of the bedchamber by gliding over the page with the thinnest of washes and indicating his figures in their most lively characteristic gestures. He had a rare ability to condense, abstract, and place his forms in an allotted space. With two dots for eyes, a single stroke for the cleft between the collar bones, a curling line for figures in movement, Fragonard calls up the youthful lineaments of his subjects without a trace of stylization. Even when he is archly anecdotal, as in scenes of young girls startled by firecrackers (fig. 23), or, still more slapstick, being aroused by a barrage of water from a hose protruding through a trap door, or when he tells of several actions at once, as in a suggestive bedroom scene with the door flung open by the scandalized mistress of the house, Fragonard, in his desire to make metaphors of light and warmth, never stiffens.

Fragonard, as Mariette reported, was never satisfied, and he continually sought to divine the secrets of the painter's art from the art of others. Late in 1767 he applied to join his friend Baudouin in order to copy in the Rubens room at the Palais du Luxembourg.[3] Perhaps a renewal of his concerted attention to Rubens's technique, with its extensive use of glazes and *alla prima* heightening, inspired him to undertake the distinctive group of works known as the *portraits de fantaisie*. In these, he challenged prevailing canons in order to express his views as a painter. The process of refreshing his knowledge of the technical procedures that Rubens developed—the use of the toned, grayed ground; thinned, glazed shadows; and opaque impasto only for accents and highlights—served Fragonard as a spur to his own inventions, which burst forth in these paintings assertively and confidently. His technique by 1769, when several of these paintings were completed, was quite unlike that of his contemporaries, as even a cursory glance at the *portraits de fantaisie* confirms. With the assurance of a painter who had delved into many problems and questioned the history of his art, Fragonard strikes out on his own in these portraits. A measure of his success as an inventor is in the flourishing literature of interpretation, much of it controversial. No matter which point of view we favor, it is obvious that that which is peculiar to Fragonard and which would mark his later masterpieces emerges with éclat in these works.

The exact circumstances for this sustained moment of excitement in Fragonard's painting life are not known. Four of the so-called imaginary portraits are thought to have been commissioned by Saint-Non. On the other hand, they may have originated in a wager, as some early chroniclers suggested. Or perhaps Fragonard, during the after-dinner conversation at Saint-Non's or his brother's home, suggested that he undertake quick impressions of the family in exotic costume. He

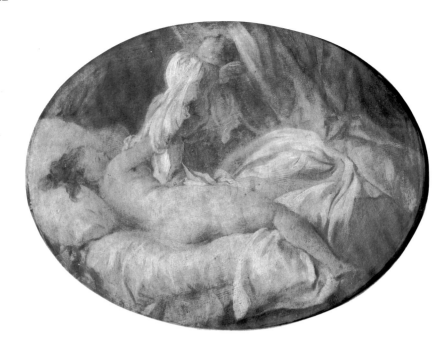

FIGURE 21. *The Stolen Chemise.* Musée du Louvre, Paris.

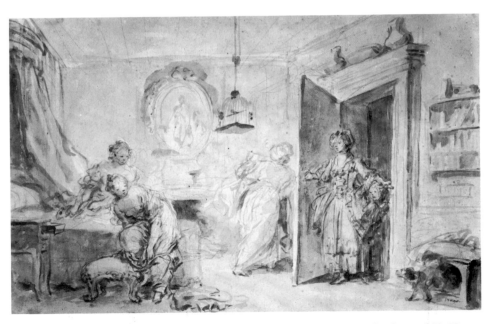

FIGURE 22. *The Bedroom.* National Gallery of Art, Washington, D.C., Samuel H. Kress Collection.

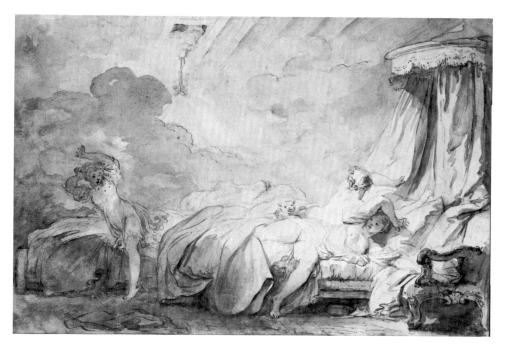

FIGURE 23. *The Firecrackers.* Museum of Fine Arts, Boston, Otis Norcross and Seth K. Sweetser Funds.

boasted that he had concluded them in one hour, according to tradition, and there is some confirmation of his boast in the memoirs of the painter Pierre-Adolphe Hall, who speaks, in his inventory of 1778, of "a head of me, from the time when he used to do sketch portraits in a single sitting for a louis."[4] There was nothing new in the idea of a *portrait de fantaisie.* It had long been a dealers' category in auction catalogs, and such artists as Chardin were listed as painters in the genre. It is clear from the outset, though, that Fragonard intended to bedazzle his friends with something new. His visible excitement in the first essays is sustained in a dozen other paintings of the period.

Saint-Non, whose discrimination and sensitivity to his friend's propensities was notable, might have used this commission as a means of encouraging Fragonard to regain the enthusiasm he had so appreciatively remarked in Tivoli. Fragonard had only recently come in for some cutting criticism in the art press, which noticed his absence from the Salon and attributed it, as did Bachaumont, to the venality of the artist: "The lure of profit and the interest in boudoirs and wardrobes have diverted the painter from striving after glory."[5] It may well be that the snide implications of more than one reference to him in the press hardened

Fragonard's resistance to these demands for sober formalities and made him all the more eager to exercise his natural predilection for movement and light.

There is a strong element of challenge and also of witty play on standard assumptions in these paintings. A long tradition of *fa presto* stood behind him, as did the long-simmering arguments in the seventeenth century that still agitated discussions among painters. There is every reason to believe that Fragonard consciously rejected both the advocates of the new morality, currently infatuated with Greuze, and those in royal circles who insisted on a new history painting of a sober and classical sort. In the *portraits de fantaisie* Fragonard set out to defend his educated interest in the spontaneous and lyrical and to extend a tradition with which he identified his own feelings.

The idea of *fantaisie* for Fragonard and his friends in the eighteenth century was rooted in new concepts of the imagination. As an eighteenth-century dictionary defines it, "of fantasy: one says it of objects fabricated, of which the value resides above all in novelty and originality." A twentieth-century dictionary defines *portrait de fantaisie* as "an idea that has something free and capricious." Originality, novelty, caprice: qualities that Fragonard valued and that he set out to capture with his virtuoso ability. (In a perceptive article on the *portraits de fantaisie,* Mary D. Sheriff writes that she considers the term a misnomer, since the eighteenth century sometimes defined such portraits as "not being based on a model." However, there was in this category, as in so much else during the Enlightenment, considerable variation and confusion, and it is not inappropriate to consider these paintings both *portraits de fantaisie* and portraits based on certain individuals.)[6]

In contributing something novel to the art of portraiture, Fragonard was well aware that the new tendency was to present more natural and psychological studies of character. Likeness was highly appreciated even by those sophisticated connoisseurs who claimed to understand that a portrait, to be of value beyond the lifetime of the subject, must draw on deeper resources than mere resemblance. Yet Fragonard's intention was to use his sitters, whose features have in several instances been tentatively identified, to express something other—something that would emanate from the whole painting and that was more than an accurate topography of a face. Certain art historians have thought he was painting general themes, such as music, the dance, or poetry. Fragonard may have started out with an allegorical intention, but as the paintings accumulated, something else took over. The flourish of his agile brush would reaffirm his strongest instincts and announce a knowledgeable defiance as well. The aesthetic he was defending was under fire from some of the aesthetic theoreticians of his time, but many painters continued to have recourse to its principles as they were shaped in the seventeenth and early eighteenth centuries by the lively writer Roger de Piles in his *Cours de peinture.*[7] This basic text was known to every painter with any formal training and was standard fare during Fragonard's student days. The book had in fact been

reprinted in 1766—a sure sign that painters were still drawing on its counsels. Who else would have bought it?

De Piles, as Thomas Puttfarken has pointed out in an excellent study of the early theorist, held that "the prime interest of painting was neither discursive nor didactic. It was a visual interest and this was *sui generis*. . . . The literary, moral, or social significance of its subject-matter was not, for de Piles, an intrinsic value of painting."[8] A painter as volatile and curious as Fragonard, leafing through de Piles, could easily find fuel for his natural predilections. He could turn to the discussion of enthusiasm—a subject the philosophes debated lengthily, without ever quite determining what it meant for the new enlightenment in the arts—and could find such brisk and satisfying pronouncements as:

- Enthusiasm is a transport of the mind, which makes us conceive of things after a sublime, surprising, and probable manner.

- Though truth always pleases, because 'tis the basis of all perfection, yet 'tis often insipid when it stands alone; but, joined to enthusiasm, it raises the soul to a kind of admiration, mixed with astonishment; and ravishes the mind with such violence, as leaves it no time to bethink itself.

- Able painters may know, by their own experience, that in order to succeed in so refined a part [*disposition*], they must rise higher than the ordinary, and, as it were, be transported out of themselves.[9]

DePiles's willingness to see painterly effects as "true painting" is evident throughout his treatise: "True painting, therefore, is such as not only surprises, but, as it were, calls to use; and has so powerful an effect, that we cannot help coming near it, as if it had something to tell us."[10]

De Piles's stress on the *tout-ensemble* (the total of all painterly effects and modes) and on the use of *clair-obscur* (chiaroscuro) to strike the viewer *au premier coup d'œil* (at first glance) definitely addressed a temperament like Fragonard's. His development of *clair-obscur,* from his student years through Tivoli to the mid-1760s, as the chief carrier of his emotional meaning is obvious. Drawing his effects from shadows to the highest of lights was his consistent pattern, leading to the masterpieces of the 1770s. He was well aware of his intentions and spoke of them in later years. In an assessment of his work by Gault de Saint-Germain—an author who might have known him, or at least knew other painters who quoted him—written not long after Fragonard's death, we find a telling description: "The dazzling effect of a vivid light in his compositions was for him so seductive that he called it the pistol-shot [*coup de pistolet*] of *clair-obscur.*"[11] The pistol shot was one of his chief delights. It was certainly in the spirit of the general principles enunciated by de Piles, that the whole painting must strike the eye immediately and that the expression lies in the whole and not the parts. This aesthetic, taken up with alacrity by Fragonard, was to be echoed later throughout modern painting, first by

Delacroix, then by his student Baudelaire (many of whose principles echo de Piles), and finally by Matisse, who wrote of the human figure in 1908:

> Expression, for me, does not reside in passions flowing in a human face, or manifested by violent movement. The entire arrangement of my picture is expressive.[12]

And again, at the end of his life:

> The essential expression of a work depends almost entirely on the projection of the feeling of the artist in relation to his model rather than the organic accuracy of the model . . . the art of portraiture is one of the most remarkable. It demands especial gifts of the artist, and the possibility of an almost total identification of the painter with his model. The painter should come to his model with no preconceived ideas. Everything should come to him in the same way that in a landscape all the scents of the countryside come to him: the smell of the earth, the flowers linked with the play of clouds, the movement of trees and different sounds of the countryside.[13]

Translated into the visual arts, the eighteenth-century preoccupation with enthusiasm and sensibility was often confusing. Diderot seemed to take both sides in the reason-versus-feeling argument. He almost quotes de Piles when he boasts in 1758, "I know how to be carried beyond myself, a talent without which one can do nothing worthwhile."[14] In his art criticism, however, he more often stressed discursive meaning in painting, even as he waxed enthusiastic over the pathos of Greuze. Although he also extolled "sensibility," Diderot was not nearly as consistent as Rousseau, whose attack on reason was blunt and forceful. In *La Nouvelle Héloïse,* which, when it was published in 1761, was one of the first modern best sellers and so quickly sold out that booksellers initiated the practice of renting it out by the day, Rousseau is eloquent about the pitfalls of "cold reason." In a letter of 1769 he says, "Reason, in the long run, takes the turn the heart gives it."[15] Rousseau's insistence that the emotions must on no account be inhibited by reason offered painters and poets an alternative to the powerful presence and omniscience of Voltaire in their lives. Rousseau's more extravagant stances came close to the specific counsels of de Piles. For instance, in the *Cinquième Reverie,* he describes himself standing beside a lake where he hears the sound of its waves and the agitation of the water. The flux and reflux "sufficed to make me feel my existence with pleasure, without taking the trouble to think."[16]

Interestingly enough, Fragonard did not swallow whole these antirational tendencies, much as he longed to experience what de Piles called the *fureur* of painting. His portraits of fantasy were grounded in close study and judicious thought about conventional portrait composition and about how convention could be altered for new effects. The goal would be to make available in a single *coup d'œil* something more than a catalog of facial expressions. His figures would express various meanings in their entire attitude—their bodily gestures, their heightened accoutrements, their brief but telling details of color. For him, as for

Matisse more than a century later, the whole was more expressive than individual expression or likeness.

There was a certain amount of support for his view in the intellectual currents of the time. The idea of the word "portrait" was very much in vogue just then. The memories of the period are strewn with elegantly styled word portraits, as, for instance, those of Julie de Lespinasse and her friend d'Alembert in their famous correspondence. In these carefully fashioned portraits, the writers strove to capture the whole person. The way he held his head, entered a room, or used his hands was described only in order to arrive at a general effect. He had "grace" or he was "hesitant" or even "clumsy." If he were squinty-eyed or lame, that was only mentioned in a subordinate clause, for the trick was to find a wholeness that characterized the entire personality. Although there was a mounting interest in psychological matters, these word portraits were surprisingly pictorial, and great emphasis was placed on gesture. On a more profound level, Diderot himself was speculating about the meaning of gesture. His exploratory essays, one on the blind and the other on the deaf and dumb, edged close to modern psychology and brought him to reflect on the fundamental nature of expression. Later he would incorporate his thoughts in his speculations about the theater.

The close relation between the worlds of painting and theater was bound to engender parallel theories. As we have seen, Fragonard had been a familiar in the world of theater since his student days with Boucher, with whom he remained in close contact until Boucher's death in 1770. The theater was always with Fragonard and had no minor effect on his approach to the *portraits de fantaisie*. In the theater, as in painting, there were many lively discussions and strong differences of opinion after the mid-century. Increasing dissatisfaction with the stylized performances at the Comédie Française was expressed in the greatly expanded press. As often happens in the history of the arts, the long hegemony of an officially approved style was challenged quite suddenly by a sated public. In such circumstances, artists usually seek to refurbish their art with materials drawn from more earthy sectors of culture.

During the last years of Louis XV's regime, the theater of the fairs and boulevards was becoming a serious threat to the official theater, which held a monopoly of the spoken word. More and more intellectuals began to support the popular theater, spinning elaborate theories about the benefits of a theater without words. Popular pantomimes were studied in a scholarly way, and the value of their gestural expressions was established. The idea of a wordless drama was discussed by Diderot in the same diction that he employed when talking about painting. The tableau was offered as an alternative to the static perorations of the official theater. Marmontel discovered that for "impassioned movements of the soul" the art of pantomime was absolutely necessary, for "there, it seconds the words, or takes their place entirely."[17] Fragonard's presence in theater circles exposed him to discussions of theater reform advocated by such intellectuals as Rousseau, Louis-

Sébastien Mércier, Marmontel, and Diderot. Even more likely, he heard of the new ideas about the value of gesture from the actresses and dancers of the opera themselves, for their careers were directly affected by them.

The ballet was very important in the general theater scene, and it, too, was undergoing radical reforms. About 1760 the dynamic ballet master Georges Noverre, four years older than Fragonard, wrote the first serious treatise on the new ballet, *Lettres sur la danse et sur les ballets,* in which he advocated sweeping changes.[18] His idea was that the ballet must be founded on a dramatic idea—the *ballet d'action*—which encompassed the extensive use of pantomime. He had begun his career in the theaters of the fairs, and he never hesitated to engage his audiences with lively dramatic situations that incorporated pantomime. His innovations were the talk of Paris, and Fragonard did not have to wander very far from his studio to hear about them. The dramatic gesture that would express a freight of meaning in a single, strong impression was of central importance.

The singular impression produced by the *portraits de fantaisie* was based on Fragonard's emphasis on a major gesture. Most of the compositions are not out of the ordinary but are based on the simple expedient of the crossing of diagonals. Yet Fragonard made sure to paint his sitters in a heightened moment of intense alertness, with a vivacity of demeanor stressed by the lilting rhythms of his long brushstrokes. The impression of a vigorous gesture in almost all these paintings is reinforced by Fragonard's overlays of brilliantly colored strokes on toned grounds, which create supplementary spaces and almost autonomous rhythms in the interest of a totally dynamic effect that will make for a true *coup d'œil.* He orchestrated his colors, saving the striking *coup de pistolet* for the climax on the head, which is thrust either back or to one side in a gesture of alertness that is distinctly theatrical. Someone is calling or offering a cue, and the actor in the painting is responding, all nerves tensed. In these paintings the gesture of the head is crucial. The gaze delimits the space on these narrow stages and fixes the viewer in a proper viewing position; it also establishes the virtual center. Fragonard always needed his center and was sufficiently at ease with his work to risk this academic tic. It is from this imagined center that his vision of what de Piles called "true painting" (the painting that "calls to us") emerges. This tactic would later be refined and exploited in a more complex way in his major decorative cycles.

One convincing reason to assume that these *portraits de fantaisie* were theatrical fantasies, that Fragonard's friends were costumed and making believe, is that in each case the sitter wears a ruff. Several explanations have been offered: that he had been copying in the Rubens room at the Luxembourg, where Marie de Medici wears a ruff; that he remembered his teacher Van Loo's painting for Mme Geoffrin called *The Spanish Conversation,* where the ruff was fancied to be a proper Spanish costume; or that he was using Italian or perhaps Dutch models. There is still another plausible explanation, that Fragonard was stressing theatrical allusion in these paintings by recalling theater in Italy, where street comedians always

wore the traditional ruff. The costumes worn in these *portraits de fantaisie* guide the viewer to recognize the imaginative character of the painting or, as in the case of a portrait of Saint-Non with a horse idling behind him, hint at a literary source. This painting, entitled *The Abbé de Saint-Non in Spanish Costume* (colorplate 3), in the Museo de Arte Cataluña, Barcelona, brings the Quixote immediately to mind. *Don Quixote* was one of Fragonard's loves, and he later undertook a series of illustrations of the celebrated book. The horse and Saint-Non's Spanish costume (so obviously derived from the wardrobe room of the theater) were comparable to other iconographical details in the series, such as a book, a folio, a lute, or a pen that are hints only and not specific enough to provide positive identification. This too was calculated, for Fragonard did not want to undermine the general effect.

The first two essays in the series were probably portraits of Saint-Non's brother, M. de La Brèteche, and Saint-Non himself, both of which bear inscriptions on the back in a handwriting of the period (Saint-Non's?) noting that they were painted by Fragonard in one hour's time. In the painting believed to be of M. de La Brèteche, known as *Music* (colorplate 4), Fragonard works from an ocher-toned ground up the scale of values to the high yellows of Brèteche's blouse and the scarlet of his lips, and thence to the rosettes of his fanciful cap. The composition displays the fruits of long years of solid drawings. At first glance—the glance Fragonard felt most important—it is a striking composition even though it is based on the well-worn convention of crossed diagonals. On closer study, Fragonard's full measure can be taken; he has composed several sequences of rhyming shapes that are intricately varied.

One sequence reads from the almost-square portfolio up against the picture plane, on which Fragonard has signed his name and the date and in which he echoes the shape of the larger whole, to the scarlet feathers on his cap. Another provides a series of *V*-shaped angles, reading from the opposite direction and skillfully composed to indicate the instrument and the music pages on the counter-diagonal. The broad half-inch strokes on the yellow garment are built out to the edges, which as always Fragonard has shaped with great care to animate the surrounding space. The head is pulled up from the toned ground with summary strokes and then heightened with impasto. The feathers and rosettes are done with such verve that there are tiny splashes of reds—mere dots—on the mantle. The companion piece, a portrait of the abbé called *The Actor* (fig. 24), is similarly animated. Long strokes glide over the glazed underpainting to the very edge, pushing the abbé's head back, while his hands, in a Hals-like composition, steady his rhetorical posture, with one resting on the *repoussoir* ledge along with a plumed hat. The mass of rich blue on the sleeve and the countering long strokes of crimson provided the *coups de pistolet* for contemporary viewers. Not until Delacroix would a painter juxtapose primaries with such audacity.

Fragonard's free, linear brushwork in networks of rhythms built up from

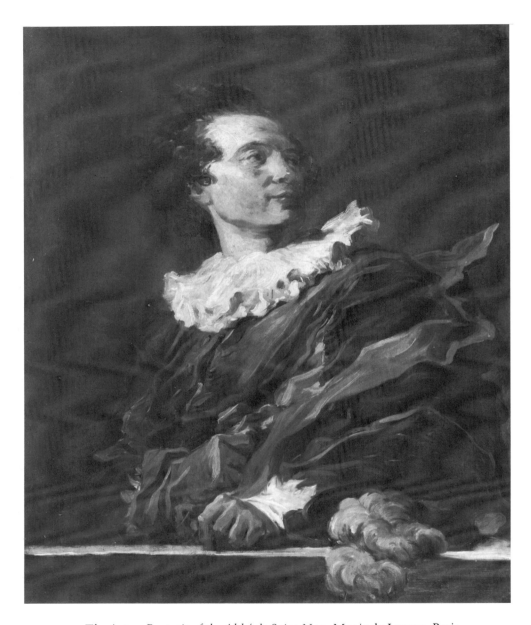

FIGURE 24. *The Actor: Portrait of the Abbé de Saint-Non.* Musée du Louvre, Paris.

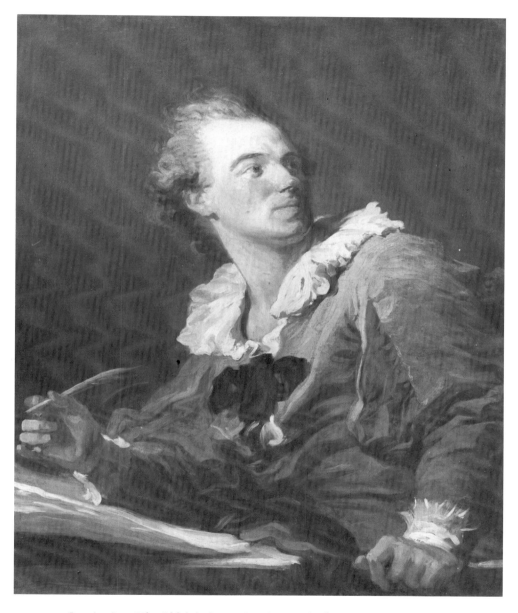

FIGURE 25. *Inspiration: The Abbé de Saint-Non(?)*. Musée du Louvre, Paris.

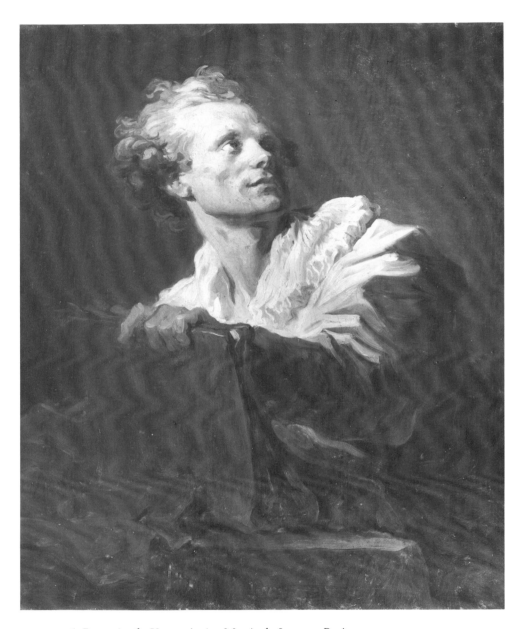

FIGURE 26. *Portrait of a Young Artist*. Musée du Louvre, Paris.

thinly toned grounds alters only in the rendition of the heads. In two of the most striking works in the series, known as *Inspiration* (fig. 25) and *Portrait of a Young Artist* (fig. 26), the heads are more heavily worked. In them Fragonard picks up the colors laid on so rapidly in the costumes but now uses short, emphatic strokes. The bold rhythms in the costume are modulated. Examine the ear of the writer in *Inspiration:* a structure composed of a few short, rapid strokes, quite angular in structure, with one dark red stroke used to describe the fusion of earlobe and jaw. Or notice the hands in both paintings. His convention of using a simple rectangle for finger joints, already noticeable in earlier drawings, is achieved with breathtaking simplicity in very few strokes, highlighting only the knuckles.

Perhaps the most baffling and arresting figure of the group is the painting known as *The Warrior* (colorplate 5). The same costume—tunic, ruff, slit sleeves, and cloak—now advances from a scumbled ground in a bold thrust. The exceptionally high value of the yellows on the sleeve suggest the unnatural light of the theater. The painting is most probably a study of an actor. The identity of the subject has only been guessed at, mostly on the basis of his large sword. But the face here, so much more individualized than the others and marked by an incipient bitterness (or the signs of a difficult and disappointing life), suggests that Fragonard was interested in studying the character of a specific person, probably not one of his intimate friends. Despite the ravishing painterliness of the whole and the flaring, extravagant shapes of the costume, it is the head that commands attention. Commentators have struggled to determine the meaning of this strange painting, which has little in common with the portraiture of the period, but no one has found the key. It does, however, clearly presage some of Fragonard's later works in which there is a hint of darker musings.

On another note, there is much to show that Fragonard was a realistic observer, when he chose to be, and that he actively sought the best means to suggest specific character. One of the paintings sometimes included in the group, largely because the sitter wears a ruff, is the Metropolitan Museum's *Portrait of a Lady with a Dog* (colorplate 6). This has the feel of a real portrait: a carefully studied face that is drawn up from a pale-toned ground of pearly gray and rendered with strokes rounded to model chin and neck. The dashing brushwork on the ruff and dog's tail—rapid strokes scraped with the handle of the brush—make it possibly one of the one-hour portraits. The feel of resemblance to a real sitter comes from the light ironies of an almost mocking brush. The pinks around her chin, emphasizing the sitter's overindulgence, and the connections made between the tiny lapdog and the generous proportions of the well-fed lady are deliberate—fair game for Fragonard, who is at once amused and mocking. This painting adds to the range and depth of Fragonard's excursion into the genre of *portraits de fantaisie*— the genre that immediately preceded his great decorative cycles.

Tangling with Terpsichore

I N 1769, after Fragonard had absented himself from the latest Salon, the journalists who accused him of having been diverted from "striving after glory" were right.[1] Fragonard's interests at the end of the sixties and during the first years of the seventies were elsewhere. Apart from his social relationships with Saint-Non and his family and friends, Fragonard was spending time with painters who continued to haunt the foyers of the many flourishing theaters, as they had during their student days. Fragonard had also kept in touch with his countrymen from Grasse, one of whom introduced him to Marie-Anne Gérard, whom he promptly seduced and who moved into the Louvre studio in the fall of 1768. They were married on June 17, 1769; their daughter, Rosalie, was born seven months later. Despite his new domestic circumstances, Fragonard seems to have felt relatively free to continue his bachelor habits. It was almost certainly during the early months of his marriage that he became acquainted with one of the most celebrated women of the theater in Paris, Marie-Madeleine Guimard, *première danseuse* at the Opéra.

The Guimard episode in Fragonard's life has been avidly discussed both by writers during Fragonard's lifetime and by modern scholars. Guimard's career was soaring at the time Fragonard met her. She had begun at the age of sixteen in the corps de ballet of the Comédie Française, and by 1761 she had been appointed to the Opéra. She was not beautiful, but was extraordinarily slender and graceful. Although her face was pock-marked, contemporaries were enthralled with her presence on stage, and she never lacked for suitors. Her private life was not private at all, for all of Paris was privy to her complicated after-hours existence. At the time Fragonard was seeing her, she was being kept on a royal scale by her *amant honoraire,* the Prince Maréchal de Soubise, and she had for an *amant utile*—to use the frank diction of the time—Jean-Benjamin Delaborde, a very rich tax farmer and lover of music. He was soon to be displaced by a wealthy monseigneur and still

others subsequently. Her amatory exploits were zealously and pruriently recorded in numerous memoirs, but so were her exceptional artistic qualities.

The exacting Georges Noverre wrote that "a noble simplicity reigned in her dance; she composed herself with taste and put spirit and feeling in her movements."[2] A quite precise description was written by the painter Louise-Elisabeth Vigée-Lebrun in her memoirs. She first described two dancers "of the genre they call *grotesque* in Italy. They made pirouettes with all their might, endlessly and without charm, but both of them, despite being fat were really surprising in their agility." Guimard, on the other hand, she wrote, "had an entirely different genre of talent; her dance was nothing but a sketch; she made only small steps, but with such graceful movements that the public preferred her to all other dancers. She was very small, thin, well-shaped, and although homely, she had such fine features that at the age of forty-five, she seemed on the stage to be no more than fifteen."[3]

Guimard's slenderness was legendary. In rival quarters, she was known as "the skeleton of the graces."[4] The wisecrack of a theater rival, Sophie Arnould, is invariably repeated in accounts of Mlle Guimard: Arnould, who had seen her dancing between two famous male dancers, Auguste Vestris and Jean Dauberval, who looked at her adoringly, maliciously described the trio as two dogs fighting over a bone.[5] A few years later, Mme d'Oberkirch, whose Protestant prudishness had to be overcome (she was very critical of Guimard's personal life, which as she noted had cost people of the court and of the city so much money), wrote of Guimard: "She is thin as a cricket but what grace! How she can make her arms seem round and hide her pointy elbows one hardly knows."[6] Despite her notorious slenderness, Guimard left spectators with an impression of softness.

This wild and gifted young woman, who was around twenty-six when Fragonard in all probability painted her as a *portrait de fantaisie* (fig. 27), pleased him inordinately. He took care to stress her exceptionally small waist and the unusual poise in her carriage. Her pose is the characteristic half-turn of head and body that might be found in one of the "mute" passages of the ballet; the quiet moment in which the gesture of the head, supported by a beautiful columnar neck (accentuated by a ribbon), is the caesura between one action and another. The chiaroscuro in this painting is even more stressed, with Fragonard working up from an almost Rembrandtesque dark ground to the light of ruff, face, and feathered headpiece, always emphasizing the contraposto of the whole figure. Her salient features— waist, neck, and head—are picked out with the high light of the stage. His interest in the face is notable, and he works it in graduated, almost sculptured flesh tones that were clearly not the product of only an hour. There is considerable debate about the object on the narrow table before her, casting doubt on the identification of the sitter, but the two thin shell-like containers and the cloth on which her hand rests were, in all likelihood, her own attributes—makeup and towel, visible in any actress's dressing room. The pose, with body thrust forward at the waist, is without question the pose of a dancer.

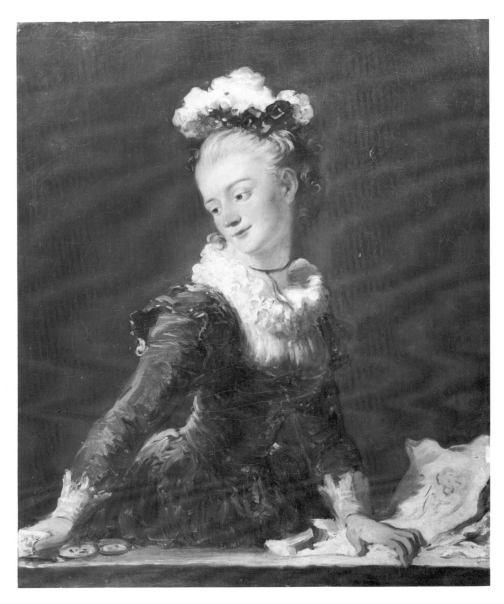

FIGURE 27. *Mlle Guimard*. Musée du Louvre, Paris.

Fragonard painted Mlle Guimard several times during a short period, proba-
bly soon after he was introduced to her. She was important in Fragonard's story for
more than one reason. It was because of her that he renewed his longstanding
interest in the theater and because of her that he frequented the Opéra as well as the
numerous other theatrical events that took place in her milieu. Guimard was
surrounded by men whose active interest in the theater went beyond the allure of
its actresses. Her notorious three dinner parties a week included one for artists and
literati. She was discussed in published writings by critics who knew her person-
ally, and her style was considered exemplary.

Those who admired Noverre knew how much his daring theories had altered
the performances of ballet, even at the Opéra, and helped to shape Guimard's
style. Fragonard himself must have known Noverre. He could have assisted Bou-
cher in 1754 when the latter worked at the Foire Saint-Laurent on Noverre's early
ballet *Les Fêtes chinoises*.[7] Noverre, never able to best his formidable rivals in the
theatrical hierarchy because of his humble beginnings in the fair theaters, was
forced to make his name outside France. For eight years, from 1759 on, he built his
radical new ballet in Würtemberg, where such dancers as the celebrated Gaetan
Vestris visited and picked up his theories, bringing them back to Paris. In addition,
Noverre had begun publishing his treatise on the ballet in the form of a series of
letters, and they had found favor in France with the intellectuals. The force of his
ideas worked with remarkable rapidity. During the time Fragonard was studying
Guimard, opera ballet was in the process of extensive transformation much dis-
cussed in criticisms of the period, much in the terms of Noverre's theories. He had
numerous enemies in high places, but his ideas seemed insuperable. Even if Fra-
gonard and others like him were not studying Noverre's texts, they were experi-
encing his ideas visually. An astute visual critic like Fragonard would not have
failed to appreciate the rebellious character of Noverre's reforms, his insistence on
bending and stretching long unchallenged rules. In addition, the increasing inter-
pretation of one art through another, and the almost reflexive discussions of
theater and painting in identical terms, was forcing a vision of a kind of *Ge-
samtkunstwerk*. A symbiosis of the arts was in active process, and no artist was
unaware of the potentials. As in Wagner's time, people were willing to believe that
the opera, ideally, could encompass all the arts in a final unity that was itself a
single work. Voltaire wrote a verse about the Opéra using the same arguments that
appeared a century later among those who advocated a fusion of the arts:

One has to go to the magic place
Where the beautiful verses, dance, music
The art of fooling the eye by colors,
The even more pleasing art of seducing the hearts,
Of a hundred pleasures make a single pleasure.[8]

Noverre himself frequently alluded to the other arts. Many of his metaphors are taken from poetry and painting. In the very first sentence of his first letter on the dance, he compares the ballet to painting:

> A Ballet is a painting, the stage is the canvas, the mechanics of the dancers'
> movements are the colors, their physiognomie is, if I dare express myself thus,
> the brush; the ensemble and the vivacity of the scenes, the choice of the Mu-
> sic, the decoration and the costumes provide the general color and finally, the
> director [le compositeur] is the painter. . . . He must revive the Art of Gesture
> and of Pantomime in a scene of action in which Dance must speak with fire,
> with energy.[9]

In the same letter Noverre stresses the importance of a *beau désordre* (beautiful disorder). In his third letter Noverre again has recourse to the visual arts, using the diction of contemporary writers of art manuals:

> If great passions are suitable for Tragedy, they are no less necessary in the
> genre of Pantomime. Our Art is subject in certain ways to the rule of perspec-
> tive; the small details are lost in the distance. In the Tableaux of the Dance one
> needs bold strokes, marked by vigorous character; broad masses, oppositions
> and contrasts.[10]

In letter five he says that a choreographer who wants to pull himself out of the ordinary must study the painters and follow their different manners of composing: "His art has the same object to fulfill, whether resemblance, the mixture of colors, *clair-obscur,* or the manner of grouping and draping figures." In letter six he brings in the ancients to buttress his argument: "The Ballet is, according to Plutarch, a silent conversation, a speaking and animated painting that expresses by move-ment, figure, and gestures."[11]

At the time Fragonard met Mlle Guimard, he had still not collected his money from the king for the *Corésus* painting. He was all too conversant with the disadvan-tages of tying oneself up with royal commissions. His friend Cochin had already long before lamented the situation, speaking of "the poor devils of artists who work for the king . . . who are not paid and are as wretched as rats in the church."[12] Even though Fragonard still had protectors at the court who were pushing for commissions for him, he must have welcomed a diversion from his problem—the question of whether or not to comply with the demands of the Academy. This profitable distraction appeared in the form of a major commission from Mlle Guimard.

The story of Mlle Guimard's commission for the now-vanished decorative cycle in her new house is entertaining and has its scandalous overtones, but it must be examined for other reasons. It was through this commission that Fragonard for the first time could work on a grand decorative scale, shaping his ideas on the nature of such coordinated cycles within a given architectural scheme. Although the works are lost, we know that they were almost the same size as his next, and

most important, commission—the cycle of murals called *The Progress of Love,* now at the Frick Collection. Judging from contemporary accounts, the Guimard murals almost certainly depicted Mlle Guimard in a pantomimic ballet, a form that Fragonard would shortly afterward develop in the Frick panels. How he came to be commissioned for the Guimard house is still not clear. What can be said is that the time was propitious and that all the necessary connections—then, as now, it was always through connections that such commissions came about—were by this time at Fragonard's command.

Paris was in an extraordinary moment. Since the end of the Seven Years' War it had known incessant change in its very visage. New neighborhoods were built through the combined efforts of entrepreneurs, speculators, provincial nobility, and a horde of nouveaux riches who sought to make their place secure through building ostentatious town houses. A breakdown of social barriers was underway that found actresses and noblemen competing for the services of architects and installing themselves side by side in the new districts of the Chaussée d'Antin or the Faubourg Poissonnière. The streets were always cluttered with the equipment of builders, and a walk through Paris was hazardous. There was hardly a street that was not strewn with the debris of recent construction. More than a third of Paris was completely rebuilt in less than twenty years. The competition among architects for luxury housing was intense. A successful architect from 1765 to the Revolution could have as many as a dozen buildings under construction at the same time in Paris and still more in the provinces. Perhaps the most eminently successful of these incredibly busy architects was Guimard's architect, Claude-Nicolas Ledoux.

One of the complicated and highly original figures with which the eighteenth century abounded, Ledoux built more than any architect in the century. His biographers have taken widely differing tacks in trying to describe his career and the nature of his personality. Some have seen him as "eccentric, cantankerous, and quarrelsome,"[13] while others describe him, as did the architect Jacques Cellérier, who knew him and was his first biographer, as having "easy manners, a tone of assurance that seduced and inspired confidence. . . . He was affable and considerate and knew how to combine pleasure and business."[14] In the astonishing flurry of building that Ledoux undertook around this time and for a long time to come, Ledoux maintained good relations with the best artisans whom he employed consistently—a fact that suggests he was not nearly as quarrelsome as some writers contend. He was obviously a good businessman. But this good businessman harbored within him the visionary, who is today celebrated for his salt works at Arc et Senans and his later febrile writings about the ideal industrial city. Hints in his early career reveal that even as a young man Ledoux entertained visions of entire cities and made his moves accordingly. He was determined to make his mark and quite deliberately set out to show his originality and his impatience with received ideas. At the end of his life, when he came to write his eccentric treatise, he was still

chortling at the thought of what his conservative teacher Nicolas-François Blondel, would have said could he have seen Ledoux's originality in creating angular columns and other works in which "the rules of grammar are violated!"[15] Ledoux's pleasure in violating the rules was as keen as Noverre's; it was a moment for violating rules. Even his writings, in the exalted tone of an unappreciated prophet, have parallels with Noverre, whose first letter compared ballet with painting. Ledoux's treatise on workers' housing begins: "You who want to be an Architect, begin by being a painter."[16]

When Mlle Guimard acquired the services of Ledoux to build her villa on the Chaussée d'Antin, he was thirty-four years old and had already created a sensation with his grand design for the Hôtel d'Uzès (1768–69), in which he had mixed allusions to Piranesi and Palladio with his own extravagant imagination, producing a stunning effect. He was probably suggested to Mlle Guimard by her lover M. Delaborde, who was prominent in musical circles and might have known Ledoux, who had married a relative of two important oboists in the Opéra orchestra.[17] Ledoux promptly drew up his plans for the house and received final permission from the Bureau of Building on June 5, 1770. Fragonard worked soon after on his four paintings to decorate a small theater in the house called the Temple of Terpsichore, where bawdy ballets and plays were to be staged (Wildenstein thinks he began early in 1772).[18] The fate of the paintings is unknown. However, the story of his quarrel with Mlle Guimard and his eventual angry departure has descended to us in several versions. Grimm's account is the most colorful. He had followed the progress of the murals and in 1772 reported on the nearly finished works, commenting: "Love bore the expense and pleasure designed its plan; no finer temple was ever erected in Greece in honor of this goddess. . . . Mlle Guimard is depicted as Terpsichore."[19]

According to the Goncourts, who depended largely on Grimm, by 1773 Fragonard had finished the central panel of *The Apotheosis of Terpsichore* when he quarreled with and was dismissed by Mlle Guimard.[20] In revenge, one day when his successor, the young Jacques-Louis David, was absent, Fragonard stole in and "effaced in an instant the smile of the goddess, substituting a pair of angry lips and the expression of Tisiphone, whom Mlle Guimard closely resembled when she entered the room a moment later to show her drawing room to friends."[21] The story is told in much the same way in a contemporary memoir of Alexandre Lenoir, who took care to say that he had the account "from the painter's own lips."[22] The other version of the story of Fragonard's break with Mlle Guimard was conveyed to the Goncourts by descendants of the Fragonard family who maintained that Fragonard was not dismissed but that he tired of his imperious patroness's constant question, Will you never be finished? He replied that he was and left forever.[23]

Both versions must be adjusted if we take into account a letter to Ledoux, from the *premier peintre* Jean-Baptiste-Marie Pierre, dated November 15, 1773.

Ledoux had apparently demanded an explanation of why David had taken over Fragonard's task. Pierre reports David's own explanation, which is that "Fragonard had agreed to work for 6,000 livres, but after his sketch he asked for 20,000 and four years." Mlle Guimard was, in David's words, highly alarmed and "not unwilling to be free of Fragonard for the other louis." Accordingly, David took up the work, "having heard everywhere of Fragonard's disgust."[24] Fragonard's quarrel with his capricious employer occurred at least three years after he had first made her acquaintance. During that time he had immersed himself in the study of the ballet and had given extensive thought to the problem of painting an allegorical sequence. The opportunity to take into account some of the architectural and furnishing details provided by the imaginative Ledoux and to embellish and, in some ways, complete the architect's scheme was of immense value to him.

CHAPTER II

The Progress of Love

N 1769 Mme Du Barry became the king's acknowledged mistress, and on July 24 he presented her with the old and creaky château at Louveciennes, which was immediately put under restoration. The courtiers who rallied to her side in the hope of advancement no doubt counseled her to uphold Pompadour's tradition. Pompadour, with her authentic artistic proclivities, had been distinguished in high circles by her taste and her independent patronage of gifted artists. In order to establish Du Barry as an equal to her predecessor, her advisers probably urged her to wrest from the king an authorization to show her ability as a patroness. She decided to build a pleasure pavilion on a hill of the estate that overlooked the Seine on one side and a vista of rich plain on the other.

Since Ledoux was the architect of the hour, he was approached and he accepted. The plans were authorized around Christmas 1770, some seven months after Ledoux had begun the Guimard project, and Fragonard was commissioned, probably at Ledoux's suggestion, to do four paintings for one of the two salons. The compact, jewellike building was completed in record time—the inaugural feast took place in Ledoux's innovative central dining room in September 1771.[1] The paintings by Fragonard (now in the Frick Collection) were still in progress or perhaps just getting underway, judging by a note of July 20, 1772, in which Pidansat de Mairobert reported on the ceiling of the *salon cul-de-four* by Restout *fils* and the "large paintings by Fragonard that unfold on the theme of the Amours of shepherds and seem allegories of the mistress of the place; they are not yet finished."[2]

Since Ledoux was known to be concerned with the most minute details in his projects and, in his own drawings, often originated the ideas for reliefs, sculptures, vases, and other elements of the total decor, the chances are that he and Fragonard were in complete agreement on the nature of the paintings for the salon at Louveciennes. In both the Guimard house and the Louveciennes pavilion, Fragonard

142

would have considered, as Ledoux planned, the layout of the room, the source of light, and the way his panels would work with Ledoux's other accoutrements. Unfortunately, the only specific information we have of how the room decor was disposed relates to the ceiling painting by Restout *fils,* described by Mairobert as a domelike painting of hazy clouds.[3] There are no documents telling of how the walls were decorated, other than by Fragonard's paintings.

Perhaps, as in Guimard's house, where Ledoux had chosen green-flocked wallpaper with occasional white highlights, the idea was to bring a garden inside, at least in illusion. Or perhaps Ledoux's conceit of mirrors, sometimes painted with trees to suggest a forest, completed the wall scheme. In any case, the room, with its curved walls opposite the main source of light—the door to the terrace overlooking the Seine—provided Fragonard with a challenge. Scholars are more or less agreed that the larger two paintings in the Frick Collection (figs. 28 and 29) were meant to be mounted on curving stretchers and to occupy the curved walls, while the two more narrow paintings (colorplates 7 and 8) were to be hung at either side of the terrace door. The somewhat lighter color scheme of the two narrow panels seems to confirm this surmise, for these paintings, facing away from the chief source of light, would be in the darkest part of the room.

The decorative program has interested many commentators, as has the establishment of the precise sequence in which the paintings were hung.[4] Which painting would the king first see as he stepped from his main salon into Fragonard's domain? Such a question has been approached repeatedly by scholars, and the question is still not absolutely resolved. But Fragonard's performance, his way of turning even a conventional motif to his own emotional needs, is what is of prime significance in this group. There was nothing particularly original about the choice of subject matter, which in any case was probably assigned. What is original lies in Fragonard's amazing painterly feints, his inventions that transcend the specific subjects. The four paintings form an ensemble that as a whole have a peculiar intensity of expression that overrides the individual episodes. Fragonard, who had been to the sites of ancient Roman wall paintings, seized the opportunity to take an enclosed space and fill it with a precisely pitched mood, an atmosphere.

During Fragonard's lifetime the scenes at Louveciennes were identified as *amours des bergers.* The general term for such motifs was the "pastoral," which Boucher was credited with having transported from Charles-Simon Favart's staging to his own decorative painting. Boucher, in one of his earliest decorative assignments for the Hôtel de Soubise, had done a series of overdoors on the theme of pastoral love, and they had been so popular that endless prints and even sculptural representations were sold to eager middle-class collectors. Fragonard knew them by heart, but there is a great difference in his own conception of the theme. Boucher's shepherds and shepherdesses, drawn from the pantomime theater of the fair, are languorous and often supine in a patently theatrical landscape full of the homely but picturesquely prettified appurtenances of a farm. Fragonard's charac-

ters, on the other hand, are in action—the kind of action Noverre advocated. The pantomime of the gestures in each of Fragonard's panels is balletic. It is not fanciful to suggest that each painting forms an episode taken from one of the ballets of the moment. Perhaps Mlle Guimard's performances inspired these paintings as the actress Mme Favart had once inspired Boucher. Fragonard does not strain to be original. He took a certain pleasure in using well-worn conventions that he then subverted in a subtle way, just as he had in his *portraits de fantaisie.*

The Frick paintings are full of details that had graced pastoral paintings from the Regency period on. They also utilize quotation, such as the sculptures derived from well-known paintings ranging from Watteau to Boucher. The only plausible explanation for the markedly artificial poses, exaggerated gestures, and mannequinlike figures of the protagonists in these paintings is that Fragonard no doubt meant the paintings to be interpreted as a lightly ironical reference to the stage. They are allegorical only to the degree that they refer to something other than the immediately perceived tableau. The pantomime within the painting is meant to recall the pantomime of the stage, and the narrative meaning of the group lies somewhere between the stage and the canvas. The extensive arguments about which painting follows which in the sequence is not vitally important if these panels are seen as episodes within a deliberately theatrical ballet on the general theme of the stages of love.

The word "episode" is found constantly in writings on the theater and opera of the period, where it refers to tableaux, the individual episodes that are complete unto themselves within a larger structure of a general thematic nature. Noverre discusses the possibility of the complete episode repeatedly. As Fragonard was undoubtedly a frequent guest at the Opéra during his Guimard adventure, it would be natural for him to reflect the experience in his suite for Du Barry. Support for the view that these paintings are on a general theme but not necessarily sequential or novelistic lies in a document of 1772, an inventory of Louveciennes that mentions four large paintings by Fragonard representing "the four stages of love," a description somewhat different from "the progress of love," which suggests direct links between the four paintings.[5]

These paintings on the subject of love speak of Fragonard's own love—one not so accessible to verbal accounts: the love inspired in Fragonard for the moods and structures of landscape, particularly the semigroomed landscape of his Italian memories. In each of these four works the wild grandeur of Tivoli is broached, elaborated, and altered to produce an expressive general mood. Fragonard had not forgotten the numerous allusions to Venus at Tivoli—in the chambers of the palace, the grottoes, and the adorning fountains. Although the paintings were carefully planned and adjusted in the working, what seemed to be the most exciting process for Fragonard was the massing of shadows, the *coups de pistolet* of light, and the final flourishes of a rapid brush that shocked his contemporaries but are quite readable for the modern viewer who has passed through nineteenth-

century Impressionism. Cayeux cites one of the shocked responses to Fragonard's paintings: an anonymous critic in 1773 reproached the artist for his "roughness, the thrashing, the lashing, the daubing" of the paintings at Louveciennes.[6] It is precisely this unusually free handling, especially in details, that provides the expressive obbligato. For example, in the ravishing trio of flowers, probably peonies, in the foreground of *The Lover Crowned* (fig. 29), Fragonard loads his brush with scarlet and shapes the voluptuous forms in single dynamic strokes. It is in this unique manner of handling color and form, and its corollary suggestion of space, that we must look for the "meaning" of these paintings, as well as in the oddities, the distortions, and the departures from standard imagery. These constitute Fragonard's secret program—his painterly plan to create a mood and to elicit emotions that are neither explicit nor dependent on narrative.

Fragonard's enchantment with the half-ruined gardens of Tivoli, reflected in the Louveciennes paintings, was likely to find admirers among *amateurs* who were busy inventing their own gardens and writing their own theories of landscape. His natural exoticism was quite in harmony with current theories. The Duc d'Harcourt, for instance, who was a close friend of the Abbé de Saint-Non and the subject of a *portrait de fantaisie,* published his famous treatise on gardening in 1775. Wâtelet too was preparing a treatise on gardens, and Louis de Carmontelle was busy inventing the garden of Monceau and a suitable theory of urban spaces. Carmontelle must have pleased Fragonard by importing poplars and cypresses from Italy for the Parc Monceau and by his exhortation, "Let us change the scenes in a garden like the decors at the Opéra."[7] At the same time, the Marquis de Girardin was shaping Ermenonville, which Saint-Non visited often, possibly with Fragonard, and certainly with Robert. Girardin thought of his decor of the landscape as a theatrical set in the manner of Jean-Nicolas Servandoni. He designed Ermenonville with the specific intention of making it resemble Tivoli. In his treatise he speaks of paintings by Hubert Robert and Ruisdael, and also of urns in the wood and inscriptions on the bark of ancient trees—both of which Fragonard painted more than once.[8] These theories of gardening were the vanguard theories of the moment, and Fragonard's contribution is obvious. He anticipated with his brush the ideas of the 1770s, published after he completed his group for Louveciennes. Gardening, like the opera, was now considered a major art form, precisely because it combined all the arts.

The assiduous drawings of Fragonard's Italian years enrich the Frick paintings in visible ways. The vertical formats are composed to give an effect of loftiness—the towering nature of the trees he had studied in Tivoli. The rather small figures of the protagonists are seen as if the viewer were in the orchestra of the theater, his eyes drawn upward by the dramatic rising movement of trees and statuary. In all four paintings Fragonard has played with conventions of composition—his favorite crossing of diagonals and numerous witty repetitions of triangular rhymes—in order to build to a crescendo a vision of *natura naturata* in

Spinoza's sense: something larger and less predictable than the carefully staged pantomimes of the young lovers. A cultivated garden gives way to uncontained growth; faint remains of trellises, a small fence, and other once-functional formal garden furniture of a civilized estate are all but erased in the hectic profusion of flowers, shrubs, and lofty trees. There is also Fragonard's affection, seen in so many of his Italian drawings, for the grottolike enclosures of flora. He had an instinctive feeling for the mystery of organic enclosures, of nesting, of a surround within which there is ineluctable shadow teeming with suggestion. Space as grotto-esque, full of hidden ambiguities, always fascinated Fragonard. He created it not only with enveloping greenery but with deep shadows and an apex of high light used to blaze away at mystery. There are melancholy intonations too, for these spaces give free rein to feelings of analogy. Cézanne used the same grottolike space when he ensconced his apples and oranges in the deep folds of a heavy tablecloth and hinted at subjects far more dramatic.

In the panel known as *Storming the Citadel* (fig. 28) (or, alternatively, *The Meeting* or *The Surprise*) the two figures are rendered in the unnatural radiance of stage lighting, and the girl's gestures derive directly from the stage. The expressive thrust of her pink hand against the dimmed greenery can be seen in countless prints of the period depicting dancers or actresses, as can the abbreviated ruff at her throat. Her movement is pantomimic, directing the viewer's attention to the coulisse—the kind of stage aside that was gaining currency in the French theater at the time. The interchange between the two protagonists is only a part of Fragonard's scenario, for the human gestures are greatly exaggerated, perhaps even meant to be mocked or belittled by the great thrusting gesture of the commanding statue above or the massed trees. Fragonard keeps the staged drama contained by means of his rhyming brush. The triangle formed by the blue ribbons at the girl's waist and shoes, and below the ruff of her visitor, forms the triangular limits of the action. The set itself is dominated by the dramatic thrust of the statue of Venus above, accented by the lightning-stricken, dying tree at right. The tense silence of the action recalls Diderot's remark in *Le Paradoxe sur le comédien* (*The Paradox of Acting*): "It is with intense pleasure as with intense pain: both are dumb."[9]

The dominating statue of Venus, fetched up by Fragonard from his humanist education, illustrates his sly way of using quotation to alter convention. She is the Venus that Watteau had borrowed from Rubens, who may have borrowed it from Abraham Bosse. Watteau used it in the second version, in Germany, of *The Embarkation for Cythera*. In Watteau this Venus is benevolent, slightly smiling, and looking at Cupid teasingly while withholding her quiver of arrows. Fragonard, who knew the painting, or at least the print made from it, makes a significantly different adaptation. The imposing figure of Venus strides almost menacingly forward, thrusting her body abruptly to one side and all but knocking the Cupid at her side from his cloud. The violence of her gesture offers a note of climactic

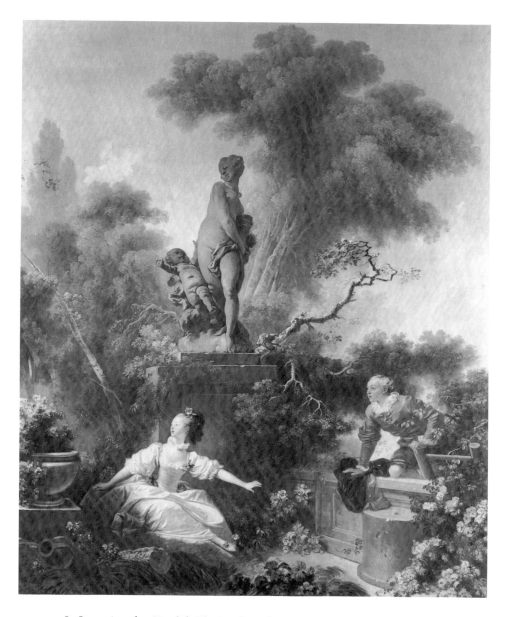

FIGURE 28. *Storming the Citadel.* The Frick Collection, New York.

disquiet—a note that had been introduced more discreetly in the detail of an overturned urn in the *repoussoir* of the lower left. These tensions are articulated throughout the painting, as when Fragonard highlights the trunk of a slender birch at left, pulling away from the statue, and the cluster of towering trees behind her that thrust to the right, or the zigzag branches of the desiccated tree that pulls the eye to the right. The crackling light on this crooked tree may be another quotation.

Many have noticed Fragonard's interest in Jacob van Ruisdael, whose wounded trees are considered to be emblematic. Fragonard certainly loved Ruisdael (he had painted scores of imitations when he first returned from Italy), and probably what he admired best was Ruisdael's dramatic play of light, the *coup de soleil* that distinguishes so many of his paintings. This tree with its pathetic misshapen branches could also be a reminiscence of Chinese paintings Boucher was said to own or of Père Attiret's famous letter from China of November 1, 1743, in which he described Chinese gardens where "a beautiful disorder reigns almost everywhere." Or it may have been a memory of Salvator Rosa. Fragonard in this ensemble was using everything at his command, but his system of psychological accents was unique. A far stronger impetus than the banal story of gallant love brought his vision to its higher power.

The companion piece of *Storming the Citadel* (at least in its identical dimensions) is *The Lover Crowned* (fig. 29). Again Fragonard used the play of light to detail plot and subplot of his nonverbal drama. Here again the familiar crossed diagonals—the armature—are echoed throughout the painting. The young artist in the foreground leans forward, initiating the diagonal, which then moves to the head of the young woman and from there to the apex of the statue of the slumbering Cupid. The opposing diagonal moves from the potted orange tree in the shadow below to the flowering orange tree above, in a pronounced path of light. Hints of drama lie in the bareness of the dark orange tree: the crackling, barren branch forms an aureole over the sculpture and the lurch of the great tree moving into the sky. This painting attests to Fragonard's strong feeling that the chaos and asymmetries in nature are the prime expressive factors in his work. The picture is an authentic decorative work intended to animate a wall and to suggest familiar themes. The scattered attributes of the arts, such as lute and tambourine, and the young artist himself are broached in his scheme as readily identifiable, often stated, even hackneyed motifs. Fragonard was not concerned with opening new iconographic paths but only with conveying feelings through his consummate handling of natural forms in light. His prodigious brush provides countless details for visual pleasure, not the least of them being the attitude of the two lovers' hands, laid palm to palm in an exceedingly erotic subtlety reminiscent of the flesh-to-flesh studies of his bathers and the lubricious young lovers he had earlier dashed off for appreciative collectors.

In *The Pursuit* (colorplate 7), the girl is again in motion and unmistakably in a ballet. Not only is she leaping in a classic ballet position, but she also wears the

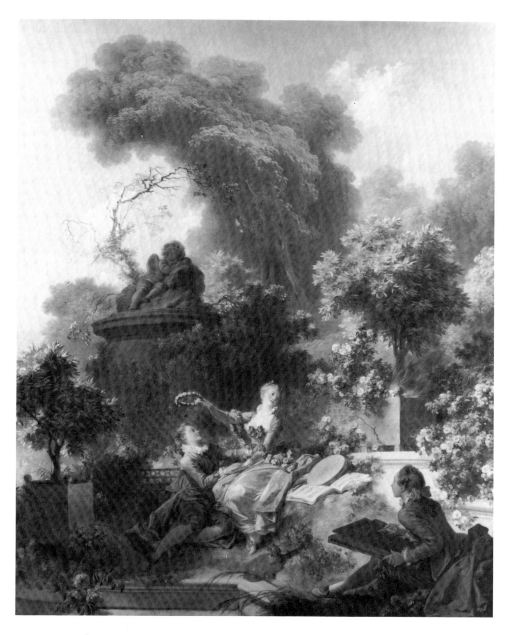

FIGURE 29. *The Lover Crowned*. The Frick Collection, New York.

soft, low-heeled ballet slippers that Camargo had introduced some years before. The very grouping of the girl and her two friends is a direct allusion to Noverre's way of composing a ballet. As in *Storming the Citadel,* Fragonard uses a sculptural quotation, this time from his old master Boucher, who often depicted Cupids with a dolphin fountain, as in the Metropolitan Museum's *Shepherd's Idyll* of 1768. Again, Fragonard darkens and makes turbulent what was conventionally (certainly in Boucher) a rather playful, benign sculpture. It is not difficult to imagine the eighteenth-century orchestra rising to a Mozart-like climax in this scene, which Fragonard heightens still more by means of his penumbral set and the meetings throughout the composition of areas of light and shade. Some commentators have seen symbolism in the still life at the lower right in which an apple dominates; but Fragonard's meanings reside rather in the way he exploits his contrasts in the light scale. This is true even in the calmest work of the series, *The Declaration of Love* (colorplate 8)—a painting that has elicited considerable iconographical discussion because of the statue of Venus as friendship dominating the scene at right. The emotional values here lie much more in the way Fragonard delighted in painting the great, almost heart-shaped clearance of sky between his trees, the marvelous pink parasol through which the sun is filtered, and the play of the girl's satiny white underskirt against the white of the love letters scattered on her pedestal. The greenish brown mass of trees at left recalls Fragonard's Italian drawings in their solid structuring and acute perception of natural light within shadow. Fragonard's attraction to penumbral effects—those regions of the canvas where light and shade meet and blend into a bluish haze—was first incited at Tivoli and never forgotten. For more than a century, since the days of Poussin and Claude, French artists had routinely gone to the Italian campagna and Tivoli to sketch and paint. That was, among other things, what painters did in Italy. But for Fragonard the experience became something more than routine; it was an opening into the light of his painter's universe. He experienced a kind of transcendence, which is felt throughout his major work. Leafy bowers and towering trees were, for him, more than picturesque images. They had lyrical meaning that is both specific and implicit in painting. He depended on the resonances he could create with his complex composing and with the accent of his idiosyncratic brush. Discussions of the meaning or sequence of these panels and the lack of any concrete evidence indicate that meaning in Fragonard is suggestive rather than literal—metaphoric in an extremely broad sense.

To read these paintings in the light of their suggestiveness rather than their literal content is not an error of the modern eye. There was much in Fragonard's own period that supports such a reading. About a year before his commission for Louveciennes, Fragonard had painted a portrait of Diderot. We know how much Diderot enjoyed conversations with artists and how much he vaunted his ease among painters. At the very time Fragonard was enough in touch with him to be thinking of doing the portrait, Diderot was working on his remarkable essay *Rêve*

de d'Alembert (*D'Alembert's Dream*).[10] Knowing Diderot's garrulity, it is not hard to conjure up a scene in which Fragonard paints while Diderot talks, and talks about what is uppermost on his mind—the essay in which there is much specula-tion on consciousness and dream and in which he designated "resonance" as essential to the thought process:

> It is this vibration, this inevitable resonance, which holds the object present, while the mind is busied about the quality that belongs to that object. But vi-brating strings have yet another property, that of making other strings vi-brate; and that is how the first idea recalls a second, the second of them a third, so that there is no limit to the ideas awakened and interconnected in the mind of a philosopher. This instrument makes surprising leaps, and an idea once aroused may sometimes set vibrating a harmony at an inconceivable dis-tance."[11]

Taking the Frick panels as an ensemble conveying a group of emotions associated with love, the reading of each and all is dependent on the very vibration, "this inevitable resonance," that holds the theme present and that inspires other associa-tions. Even the pronounced gestures of the figures can be interpreted as setting up the vibrations that institute larger metaphors. Although the figures seem to be enacting scenes for a ballet, they are also suggestive individual characterizations. It is apparent that each of the young women depicted is different; each has specific facial characteristics that obviate a novelistic sequence. Yet each has the familiar coquettish gestures found in many eighteenth-century drawings and paintings. They would have been easily accepted by contemporaries for they were the normal gestures of adolescent girls of the period, exaggerated to meet the balletic need for stress. Just as today's adolescent girls adopt the postures and gestures of movie and television stars—how they walk, stand, and hold their heads—so Parisian girls (and still more, provincial girls) adopted the gestures, attitudes, and gaits of the belles of theater in Paris. A mincing walk and a head inclined to one side were commonplace. When one looks at views of events in Paris by the genre painter Étienne Jeaurat, the men invariably stand with their toes pointed out in third position, while the women are tilting slightly forward like a ballet dancer about to rise on points. The figures in Fragonard's ensembles, then, would not have been perceived as unduly artificial by Du Barry or any other contemporary, nor would they have appeared dated. All the same, something went wrong for Fragonard with his patroness, just as it had with the imperious Guimard. For whatever reason, his masterful paintings were rejected, and the neoclassical substitutes by Joseph-Marie Vien were installed in their place.

According to contemporaries, Du Barry was liberal in her suggestions to her artists and did not always use the tact her predecessor, Pompadour, was known to employ. It is possible that Fragonard bridled at her instructions. Of the three main arguments used to explain the abrupt termination of Fragonard's favor with Du Barry—that the apparent allegory of her personal life with the king offended either

her or the king himself; that the architect found their Rococo character out of keeping with his classicizing structure; that Fragonard was in general querulous and defiant—it is the last that seems most likely. The suggestion that Ledoux himself rejected them is highly unlikely. He had obviously been distressed when David took over from Fragonard at the Guimard villa, and his own drawings for decorations tended toward the curvilinear, light style of an earlier period, as his sketch for the ceiling of the Hôtel de Montmorency in 1769 indicates, with its oval shape surrounded by garlands and putti and fleecy clouds. There is no reason to believe that Ledoux had replaced Fragonard's style with Vien's rather insipid classicizing in his own affections. There is reason to believe, on the contrary, that they maintained their friendship in later years. Fragonard's protégée, his sister-in-law, Marguerite Gérard, much later painted two portraits of Ledoux, which she would hardly have undertaken if Fragonard and Ledoux were antagonists.

As in so many other details of Fragonard's professional life, it seems that the question of the failure of these paintings will not find a clear answer. Fragonard must have felt he had accomplished something important, for he took care to roll the canvases and hold them for many years. In 1790, when he retreated to his cousin's house in Grasse, he brought them with him, installed them in the ground-floor main drawing room, and painted a dozen other works for the room.

The incident with Du Barry must certainly have infuriated and demoralized Fragonard, for he soon accepted with alacrity a chance to flee Paris and the scene of his humiliation.

CHAPTER 12

Italy Revisited

AFTER THE deeply disappointing results of his intense activities in the early 1770s, Fragonard had every reason to be disaffected with Paris and to seek again the inspiring sites of his youth. The opportunity presented itself when Jacques-Onésyme Bergeret de Grancourt, the fifty-eight-year-old brother-in-law of Saint-Non, invited him to become his cicerone on a grand tour of Italy. Bergeret, probably at Saint-Non's prodding, had been an early collector of Fragonard's work, but he was a different type of *amateur* from his refined and intellectual brother-in-law. He was extremely wealthy, the son of a tax farmer and himself the treasurer-general of finance for the Montauban region. He owned several large estates, of which he was exceedingly proud, and he thought of himself as the equal of old nobility. His ample fortune and his reputation as a collector brought him many obsequious hopefuls whom he treated with a condescension that Molière might have found worthy of mockery. His very explanation of the way he invited Fragonard and his wife to join his little troupe setting out for the grand tour suggests his tactlessness and basically insensitive nature: "Our baggage is composed of a berlin in which we are M. and Mme Fragonard, excellent and talented painter, who is necessary to me above all in Italy, but also, very convenient for traveling, and always even-tempered. Mme is the same, and since he is very useful to me, I wanted to pay him my respects in procuring his wife, who has talent, and would enjoy such a voyage, rare for a woman."[1] These opening phrases of his "journal," written as a series of letters to his nieces but clearly meant for eventual publication, set the tone of his journey. If Fragonard had qualms about a protracted voyage in such close quarters, they were probably overcome by his need to get away from Paris. He decided to accept, and he and his wife embarked, leaving their infant daughter, Rosalie, with a nurse.

The trip was arduous, and there is indirect evidence both in Bergeret's journal and in his angry emendations afterward that for all his presumed even temper,

Fragonard became exasperated more than once. Bergeret had begun his journal by calling himself "master" of his little band and patronizingly praising the Fragonards. After they returned to Paris the following year, there was a dispute over Fragonard's drawings. Bergeret angrily altered his journal, accusing Fragonard of various deficiencies, among them that of hypocrisy in not saying what he thought (here one can imagine the somber silence of an artist tried beyond his patience), and also of being "a wretched guide because his knowledge is of little use to an *amateur,* being swamped in much fantasy."[2] This is perhaps the most telling remark, for it indicates that Fragonard's artistic evaluations of what he saw were imaginative and not pedantic, and that his insights were well above his patron's head. The "fantasy" Fragonard expressed in his confrontation with various masterpieces can be read in his interpretive drawings, which are flexible, imaginatively cast, and probably required more innate sensibility than Bergeret could lay claim to.

Bergeret's rather prolix journal reveals a basically dull man with a disproportionate fund of self-esteem—what the French call *suffisance*—who set out to follow the established routes with Cochin's guidebook in hand. His comments are more spirited when he discusses the meals prepared by his own chef traveling in the entourage than when he dutifully records seeing some revered work. No matter how closely we read the journal, it is impossible to get any impression of the presence of the Fragonards. Bergeret never mentions any comment of Fragonard. Indeed, he hardly mentions Fragonard at all. One can imagine Fragonard's distress when, during a visit to Tivoli, Bergeret was only mildly impressed and gave it only an afternoon, or when Bergeret visited the Villa Pamphili, where once Fragonard had sketched, and found it neglected and uninteresting, boasting that "you will find few people who dare to give their opinions like me."[3] Probably the only mitigating factor in this uncomfortable journey was the presence of Bergeret's son, a young architect who seemed to have a special bond with Fragonard and who would later treat him with great deference. It is possible that Pierre-Jacques *fils* was the mediator between his opinionated father and the proudly independent artist.

In return for bearing the expenses of their travels, Bergeret expected that the Fragonards would compile documentary drawings, probably to illustrate his journal, as was often the custom then. They set out on October 4, 1773—five travelers with five domestics in one large vehicle, with a smaller cabriolet for Bergeret's son and his valet. Bergeret brought with him Jeanne Vignier, said to have been a lady-in-waiting to his dead wife. She would later bear him a child and become his wife. In his journal, Bergeret described Vignier exactly as he described the Fragonards, as "useful." This oddly assorted troupe made its way first to Bergeret's estate in Montauban, where he described with lordly satisfaction the deference of the peasants. They remained two weeks and then set off for Antibes where the party was to embark by boat for San Remo. Bad weather, seasickness, and other difficulties abounded. But Bergeret in his notes stressed that nothing disturbed his little

band and that they were never tired. This he reiterated constantly, protesting too much. They avoided further travel by sea, to everyone's relief, and set out for Genoa overland on donkeys, arriving at the port city on November 15. Bergeret was not much impressed with Genoa and hastened on to Pisa, where he spent a single day and noted only the leaning tower with guidebook dryness. The next stop was Florence, which Bergeret assessed quickly and decided to cover on the way back. The party then rushed off for Rome, arriving December 6.

The sojourn in Rome lasted almost five months. They were satisfactory months for Bergeret, who immediately presented his letters and threw himself into the lavish social life of the privileged *amateurs*. He noted that the day after they had arrived and settled into convenient quarters at the Piazza di Spagna, he had visited Natoire, whom he hadn't seen for twenty-five years, at the French Academy, only a few steps away from his apartment. He immediately praised the high quality of the four painters, four sculptors, and four architects resident at the Academy, and then, with obvious triumph, added that he had been invited by the Cardinal de Bernis to one of his *conversazioni*— a kind of open house with refreshments—on one of the days when there were "cardinals, ambassadors, and noblemen."[4] Bergeret was right to be grateful for the honor, for Cardinal de Bernis was one of the most important men in town. Once a favorite of Mme de Pompadour, who had called him her "fluffy pigeon," the cardinal was worldly and, as Charles-Augustin Sainte-Beuve wrote, "one of the most graceful and polished minds in his epoch." Voltaire was less flattering. He called him the "flower girl of Parnassus." Bernis's fabled *conversazioni* reflected his international interests. Soon after he took up his post in a grand palazzo on the Corso in 1769, his elaborate system of entertainments brought him just about everyone of any note who lived in or visited Rome. His salon was also the center of the art world in Rome. He won the presence of two of the most celebrated painters of the time, Pompeo Batoni and Anton Raffael Mengs, and his refreshments were served on plate painted by Baudouin.

It was a different Rome, artistically speaking, by 1774, and Fragonard might not have been completely pleased with it. Winckelmann's judgments had made a deep impression, and no doubt some of Bergeret's reticence concerning his own famous painter was because of his exposure to the new currents of taste, to which Fragonard would not conform. No doubt the art world in Rome had changed little when, a decade later, Goethe would characterize it:

> In this artistic colony one lives, as it were, in a room full of mirrors where, whether you like it or not, you keep seeing yourself and others over and over again. . . . Each little circle, though they all sit at the feet of the Queen of the World, now and then displays the spirit of a small provincial town. In fact, they are no different here than they are anywhere else. I am already bored at the thought of what they would like to do with me. It would mean joining a clique, championing its passions and intrigues, praising its artists and dilettantes, belittling their rivals, and putting up with everything that pleases the Great and the Rich.[5]

Fragonard had little taste for this life of mirrors and seems to have spent a great deal of time sketching. Bergeret's snobbery, his need to be present whenever possible at the functions of the mighty, proved a boon to Fragonard, who was mercifully released from constant attendance. He handed over his duties as guide to his new friend, the architect Pierre-Adrien Pâris, leaving himself free to renew his memories of Rome and its environs.

Bergeret's ambitions grew as the weeks unfolded in Rome, and he soon set up his own *conversazione* in his quarters every Sunday morning from ten to twelve. At first his guests were mostly the denizens of the French Academy and its extended community. The young artists eagerly seized the chance to present their work to a known collector who might then, or later, pave their way to fame. Soon after, the gathering grew larger, swelled by antiquities merchants and art dealers whom Bergeret cannily kept at arm's length, noting in his journal the useful axiom that "one should see much but buy little." Fragonard, as his employee, was expected to present his week's work at these gatherings. By March 6, Bergeret stated, "we were twenty-five," and noted that the work of the young painter François-André Vincent was exhibited along with Fragonard's.[6]

Vincent had been one of Vien's pupils and had arrived at the Academy in 1771. Fragonard was apparently taken with him, and the two went out sketching together frequently. Vincent was observant, and Bergeret's imperious manner was not unremarked by him. In his portrait of Bergeret (fig. 30), at Besançon, Vincent shows the patron in pantoufles and informal satin morning dress, standing like an emperor among his treasures. Vincent's "licked" style shows the influence of both Vien and Mengs, whose surfaces Michael Levey has described as having a final effect of being "glossy, glassy, and enamellike."[7] Tall, fat, and with a hard face, Bergeret in Vincent's characterization does not seem an amiable figure. If a drawing by Fragonard said to be of Bergeret (in the Atget Collection, Montpellier) is indeed of his patron, Bergeret was certainly fat, but not tall and not quite as commanding as Vincent portrayed him.

Whatever his duties toward Bergeret during those months in Rome—and Bergeret, as usual, mentioned Fragonard only in passing—Fragonard took the time to pursue his own interests. He once again addressed himself to the direct observation of important Roman sites and Renaissance parks, both public and private (figs. 31 and 32). His interest was still stimulated by the way nature had redesigned those well-planned gardens that had been neglected for so long. As before, the wild abandon of the foliage excited him, as did the way the light became mysterious with the introduction of natural asymmetry. His preferred medium this time was the wash drawing—a means that favored his painter's need to suggest colored mass and describe specific features with some rapidity. Thirteen years before he had primarily used the sanguine stick to build his compositions. Now he most often used a light undersketch of black chalk that he covered with increasingly broad tonal washes. These drawings hover always around the idea of creat-

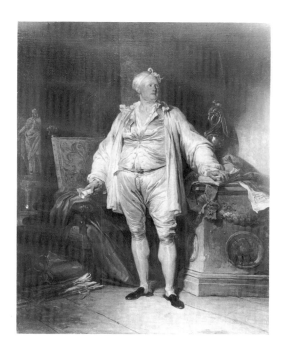

FIGURE 30. François-André Vincent, *Portrait of Bergeret*. Musée des Beaux-Arts, Besançon.

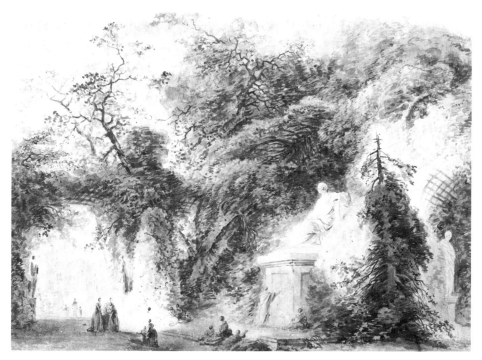

FIGURE 31. *Italian Garden*. Museu Calouste Gulbenkian, Lisbon.

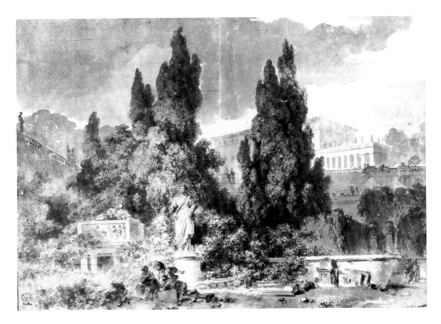

FIGURE 32. *Gardens of a Roman Villa.* Musée des Beaux-Arts, Besançon.

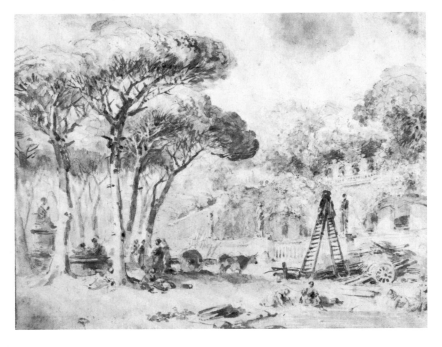

FIGURE 33. *Gardens of an Italian Villa.* National Gallery of Art, Washington, D.C., Samuel H. Kress Collection.

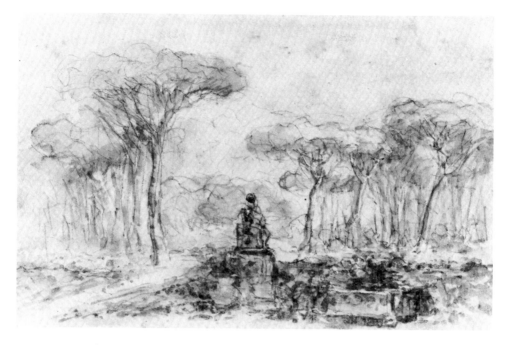

FIGURE 34. *Park Scene.* The Fine Arts Museums of San Francisco, Achenbach Foundation for Graphic Arts, gift of Mrs. George Brashears.

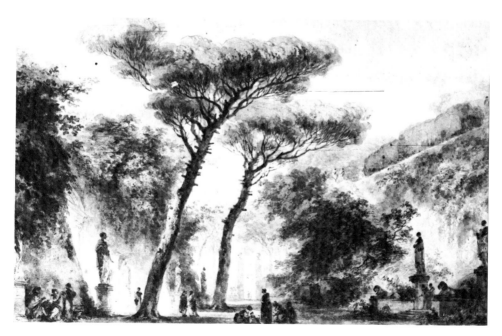

FIGURE 35. *Garden of Parasol Pines at Rome.* Musée des Beaux-Arts, Besançon.

ing the vibration of natural light, a project that would much later become the touchstone of nineteenth-century painters. The word "vibration" was entering the diction of eighteenth-century theoreticians, as was the word Diderot favored, "resonance." Both terms were to remain relatively abstract until first Delacroix and then the Impressionists gave them substance. Fragonard cultivated his perception of the vibrations in nature during his second trip to Rome, and his results were sometimes arrestingly modern. The planes he laid on in thin washes were distinctly structural, angular, almost as in the late watercolors of Cézanne.

In some of his Roman wash drawings, the motifs are identical with those of his first trip; the handling, however, has radically changed. Instead of building his masses stroke by stroke, as he had in the chalk drawings of 1760, Fragonard now relies on overlays of pale wash, accented with either short strokes that serve both to describe and to model his forms, or with delicate dots that prompted Otto Benesch to call it his "pointillist" style.[8] The composition is bound by these accented points of deep brown. A drawing that at first glance might appear conventional, indeed, might appear to be a reprise of his earlier drawings, becomes when studied closely a radical departure. *Gardens of an Italian Villa* (Villa Medici?), in the National Gallery of Art, Washington, D.C. (fig. 33), seems relatively straightforward in its reportage. People are at work beneath the parasol pines, or they watch others work. There are the ladder and the working bull to represent the everyday aspect of life in this public park. These are rendered with the brush in single, rapid strokes that shimmer against the white of the page and are surprisingly free of determining outlines. The light on the trunks and crowns of the pines consists of an absence of color that Fragonard repeats in the deftly suggested standing sculptures in the middle ground. Once again, something in the crests of the trees and the way they are shaped by daylight moves Fragonard, and he deepens his wash to hint at the shadowy truths that underlie all illumination.

The emotional tremolo is still more apparent in less finished sketches, such as *Park Scene* (fig. 34), in San Francisco, in which once again the parasol pines dominate, sketched cursorily with black chalk and given an existence in space and light by dappled areas of wash. Here the foreground sarcophagus, an amphora, and the centered sculpture are rendered with unusual freedom in loose wash strokes. These invented brush forms, so like those of Cézanne, can be seen in many drawings of gardens and parasol pines (see, for instance, the same motif in fig. 35) that were undoubtedly done during Fragonard's second sojourn in Italy. The development of a new system in a new technique clearly excites Fragonard. His central preoccupation—the rendition of oscillation, of high, flickering, constantly moving light—leads him to brush highly unusual inventions that he would use in various compositions, such as *A Bull of the Roman Campagna* (fig. 3), in which an extraordinary cluster of rectangular wash overlays articulates a mass of hay above a lumbering bull. Fragonard's pleasure in this technique of flickering, planar washes is obvious. His witty evocation of the phantom head of a second bull

through an absence of color is once again an indication of his interest in the mysterious functions of the highest of lights. The striking freedom displayed in this and other wash drawings inspired during Fragonard's second sojourn in Italy shows his determination to capture the essence of whatever he studied in ways that, as connoisseurs of the nineteenth century such as the Goncourts and Gerard de Nerval noticed, made him a precursor of painters in the Romantic era.

Once again, as he had with Saint-Non, Fragonard found a sympathetic and intelligent companion in the twenty-eight-year-old architect Pierre-Adrien Pâris. Although enjoying entrée to all the best houses in Rome, including those of Cardinal de Bernis, the Baron de Breteuil, the Princesse Doria, and Cardinal Orsini, Pâris was far from a frivolous participant in the more superficial functions of life in Rome. He was a serious student of antiquity and, even more, of landscape gardening, which was to become one of his major interests. He had studied natural history as a boy and then architecture in Paris, and he spent five years in Rome, from 1769 to 1774. Fragonard liked him well enough to introduce him to Saint-Non, with whom Pâris later collaborated on *Le Voyage pittoresque ou descriptive des royaumes de Naples et de Sicile*. Pâris, clearly, was a great admirer of Fragonard's drawings. Years later he bought from the Bergeret sale in 1786 a large group of the drawings Fragonard had made while in Rome in 1773–74, and he continued to buy Fragonard's work long after they both returned to France. Pâris's interests in landscape-gardening theory was already well evolved during the months Fragonard was in Rome, and the two probably had interesting discussions.

Landscape was not the only beneficiary of Fragonard's renewed enthusiasm in Italy. There was a marked evolution in his treatment of the human figure during this Italian journey, as attested by a number of fine drawings of the figure in which Fragonard expands his vocabulary of wash values while strengthening his tectonic composition. *Portrait of a Young Lady* (fig. 36), in Chicago, inscribed with the date 1774, is, for a work of small scale, unusual in its feeling of monumentality. Fragonard takes the triangular structure produced by the clothing of his model and plays upon it, making an armature of deep bistre shadows moving up to the crest of her hat. The firm patterning of horizontals and verticals suggests that Fragonard's recent acquisitions had been carefully studied: in 1771 he had bought some sixty-nine drawings and twenty-three prints by Rembrandt and his school from the Boucher sale. In Fragonard's *Portrait of a Young Lady,* the fluttery character of earlier drawings of female models that Fragonard had inherited from Boucher gives way to a solid structuring far more related to the late drawings by Rembrandt. That Rembrandt was on his mind around this time, perhaps filtered through renewed contact with Tiepolo, is evident in *The Pasha* (fig. 37), in the Louvre, in which deep bistre tones are brushed on with élan and constitute a kind of shorthand system of wandering lines drawn from Rembrandt.

The Chicago *Portrait of a Young Lady* also indicates a growing interest in

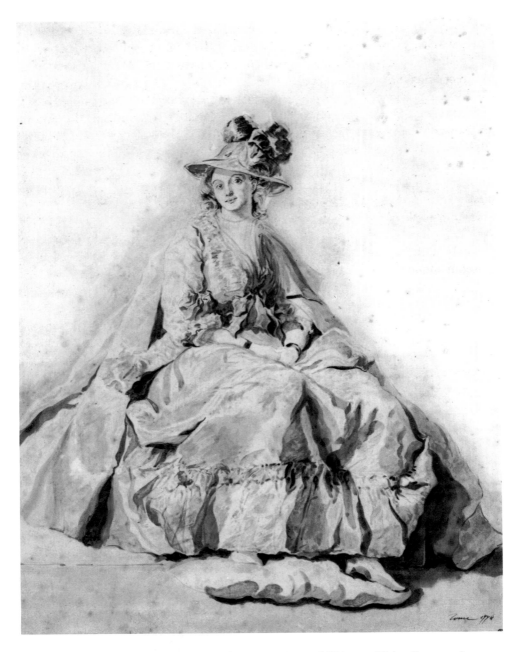

FIGURE 36. *Portrait of a Young Lady.* The Art Institute of Chicago, Helen Regenstein Collection, 1960.209. © 1987 The Art Institute of Chicago. All rights reserved.

specific rather than imaginative portraiture. "The beautiful, aristocratic face of the sitter, with large, limpid eyes and a Grecian nose," as Harold Joachim has described her, is quite specific and appears in other drawings.[9] Still more striking in its direct observation is the signed and dated *Portrait of a Neapolitan Woman* (fig. 38). Eunice Williams has called it "a portrait of exceptional strength, honesty and sympathy . . . almost unique not only in Fragonard's oeuvre, but also among portrait drawings before Degas in the 19th century."[10] She points out that the sitter might have been a street vendor, for Fragonard notes on the drawing that the portrait was taken in the Passeggiata di Santa Lucia, a popular route for Sunday strollers. Though not much has been made of the fact, it is nonetheless of possible significance that during the Italian journey Fragonard seemed to have studied ordinary people with far more attention than before.

Fragonard's interest in portraying specific people of the Third Estate and peasantry emerges forcefully in the chalk drawings of the Pâris collection in the museum and library of Besançon. These are masterful studies in a broad and sure technique, stunning in its modernity. The signed drawing *Young Girl and Her Little Sister* (fig. 39), in Besançon, is marked by its empathy and dignity. With absolute certainty Fragonard builds up the two figures in graduated values so that the coruscating light both models and glides over the forms. The head of the older sister is rendered in a completely Impressionist manner, her cheek being left without final contour to indicate the shaping power of the sunlight. The strong characterization in the diffident tilt of the younger girl's head and the straightforward glance of the older girl are enhanced by the solid volumes and sturdiness of the bodily structures. The sanguine drawings of children in Besançon are evidence of Fragonard's satisfaction in discovering a means to give a full and naturalistic description of masses in light without relying on the schematic systematization of line of his earlier drawings. The broad use of the sanguine stick, as in *Three Young Girls* (fig. 40), allows for painterly effects that he would soon put to use in painting itself.

The simplified structure of his composition, with its increasing use of stabilizing horizontals and verticals, brings Fragonard into his mature draftsmanship with an acknowledgment that the boneless flesh he had learned to depict from Boucher can no longer satisfy him. On another level, his attitude toward figure drawing is no longer so much committed to fantasy. Although earlier eighteenth-century artists, especially the great master Watteau, had often turned to common people as their models, they had usually sought some picturesque attribute: the Savoyards with their marmots, or peasants with their sheep and cattle or in their colorful dress. Fragonard's studies, particularly those sanguine drawings dated to 1774, such as *Young Girl and Her Little Sister,* completely avoid picturesque detail. They are sympathetic observations of people he encountered—children and young women above all—in simple, unaffected poses. These drawings have the look of works that the artist completed with satisfaction for himself alone or for his

FIGURE 37. *The Pasha.* Musée du Louvre, Paris.

FIGURE 38. *Portrait of a Neapolitan Woman.* Collection of Mr. and Mrs. Eugene Victor Thaw, New York.

FIGURE 39. *Young Girl and Her Little Sister.* Musée des Beaux-Arts, Besançon.

FIGURE 40. *Three Young Girls.*
Musée des Beaux-Arts, Besançon.

understanding friend and later collector, Pâris, who shared Fragonard's point of view. Free of the demands of *amateurs* and courtiers, Fragonard approached the depiction of ordinary people of the peasant or working classes with an empathy expressed in the quiet dignity with which he endows them. Was this an oblique expression of his view of society? Was his subsequent history—his friendships with the revolutionist the Comte de Mirabeau and David, for instance, and his work as a functionary in the revolutionary regime—a confirmation of a distinct social attitude expressed occasionally in his drawings? In any case, it was during this second voyage to Italy that Fragonard seemed to have sought out opportunities to observe ordinary people with close attention.

During the rest of the trip, Fragonard continued working both on incidental sketches and sketches of record, such as the marvelous wash drawing dated May 7 of a skeleton in Pompeii (Musée des Beaux-Arts, Lyon), in which Fragonard's dramatic light captures the shock of the little group. Bergeret lingered a while in Naples, passed back through Rome, and began the return journey, which took them to Florence, Bologna, Ferrara, Padua, and Venice in rather brief visits marked in the journal with conventional guidebook commentary, not very informative about the activities of Fragonard. In Venice, Bergeret mentioned visiting the Palazzo Labia where there was "a great salon painted by Tiepolo," but he didn't seem very much interested.[11] From Venice they traveled to Vienna, where it is likely Fragonard copied for Bergeret, and to Dresden where Bergeret noted that

both Fragonard and his wife worked early in the morning at the museum. There is the signed and dated drawing *Satyr Pressing Grapes beside a Tiger* (fig. 5), probably from that morning, in which Fragonard takes the occasion to copy Rubens (at least in those days it was considered a Rubens), using his heightened wash technique to register the rippling musculature of the satyr and the dimpled flesh of the attendant putti. From Dresden they went on to Strasbourg and thence to Paris where they arrived early in September.

Curiously, once again Fragonard returned to Paris during a period of immense upheaval. He had returned the first time to a Paris undergoing the effects of the end of the Seven Years' War. The second time, he was returning to a city in which the entire administrative order was being reshuffled. The death of Louis XV, announced while the Bergeret entourage was in Naples, not only led to the customary jockeying for position in the new court, but also had the effect of bringing to a climax a host of spirited arguments in the art world. The last traces of Pompadour's policies were energetically erased by a group of interested parties who had been preparing their opportunities for more than a decade. The official attitudes were still less sympathetic to the kind of values Fragonard stubbornly sustained. Their chief interest was now to regulate painting and sculpture according to the ambitions of the monarchy. Fragonard, in his forties, refreshed and inspired by his contact with the sources and sites of his early inspiration, returned to a city in which artistic polemics were shrill and mostly in support of tendencies directly opposed to his own. Once again he had to assert his will, well aware that he was working against the grain. He had his supporters, of course, and could still command an adequate group of collectors; but his reputation, despite his being only forty-one years old, was already that of an old-fashioned artist who was not keeping up with the times.

CHAPTER 13

The Fête at Saint-Cloud

BEAUMARCHAIS PUBLISHED his *Barbier de Séville* in 1775 with a preface in which he asserted, "Investigation shows that what we call passion is nothing but desire inflamed by obstacles."[1] Beaumarchais's cynicism and his covert social criticism found a ready audience in a city that was experiencing marked and rapid changes. In his own art, Fragonard had anticipated Beaumarchais's ideas and was as wise and observant as the dramatist. He had long since depicted situations on Beaumarchais's theme. He, too, had his passions, and they were certainly inflamed by obstacles. Throughout his career as a painter he had demonstrated a certain stubbornness born of passion. The situation for artists in Paris when Fragonard returned would test his strength. He was confronted with an art world that was holding its breath to see what the new culture minister, Charles Claude de Flahaut, the Comte d'Angiviller, would do. They didn't have long to wait.

Almost immediately upon taking office, d'Angiviller decreed that, in effect, royal commissions would thenceforth be used to shore up the monarchy. "The king," he announced in 1774, "will see with particular interest his painters of the Academy retrace those actions and facts honoring the nation. What activity is more worthy for the arts than this kind of association with the legislation of customs?"[2] D'Angiviller's zeal was expressed in another significant action when he suppressed the École Royale des Élèves Protégés, calling it "a foyer of anarchy."[3] As Thomas E. Crow has written, "D'Angiviller, in his background and affiliation, represents the marriage of enlightenment rationalism to the needs of an authoritarian state."[4] Official patrons and the *amateurs* in their circle were moving in the direction of moralistic history painting, which suited the ambitions of the new generation of Prix de Rome artists but was far from Fragonard's vision. The kind of regulation favored during the reign of Louis XVI left a man of Fragonard's temperament in limbo. He had renewed his emotional ties to Italy during the

important journey, but in its wake appeared a certain dawning melancholy, an intuitive apprehension of the increasing emotional disorder of the time. In the absence of a single clear and predominant mode in painting, Fragonard, who like any artist had to respond to some aspect of his century's belief systems and mores, turned to the romance of gardens, ruins, and rural landscape to give expression to his deepest feelings.

For what was to be his masterwork, Fragonard took, according to tradition, a fairly conventional theme: the festival in the king's park at Saint-Cloud that took place during the last three Sundays in September of every year. (Or at least it was a public fête in some location near Paris. Tradition has it in Saint-Cloud, and there is no reason to doubt that the annual fête there inspired Fragonard.) Fragonard managed to turn this often-painted spectacle in his *Fête at Saint-Cloud* (colorplate 9) into a unique embodiment of the uneasy, elegiac relationship between himself and his time. This popular fête, sketched by many of Fragonard's contemporaries, became a pretext for a group of complex meanings that Fragonard gathered up from his entire past experience.

Nothing much is known of the circumstances in which the painting was commissioned, nor even the exact date. The Duc de Penthièvre most probably approached Fragonard merely to make a decorative painting for the wall of the dining room in his Parisian mansion the Hôtel de Toulouse (now the Banque de France), leaving the subject to the artist. (Again, there are no documents to confirm that the Duc de Penthièvre was the patron, but the traditional association with his name is still the most reasonable ground on which to speculate.) The duke, a direct descendant of Louis XIV, had many properties, and his existence was, according to Mme d'Oberkirch (who tells us so much about eighteenth-century Parisian life in her memoirs), that of a wanderer from one property to another. But, she added, "all his houses are admirably furnished and maintained."[5] In Fragonard's circle, the Duc de Penthièvre was admired for his benevolence and was known as "king of the poor." The minor poet Florian, a member of the duke's retinue, wrote an encomium:

> *Bourbon n'invite pas les folâtres bergères*
> *a s'assembler sous les ormeaux;*
> *Il ne se mêle pas à leur danses légères*
> *mais il leur donne des troupeaux.*

> (Bourbon doesn't invite the playful shepherdesses
> to assemble under the elms;
> He doesn't get involved with their light dances
> but he gives them flocks.)[6]

The duke would have been no less generous to his painter. Fragonard seized upon this major commission to make a large statement, one that would enfold his

deepest preoccupations, his strongest convictions in an atmosphere of willed ambiguity. He was no longer a callow youth. He was an artist who had had a number of embittering experiences—the episodes with Guimard and Du Barry and the lawsuit with Bergeret—that could not have left him indifferent. The time was propitious for him to make a summation of his most passionate preoccupations.

Almost every aspect of this painting had been prepared in Fragonard's artistic past. The subject itself was conventional, with its roots in Fragonard's youthful study of Watteau, prompted by Boucher. Yet, Fragonard's version is quintessentially different. His observation of people of all classes entertaining themselves at the various fair attractions goes back to his own youth: he, the poor son of a petit bourgeois, who had begun his Parisian education as a *saute ruisseau*. In his depiction of the *petits gens,* Fragonard, long since a familiar in the elite circles, remembers his origins. There is no condescension, no exaggeration in the way he paints them. He had known the lives of many and was prepared to see humanity as basically equal, not, perhaps, as his more politically involved friends saw it but as an artist who moved easily among peasants and artisans and in the *haute monde,* watching, recording, and finally establishing universal likenesses.

Other aspects of the painting had also been well prepared in Fragonard's experience. There was his consistent attraction to the theater and his acute sense of theatrical decor. There was the sentiment, already incipient in the Frick murals, that nature held hidden truths, some of them disquieting. There was his friendship with the younger Bergeret, who was deeply engaged in landscape architecture, and also with Pâris, who was translating English treatises on landscape gardening, and with the old enthusiast in the art of theatricalizing nature, Wâtelet. Finally, there was his long meditation on the painter's universe and his search for the appropriate means to express a particular view of the world. The old propositions of Roger de Piles were still intact for Fragonard.

In order to render justice to his extraordinary mural, we must ask what are the many things it means and how meaning is achieved. On the obvious level, the painting means that Fragonard was a keen observer of the customs of his contemporaries, including their passion for marionettes and performing charlatans and vaudevillians. His discriminating eye notes the colorful displays of marionettes, dolls, kerchiefs, and tambourines. He notices the absorption of those watching one of the games of chance, the wandering gazes of the children and housemaids in the festive scene. He notices their dress, their gestures, and their sense of anticipation. On a deeper level, the painting means that Fragonard is meditating about the relationship between man, with his toys and baubles, and the grand, towering forces of nature. The moody strength of this painting derives partly from the contrast. Most important, its meaning lies in Fragonard's vision of potential disturbance, his sense of foreboding. This is clearly stated in the exceptional prominence of the exactly centered, overturned potted tree.

Fragonard included broken vessels and overturned plants many times in his

compositions. In the *Blindman's Buff* (fig. 41) at the Timken Art Gallery in San Diego, for instance, a similar potted tree is depicted on its side, and storm clouds are gathering over a barely visible ruin in the background. These broken vessels and overturned plants certainly had a standard symbolic value. But in *The Fête at Saint-Cloud,* they assume far more significance. The overturned tree conspicuously placed in the foreground is a key to the meaning of the painting. Other hints of Fragonard's implicit meaning are also provided. There is another overturned tree, it seems—a tall, shaped shrub lying on its side before the charlatans—that serves as a *repoussoir.* Finally, there is the muffled statue on the right, seen from behind. These cues to the essential meaning of the painting are enhanced by the expressive use of flickering light, a light meant to conjure an underlying sense of irreality and potential drama. Yet, unlike the frankly theatrical light flourishes of the Frick cycle, the light Fragonard uses here offers, in purely pictorial terms, a mute image of caprice and potential ruin. The light is used both to enhance hidden drama and to speak of differing climates: the full light of a September day, or dusk; the artificial light of life's theater; or the tremolos of approaching storm. The painting is no mere record of a pleasant event. Unlike his friends Hubert Robert or Gabriel de Saint-Aubin, both of whom represented the fête at Saint-Cloud, Fragonard gave his observations a depth that went beyond the occasion. In this painting there is an argument.

The standard explanation for the artists' interest in these quasi-rural festivals occurs in a letter concerning Hubert Robert, cited by Georges Wildenstein. After his arrest in 1793 during the Terror, Robert was held in Saint-Pélagie prison where he apparently talked a great deal about his past to a fellow prisoner named Roucher. He recounted that he and his close friend, the painter Vernet, went twice every year "as a pilgrimage to beautiful nature" to the fêtes at Saint-Cloud and at Sceaux:

> Among *tout Paris* which they saw assembled in the most beautiful and elegant settings, they walked. They strolled, saluting acquaintances, but not stopping with any, observing with a studious eye this moving tableau, so varied; this magnificent mélange of all objects of nature, adorned, embellished, and perfected by society. The grass of the lawns, the foliage of the trees, the light, the noise, the play of fountains that snaked, extended, fell and rose up . . . strokes of light that often pierced the foliage, made dense, by contrast the elongated shadows . . . and all that, still more embellished by the soul that gives to the countryside the spirit of man."[7]

Fragonard's Saint-Cloud is quite different. It is not certain at all that "society" can perfect this nature or even dominate it. The spirit of man cedes to the spirit of capricious and, finally, triumphant nature, before which the artist is in a state of admiring awe. Although the standard reading of the painting as a response to a contemporary event is valid, it must be seen also as a thought—that the human presence might be dwarfed and rendered insignificant by the splendid powers of

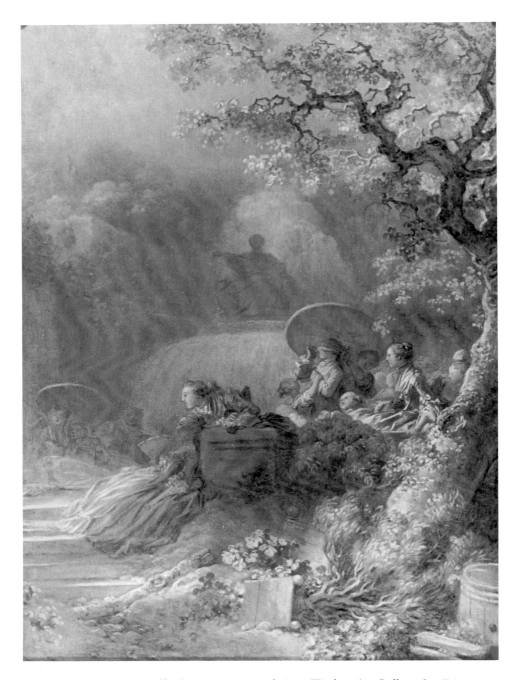

FIGURE 41. *Blindman's Buff*. The Putnam Foundation, Timken Art Gallery, San Diego.

nature. It reflects the great philosophical discovery of the late seventeenth and mid-eighteenth centuries that there is universal analogy and, also, a power that might be called the primacy of nature. The props in this painting appear in paintings by others, and if it were not for its compelling pattern of light and shadow and its unique color, perhaps it could be accepted as a typical response to a typical eighteenth-century event. But Fragonard was a visually intelligent man with urgent emotions. In this painting, he takes the traditional motif, the fête, and invests it with a new meaning to correspond to his intimations of a waning cohesion. The fallen trees were cultivated by man who hoped to dominate nature through artifice. We do not know, in Fragonard's painting, whether man or nature overturned these comely trees. We can only feel the melancholy that these supine living objects induce.

Fragonard painted this embellishment for a rich man's house at a time when the social order was being questioned on every side. And not only the social order, the aesthetic order was being vociferously challenged both from within the artists' milieu and from without. Critics criticized more loudly, and the so-called philosophers became bolder in their pronunciamientos. The world of forms was being expanded despite the new regime's effort to control it ever more strictly. Against this background, Fragonard's insistence on a markedly traditional motif might be seen as a rear-guard action or, alternatively, as an assertion of conviction that many other connoisseurs shared. The fact that he maintains analogy as the organizing principle of his view of the universe, with its corollary that sensibility will provide the means of interpretation, indicates that he was taking a position and sharing it with others on one side of the intellectual avant-garde. Here Rousseau's impact was not negligible. His writing style cleaved to the romantic notion of a world of hidden correspondences, a world Baudelaire would make vivid less than a century later.

But what was the nature of this position, with its emphasis on sensibility? It was certainly distinct from the emotions elicited in the *comédie larmoyante* (a sentimental domestic drama; literally, tearful comedy) introduced by Diderot. The tearful messages of Greuze were also not consistent with Fragonard's idea of sentiment. There is a lofty distancing in Fragonard's image of a fête that refuses to pander to the widening public for art, described with such disdain by Sir Joshua Reynolds in 1777:

> At the Salon, the Savoyard elbows with impunity the "cordon bleu"; the fishwoman exchanges her odors of brandy with the perfumes of the woman of rank, who is often obliged to hold her nose; here scholars give lessons to their masters.[8]

Although Fragonard did not paint for this new public, he harbored none of the distaste so salient in Reynolds's account. On the contrary, Fragonard endows the shop girls in his painting with the same dignity as the *hautes bourgeoises* and the

nobility. Wildenstein speaks of a print made after a work by Jean-Michel Moreau *le jeune*, depicting the same subjects in much the same positions, indicating that the two might have sketched there together on a specific day. There are the same charlatans, the boutiques of marionettes, and a woman with a parasol. Significantly, based on the print, it is apparent that for Moreau *le jeune*, unlike Fragonard, only the well-dressed members of *tout Paris* are there.[9]

To offer his painterly vision, or intuition, of the nature of the world he lives in, Fragonard goes beyond the occasion. The magnitude of his feelings and the depth of his commentary grows as he works, taking him beyond anything he had done previously. The closest equivalent to the general character of the lyrical emotion here occurs in a work of art that was causing an immense furor at the very time that Fragonard was painting *The Fête at Saint-Cloud:* Christoph Willibald Gluck's *Orfeo,* which was performed frequently from late 1774 through 1775 to great sighing and gnashing of teeth. This opera instigated a ridiculously overblown public dispute that no one in Fragonard's circle could have avoided. Fragonard himself, by long habit going back to his student years at Mme Van Loo's soirées, was bestirred. His great admiration for Gluck was expressed in a drawing in which a poet is seen gazing at the busts of Gluck, Virgil, and Homer, who are called "friends of the arts."[10] These literary muses were fashionable enough at the time, but Fragonard's respect for Gluck surely stemmed from his sensitivity to the radical undertaking in Gluck's new operas. One cannot help but feel that the noisy discussions among Gluck's partisans and the partisans of the Italian Nicolas Piccini, among them several prominent philosophes, left Fragonard indifferent. What spoke to him and what remains is the moving music.

The public dispute among the Piccinists and the Gluckists was played out in the increasingly influential columns of the press. Gluck felt compelled to defend his position, and in the February 1773 issue of the *Mercure de France* he answered his vociferous critics:

> Whatever talent a composer may possess, he can write only indifferent music if the poet does not arouse in him that enthusiasm without which productions in every artistic field must be feeble and languid . . . my music, always as simple and natural as I can possibly make it, only tends to enhance the expression and to add force to the declamation of the poetry. For this reason, I do not employ those shakes, passages and cadences which the Italians use so lavishly."[11]

Gluck's reform, as he had written in 1769 to a patron, consisted of eliminating "superfluous ornamentation" and accomplishing "what brilliancy of color and a skillfully adapted contrast of light and shade achieve in a correct and well-designed drawing, by animating the figures without distorting their contours." He felt that "simplicity, truth, and nature are the great touchstones of the beautiful in all artistic creation."[12]

Apart from being deeply moved by the haunting music of *Orfeo,* Fragonard

may have felt a rush of artistic solidarity when he encountered Gluck's views. His own work was evolving in a comparable way. He responded to Gluck as an artist and recognized his genius, as did Hector Berlioz half a century later, who said that Gluck's "truth of expression, purity of style, and grandeur of form belong to all time," or Gabriel Fauré in the twentieth century, who praised Gluck for abandoning "Italian titillation of the ear," resolving instead "to penetrate the spirit and to move the heart, and so conceived that powerful and expressive art, each manifestation of which always moves us so profoundly."[13] Fragonard drew close to Gluck through sympathy with a fellow artist who had been scolded in the same shrill tone as he had himself on more than one occasion.

The lyrical expression in *Orfeo* corresponds to the mood Fragonard creates in his *Fête at Saint-Cloud*. There, he avoids the operatic flourishes that were still important in the Frick murals and seeks to eliminate what Gluck called "superfluous ornamentation." Yet, his object is to rouse poetic passion, and to this end he uses his great painterly skills to make hidden analogies. The soaring geyser of the fountain rhymes with the soaring trees. It is as pure an expression of Fragonard's passion as the beautiful rising lament of Orpheus as he sings of his tragic forfeit. The sense of loss in Fragonard's painting is implicit but can be sensed strongly. This is an elegiac painting that speaks to the same feelings as the English lyrical poetry that was so deeply affecting many of Fragonard's contemporaries.

Both English poetry and English theories of gardening had been in vogue for several years. Edward Young's *Night Thoughts* had met with unparalleled success in 1769, when Pierre Le Tourneur published his translation, three years after the poet's death. In salons throughout France the poem was cited and discussed. Young's ideas were as well known to French readers as those of Laurence Sterne, whose generous praise of the "great sensorium of the world" was frequently cited in letters and memoirs of the last quarter of the century. Young's vision of an organic aesthetic ran counter to the neoclassical tendencies then prevailing in French art and literature but found enthusiasts among those whose senses had been stirred by Rousseau. The exhortations in *Night Thoughts* kindled in his readers a confidence in their own instinctive preferences:

> In senses, which inherit earth and heavens,
> Enjoy the various riches nature yields;
> Far nobler! give the riches they enjoy;
> Give taste to fruits and harmony to groves;
> Their radiant beams to gold, and gold's bright fire;
> Take in, at once, the landscape of the world,
> At a small inlet, which a grain might close,
> And half create the wondrous world they see.
> Our senses, as our reason, are divine.

But for the magic organ's powerful charm,
Earth were a rude, uncolored chaos still.
Objects are but the occasion; ours the exploit;
Ours is the cloth, the pencil, and the paint.

Young's aesthetic, as Lorenz Eitner has stressed, was extremely influential as an early expression of the organic view of creativity, expressed in his 1759 *Conjectures on Original Composition*. Eitner points out that "a special beauty began to be discovered in those forms of nature or of art which, though lacking in regularity and smoothness, possessed the vigor and character expressive of organic growth."[14]

For Fragonard, the elegiac spirit that infuses Young's verses moved through his own work less in the description of broken columns and overgrown amphorae than in the vibrations of nature that could overwhelm the artifice of man. Ruins contributed to the overall mood but were not the source of the emotions Fragonard strove to elicit. More than a century later, the sociologist and philosopher Georg Simmel attempted to define the perceived value of ruins. He thought that the charm of a ruin

> resides in the fact that it presents a work of man while giving the impression of being the work of nature. . . . Nature has used man's work of art as the material for its own creation, just as art had previously taken nature as its raw material. . . . This explains why a ruin is easily assimilated into the surrounding countryside, why it lies there like a stone or takes root like any tree, whereas a palace or a country house, or even a peasant's cottage, no matter how well they may be adapted to the character of the countryside, always suggest another order of reality and only later seem to fit in with the purely natural order.[15]

Fragonard's premonitions of impending disorder in *The Fête at Saint-Cloud* are of a less schematic nature. The nostalgia, if it can be called that, is moored in the senses, as Young recommended, as in Orpheus's aria of loss. As such it suffuses the work rather than describes itself. It is a scatter of feeling in the way Mallarmé wrote of "a scatter" of feeling throughout the poem—a constellation of sentiments that form a whole when seen from a distance.

The depth of Fragonard's feeling surely overtook him as he worked on this large canvas. Nothing in the various sketches related to the fêtes in the parks near Paris suggests the largesse of sentiment in the finished work. There are several drawings that are thought to be related to *The Fête at Saint-Cloud*. In the Lehman Collection at the Metropolitan Museum of Art there is a lovely faded wash drawing (fig. 42) traditionally cited as a study for the painting. But, as Eunice Williams has said, the painting "incorporates so many familiar ideas, motifs, and figures that several of Fragonard's park scenes might qualify as studies in spirit if not in detail."[16] The Metropolitan's tinted sketch does hint at Fragonard's shift in approach, however, in the way he calmly observes the crowds without exaggerating

their gestures. They are there, holding parasols, reclining, watching dancing children, but not gesticulating. The sensuousness of the light bathes the page gently, and except for the sequence of a dark tree, lighter statue, and very light passage behind that is probably a fountain, there is little play with dramatic effect. The composition is characteristic of Fragonard, with the crowds on the nearest horizontal plane echoed by the horizontal of the balustrade. On the verso of the Lehman drawing (fig. 43) is a black chalk drawing summarily suggesting the grouping of figures, admirably anchored with parallel lines and angles in the firm, abstract way Fragonard had developed during his second sojourn in Italy. The presence of the overturned potted tree here suggests that he had a specific day at a specific place in mind, but this does not presage its prominence in the painting.

The true beginning of the special emotional intonation of *The Fête at Saint-Cloud* is apparent in two small oil sketches in which Fragonard specifically prepares the three major motifs of his painting. The two studies are for the left-hand portion of the painting, and together they form a roughly triangular segment. *The Charlatans* (colorplate 10) is an almost self-contained tableau of the charlatan's theater mounted in a clearing closely bounded by dense foliage and lofty trees. Fragonard has already cast his spectators in a strange, blanching light while the background of forest is a glimmering mass, as though at twilight. He picks out the figures with the same Rembrandtesque flourish of the brush as he does the foliage on the nearest trees. The composition mounts from the naturally observed figure of the small child turning away, to the actress leaning forward to show her wares, and then to the banner flying in the wind at the crest of the painting.

The other small oil sketch (colorplate 11) depicts the tent of the toy seller against the blue-green density of the forest. This strange composition is emphasized with an exceptionally free brush. Fragonard places the fallen potted tree at the lower right, straight against the picture plane, and heightens its full-bodied leafage with dashes of yellowed light that suggest its dramatic importance. The interior of the tent is a roseate creation of remarkable intensity. The toy seller is limned with the simple linear flourish of light that Fragonard may once have admired in Tintoretto. The clusters of toys hanging from the upper reaches of the tent are laid in with a brush as summary as the Impressionists might have used, and the gaping figures to the left of the tent are suggested with equal concision. Both scenes have remarkable presence and, in the emanation of their strange light, indicate that Fragonard intended to intensify the dramatic overall ambience of his painting without resorting to the theatrical gesticulation of earlier works. The study for the right-hand side of the painting, which I have never seen, seems from the photographs to follow the same quick and painterly approach and works out the chiaroscuro pattern of light in the significant details.

In the finished masterpiece (colorplate 9), it is immediately apparent that Fragonard retained the strange effects of light and made only slight adjustments, such as giving the overturned potted tree even more emphasis in relation to the toy

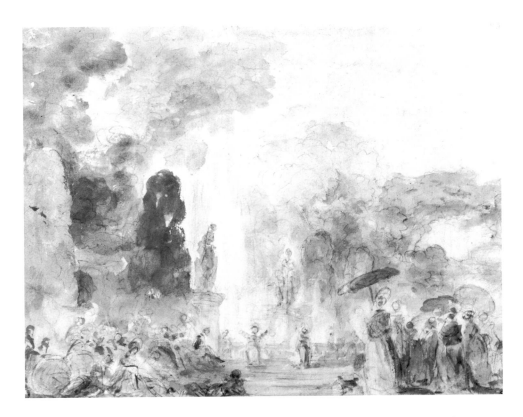

FIGURE 42. *The Fête at Saint-Cloud.* The Metropolitan Museum of Art, New York, Robert Lehman Collection, 1975.

seller's tent, and shifting the parasols, one red and one gray, into more conspicuous focus. He retained, however, the flickering brushwork. If critics found his rendering of foliage and flowers disturbingly free in the Frick murals, they would certainly have been shocked by the ease with which Fragonard eliminated detail, as for instance in the dress—consisting of a few strokes over a toned ground—of the elegant woman seated below the puppet show. On the other hand, the occult lines of the elaborate composition might well have baffled them. Fragonard has, it is true, massed three major areas. They are made to interact by means of invisible sight lines that form a kind of cat's cradle and also by means of rhyming color accents and chiaroscuro patterns. Fragonard takes considerable liberty with perspective lines in order to cede the activity to massed shadows and lights. The cat's cradle of containment is paradoxically established in the diagonal lines of the quivering, wind-swept tree on the left and the equally shuddering branch overhanging the puppet show on the right in its strangely golden light.

As the eye travels the scenes shift. The tranquil group playing a game of

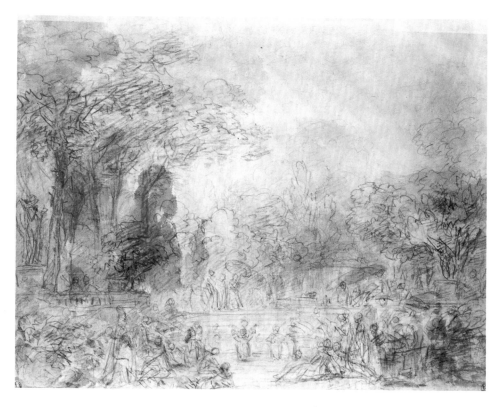

FIGURE 43. *The Fête at Saint-Cloud,* verso. The Metropolitan Museum of Art, New York, Robert Lehman Collection, 1975.

chance in the right foreground and the servants, one with a brilliant scarlet parasol, are in a quite different light from that of the important sequence of puppet show and statue. Fragonard announces the shift by means of a sudden brilliant gold light cresting on the pile of devastated puppets, signaling the climatic end of the traditional Pulchinello. Because of the lighting, it would seem Fragonard was using this scene of rout, with its significant goat puppet, to speak of other things. Certainly the brooding figure of the statue in its green bower is like the alarmingly exaggerated stone figures in the Frick murals, but far more suggestive. Fragonard and everyone else during the period was well aware of the expressive power of the puppets. Their relationship to the stone statue is probably deliberate, for puppets, like statues, were used to say things that dramatists did not wish, or were forbidden, to say overtly. There was a puppet craze in Paris, and Fragonard could have seen them every day at the Palais-Royal, certainly at the fairs and on the Boulevard du Temple. Puppets were relished not only by high society but also among actresses with whom Fragonard was still on good terms. Mlle Péllissier, an actress at the

Opéra, actually paid a puppeteer to provide her with a show twice daily, according to a book published in 1778, and drama critics were constantly alluding to the vices and virtues of puppeteers, sometimes in quite lofty theoretical terms.[17] While it is possible to see Fragonard's representation of the common puppet show of the Punch and Judy type as merely a picturesque detail, the fact that he has insisted on a relationship to drama—both in the overhanging branch of the tree attacked by a *coup de soleil*, as if by lightning, and in the stony, larger-than-life statue—cannot be ignored.

If there is no verifiable way to insist on significance in the motifs themselves, the specific use of light and shadow ordains the emotional timbre of the painting. In its alternations of feeling, the painting might well be considered a visual counterpart of what Jean Starobinski has called the pastoral dirge: Goldsmith's *Deserted Village*, Gray's *Elegy Written in a Country Churchyard*, Gessner's *Der Tod Abels*, and, to some degree, Goethe's *Werther*.[18] These, Starobinski says, are works in which the idyllic spirit is manifested for a short time only to reach the limit at which internal requirements of truth and fatality demand the death of the idyll: "Forced back into the universe of death and of past time, the idyll becomes the elegy, the 'sentimental' poem of lament and nostalgia."[19] If Fragonard is not as mournful as the dirge poets, he was nonetheless aware of the impossibility of the conventional idyll as Watteau and Boucher had conceived it. The light of nostalgia touches the painting glancingly, but there is also something of a realistic, knowing sadness. It is tempting to think that Fragonard sensed that the idyllic ventures into nature by the Parisians were already threatened by changes in the social order and the many current avatars of a troubled future. There have been many comparisons with Mozart apropos of this painting. The statue has been seen by David Wakefield as the Commendatore in *Don Giovanni*,[20] and Fred Licht has compared the general tone to that of *Cosí Fan Tutte*: "The play is about treachery, disloyalty, superficiality, and never tries to hide it. But it is unlike any other later examination of betrayal in being *serio* and *scherzo* all at once."[21]

Fragonard's pensive mood is more explicit in the strange painting known as *The Fête at Rambouillet* (fig. 44). This, too, presents a motif that many painters had depicted: the pleasure jaunts of the titled nobility on their artificial lakes in their artificial Venetian barques. But Fragonard takes the theme into a realm of startling excess. All shadows are heightened by the invasion of piercing lights, and the depths of the grotto are hardly comforting. The atmosphere of drama is more emphatic than in *The Fête at Saint-Cloud*, although there is a similar mixture of direct observation and imaginative reformation characteristic of this phase in Fragonard's painting life.

Far removed from Watteau's *Embarkation for Cythera*, with which it has been compared, Fragonard's *Fête at Rambouillet* comes close to the extremities of later Romantic painting. There are powerful and exceptionally accented contrasts of light and shadow. The vaults within the darkish green foliage of the grotto are

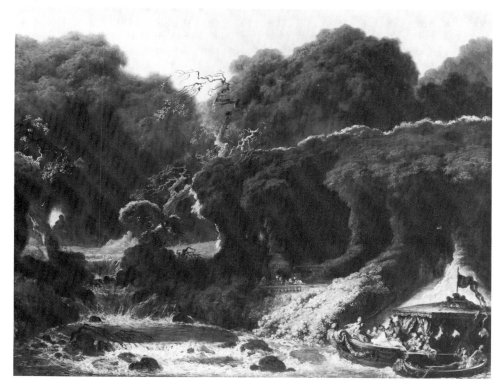

FIGURE 44. *The Fête at Rambouillet.* Museu Calouste Gulbenkian, Lisbon.

deep caves of blue-black, darkly suggestive and deliberately concealing their mysteries. Figures on the fanciful stairway leading down into the turbulent waters are scarcely discernible. They issue from depths that are not simply leafy bowers, but meant to be disturbing foils for the wild run of lights, as if along a charged electric wire, at their summit. This lacy fringe of impastoed dots of light rushes along the crest of the grotto to the forked dead tree, highlighted as if by lightning, as in other works of Fragonard, but repeated once below in almost the same conformation. These two dramatic trees are then echoed again by two similarly stripped and stricken dwarfed trees arising from the rocks and frothing waters below. There is repetition also in the phrasing of the two significant statues terminating the lower diagonal of the composition. The first, a white marble reclining ancient figure, lies etched in the intense light that has stricken the trees above it, an apparition of considerable ambiguity. The second is a seated figure in the rear plane, aureoled in intense light, much as is the standing figure with its back toward us in *The Fête at Saint-Cloud.* Repeated doubling in this painting is an odd feature that will not be seen again in painting until the late nineteenth century, when the symbolists, mad about mirroring and its symbolic connotations, adopted it. The insistent rhyming

scheme in this painting is maintained throughout, even to the strange cascade of roses that descends from the grotto into the water and is rhymed with its foam.

In the intense color, which can never be reproduced, and in which the blue-black depths are played against lapidary greens and spots of bright primaries, Fragonard expresses feelings that go well beyond the delicacy, the "appropriateness," of the genre of *fêtes galantes.* There is little explanation for this exceptional painting in his oeuvre—a painting that always stands apart from other works of the period. Commentators have sought to find its meaning in seeking its purpose. Was it meant to celebrate a specific fête, such as that held in honor of the Grand Duchess of Russia traveling as the Comtesse du Nord? If so, the painting could be called merely a reflection of a doomed courtly culture. But there is little convincing evidence that Fragonard was given this specific assignment. Although the painting is traditionally called *The Fête at Rambouillet* and, alternatively, *The Island of Love,* when it was first shown in Pahin de La Blancherie's Salon de la Correspondance in 1782, it was simply described as *"une grotte ornée d'archtectures avec figures"* (an ornate grotto of architecture with figures). It was sold on June 14, 1784, in the Delaborde sale, suggesting that the rich financier had bought it from the Salon of 1782. At the time, Delaborde was working closely with Hubert Robert who was designing fanciful gardens for his estate. He might have been drawn to the painting as an imaginary landscape in an artificial setting. If the painting had in fact been commissioned by the Duc de Penthièvre to commemorate a fête in the park of his Château de Rambouillet (which he sold to the king in 1783), it would seem unlikely that it would have been so quickly sold to Delaborde. If it was, as Jacques Thuillier has suggested, a painting of the entertainment offered by the Prince de Condé at Chantilly to the Russian duke and duchess, and the guests (including the Duchesse de Chartres and the Princesse de Lamballe, the Duc de Penthièvre's daughter) were represented as *batelières de l'île d'Amour* (boatwomen of the island of Love), it would still be unlikely to have been owned by the Marquis Delaborde.[22] Thuillier cites Mme d'Oberkirch's account of the fête, but she, in her entry for June 3, 1782, locates the fête at Sceaux, another estate of the Duc de Penthièvre, whom she calls the "most virtuous, the best of princes . . . and certainly the most perfect man on earth" whose estate is "enchanted." Her account of the day hardly suggests Fragonard's painting:

> Madame the Duchesse de Chartres did the honors with extreme amiability. The waters played everywhere. One visited this park and this enchanting place in carriages drawn by six horses, that is to say, two open calèches in which almost all the women were placed. The company was choice; the luncheon of exquisite magnificence.[23]

Art historians have tried to explain certain features of the painting by tracking the origins of the exceptionally accented, crackling, dead trees. David Wakefield believes the type derives from Salvator Rosa.[24] Wildenstein thinks it derives from Wu Chen, or possibly a reproduction of Shen Chou, owned by Bergeret.[25]

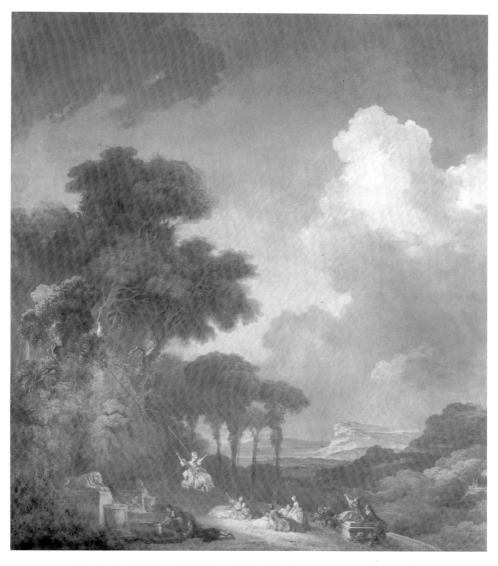

FIGURE 45. *The Swing.* National Gallery of Art, Washington, D.C., Samuel H. Kress Collection.

Others suggest Ruisdael. No doubt any of these sources was possible, although Ruisdael seems the most likely; if so, Fragonard's intentions were specifically emblematic. Even if we knew the exact source of Fragonard's painting, we could not assume we had encompassed Fragonard's meaning, which cannot be explained iconographically. In this painting, as in *The Swing* in the Wallace Collection (colorplate 1), painted much earlier, the conventions are so much altered that the sources are overwhelmed. Of course there are reminders of Watteau in this

painting, but whatever lingers of Watteau's inventions has been thoroughly recast to Fragonard's actively emotional purpose. The turbulence and occult lights are his alone.

The two *Fêtes* are exceptional in Fragonard's oeuvre. If we look at works presumed to be of the same period, such as *Blindman's Buff* and *The Swing* in the National Gallery of Art in Washington, which do not reflect romantic melancholy, there are, all the same, some rather curious features. The two were possibly commissioned by the Abbé de Saint-Non for whom Fragonard would have used his recent drawings and impressions from Italy, commemorating their own singular summer in Tivoli years before. Both paintings have details that can easily be traced in his Italian sketches. In *Blindman's Buff* (colorplate 12), the statue of Minerva high above the trellised bower in which a picnic is prepared was sketched frequently during both of Fragonard's sojourns in Italy. So were the two cypresses that find their consummate expression in this landscape. Fragonard uses all his accumulated knowledge of structure to build these superbly articulated, dense forms shooting up into a summer sky. The sun that models their masses also discerns, with strong strokes, the full-bodied fountain emerging from between them. Fragonard's attention to rendering the green-yellow reflections within the trellised enclave is exceptionally bold. More than one commentator has seen in this detail a prophet of Impressionism.

In the companion piece, *The Swing* (fig. 45), there is again little to suggest the elegiac, but certain simplifications are notable in the calm grouping of the figures, in the naturalism of their gestures, and in the bravura of the painting of the white figures in full sunlight and the chalky cliff in the far distance, held in the reflection of the bright sky by its ghostly coloration. The only note that might be interpreted as an invocation of nostalgia is in the figure of the young woman, seen from behind, peering through her telescope to the far distance. *The Swing*, compared with the early version in the Wallace Collection (colorplate 1) or with the Frick murals (colorplates 7 and 8, figs. 28 and 29), shows how far Fragonard had advanced in his desire to express the poetry of the Italianate landscape. All his experience of the campagna is synthesized, made precise here. Fragonard, spiritually close to Ruisdael, an admirer of Rembrandt and of Tiepolo, understood what moved him most deeply and what, in painting, could fulfill his expressive needs. The fêtes and imaginary Italian landscapes of this period were at once expressions of his *sensible* self and pretexts for the mature articulation of his deepest feelings about the universe of painting.

CHAPTER 14

En famille

FRAGONARD'S ACTIVITIES after he completed *The Fête at Saint-Cloud* for the Duc de Penthièvre become increasingly difficult to follow. He rarely signed and dated his paintings, and he did not capture the interest of the pamphleteers and chroniclers. Most of what we assume about his life, associations, loves, and artistic production is the result of considerable speculation, with the biases of the narrator usually taking over. Some writers propose that during the 1770s, after his return from Italy, Fragonard was warmed by the presence of his daughter, Rosalie (born in 1769), and became a tender family man, with eyes only for the joys of paternity. Others consider important his many services for a family of actresses, the so-called Colombe sisters of the Comédie Italienne. Two of the sisters, Marie-Catherine and Adeline Riggieri, were young, attractive, and very well looked after by adoring patrons, one of whom, Jean-André Vassal de la Fortelle, was a collector of Fragonard. When Vassal bought a house for Marie-Catherine in Saint-Brice, he hired Fragonard to decorate it. The numerous portraits of these two belles of the theater attributed to Fragonard were painted sometime around 1777.[1] The sisters also served as models for any number of Fragonard's potboilers that seemed to find a market among the wealthy swains who frequented stage doors. Fragonard's more contemplative subjects—many drawings and several paintings of young women reading (fig. 46) or having quiet conversations—have led certain commentators to believe that he was deeply stirred by the arrival in 1775 of his wife's fouteen-year-old sister, Marguerite Gérard, whom he enthusiastically initiated into the secrets of the atelier and with whom he later conducted a relationship that some have hinted was more than brotherly.

There is scant evidence for any of these interpretations of his character and work during the period leading to the Revolution. Some hint of his business acumen is suggested by the frequently announced publications of prints after his

FIGURE 46. *A Young Girl Reading.*
National Gallery of Art, Washington,
D.C., gift of Mrs. Mellon Bruce in
memory of her father, Andrew W.
Mellon.

more playful erotic subjects and many others after his sentimental scenes with
children. There is evidence of his attachment, still, to the world of theater; evi-
dence of his accession to temporary fads in the art world; and evidence, too, of a
secret emotional life. A good case can be made for Fragonard's being an exemplary
product of his period, a creature shaped by history and also victimized. On the
other hand, an equally good case could be made for his secret resistance to the
demands of his period and a fully conscious attempt to preserve his independence.
His meandering course seems to reflect the extreme volatility of a period through
which an artist had to pick his way with care.

If he were still working in his studio in the Louvre, which was probable,
though he and his family might have had living quarters elsewhere, Fragonard
would have been interrupted frequently by quite unnerving events. He witnessed
many street demonstrations and heard much excitable gossip in the cafés around
the Palais-Royal. From the moment that Louis XVI acceded to the throne, there
were constant disturbances. While Fragonard was at work on his *Fête at Saint-
Cloud,* the specter of famine brought a menacing invasion of thousands to Ver-
sailles. Bread riots were frequent. Later in Louis XVI's reign, most of Fragonard's
friends and acquaintances were engaged in daring critiques of the government and
all its institutions. At times, as Crow has said, the threatening disturbances were
within earshot of the studios of the painters to the king. In August of 1787, for
instance, "there were two weeks of continuous rioting outside the Palais de Justice;

copies of the new disputed tax decrees were publicly burned; the crowd ransacked the home of a wine merchant, forced the police to release two of their leaders . . . 1,900 guards had to be stationed on the Île de la Cité to suppress political agitation and the sale of pamphlets."[2] There is not a line in any document to tell us how Fragonard responded to all this or if his work habits were disturbed. Yet, by negative reasoning we can assume that he was, along with Saint-Non, a liberal and thus interested in reform. He never abandoned his materialist position, avoided religious subjects, and probably would have chuckled when told that Voltaire addressed God: "I believe in you, God, but as for M. votre fils, and Mme sa mere . . .!"[3] He also never painted flattering portraits of the nobility and certainly not of the royal family, and he slipped out of his academic responsibilities and commissions whenever possible.

The educated *amateurs* with whom Fragonard had dealings were becoming strongly aware of the many contradictions bedeviling their existence in the years immediately preceding the Revolution. The most eloquent testimony was left in his memories by the Comte de Ségur, who observed the disintegration of good judgment even in the court, where Voltaire's *Brutus* was enthusiastically applauded in a performance at Versailles, particularly the lines:

> *Je suis fils de Brutus et je porte en mon cœur*
> *La liberté gravée et les rois en horreur.*
> (I am the son of Brutus and I carry freedom
> engraved in my heart and hold kings in horror.)[4]

The Comte de Ségur's summary of his youth, written after the Revolution, characterizes the attitudes of many of Fragonard's patrons, and possibly his own as well:

> Irritated by the tiresome etiquette of the old regime, estranged from our fathers who disliked our new fashion of simple egalitarian clothes, we felt inclined to fall in enthusiastically behind the bold writers. We took secret pleasure in seeing them attack the old scaffolding that seemed ridiculously antiquated to us. And though it was our privileges that were being undermined, their little war pleased us. . . . We laughed at the alarm felt at court and by the clergy. . . . The idea of equality attracted us; it is agreeable to descend when you believe you can go back at any time you want to. Lacking foresight, we enjoyed at the same time the advantages of being aristocrats and the charms of the plebian philosophy. . . . We walked gaily across a carpet of flowers that concealed an abyss.[5]

A great cauldron of fermenting passions, criticisms, and novelties, Paris in the 1780s was a source of wonder to visitors who sometimes sensed hysterical undercurrents. Reports range from the practical and intelligent Baronne d'Oberkirch to a more simple English visitor, Mrs. Cradock, who wrote in 1784 of a visit to the fair at Saint-Germain where "they sell everything," and of a Sunday when she witnessed with pious distress a religious procession directly followed by a camel, some

monkeys, and performing Savoyards and clowns. She found this city where "religion and amusements are mixed together" unnerving.[6]

The rising tide of social contradictions noted by the Comte de Ségur more or less played into Fragonard's hands as a wage-earner. He now had a rather large family. In 1780 his son, Alexandre-Evariste, was born, and there is some sketchy evidence that various poor relatives lodged with him at one time or another, as did assorted students. The mixture of audiences gave Fragonard's versatile hand various opportunities. The habits of the ancien régime did not change appreciably, but they were assigned different values. The existence of libertinage, for example, brought forth volumes of indignant, censorious writings. But it also brought forth volumes of critiques disguised as salacious writings (or was it the reverse?), as in the case of Mirabeau and Choderlos de Laclos. Mirabeau, when imprisoned in Vincennes from 1777–80 along with his archenemy the Marquis de Sade, used his time to write licentious tales in order to make money, but also, as he wrote to his lover Sophie, in order to criticize the wanting morality of his time. Anyone who wants to know how basically chaste Fragonard's erotic subjects were need only to look at contemporary editions of Mirabeau, with their egregiously pornographic engravings, to understand how very free some sectors of society were. At some point after his release, probably in Paris, Mirabeau met Fragonard, whom he may have known earlier because of his family connections in Grasse. They must have been relatively friendly, for Mirabeau penned the little shadow portrait of Fragonard in the museum at Grasse. Whatever their relationship, they might have shared a laugh or two, for both were denizens of a rather worldly milieu in which there was much to laugh at.

Laclos published *Les Liaisons dangeureuses* in 1782, and it immediately became a bestseller. It was intended as a critique. Laclos left no doubt about his intention by inserting a sarcastic passage in a fictional publisher's note at the beginning of his epistolary novel:

> It seems to us that the author, in spite of his evident attempts at verisimilitude, has himself destroyed every semblance of truth—and most clumsily—by setting the events he described in the present. In fact, several of the characters he puts on his stage are persons of such vicious habits that it is impossible to suppose they can have lived in our age: this age of philosophy, in which the light of reason, illuminating every heart, has turned us all, as everyone knows, into honorable men and modest and retiring women.[7]

In the world of roués ("worthy of being put to the wheel") and libertines (originally referring only to those who denied religion), the military strategist Laclos saw that mere philosophy could do little to change the habits of the privileged. While certain eighteenth-century novels dealt with the issue of libertinage in a rather playful way, Laclos was serious. Roger Vailland has compared the novel to a corrida: "It is a dramatic play with exactly determined moves that lead to the 'moment of truth' and the 'kill'. . ."[8] Although Laclos indicts the nobility in his

novel, the laxness in morals was by no means limited to the leisured noble class, as Fragonard well knew. His concourse with actresses and their patrons brought him into many situations in which the bourgeoisie and the newly titled behaved with eminent indifference to moral codes. From these urban wealthy, who were rapidly filling Paris with their sumptuous houses, Fragonard drew his clientele, particularly for the mildly prurient works he continued to turn out. And it was not only the urban wealthy who hastened to acquire a print "by his own hand" after the drawing *The Armoire,* advertised in 1778, which showed an abashed young lover emerging from an armoire while the girl's scandalized parents look on. All the purveyors to the rich—grocers, framers, perfumers—also got richer and began to adorn their own walls with the same prints as their patrons.

In this most confusing of times, there existed both a robust sensuality in the air and a conscious sense of decay. Mirabeau spoke repeatedly of "rottenness" in his pornographic tales. All over Europe the French were perceived as either cynical or hypocritical about matters of love and certainly given to practices more extreme than anywhere else. The German Jean-Paul Richter wrote a recipe for love in the French manner: "Take a little ice, a little heart, a little wit, a little paper, a little time, a little incense; mix them and place them in two persons of quality: you will obtain an excellent *amour à la française.*"[9] The general failure of reason to correct the excess remarked by Laclos was also noted by other alert Parisians and even foreigners. Apart from their slack morals, the French were now going to excess in other ways. The reliable Baronne d'Oberkirch noticed the definite surge of interest in viewpoints that could hardly be considered within the realm of reason:

> Something very strange to study, but very true, is how much this century, the most immoral that has ever existed, the most incredulous, the most loudly philosophic, turns, toward its end, not to faith but to credulity, superstition, the love of the marvelous. . . . Looking around us we see only sorcerors, adepts, necromancers, and prophets. . . . What will the last years of this century be, this century that began so brilliantly, that used so much paper to prove its materialist utopias, and which is now only occupied with the soul and its supremacy over the body and its instincts? One doesn't dare to think."[10]

The staunch materialists, among whom we must count Fragonard, continued to talk and publish and paint, but many of their former acolytes became quite skittish. They were drawn to occult salons, to the seances of Franz Anton Mesmer and others, and, more significantly perhaps, to the lodges of the Freemasons. Yet Fragonard continued to produce drawings of lovers and worldly upper-class gatherings that still found eager collectors. A typical, mildly naughty drawing probably from this period, judging by the technique, is *What Does the Abbé Say about It?* (fig. 47), in which Fragonard depicts a well-appointed, upper-class interior. The eternal abbé, a kind of perpetual boarder known to many such households, is seen supposedly studying a learned tome, but in reality he is smiling concupisciently as

FIGURE 47. *"What Does the Abbé Say about It?"* Museu Calouste Gulbenkian, Lisbon.

FIGURE 48. *The Love Letter.*
The Metropolitan Museum of Art,
New York, Jules S. Bache
Collection, 1949.

the son of the house—or perhaps the violin teacher or dancing master—lustily sweeps a young girl off her feet. The older ladies, oblivious of the action on the center stage, continue training a little dog. This drawing is quite typical of Fragonard's gift for anecdote. At the same time it displays his great flair for summary detail. The violin on the floor, the bouquet of flowers, and the table it rests on are rendered in the swift, sure washes that endeared Fragonard to connoisseurs. (When this drawing was sold in the Varanchon de Saint-Géniés sale in 1777, it was bought by Hubert Robert.)

Besides the drawings and prints after them that brought a steady income, Fragonard probably accepted commissions for portraits and intimate scenes from his faithful clients or new ones who sought him out at the Louvre, which was increasingly the custom during the reign of Louis XVI, or from enterprising dealers. A painting such as *The Love Letter* (fig. 48), in the Metropolitan Museum of Art, might have been a commission, probably dating from the later 1770s. Although the tone of the anecdote is light and playful, as in an earlier period, there is much in the painting to suggest that Fragonard quite deliberately took up his position in defiance of the prevailing preferences. His characterization both of the little dog and its inwardly amused mistress differentiate him from contemporary portrait painters who used either a more realistic tactic, as did David, or preferred a more formal pose and more finished surface. Fragonard's palette has much in common with the light fresco tones that he had seen again during his second trip to Italy, with pale greens, deep ochers, siennas, and pinks predominating. But whereas his contemporaries were recalling antique frescoes by stiffening the relief effects into a neoclassic stereotype, Fragonard sought from them only the most painterly inspiration. The way the yellow abuts the pink in this painting is more important than any other aspect.

Fragonard's busy atelier, with his wife, sister-in-law, and probably assistants working for the market, was, of course, not indifferent to the fashions that moved in and out swiftly during the latter part of the eighteenth century. It suited Fragonard never to show again at the official Salon, but he exhibited frequently in the unofficial salon initiated by Pahin de La Blancherie in 1779, as did his wife and sister-in-law. This salon, greatly misprized by the Academy and always threatened with royal displeasure, enabled Fragonard, and also his friend Greuze, to kill two birds with one stone. On the one hand, Pahin's salon was an open defiance of the Academy and, on the other, a showcase that drew distinguished collectors. In general, the public for painting was increasing enormously. The same bourgeois who faithfully attended the official Salon could also be found at Pahin's Salon de la Correspondance and knocking on the doors of painters such as Greuze and Fragonard who often dealt from their own studios. A letter in the *Journal de Paris,* August 24, 1781, reflects the attitude of a newly established collector:

I have a small collection of our School proportionate to my fortune, and when
my economy permits me to augment it, I await with impatience the opening of
the Salon, certain to find there always some paintings belonging to their au-
thors and I deal with them; I prefer to buy a work of an Artist from that Artist
himself rather than from a dealer whomever he may be; because aside from
the fact that I have the work at a better price, I also have the pleasure of deal-
ing with a man whose procedures must be as noble as is his Art.[11]

The throngs at the official Salon indicate the flourishing possibilities for
commerce. In 1759 it was estimated that about fifteen thousand visitors attended
the Salon, and by 1781 there were some thirty-five thousand. Craving culture,
these visitors were drawn from the increasingly diverse classes that made up the
greatly enlarged public for reading. They read everything from the scandalous
pamphlets that flourished in every field to the prescriptive books on ethics and
education produced in surprisingly large editions. Mme de Genlis, busy raising the
standards of royal princes, found time to write a three-volume, 1,225-page didactic
novel with the imposing title *Adèle et Theodore, ou Lettres sur l'education, conte-
nant tous les principes relatifs aux trois differents plans d'education des princes,
des jeunes personnes, et des hommes.* To her great satisfaction, the first edition was
sold out within eight days. Mme de Genlis was tireless in her instruction, and once,
in her effort to elevate the mind of the Duc de Chartres, she wrote two stories that,
it is said, she engaged Fragonard to illustrate. Another vastly successful publishing
project was Arnaud Berquin's sixty volumes, beginning to appear in 1774, *L'Ami
des enfants.* Berquin's saccharine moral tales—counterparts in words to Greuze's
more sentimental essays—became so notorious that his name entered the French
language: a *berquinade* is an insipid work or one of excessive sentimentality.

Art historians of a practical bent are more inclined to take social history into
account than Fragonard's personal family life when they enumerate the works
presumed to be of the 1770s and 1780s, in which the painter either described happy
family scenes, scenes of visits to the wet nurse (although one of the few fads early in
Louis XVI's career was to nurse one's own child), or scenes in lower-class schools.
The Schoolmistress (fig. 49), in the Wallace Collection, one of the few signed
works of the 1880s, is one of Fragonard's numerous drawings and paintings on
educational themes. The schoolmistress, ensconced in the basement of an aban-
doned building, perhaps a romanesque church, confronts a chubby charge, some-
times identified as Fragonard's son, Alexandre-Evariste. The scene is reminiscent
in composition of earlier Italian scenes, such as the Metropolitan Museum's *Italian
Family* (colorplate 2), with a high light picking out the features of the child and the
teacher, set on a kind of stage. This and other works in the genre were presumably
directed at a specific clientele—those avidly consuming the new literature on
education and family life. The attitude toward children, radically revised by Rous-
seau, is reflected in these scenes of Fragonard's in which children now occupy
center stage. Where in earlier scenes of peasant life, such as *The Italian Family,*

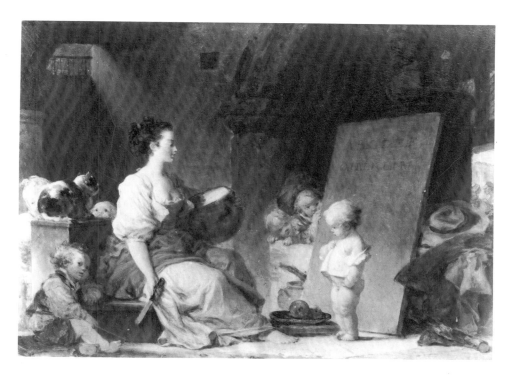

FIGURE 49. *The Schoolmistress.* The Wallace Collection, London.

children were among the clusters of adults, now they are represented either as the main protagonists of the action (in works with titles such as *The Little Preacher* or *Say Please* or *Education Is Everything*) or at least equal in interest to the adults.

While Fragonard clearly had his eye on the fashions of the late seventies and early eighties, he also worked for his own pleasure, as a number of park scenes and sketches of his children suggest. It seems that his drawings, even those he did for himself in odd moments, always found connoisseurs eager to buy them. He appeared to use his ailing daughter, Rosalie, as a model, either in directly observed drawings describing her features or in stylized works meant for the public. A watercolor in the Albertina (fig. 50) shows Rosalie (it is probably she—there is no precise documentation) as a Savoyarde in the old pose with the marmot. Her porcelain features are modeled with sensitivity to produce the full youthful roundness of her slightly cocked head and the grace of her slender figure. Fragonard's brush warms the flesh tones, dodges agilely round the folds of her simple costume, and renders her hands with absolute precision. The marmot is shown emerging from its box in the traditional way, but with the witty economy that Fragonard had learned to command totally. Far more direct is a counterproof sketch in San Francisco (fig. 51)—a sanguine drawing with touches of graphite and brown

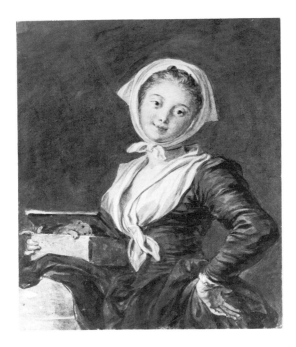

FIGURE 50. *Girl with a Marmot.*
Graphische Sammlung Albertina,
Vienna.

wash—probably done toward the end of Rosalie's short life (she died of consump-
tion at eighteen). Inspired by the pale, softened effects of his counterproof, Fra-
gonard created a new drawing by emphasizing the folds of the dress and adding a
cockatoo, rendered in a few swift lines and accented with a single stroke of his
brush. The whole drawing is wonderfully composed, the central axis of the figure
building from a group of triangles—the footstool, the center panel of her dress, the
bosom crossed by an arm, and, finally, the crest of her head with its ponytail that
may have suggested to Fragonard his addition of the crested parrot. He was, after
all, an inveterate rhymer. The accents and folds on the garments are calculated to
bring out the delicate features of his daughter's head. The folds peel away from the
central axis in the same roselike pattern of the early painting of *The Swing* in the
Wallace Collection. But the drawing is far more simple and bold in its handling and
presages work of later periods. One wonders, for instance, if Manet had seen this
drawing when he painted his own woman with a parrot or whether the stimulated
interest in Fragonard touched him after the showing of the Lacaze Collection in
1869.

In the absence of reliable information about Fragonard's activities during the
years after he made *The Fête at Saint-Cloud* and because so many of his works are
disputed, it is hard to imagine what kept him from producing any large-scale
works. The one thesis that suggests itself is that he ceded some of the commercial

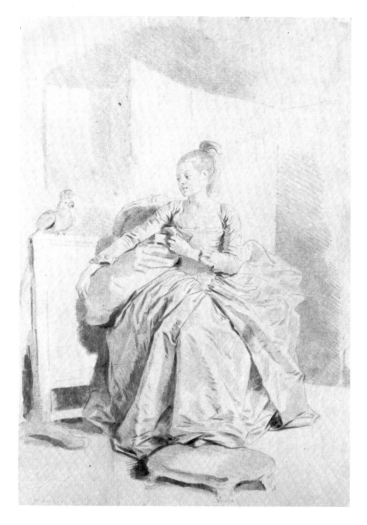

FIGURE 51. *Woman with Parrot.* The Fine Arts Museums of
San Francisco, Achenbach Foundation for Graphic Arts,
bequest of Mrs. Henry Potter Russell.

activities to his women and retreated into a romantic world of his own—a world
derived from literature. His numerous and, strangely enough, unpublished book
illustrations were probably undertaken during these years. His penchant for illus-
tration had early announced itself and was sustained throughout his life. Books
were not only an important source of inspiration; in some cases, they were his
primary sources.

CHAPTER 15

Orlando and Quixote

OLTAIRE to Casanova: "Who is your favorite poet?" Casanova: "Ariosto; but I cannot say I love him more than the others, for he is the *only* one I love. All pale before Ariosto. When I read what you said of him fifteen years ago, I predicted that you would retract it all when you had read him."

Voltaire: "I have read him, but when I was young, and knew your language only superficially. I was prejudiced by savants who adored Tasso, and I unfortunately published a criticism which I thought was mine, but which was only an echo. Now I love your Ariosto."[1]

In this scene in his memoirs in which Casanova chides his host, Voltaire felt compelled to prove his revised attitude by reciting from memory two long extracts from Ariosto's *Orlando Furioso,* cantos 24 and 25. Casanova, in turn, recited lengthy passages from the celebrated twenty-third canto in which Orlando goes mad with jealousy and grief. When he had finished, "tears were in all eyes." Such ready tearfulness was in fashion in Paris at the time, under the spell of "sensibility," but was not shared by everyone. From his own day to Fragonard's, Ariosto had found both detractors and defenders, and for much the same reasons. Montaigne compared him unfavorably to Virgil:

> We see the former [Virgil] on outspread wings in lofty and sustained flight always pursuing his point; the latter fluttering and hopping from tale to tale as from branch to branch, not trusting his wings except for a short hop, and alighting at every turn for fear his breadth and strength should fail: He tries his wings in short excursions—Virgil.[2]

Diderot agreed with Montaigne: "Ariosto shows me everything; he leaves me nothing to do; he exhausts me, makes me impatient."[3] Diderot's friend the Scottish philosopher David Hume, however, whose influence was deeply felt in France, found something to say in defense of the Italian poet in 1757:

Ariosto pleases; but not by his monstrous and improbable fictions, by his bizarre mixture of serious and comic styles, by the want of coherence in his stories, or by the continual interruptions of his narration. He charms by the force and clearness of his inventions, and by his natural picture of the passions, especially those of the gay and amorous kind: And however his faults may diminish our satisfaction, they are not able entirely to destroy it.[4]

Ariosto's "natural picture of the passions" had stirred Fragonard in his youth. The poet's mixture of shrewd observation, passionate flights of fancy, and roiling emotions suited the young painter. When, however, he undertook his extensive group of illustrations for *Orlando Furioso*, most probably in the 1780s, he was listening with a different ear to the Italian bard. He had renewed his memories and probably also his relationship to the language during the second trip to Italy. Ariosto was eminently quotable, and many Italians could sing out the rhymed stanzas, relishing Ariosto's heightened language and inspired metaphors. For Fragonard, now in his late middle age, it was the tone, the atmosphere that Ariosto could make into substance that held him. His instinct at this juncture of his life was once again to free himself by following his bent. The approximately 150 drawings for *Orlando Furioso* were a means to return to himself, a means to what Adrian Stokes has called the incantatory process, in which the artist's feelings, so long nurtured, would find a satisfying release in having made or created something. Throughout the known drawings Fragonard maintains a furor that speaks not only of his total immersion in the project, but of a curious wholeness, a sustained plenum of feeling available only to a mature, single-minded artist. There is hardly a scene in the entire group that does not admirably condense and form a visual accompaniment to the high moments in Ariosto. Fragonard's singular visual intelligence never flags as he approaches, canto by canto, the most eloquent passages in Ariosto.

As is most always the case in Fragonard's story, the occasion for these drawings is unknown. Usually when an artist in Fragonard's time undertook to illustrate a literary work, there had been a request by a publisher or at least a show of interest. There is, however, no record of any publisher asking Fragonard to illustrate Ariosto. Moreover, as everyone who has written on the drawings points out, they are far too free to have been intended for engraving. When there *was* a commission, as in the case of some rather uninspired drawings for Marmontel's *Contes* and probably for the three sets of drawings for Jean de La Fontaine's *Contes,* Fragonard worked in the meticulous illustrator's manner to properly prepare his drawings for the engraver. His illustrations for La Fontaine—including *The Prayer of Saint-Julien* (fig. 52) and *The Amorous Courtesan* (fig. 53)—are beautifully rendered, it is true, but relatively conventional (the best of his contemporaries, such as the illustrator Hubert-François Gravelot, were not that much different in their approach). The La Fontaine drawings were undoubtedly undertaken as a business proposition. The nature of the Ariosto drawings, however,

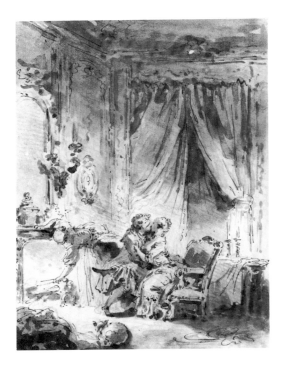

FIGURE 52. *The Prayer of Saint-Julien.*
Musée du Petit Palais, Paris.

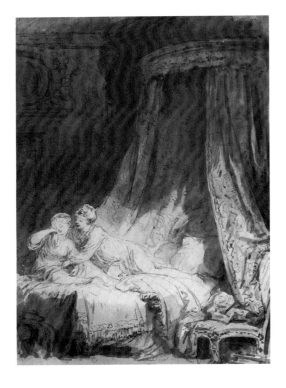

FIGURE 53. *The Amorous Courtesan.*
Musée du Petit Palais, Paris.

suggests that there was not a client in sight, or if there had been originally, Fragonard's ambitions had discouraged him. The free and imprecise nature of the drawings—black chalk and wash—and their astonishing number suggest that Fragonard was caught up with this absorbing project for its own sake. He embarked on the Ariosto drawings with the stubborn willfulness of another of his heroes, Don Quixote, whom he also illustrated, perhaps around the same time or shortly before. In the light and shade of Ariosto, he found a suitable retreat from the demands of his worldly life.

This chapter in his life is one of the most tantalizing, and the cross threads are numerous. The group of Ariosto drawings constitutes one of his masterworks, and if anything at all can be assumed about who this artist was, the raw material is found on the pages of *Orlando Furioso*. There are hints, also, in his drawings for Cervantes's *Don Quixote*. There are thought to be some thirty *Quixote* drawings, most in black chalk and wash, of which nineteen were in the collection of the versatile Baron Vivant Denon. Denon, whose talents were manifold—he was an illustrator himself, an engraver, an archaeologist, an art historian, an administrator, and also a collector—was celebrated in his own time as an eccentric. His curiosity was exceptional, and he went far beyond the bounds of the tasteful Parisians of his time, seeking out works from South America, China, and even the as-yet-unappreciated Italian primitives. It is, then, of some significance that he, whom Saint-Non introduced to Fragonard, should be the owner of so many of the *Quixote* drawings. If he solicited them directly from the artist, we may be sure that the more subtle interpretations of Cervantes's masterpiece were discussed among the three men. Fragonard's interpretation is relatively direct, and he chose recognizable moments in the story to illustrate, but they are moments of special significance. For example, he chose the scene in which the priest supervises the destruction of Don Quixote's books (fig. 54), depicting the relish with which the housekeeper and niece fling them onto the pyre. That scene, early in book one, contains the first of Cervantes's innumerable critical references to Ariosto, who, although he wrote in the genre Cervantes set out to mock, nevertheless commanded his respect: "If I happen to meet with him in this bad company, and speaking in any other language but his own, I will show him no manner of favor; but, if he talks in his own native tongue, I will then treat him with all the respect imaginable."[5] In this passage and others throughout the book, Cervantes laments the shortcomings of the translators who can never "preserve the native beauties and genius that shine in the original." Not only does Cervantes use figures from Ariosto throughout his novel, but in the second volume toward the end (and hundreds of pages after the book-burning scene), Cervantes returns to the problem of translation and again associates it with Ariosto. In his visit to the printing plant, there is the famous analogy: "Sir, I think this kind of Version from one Language to another, except it be from Greek or Latin, is like viewing a Piece of *Flemish* Tapestry on the wrong Side, where, though the Figures are distinguishable, yet

FIGURE 54. *Priest Ordering
Destruction of Don Quixote's Books.*
British Museum, London.

there are so many Ends and Threads, that the Beauty and Exactness of the Work is
obscur'd, and not so advantageously discern'd as on the right Side of the Hang-
ings."[6] It is in this passage that Cervantes has Don Quixote say: "I am a little
conversant in the Italian and value my self singing some Stanzas of Ariosto."

This connection of Cervantes with Ariosto is just the kind of line that the
Baron Vivant Denon might have seen and discussed with Fragonard and Saint-
Non. In all written commentary on Fragonard's illustrations, there is hardly one in
which the authors have not emphasized the intelligence of Fragonard's approach.
There is every reason to believe that, far from being the unlettered sybarite that so
many careless accounts have described, Fragonard was acutely attuned to the
literature that moved him and studied it in depth. His affinities with both Cer-
vantes, who is at once ironical and serious and who shifts so effortlessly from
mood to mood, and Ariosto, who, like Cervantes, lightly mocks his heroes and yet
at times treats them with grave dignity, were genuine. Furthermore, his interest in
the Quixote story had a long history. *Don Quixote* had certain features that
attracted the interest of the seventeenth century. The banishing of books, for
instance, was a familiar problem. Cervantes's remarks about censorship (his allu-
sions to the Inquisitor) were well understood by Fragonard and his contempo-

raries. Above all, sophisticated Parisian readers could appreciate his quips about virtue, his noncensorious descriptions of the easy manners of young peasants, and his jibes at hypocrisy. They also appreciated his broad-minded attitude toward travel and the observation of all cultures for knowledge. Fragonard's associations in Saint-Non's circles equipped him for the exploration of the great Spanish writer's satire.

He had painted the portrait of a man in Spanish costume—a grave-faced older man—at the Art Institute of Chicago, which is traditionally known as *Don Quixote* (fig. 55), and there is the portrait of Saint-Non in Spanish costume (color-plate 3), in the Museo de Arte Cataluña, Barcelona, considered one of the group of *portraits de fantaisie* painted around 1769. In the Barcelona painting Fragonard poses the abbé in his Spanish cavalier's costume leaning on a huge, almost comically large sword, with his horse, head lowered, behind him. Aside from the audacious novelty in posing the horse in so unheroic a pose and cropping him at the head, there is the slightly mocking amusement in the abbé's face to suggest that he is impersonating the famous Don. Fragonard was certainly interested in the various interpretations of the book, for in the drawing in the Louvre known as *Don Quixote Reading a Romance of Chivalry to One of His Neighbors* (fig. 56), the atmosphere of a library is almost reverent. The reader flings out his hand in emphasis and his listener is raptly attentive. There is an exceptional atmosphere of pious respect for the book in the drawing.

Fragonard's admiration for Ariosto was boundless. The poet's ability to mix both keen, naturalistic observation and extended but infinitely pictorial similes of states of feeling had a peculiar appeal for Fragonard and kindled his imagination. Ariosto's descriptions could be remarkably precise. In canto 19 of *Orlando Furioso*, for instance, there is a deftly sketched scene in which the young Medoro finds himself surrounded by a hundred horsemen and "turns like a top" seeking to defend himself. He slips out and shelters behind oak, beech, and ash trees. Here the action—turning like a top—moves into the woods, is countered, and becomes quiet by means of the exact and prosaic naming of the trees. In other passages Ariosto offers images of dark paths through cool forests, natural arbors or nestlike enclosures, and sheltering caves—all images endemic to Fragonard's way of imagining, images to which he returned again and again. He had demonstrably many affinities with the earlier poet. Ariosto's sense of light and color was akin to his own, as was his sensuous interest in the female body, which, like Fragonard, he rarely described in small details, but rather in bold strokes that captured bodily movements and quick emotional sorties.

The Ariosto drawings were for Fragonard another means to recapitulate his immense experience of Italy. It is obvious that he not only conscientiously conveys the letter of the poem, as Jean Seznec has written, but also the spirit: "From the outset we find ourselves immersed in that unique atmosphere of *Orlando Furioso*,

FIGURE 55. *Don Quixote*. The Art Institute of Chicago, gift of Mr. and Mrs. Leigh B. Block in honor of John Maxon, 1977.123. © 1987 The Art Institute of Chicago. All rights reserved.

FIGURE 56. *Don Quixote Reading a Romance of Chivalry to One of His Neighbors.*
Musée du Louvre, Paris.

the constant alternation from the real to the dreamlike, from the concrete and picturesque to the chimerical and extravagant."[7] It was not by chance that Fragonard so effortlessly seized the character of the poem. His connoisseurship so much admired by David had brought him through many art-historical climates, including that of Ariosto's own period. He was equipped not only through his study of Ariosto's contemporary Correggio but also through his own culture—that is, the culture of his universe, which was that of painting.

By the time he undertook the Ariosto drawings, he had created an oeuvre in which he wore his learning lightly and was criticized for it. He had avoided grand themes and religious issues in his paintings. There is a light irony gracing a good deal of his work, comparable to Ariosto's. In Ariosto, Fragonard could find an artistic *semblable* that emboldened his own imagination. What drew Fragonard to Ariosto was what Benedetto Croce called his "tone of expression" and his "disengaged, light, infinitely various style." Croce saw Ariosto's verse as steeped in an "enveloping" irony, but with certain knowing sorties into direct narration or sheer lyricism. In a certain sense, Croce wrote, "the whole world becomes for Ariosto 'nature,' a lined and colored surface, shining but insubstantial."[8] Certainly this shiningness—the total extension of the nature metaphor—is what characterizes Fragonard's works. It radiates from the Ariosto drawings. Many of Croce's comments on Ariosto could be transposed to serve as comments on Fragonard:

> How could there be, in *Orlando Furioso,* an epic quality when its author not only lacked the ethical sentiments proper to epic poetry but proceeded to dissolve in harmony and irony even such scraps of the epic traditions as he might, somewhat dubiously, seem to have inherited.[9]

The characters in *Orlando Furioso,* Croce said, are "all contrasting notes of the poet's soul . . . sparks of one central flame." Above all, Croce's recommendations to the reader of Ariosto can be translated into advice for viewers of Fragonard. The reader, he said, must follow the details of the stories and various descriptions, but more important, he must "look beyond them to a content which is always the same, yet clothes itself in ever novel shapes, and attracts us by the simultaneity of this sameness and this inexhaustible variety."[10]

If one leafs through the drawings without pause, what is revealed is Fragonard's decision to establish a palpable atmosphere that is consonant throughout. To this end he enlists the light washes that bind his pages and enable him to establish a rhythm that corresponds to the rhythms in Ariosto—not only to the rhythms within the entire poem, which are conventional enough, but to the sequential rhythms within each tale as well. What distinguishes both Ariosto and Fragonard in these images is their ability to play upon convention, to use many of the little tricks inherited from a lengthy past, and to emerge with startling originality. If Fragonard's drawings were hung amid hundreds of drawings of his period, they would be seen as remarkably distinct. Only Goya could rival the dramatic

simplicity found here. What Fragonard set out to capture was the unceasing movement and light in Ariosto, the active movement of all nature—trees, sky, water, and living creatures alike. The animation shifts from the quietness of pale washes that meander slowly, almost always in a spiral pattern to the top of the page, to dashing diagonals that clash in electric effusions of light. Always the brush carries its signature from page to page.

It seems that Fragonard began at the beginning of *Orlando Furioso* and that he eventually abandoned the project, for only about a third of the book is illustrated. Fragonard's behavior is puzzling, for while he carefully selected coherent groupings with the early cantos, he skipped forward and took up certain of the later ones, pointing to either his great eagerness and desire to establish an overall design or to the possible loss of some of the drawings. Further, it is puzzling that so many of the drawings were never worked further or neatened up for publication. On the contrary, Fragonard's intention seems to have been to create a visual poem for its own sake: to render with all the power of his storyteller's art something equivalent to the spellbinding beauty of an opera. In fact, many of the sequences in his set immediately suggest Fragonard's musical sensibility and, above all, his response to Gluck. No language captures so well the overall essence of his *Orlando Furioso* better than the music of *Orfeo*. As Gluck simplified his dramatic situation, using only two or three motifs and at times only solo instruments to build the intensity of emotion, Fragonard uses only the sketchiest of formats, picking out the mounting feeling with a few light touches of black chalk that often move out into the washed atmosphere in independent flourishes, much as Gluck's oboe quavers or slides down a scale. Similarly, when Gluck wants to invoke the Elysian fields, his music murmurs, expands, suggests breezes, but is never overtly descriptive. Fragonard, who in this series uses his commanding brush to pick out leaves, to intone the rush of waters, to make, sometimes in a single stroke, the hardness of a boulder, avoids explicitness in order to incite a general feeling or tone.

There are many instances here where Fragonard's dramatic intelligence is obvious and in which, incidentally, he shows how closely he studied and how much he was impressed by Ariosto's psychological observations. Take the drawing for canto 23, for instance (fig. 57). Fragonard unexpectedly selects the moments before Orlando's access of madness, in which he discovers the names of Medoro and his beloved Angelica engraved on the rock. It is this evidence of Angelica's perfidy that brings on the mad scene, but Fragonard is more interested in Ariosto's keen observation of a moment of incredulity, an arresting moment in which the victim responds in a long, frozen pause. Ariosto described it:

Tre volt, e quatro, e sei lesse lo scritto
Quello infelice, e pur cercando in vano
Che non vi fosse quel che v'era scritto
E sempre lo vedea piu chiaro e piano.

FIGURE 57. *Orlando Discovers the Names of Angelica and Medoro Carved in the Rock.*
Collection of Mr. and Mrs. Eugene Victor Thaw, New York.

(Roughly: Three times, four, even six he read what was written / That unhappy man, seeking in vain / To find that it wasn't what seemed to be written / And always he saw it more clearly.) For Fragonard, the psychological moment of Orlando's transfixed response to the awful discovery is more tempting than the mad scene. Here he uses his vocabulary of swirling and zigzagging brush strokes to dramatize the moment. The horse is rendered in nearly abstract curving sequences, and the foliage at the mouth of the cave is equally abstract. Light moves from every side into the vortex, in which Orlando stands immobile, emphasizing his spiritual turbulence.

In other drawings, Fragonard reduces his elements and brings his brush to bear on one or two figures in a nearly abstract landscape. Jean Seznec has rightly singled out the sequence of six drawings recounting the story of Olympia as an example of Fragonard's method of seizing upon the most telling detail to carry a narrative:

> There is first the awakening of the young woman who, still drowsy, stretched out her arm to touch the companion she believes to be by her side. But the faithless fellow has disappeared: terrified, she runs to the shore, climbs upon a rock hanging over the sea to peer out toward the horizon. A sail is disappearing in the distance. She swoons. Then, regaining her senses, she returns to the pavilion, throws herself upon her bed with reproaches and tears. Finally, she goes back to the shore and remains motionless, transfixed by despair. A single character, a whole succession of attitudes.[11]

The drawings in this sequence are, as Seznec has said, exemplary indications of Fragonard's way of using a series of stanzas to extract the synoptic single motif. But they also underscore his originality as an illustrator. As Seznac says, there is nothing here that he did not find in Ariosto.[12] Yet there is much here that cannot be found in any contemporary illustrators, for in this sequence Fragonard draws on all his previous experience. He simplifies and abstracts, and brings up close, in a manner much more in keeping with later illustrators such as Eugène Delacroix. As Olympia rushes to the seashore (fig. 58), she moves in a sparse landscape in which a rock is given in a single broad wash, a shore in a few wispy, low reeds. Her haste is expressed in the coursing chalk lines of her garment. In *Olympia Swoons* (private collection), she swoons on a rock brought close to the picture plane (oddly similar to many of Goya's low promontories in the late drawings) and is cradled in the rock's recess in a most unusual gesture of total collapse, handled with a minimum of anatomical detail. Rock and unconscious figure become one in a cruelly blank universe that few eighteenth-century artists would have dared to leave so suggestive, so—it must be said—impressionistic.

The use of watercolor washes to augment the sense of motion given by summary lines is nowhere so wonderfully demonstrated as in Fragonard's numerous and unending inventions to depict horses. It is strangely comparable to the way Delacroix worked once he had been to North Africa. Fragonard almost never

FIGURE 58. *Seeking Bireno, Olympia Runs to Shore.* Private collection.

FIGURE 59. *Angelica Removes Orlando's Helmet during the Duel.* Private collection.

FIGURE 60. *With Logistilla's Guidance, Ruggiero Masters the Hippogriff.* Collection of Mr. and Mrs. Eugene Victor Thaw, New York.

FIGURE 61. *Atalante, Mounted on the Hippogriff, Swoops Down upon Bradamante.* Art Gallery of New South Wales, Sydney.

FIGURE 62. *After the Shipwreck, Isabella Is Rowed to Shore.* Collection of Mr. and Mrs. Eugene Victor Thaw, New York.

FIGURE 63. *Ferrau and Orlando Part to Look for Angelica.* Collection of Mr. and Mrs. Eugene Victor Thaw, New York.

FIGURE 64. *Bradamante Weeps upon Reading the Letter of Ruggiero.* Collection of Mr. and Mrs. Eugene Victor Thaw, New York.

draws a horse in this story in the traditional attitudes. His close observation of the way a horse turns, lowers its head, finds its balance in the scene where Angelica removes Orlando's helmet (fig. 59) can only be compared to some of Delacroix's watercolors from his Moroccan notebook. Even in his depictions of the mythical horse, the hippogriff (figs. 60 and 61), Fragonard's imagery is closer to a nineteenth-century vision (that of Odilon Redon, for instance) than to anything of his own time.

In some of the drawings, as, for instance, *After the Shipwreck, Isabella Is Rowed to Shore* (fig. 62), the use of a nervous, repeated line—the line Honoré Daumier is said to have observed and appropriated—moving out into the surround in humming intensity is Fragonard's way of generalizing and getting past the depiction of picayune detail that so often bogged down illustrators. In others, such as the extremely light-handed composition showing Ferrau and Orlando setting out in different directions (fig. 63), he seems intent on suggesting the constant analogies in the movements of nature. In still others, such as the drawing thought by Seznec to show either Bradamante reading a letter and weeping or Astolfo reading the magic book (fig. 64), Fragonard captures in a single gesture the inward feeling.[13] While the composition places Bradamante (if it is she) in a contemporary setting, it has little of the specific drawing-room atmosphere found in many eighteenth-century drawings and even in other works of Fragonard himself.

It does not do to point out only the way Fragonard availed himself of his training (the many familiar composing devices learned for so many student years) or to see prototypes, which are certainly there, in certain of his illustrations. It is not even useful to speak only of the way Fragonard experienced poetic space (in motion; spiraling up the page; intimate and shallow). In the Ariosto drawings, he comes close to fulfilling his deepest purposes, which were always to incite the senses by means of movement and light. In some ways the only appropriate critical response would be to invoke that criterion that was put forward unabashedly in the seventeenth century: these drawings have a *je ne sais quoi* that lifts them from the commonality of their period. The broken lines, the pure washes without the usual binding accent of the pencil, the eloquent silences of the white of the paper, the free interpretation of the nature of form, particularly when it is flattened by full light—these are the means that Fragonard had developed for so many years, the means that found their apogee in the *Orlando Furioso* and that are often so uncannily prophetic of the next century's approach.

CHAPTER 16

Before the Deluge

WHEN Fragonard was a pensioner at the Academy in Rome, Natoire remarked on his astonishing ability to shift from one course to another. Throughout his working life, Fragonard moved among the idioms and motifs available, at times adapting to fashion but always managing to maintain his own accent. He might have remembered Poussin's boast that he had left nothing untried, or perhaps he had moments of the competitive spirit that urged him to masquerade in another's raiment. At any rate, it was during the 1780s that he produced a few paintings and drawings that are sometimes referred to as being "influenced" by the "neoclassic" style, a simplification that is just as useless as the other simplification that holds Fragonard the "Rococo" painter par excellence. When the so-called neoclassical style made its first appearance at the Salon, it was quite simply called painting *à la Greque.* A contemporary critique of Vien's painting in 1763, as Anita Brookner has pointed out, shows the rather uncomplicated response:

> The works of M. Vien are distinguished in the Salon by a rigorous imitation of the antique . . . great simplicity in the positions of the figures which are almost upright and without movement, very few draperies, and those very thin and, as it were, clinging to the body; a severe sobriety in the accessories, all these features being well known attributes of the antique.[1]

There was more response to the sentimental content of the Vien painting than to pictorial expression, Brookner says, and adds: "Prayers, oaths, and sacrifices to love then followed with monotonous frequency."[2] Among them were Fragonard's. But Fragonard's invocations and oaths to love came some twenty years later in such works as *The Fountain of Love* (fig. 65). Although their finished appearance—the smooth, "enameled" surfaces referred to by contemporary critics as the neoclassic finish—suggests that he had his eye on the marketplace, the quality of feeling is, as it almost always was in his work, markedly his own.

216

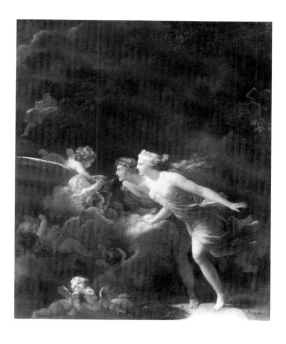

FIGURE 65. *The Fountain of Love.*
The Wallace Collection, London.

How very much such a seemingly banal observation is true can be confirmed by a stroll through the eighteenth-century galleries at the Louvre. The works reflecting interest in the antique that absorbed so many after the mid-century are most often as "cold" and "insipid"—those two adjectives are so often encountered in eighteenth-century criticism of neoclassic tendencies—as their critics claimed. In their midst there is a very small oil sketch by Fragonard, *The Invocation to Love* (colorplate 13), which has the magnetic presence we sometimes encounter when we obliquely glimpse a beautiful or spiritual visage in an otherwise undifferentiated crowd. Fragonard demonstrates once again his chameleonlike versatility. His very technique is altered—Wildenstein called it "very peculiar"[3]—to accommodate an expressive emotional end. On this small scale Fragonard managed to evince the acute turmoil, the wave of despair, that had roused his feelings in the more passionate passages of Ariosto. Here a young woman imploring a shadowy god is portrayed in a moment so intense that Fragonard all but obliterates her features in the brilliant, although lunar light. It is true that she is seen in profile, as the antique reliefs dictated, and that her garment clings as though wetted to her body, but there the conventional association with the antique (if you exempt the iconography) ceases. As in some of his most complete expressions, Fragonard has offered from his experience, from his imagination, an authentic emotion, a truth that is his own. *The Invocation to Love* is expressive in its whole conception. Out of the scumbled depths of this secreted place he draws the full measure of the girl's emotional anguish and instinctively, as he had in *Corésus Sacrifices Himself to*

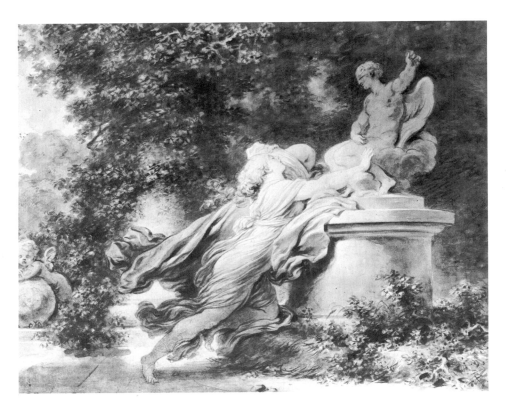

FIGURE 66. *The Invocation to Love.* The Cleveland Museum of Art, Grace Rainey Rogers Fund.

Save Callirrhoé, (fig. 15), casts it in a light that obscures specific features. In a drawing of *The Invocation to Love* (fig. 66), the effects of this heightened light are emphasized by Fragonard's strange system of white flecks, gouache highlights indited with a sharp turn of the brush, dispersing the lunar glow emanating from the woman's garments and flesh. Fragonard's old reflexes—to find secret enclosures in landscapes and to invest them with poetic presences that nature, through her capricious light, all but banishes—are fully active in these works, despite the shift in subject matter. The passionate, almost trancelike gesture of the young lover is no longer the mincing gesture of the coquette, but it is still the thrusting movement that one finds throughout his drawings of women, from the disporting shopgirls in their dormitories to the heroines in Ariosto. Fragonard was no stranger to Greek garments. Memories of his copies of the Farnese *Flora* with its light step and clinging chiton recur throughout his work, most especially in the Ariosto drawings. (The *Flora* is a Roman copy of a Greek Aphrodite, according to some, and a portrait of a courtesan according to others—an irony that would not have been wasted on Fragonard.)

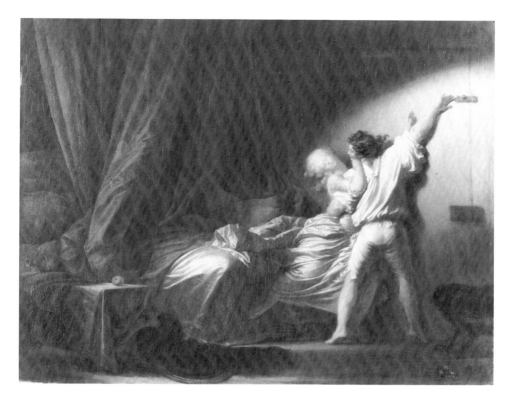

FIGURE 67. *The Bolt.* Musée du Louvre, Paris.

It is not the antique reference or even the allegorical intent in this small and commanding painting that gives *The Invocation to Love* its allure, but rather the passion of the painter seeking to express a condition of emotion with which he was intimate. That is certainly less true of another small painting, *The Bolt* (fig. 67), thought to have been commissioned also in the 1780s. This much-discussed and controversial painting, far more anecdotal than *The Invocation to Love,* depicts a seduction scene that, in its drawing, is not so very different from Fragonard's earlier illustrations of bedroom frolics. What calls attention to this painting is the technique—the "licked" technique of the Dutch little masters, perfectly learned and used, once again, to dramatize the subject matter. Even in so familiar a motif and so polished a style, Fragonard enters his painting with strong feeling. The group of seducer and girl, rhymed and complementary in its forms, is as active as any of his earlier works on the same theme and an invention of singular grace despite the violent undercurrent.

What brought Fragonard to experiment again with the technique of the Dutch little masters or to enter the realm of allegory remains obscure. In fact,

everything in his artistic life after around 1880 is maddeningly difficult to construe due to the paucity of facts—if we consider the significant facts in an artist's life to be his works. There is no body of work that is surely dated about which to discuss such common issues as an evolution in style or a shifting of interest. On the contrary, whatever evidence there is points to Fragonard's usual uneven pace and his eclectic tendencies. Judging by sales, his works still found influential buyers and, even more, buyers who saw a good opportunity to make a profit. Several of the dated works were bought and resold at auction for mounting profits. He seemed, also, to reap royalties from the engravings after his popular paintings, both before and after the Revolution. His atelier, dominated by his two women, his wife and his sister-in-law, apparently kept bread on the table by producing and selling miniatures, and he himself probably aided the industry. But how he responded to the clashing tides in the animated Paris of just before the Revolution can only be a matter for speculation.

How, for instance, did he react to the unusually exacerbated wave of discussions brought on by David's 1785 coup in the Salon with *The Oath of the Horatii?* As Thomas Crow has definitively demonstrated, this notable event in cultural history brought a great outpouring of approbation.[4] It was a culmination of years of growing critical boldness and an answer to a long-standing demand for reformation in the arts. It was also a blow to the Academy, which, when he later took power as a revolutionary arts administrator, David promptly abolished. If Fragonard was, as he seems to have been, a relatively sophisticated watcher and a long-standing resister to the power of the Academy, it would be likely that he welcomed David's triumphal entry into the art world as an ideologue. He seems to have been a friendly witness, a good colleague interested in other artists, and a close observer. Besides, there is every reason to believe that Fragonard was friendly with David, to whom he sent his son as a student and who later protected him. Fragonard probably shared the open-minded nonchalance of his teacher Boucher, who had sent David off to study with Vien, telling him he could always drop into his own studio when he needed to "warm up" his style. The many differing approaches to painting after the mid-century would have prepared Fragonard for even the extravagant novelty of David's bombshell. But would it have affected his own course? Again, no works exist that can give a reliable gauge of his artistic life in the years immediately before or after the Revolution.

As for his sympathies during those years, there are faint traces here and there of a generally progressive attitude, but there is nothing definitive. There are some facts about his movements, but little to suggest how to interpret them. Once again, the speculation depends on the speculator's bias. Wildenstein thought he was not unsympathetic at least to the opening phases of the Revolution. His friend Saint-Non was one of the first to offer financial support to the revolutionary government, and Mme Fragonard and Marguerite Gérard were among the group of artists' wives who in 1789 presented their jewels and other precious items to the

National Assembly to help pay off the public debt. The Goncourts wrote that "Fragonard's household was inspired with the enthusiasm which ran like wildfire through the studios and inflamed the mind of the artistic community."[5] For artists who had long been used to hearing demands for all kinds of reform and whose conversations in the cafés were often quite openly revolutionary, the events were exhilarating. Fragonard was probably no exception.

Then, there are little shades of meaning in certain of his activities that might be construed as showing his republican sympathies: his visit with Benjamin Franklin, during which he demonstrated the etching technique to the old American revolutionary, the same year that Franklin met with Mirabeau; Mirabeau's connection, through his sister, to the Grassois society, and Mirabeau's little profile of Fragonard; the important revolutionary activities of Maximin Isnard, who first proposed the Committee of Public Safety, a distant relation of the Fragonard family and, some report, a friend of Fragonard himself; and finally, his relations with the Freemasons, who in certain lodges were fairly radical in their politics.

In a less direct way, there was Fragonard's general interest in the more critical members of the artistic elite of his time. He approved of Beaumarchais's critique, as evidenced, according to Wildenstein, by at least one drawing after scenes in *Le Mariage de Figaro*.[6] That first season during which Beaumarchais—Fragonard's exact contemporary—presented *Figaro*, his daring sequel to *Le Barbier de Séville*, publicly in Paris in 1784, there were many who saw it as a fateful and threatening phenomenon. The Italian Carlo Goldoni, who had spent his last years under the protection of the court, was quick to see the subversive spirit in the play and noted cautiously in his *Mémoires* that commentators withheld their criticism because they saw that the public was swept up into "a kind of fanaticism" that might become contagious.[7] The Baronne d'Oberkirch forthrightly commended the comedy, calling it "sparkling" and "a real firework" in which "the rules of art are contravened from one end to the other."[8] But still, she said, in the unusually long play there was not a moment of boredom. Then, she makes a prophecy; she says that the *grands seigneurs* were wrong to applaud the play which was a slap to their own cheeks.

> They laughed at their own expense, and still worse, they made others laugh.
> They will repent of it later. The witticisms which they applauded put the
> horns on themselves and they don't see it. Beaumarchais presented them with
> their own caricature and they answer: that's it, just the way we are. A strange
> blindness that![9]

The best explanation for why Fragonard packed up his family in January 1790 and retreated to his cousin Alexandre Maubert's house in Grasse is not that he had anything to fear from the new authorities, as some have claimed, but rather that the death of his daughter, Rosalie, a little more than a year before had cast him into a prolonged depression. In addition, the economics of the art world were

undoubtedly volatile. Already for some years the Fragonards had been prudently building up other resources, such as rent-providing properties and annuities. In any case, Maubert was not only a relative but also a patron, who had been acquiring works by Fragonard for some years. He was a prominent citizen of Grasse, a well-known bibliophile, a music connoisseur, and a member of the Freemasons in high standing since 1782. He was probably an early sympathizer with the Revolution as well and, judging by his survival through the Terror, must have been an outspoken republican. Fragonard installed the ill-fated paintings *The Progress of Love* in Maubert's house and added the painting, probably unfinished, known as *Forsaken,* or *Disillusionment,* as well as a group of overdoors. In the stairwell of the house there are wall paintings with republican symbols that were considered by early biographers to be the work of Fragonard. However, they were almost certainly not by Fragonard nor by his ten-year-old son. As M. Vindry, director of the Musée Fragonard in Grasse, has said, the portraits of l'Abbé Grégoire and Robespierre in the stairwell could only have been painted between 1792 and 1794, when the Fragonard family was long since back in Paris.[10] Alexandre-Evariste, Fragonard's son, was enrolled in David's classes soon after the Fragonards returned to the capital in March 1791, lending more weight to the argument that Fragonard was a friend of David and a republican sympathizer. David acted swiftly to help the older painter by proposing to the National Convention on December 18, 1793, that Fragonard become one of the directors of the newly established national museum. In his speech he said that warmth and originality were Fragonard's chief characteristics, that he was both a great painter and a connoisseur, and that Fragonard could devote his declining years to the preservation of the masterpieces to which he himself had added.[11] Fragonard's assiduous work during the next few years has been detailed by researchers who confirm that David's confidence was not misplaced. Fragonard's great erudition was put in the service of creating the great museum, now the Louvre, and his practiced eye used to detect authenticity in the many confiscated works of émigrés. His services were required constantly until the fall of David's ministry, when they were not appreciated by the new, conservative *directoire.*

There is little evidence to support the legends of Fragonard's extreme poverty and neglect during his last years, although it is certainly true that his work was eclipsed by the new Napoleonic vogues. He and his wife probably lived as modest *rentiers* until his death in 1806. The year before his death, all the artists had been commanded to evacuate their quarters in the Louvre to make way for the emperor's grandiose plans. The Fragonards then moved into an apartment in the Palais-Royal district, apparently in possession of Marguerite Gérard, who was by then well established as a painter in the new court. The relations among this former *ménage à trois* remain obscure, and the questions are many. Was Marguerite Gérard an ungrateful protégé? Was she still flirting with the aging master? Were her

letters to Fragonard of around 1800 in Aesopian language? Was there friction between the rising and ambitious Alexandre-Evariste and his aunt? Did the younger Fragonard treat his father disdainfully? Did he really burn his father's collection of engravings? Whatever Fragonard's situation in his private life, his public life was seemingly reduced to almost nothing during the last few years, and there are no firmly dated works to speak of his state of mind. While some think he was bewildered by the turn of events, bemused would be a more likely description for a man who had so often demonstrated his psychological agility.

CHAPTER 17

Conclusion

I WILL CALL this chapter "conclusion" although, as has been demonstrated, there is a very little in Fragonard's story that can be called conclusive. This diminutive, often impetuous artist, with his open face and his reputation for generosity, left only his works from which we can attempt to draw a rounded portrait, and even many of them are in dispute since he rarely signed and dated them. There are a few self-portraits, such as the one in Grasse (fig. 68), in which Fragonard, who in his *portraits de fantaisie* paid his respects to the lyrical temperaments of his subjects, plays down his own. There is no self-dramatization; indeed, there is a distinct tendency to present himself as unassumingly as possible. In 1789, the year of the outbreak of the Revolution, he was probably visiting his good friend the architect Bergeret *fils* when he dashed off the little round sketch (fig. 69) showing himself in a casual pose, head on hand, depicted with almost caricature-like simplicity in short, masterfully emphatic strokes of the black chalk to describe his simple raiment; with two dots for eyes and single strokes for nose and mouth. This drawing probably belongs to a group of many lost works done as after-dinner entertainments in which Fragonard displayed his skills and humor to amuse admiring guests. The grandson of Bergeret *fils* recalled that the old painter used to come almost every evening and that after dinner "there would be drawing and music."[1] Other drawings, such as a red chalk drawing of a studio with Fragonard in good humored conversation, probably with his wife (fig. 70), are keyed to a modest self-image—modest, but firm in its composure and not self-deprecating. Yet Fragonard's few crucial actions in his life, such as his quarrel with Guimard and rift with Mme Du Barry, his struggle with Bergeret and the subsequent lawsuit, and, above all, his renunciation of the crowning acclamation of the Academy, suggest that he was well endowed with pride and shared with some of his more assertive contemporaries a belief that an artist of genius (the pre-Revolutionary artists believed in genius in the simple sense of *ingenium*) could never be a lackey.

FIGURE 68. *Self-Portrait,*
c. 1800. Musée Fragonard, Grasse.

Although Fragonard almost managed to have it both ways—he was after all still a painter to the king and had lodgings in the Louvre—he took care never to be put upon by authority. There can be no doubt, judging by reports of his behavior at the Academy in Rome, that he had held himself in a position of independence worthy of a painter. His instinctive resistance to authority led him to stand up to the authority of the Academy. He was an early resister. Respect for the Academy as an institution of authority began sliding rapidly only some fifteen years later, despite Pierre Rosenberg's assertion that the Academy was respected throughout the century. Rosenberg cites a letter from Louis Lagrenée *l'aîné* to the Comte d'Angiviller, the director of public buildings, in 1781:

> No one can order talent. . . . One is born a painter or a poet; vainly some will formulate regulations to make painting progress: they will ask to get up at a certain hour, to work on such or such painting at a precise time; even if these regulations came from the Eternal Father . . . they would amount to nothing. . . . Painting, as well as poetry, is like a great fire that burns within us; no one else can start it.[2]

This letter, far from showing that the Academy was meant to support rather than control artists, as Rosenberg proposes, seems to be more a resisting response to d'Angiviller's insistent desire to discipline and shape artists for the regime. It does show, however, the attitude that certainly Fragonard shared with his contemporaries that no one should be able to give an artist orders. One aspect of Fragonard's

FIGURE 69. *Self-Portrait,* 1789. Institut Néerlandais, Paris, Collection F. Lugt.

FIGURE 70. *Artist in the Studio.* The Fine Arts Museums of San Francisco, Achenbach Foundation for Graphic Arts, purchase.

character can be firmly established: he had a strong sense of pride in his metier and a compelling instinct for freedom from restrictions.

As for his character as a painter, was he, as the Goncourts wrote, an inspired *pasticheur?* One side of his professional life certainly demanded that he adopt the *pasticheur*'s style. After all, he spent his formative years in the studio of Boucher, who conformed, to a certain degree, to an earlier view of the artist's function. Boucher apparently suffered none of the torments and stung pride of the next generation—a Greuze or even Fragonard—and found it perfectly natural to be commanded to paint Easter eggs for the king. While there is no indication that Fragonard produced occasional artifacts on demand, he certainly made many drawings, prints, and paintings to satisfy the patrons who offered the material support he required. Yet a close look at the best of his works shows a coherence of preoccupation and style and none of the *pasticheur*'s glib insincerity. Jean Seznec, one of Fragonard's most sympathetic twentieth-century commentators, has said that he chose Folly as his muse, and indeed, in the fine drawing for Ariosto (fig. 13), the poet is contemplating Love and Folly, his own prime muses.[3] This "Folly" suited Fragonard, who was described by contemporaries as fiery and ardent in temperament and who, like most educated Frenchmen, was aware of the etymology of the word, or at least of its root meaning. The word *fou* from the Latin *follis*—meaning a sack or bladder full of air—appeared in the *Chanson de Roland* in 1080. Thus, a *fou* meant "one tossed this way and that." By Fragonard's time, as the great translator Helen R. Lane has written,

> the connotations of *folie* were shifting and the word was associated both with the idea of the folly of love and with the idea of the imagination. Love-madness in the classic era, and at least down to the seventeenth century, was a grave and serious folly. Bossuet, the great seventeenth-century Christian orator, speaks of *l'amour passion* as "de toutes les *folies,* la plus *folle*" (of all madness, the maddest). But by the eighteenth century, love has become, both in literature and in painting, a delightful folly . . . a polar opposite.[4]

For Fragonard, the situation of being tossed this way and that, at least emotionally, was not unfavorable. On the contrary, his relationship with *la folie* was one of complete faith. Like so many men of the enlightenment, he counted the passions as morally significant. Moreover, he came down on one side of an argument that toward the end of the century would find passionate adherents: the association of *folie* with *fantaisie* and the growing belief in a faculty called "imagination" that Coleridge would describe with great accuracy and that Baudelaire would later call "queen of the faculties." Fragonard consistently upheld the primacy of the imagination over what he considered mindless naturalism, which is probably why painters of Baudelaire's generation recognized him as a precursor.

Conclusions concerning Fragonard's psychological makeup can derive only from his work. We are mercifully spared psycho-history here since almost nothing is known of his family, his relationships to his father and mother, his childhood

traumas. Saint-Non's descriptions of Fragonard's furor in Tivoli are certainly borne out in his work. He was a man of emotional intensity. The thrusts of the great trees are not less emotional than the thrusts of amorous human bodies in his later works. They are evidence of powerful internal emotions responding to physical events in the external world. He always worked from these inner stirrings, from the inside out, so to speak. The great flickering lights in his best work, as they glide over trees or human bodies, are integrally related to the pulsation of his feelings. His whole enterprise, at least in his masterworks, was to somehow arrive at a correlative or even a homologue of the surges of feeling that possessed him as he worked. Once moved, he craved to be moved again. His was an emotional, sometimes volcanic, personality, and shifts in taste, in discourse, in patronage did not seem to make great inroads. From his youth he had acknowledged his bent. In his youth he had been moved by his experience in the Villa d'Este, and throughout his life he sought to retrieve the heightened feelings of that magical sojourn. The illustrations of Ariosto are the best witness to his nostalgia—not for some literary golden age, but for a specific timbre of feeling he had once experienced.

This quest found fulfillment in certain works of exceptional quality—works that, taken together, indicate the coherent approach of an artist who, though not averse to being tossed this way and that in his painting life, had his own style. His purposes may have differed, as in the Frick cycle (colorplates 7 and 8; figs. 28 and 29) and *The Fête at Saint-Cloud,* (colorplate 9), but there is an underlying cohesion based on the language of painting that he had brought to an expressive height. Also at the Banque de France, where his masterpiece *The Fête at Saint-Cloud* survives time and fashion, are Boucher's interpretations of Tasso's *Sylvie*— pure representatives of the stilted nostalgia for a golden age underlying the whole of Boucher's production—a cliché of the era. These pastorales are immensely remote from the reverie of Fragonard in *The Fête at Saint-Cloud.* Where Fragonard began, as Boucher's pupil, by seeing landscapes with the stylized eye of his master, where each place, no matter how humble, takes on a certain artificial luster, Fragonard, with a sure instinct, moved on to a sense of place that derived from his direct experience. From the moment he felt the specific reality of a beloved place, as he did in Tivoli, Fragonard was no longer a typical Rococo artist and distanced himself from the niceties of Rococo painterly usages. In *The Fête at Saint-Cloud,* it is true, a strangely elegiac mood is established, but it is based on what Fragonard felt as he looked. His careful observations were in the service of an expressive intent. For the Frick murals he has stayed within the traditional canons to the degree that he used episodes from theater in their frankly artificial guise. But even here the boldness of his brushwork strikes out into new territory quite shocking to his contemporaries. In *The Fête at Saint-Cloud* he positioned himself as an observer with an eye that took everything in, that valued realistic detail, and that made no effort to make hierarchical distinctions, much as Watteau did before him when he painted the art dealer Edmé Gersaint's sign, which he did, Gersaint tells us

(one of the most telling details of all about that enigmatic artist) "to take the chill off his fingers" and which was "the only example of his work that in any way stimulated his self-esteem; he admitted this to me unhesitatingly."[5] Fragonard, like Watteau, took the measure of himself through a cultivated attitude toward the direct experience. Long before the Impressionists made a special point of the importance of working *sur le motif,* Fragonard understood its importance. *The Fête at Saint-Cloud* is an indirect result of his meditations on the degree to which direct observation must be the basis of all painting.

The fact that so many have found in Fragonard a precursor of both nineteenth-century Romantic painting and Impressionism is significant. There are signs of his historical prescience in many works. If we speak of an immanent history of painting, then Fragonard's contribution takes on considerable importance. In otherwise relatively period-bound paintings, such as the two works in Washington, *The Swing* (fig. 45) and *Blindman's Buff,* (colorplate 12), Fragonard's brush anticipates that of his admirer Renoir in the way he insists on the flickering character of sunlight. The whole passage at the right in *Blindman's Buff* showing a picnic table in a trellised bower is rendered with an Impressionist's freedom. The pulsating green-yellow reflected lights are applied by the artist in small patches that in places seem rubbed on with a flick of his thumb (although I suspect that ferocious cleaning has changed both paintings, unfortunately). In *Blindman's Buff,* in which Fragonard, true to his conviction that imagination must prevail, used old memories of the Villa d'Este—the towering cypresses and the statue of Minerva seen in many of his Tivoli drawings—he has represented the immediacy of his feelings of specific place. He smuggled these radical impulses into his large decorative works, which otherwise fit very well into the demands of the period for appropriateness and an overall pattern of contrasting values. I am inclined to think that even in works that more nearly accommodate the taste of his contemporaries, such as *Portait of a Lady with a Dog,* (colorplate 6), in the Metropolitan Museum of Art, Fragonard's wit was purveyed through his idiosyncratic painterly impulse. The intonations of the Venetians Tintoretto and Veronese are here. But with a twist of his brush, laden with deep pink, Fragonard converts his painting into what may be a parody of the Regency portrait. The woman certainly seems to be sharing an in-group joke, and the rhyming of her ear, nose, and mouth with the little dog's ear, tongue, and nose is intentional and wittily malicious.

Fragonard's strength lay not in his choice of subjects, which were often enough either modish or conventional, nor in the manner in which he chose to compose them, which was also fairly often common to a whole circle of painters of his time, but rather in his persistent quest for the proper expression of his vision of light—the light that all painters of mettle have sought to harness to expressive ends. There are always intellectual or cultural sources in the period to nail artists to, but so often they dissolve before the accomplished work of art. Fragonard's course was not greatly altered by the vicissitudes of his moment, for it was directed

by a commanding instinct, guided by his connoisseurship. The instinct was power-ful even in youth. If the tiny painting *Joash and Joad* (colorplate 14) was indeed painted early and if it was an exercise in the manner of Rembrandt, it is still an utterly characteristic work by Fragonard, bespeaking his deepest drives as a painter. An essay in chiaroscuro, this little painting, which describes the gesture of an older man thrusting forward in a sheltering position and a child rendered in warm ochers with breathtaking simplicity, draws its expressive meaning through the disposition of light—the red accent of the man's hat, the reddish highlights on his hand, and the fragile lighter hues of the youth. These details are brought up close to stress the immediacy of Fragonard's feeling—a device he used on many occasions. In his mature years Fragonard stepped easily beyond the disciplined canons inherited from his systematic training. The drawings of *Orlando Furioso* have little in common even with his own early drawings. In his early works Fra-gonard was careful to align his values in orderly transition. The diminution of halftones was always weighed out carefully. But in the Ariosto drawings Fra-gonard allows his brush to range over the paper with unaccustomed freedom. Masses of "color" had none of the orderly progression of tone that the art of drawing was assumed to require. The dark-to-lighter-to-lighter hatching is aban-doned as Fragonard gives his brush free rein to invent forms—not just a code of circumflexes, zigzags, and checks and curves, but forms that spring free from his brush as he looks, as he works, as he seeks them out. His liberation from the rules is apparent everywhere in his later drawings. One of the few dated drawings, *Italian Park* (fig. 71), in the Crocker Art Gallery, shows that his driving intention is to speak of the saturated quality of sunlight in Italy. He draws on his old resources—his sketches from the two Italian sojourns, with various ancient details—but they become incidental. What speaks here is a painter's vision of light on stone, foliage, towering trees, and sky. Touches of capricious shadow are indicated with a dot of the point of the brush, much as the Impressionists would work later. Form, no longer outlined in its contours, is given the fugitive character it assumes when struck with scavenging light. In *Italian Park* and similar drawings, such as *Park with Arcade* (fig. 72), Fragonard shows how much he was "natively a painter," to use a phrase of Delacroix, whose admiration for Rembrandt was expressed with it.[6] The native painter, Fragonard, leaves behind his professional baggage in his flight into the sun. His job as a draftsman was still the same—what it always was and is—to locate and characterize things in space. For this he had behind him his long training and assiduous practice. Drawing was second nature. But wringing from space correlations to his feelings was a task that never abated in its urgency for him. For this he had to alter and even abandon what he had learned. He did not hesitate. The motif was important to him to the degree that he could get at his primary task. "I take it for granted," Andrew Forge has written, "that the major ingredient will be the painter's sense of pictures, that accumulation in his bones that makes him a painter. I want to stress the experiential side, those types of

FIGURE 71. *Italian Park.* Crocker Art Museum, Sacramento, E. B. Crocker Collection.

FIGURE 72. *Park with Arcade.* Galerie Cailleux, Paris.

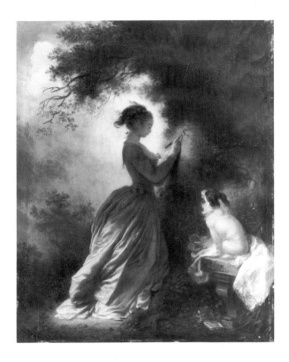

FIGURE 73. *The Souvenir.*
The Wallace Collection, London.

spatial relationships, those natural physiognomies in which the painter recognizes himself and around which each encounter will lay down deeper and deeper deposits of feeling."[7]

In looking at Fragonard at his best (I find it easy to disregard his potboilers), I see that there was something that quickened his pulse, that gave him an extraordinary sense of elation, and that was the motif of his life's work: he took the light and magic of his experience of nature and used his imaginative ability to transform it into a picture. The vexed question of "representation" is superfluous here. He presented what he knew to be authentic feelings. It doesn't matter whether he painted after Dutch landscapists or his friends' boudoir scenes for a ready market. We have to descry the moments in which his talent rose to its most authentic pitch. His talent is marshaled to his fundamental vision. If we look closely at the most coquettish of his small paintings—those soft and erotic visions of nude women or such a painting as *The Souvenir* (fig. 73)—even there his overriding concern is with the play of light. There is none of the specific anatomical detail found in Boucher and others. He is not interested. He is only interested in the breathing beauty of a living object swathed in light. The caress is of light alone.

It is true that in each epoch the artist takes his small portion. His critique is intuitive. He tells himself, take this, not that. He hones his means through looking around—at other artists, at things, at situations. He develops what artists some-

times call their handwriting. He is biologically historical. The link between him and his time is umbilical. But the immanent history of painting is not always synchronized with the history of human events. Anyway, the Enlightenment was far too vivid and complicated an epoch to reduce it to a project of one kind or another.

Remember that Fragonard moved into an art world that was experiencing a period of rapid transition (even perceived by the contemporaries living it), with forces powerfully at work to disturb the old order. The art world is always part of and often a reflection of the great world, and for Fragonard after the mid-century, just as he was beginning to function professionally, everything shifted ground. All that remained in place was the history of his art, with various temperaments that would provide him with a spiritual family. It is not surprising that in the nineteenth century, also wracked by changes of an eruptive nature, there were so many who were moved by Fragonard. The poet Gerard de Nerval, who gave his works by Fragonard to his beloved, the imperious but mediocre actress Jenny Colon, described his moment in the novel *Sylvie*. The parallels are inescapable:

> We were then living in a strange period, such as usually succeeds revolutions or the decline of great reigns. It was no longer the gallant heroism of the Fronde, the elegant dressed-up vice of the Regency, or the skepticism and in-sane orgies of the *Directoire*. It was an age in which activity, hesitation, and indolence were mixed up with dazzling Utopias, philosophies, and religious aspirations, vague enthusiasms, mild ideas of a Renaissance, weariness with past struggles, insecure optimisms—somewhat like the period of Peregrinus and Apuleius.[8]

This description of France published after the failure of both revolutions, 1830 and 1848, has much in common with contemporary eighteenth-century accounts of those who began to doubt after the fall of Louis XVI, and even more with those who became skeptical even about skepticism, as the nation inclined more and more perilously to the shattering explosions of 1789. It occurs in Nerval's *Sylvie*, which is essentially a pastoral elegy in the great French literary tradition, but with a knowing undercurrent, a psychological candor that makes it perpetually modern. The realistic details dispersed throughout this eloquent work speak again and again to the modern reader who, since Freud, has been steeped in the lore of psychology:

> Such are the delusions which charm and beguile us in the morning of life. I have tried to set them down without too much order but many hearts will un-derstand mine. Illusions fall, like the husks of a fruit, one after another, and what is left is experience. It has a bitter taste, but there is something tonic in its sharpness—forgive me this old-fashioned manner. Rousseau claims that the contemplation of nature is a balm for everything. Sometimes I try to find my woods of Clarens lost in the mists somewhere north of Paris. All that has altered.[9]

Nerval is succeeded by Mallarmé who is succeeded by Valéry in being faithful to the pastoral tradition, but conscious always of the cracks in the vessels and the elusive turnings of the psyche that are so difficult to account for, much less describe. Even Ariosto had a premonition, *"O mente ancor di non sognar incerta"* (Oh mind still uncertain if it dreamed or not), in canto 8. Perhaps Mallarmé was thinking of Ariosto when he had his faun ask himself if he had dreamed that he had seen himself in the reeds—the scene Manet illustrated with a hand so Fragonard-like—and perhaps Valéry was thinking of it also when in *Jeune Parque* he wrote the lines about having seen himself seeing. All this speculation in revery is punctuated by sharp, realistic observations in the very mode that Fragonard employed in *The Fête at Saint-Cloud,* which by the time he painted it was certainly not a fashionable subject. But here precisely is the juncture at which art history is no longer a sufficient guide. At the moment Fragonard was musing on his masterpiece, the *Fête,* the social demand was for Roman paeans to virtue, or so it would appear if the titles of works shown in public in the exhibitions of the 1770s and 1780s are reckoned. Fragonard never painted a paean to Roman virtue, and the closest he came to an allegory was in *The Invocation to Love* (colorplate 13). Yet the period was not nearly so homogeneous as the theory of art history unfolding in decades tends to suggest. "In the late eighteenth century, a one-to-one correlation of style and subject was as frequently the exception as the rule," observes Robert Rosenblum in his important study *Transformations in Late Eighteenth-Century Art.*[10] The point is that Fragonard knew in his painter's bones that the subject he was painting was not the only subject—not, in fact, the most important subject. The Venetians could paint courtesans with the same passion as they painted madonnas, but madonnas or prostitutes, grand bourgeois ladies or shopgirls, the goal of the native painters or, rather, the immanent goal, was often the same—to capture the light and space of the world, to record sensations of the world in order to experience and to give experience of what Poussin had said was the goal of painting: delectation.

Fragonard caught in the toils of history? Perhaps not. Perhaps he sustained his inner vision impervious to the twists and turns of his time. He was an urban painter certainly and probably a bohemian in his habits. One of his friends was Gabriel de Saint-Aubin. Saint-Aubin, described by his own brother as "dirty" and "bizarre," and according to Greuze, suffering from "a priapism of drawing," was an early *flâneur* in Baudelaire's sense and knew every stone of bustling Paris—a city greedy for spectacle. (In 1783 more than six thousand people paid high fees for tickets for privileged places on the Champs de Mars to watch Montgolfier's balloon ascend, and thousands more lined the boulevards.) He and Fragonard shared a taste for the enormously increasing variety of spectacle in the city. If Fragonard struck a minor key in his *Fête at Saint-Cloud,* it is probably more akin to Georges Seurat's gravity in *The Grande Jatte* than it is to any of the fêtes depicted by his own

contemporaries, including Saint-Aubin. It is true that we will never be sure about Fragonard's experience of the important public events of his time. It is hard in general to be sure of anything much during the period, since local contemporary sources are notoriously unreliable. One comes across, for example, repeated references to Bachaumont's *Mémoires sécrets,* but Bachaumont died in 1771, and his publication was taken over by Pidansat de Mairobert, lawyer, censor, pornographer, and pamphleteer, who committed suicide in 1779 and whose editorship was as shaky as his various undertakings. Yet, despite this unsettling absence of verifiable documents, the many parallels with our own time offer yet another entry into the unique world of Fragonard—a world no less perplexing in its variety of currents than our own.

The latter half of the eighteenth century certainly offers the occasion to speculate about the sources of the problems of our own. There was a similar wild confusion, a flying off in many directions: prudery on the one hand, license on the other, with Diderot alternating between the two. There was the "democratic" painting, as Sir Anthony Blunt saw it, of a sensuous character, side by side with the stern classicism that led from Vien to David. Perhaps the juxtaposition of painting moralists such as Malevich and Mondrian with more hedonistic currents is a twentieth-century version. Fragonard was working in a fin-de-siècle atmosphere not so different from our own: the veering from soft to hard (both in thought and material), from popular to mandarin, from sensuous to austere. In our own moment, the swarming of those addicted to discourse, putting artists at risk of verbal innundation, is the culmination of an extended history that began in the eighteenth century. If we think of the line of "theory" from the mid-eighteenth century on, we see the French worried constantly about morality and intellect. The attempt to renew history painting, undertaken repeatedly in the eighteenth century, was basically an attempt to make painting into a mode with intelligible intellectual content—intelligible to intellectuals, that is—and therefore worthy of higher esteem. Even Diderot pontificated in this direction, making exception only for Chardin. Baudelaire, although more sensitive to purely pictorial values and full of astounding insights, was still worried about content, insisting on the role of intellect as he found it in Delacroix. Valéry definitely rejected the purely painterly approach in his reverence to Leonardo, as did Duchamp, who did not wish to be, as the French saying has it, *bête comme un peintre* (dumb like a painter). Both Diderot and Rousseau played paradoxical roles in their period, speaking on the one side for pure feeling and on the other for moralistic significance. We have our own such pontificators, only they often go under the heading of other disciplines such as sociology and political science. If we see Fragonard as buffeted by similarly imperious gusts of ideas and besieged by current events that threatened to overwhelm him, his singularly single-minded adherence to early experiences and their enrichment through his art is admirable.

Quite contrary to prevailing beliefs that we must try to see artists with the eyes of their own time, I believe we must use our own eyes. If a work survives at all, it survives both as a living emblem of a place and time and as an inner structure that never changes but can generate meanings time and again. We must do with seeing what Jorge Luis Borges said the reader must do with reading: "The duty of the reader is to enrich what he reads."[11]

Notes

INTRODUCTION

1. Charles Collé, *Journal et mémoires de Charles Collé,* ed H. Bonhomme (Paris, 1868).
2. Ibid.
3. Marie-Catherine Sahut and Nathalie Volle, *Diderot et l'art de Boucher à David* (Paris, 1984).
4. Donald Posner, "The Swinging Women of Watteau and Fragonard," *Art Bulletin* 64, no. 1 (March 1982).
5. Ibid.
6. Kunsthalle der Hypo-Kulturstiftung, *Albertina Wien, Zeichnungen 1450–1950* (Munich, 1986).
7. Erwin Panofsky, *Meaning in the Visual Arts* (New York, 1955).
8. Abraham Bosse, *Traité des manières de graver en taille-douce* (1645), revised by Charles-Nicolas Cochin (Paris, 1745).
9. Quoted in Jean Seznec, *Essais sur Diderot et l'antiquité* (Oxford, 1957).

CHAPTER I

1. Quoted in preface to Denis Diderot, *Rameau's Nephew and Other Works,* trans. Jacques Barzun and Ralph H. Bowen (New York, 1956).
2. Baron Roger Portalis, *Honoré Fragonard: Sa Vie et son œuvre* (Paris, 1889).
3. Stendhal, *The Red and the Black,* trans. C. K. Scott Moncrieff (New York, 1926).
4. Edmond and Jules de Goncourt, *L'Art du dix-huitième siècle* (1860), trans. Robin Ironside (New York, 1948).
5. Ibid.
6. Denis Diderot, Jean le Rond d'Alembert, et al., *Encyclopédie* (1751–65), Pellet edition (Paris, 1777).
7. Sahut and Volle, *Diderot.*
8. Thomas E. Crow, *Painters and Public Life in Eighteenth-Century Paris* (New Haven and London, 1985).
9. Janet Aldis, *Madame Geoffrin: Her Salon and Her Times* (London, 1905).
10. Ibid.

11. Ibid.
12. Goncourt, *L'Art du dix-huitième siècle*.
13. Quoted in Ernst Cassirer, *The Philosophy of the Enlightenment*, trans. F. Koelin and J. Pettegrove (Princeton, 1951).
14. Goncourt, *L'Art du dix-huitième siècle*.
15. Ibid.

CHAPTER 2

1. Jean le Rond d'Alembert, "Éléments de philosophie," *Mélanges de littérature, d'histoire, et de philosophie*, vol. 4 (Amsterdam, 1759).
2. Georges Wildenstein, *The Paintings of Fragonard* (London, 1960).
3. Hervé de Fontmichel, *Le Pays de Grasse* (Paris, 1963).
4. Jean-Jacques Lévêque, *Fragonard* (Paris, 1983).
5. Nicolas Edmé Restif de La Bretonne, *Le Paysan et la paysanne pervertis* (1775), trans. Allan Hull Walton (London, 1967).
6. Ibid.
7. Nicolas Edmé Restif de La Bretonne, *Les Nuits de Paris: A Selection*, trans. Asher and Ellen Fertig (New York, 1964).
8. Sahut and Volle, *Diderot*.
9. Ibid.
10. Ibid.
11. Diderot, *Salon of 1763*, quoted in ibid.
12. Goncourt, *L'Art du dix-huitième siècle*.
13. Ibid.
14. Much of the information on Boucher is from Alastair Laing et al., *François Boucher: 1703–1770*, the catalog for a large exhibition at the Metropolitan Museum of Art, New York, in 1986.
15. Jean-François Marmontel, *Mémoires*, ed. M. Tourneux (Paris, 1891).
16. Pierre Francastel, *Histoire de la peinture française*, vol. 1 (Paris, 1955).
17. Ibid.
18. Lévêque, *Fragonard*.
19. Quoted in Janine Bouissounouse, *Julie* (New York, 1962).
20. Laing, *François Boucher*.
21. "Histoire manuscrite de l'opéra," Beffara Papers, Bibliothèque de l'Hôtel de la Ville, Paris.
22. Goncourt, *L'Art du dix-huitième siècle*.

CHAPTER 3

1. René Huyghe, "Fragonard," *Cahiers de Bordeaux* 3 (1956).
2. Quoted in Jacques Thuillier and A. Châtelet, *La Peinture française de Le Nain à Fragonard* (Geneva, 1964).
3. Marmontel, *Mémoires*.
4. La Font de Saint-Yenne, *Réflexions sur quelques causes de l'état présent de la peinture en France* (The Hague, 1747).

5. Christian de Mannlich, *Mémoires* (Paris, 1949).

6. Sahut and Volle, *Diderot.*

7. "Notice sur Carle Van Loo," *Correspondance littéraire,* July 15, 1765, in Carle Van Loo, (*Œuvres complètes* (Paris, 1980).

8. Mannlich, *Mémoires.*

9. Jean-Jacques Rousseau, *Écrits sur la musique* (1838), in *Œuvres complètes,* ed. Bernard Gagnebin and Marcel Raymond, 4 vols. (Paris, 1959–69).

10. Restif de La Bretonne, *Le Paysan et la paysanne pervertis.*

11. Rousseau, *Écrits sur la musique.*

12. Paul Nettl, *The Other Casanova: A Contribution to Eighteenth-Century Music and Manners* (New York, 1970).

CHAPTER 4

1. Charles Montesquieu, *Voyage d'Italie* (Paris, 1728).

2. Diderot and d'Alembert, *Encyclopédie.*

3. *Correspondance des directeurs de l'Académie de France à Rome avec les surintendants des bâtiments,* ed. J. J. Guiffrey and Anatole de Montaiglon, vol. 2 (Paris, 1901). The following exchange between Natoire and Marigny concerning Fragonard is from this source.

4. Alexandre Lenoir, *Biographie universelle ancienne et moderne,* vol. 15 (Paris, 1816).

5. *Correspondance des directeurs,* ed. Guiffrey and de Montaiglon, vol. 2.

6. Johann Wolfgang von Goethe, *Italian Journey,* ed. W. H. Auden and Elizabeth Mayer (New York, 1968).

7. Carlo Goldoni, *Mémoires de M. Goldoni* (1787), ed. Paul de Roux (Paris, 1965).

8. Ibid.

9. Goethe, *Italian Journey.* The discussion that follows and all quotes are from this source.

10. Goldoni, *Mémoires.*

11. Lorenz Eitner, *Neoclassicism and Romanticism: 1750–1850,* 2 vols. (Englewood Cliffs, N.J., 1970), vol. 1.

12. Ibid.

13. Ibid.

14. Quoted in Remy G. Saisselin, *Neo-Classicism: Style and Motif* (Cleveland, Ohio, 1964).

15. For comprehensive information on Piranesi, see Académie de France à Rome, *Piranèse et les français* (Rome, 1978).

16. Baron d'Holbach, *Système social,* in Georgette Cazes and Bernard Cazes, eds., *D'Holbach portatif* (Paris, 1967).

17. D'Holbach, *Système de la nature,* in ibid.

18. Jacques Chouillet, "Du Langage pictural au langage littéraire," in Sahut and Volle, *Diderot.*

19. Quoted in Sahut and Volle, *Diderot.*

20. Francis Haskell and Nicholas Penny, *Taste and the Antique: The Lure of Classical Sculpture* (New Haven, 1981).

21. Ibid.

CHAPTER 5

1. Jacques Casanova, *The Memoirs of Jacques Casanova* (New York, 1929).
2. Quoted in Sahut and Volle, *Diderot.*
3. Quoted in Laing, *François Boucher.*
4. William Howard Adams, *The French Garden: Fifteen Hundred to Eighteen Hundred* (New York, 1979).
5. Quoted in Bouissounouse, *Julie.*
6. Ibid.
7. Laing, *François Boucher.*
8. Jacopo Sannazaro, *Arcadia* (1502), trans. Ralph Nash (Detroit, 1966).
9. Goethe, *Italian Journey.*
10. Ibid.
11. Louis Guimbaud, *Saint-Non et Fragonard d'après des documents inédits* (Paris, 1928).
12. Ibid.
13. Ibid.
14. Ibid.
15. *Correspondance des directeurs,* ed. Guiffrey and de Montaiglon, vol. 2.
16. Elizabeth Mongan, "Fragonard the Draughtsman," in Elizabeth Mongan, Philip Hofer, and Jean Seznec, *Fragonard: Drawings for Ariosto* (New York, 1945).

CHAPTER 6

1. Quoted in Thuillier and Châtelet, *Le Peinture française.*
2. Quoted in ibid.
3. *Tivoli and Its Artistic Treasure* (Rome, n.d.).
4. Wildenstein, *Paintings of Fragonard.*
5. Ibid.

CHAPTER 7

1. Charles-Nicolas Cochin, *Voyage d'Italie* (Paris, 1758).
2. Marianne Roland-Michel, *Artistes en voyage au XVIIIe siècle* (Paris, 1986).
3. Ibid.
4. Goethe, *Italian Journey.*
5. Anthony Blunt, "Naples as Seen by French Travellers 1630–1780," in *The Artist and Writer in France: Essays in Honor of Jean Seznec* (Oxford, 1974).
6. Ibid.
7. Ibid.
8. Johann Joachim Winckelmann, *Winckelmann: Writings on Art,* ed. David Irwin (London, 1972).
9. Michael Levey, *Rococo to Revolution* (New York and Toronto, 1966).
10. Eugenio Riccomini, *Correggio and His Legacy* (Washington, D.C., 1984).
11. Quoted in Henri Focillon, *Giovanni-Battista Piranesi, 1720–1778* (Paris, 1918).
12. Goethe, *Italian Journey.*
13. Casanova, *Memoirs.*

CHAPTER 8

1. Quoted in Seznec, *Diderot et l'antiquité.*
2. Peter Brooks, *The Melodramatic Imagination: Balzac, Henry James, Melodrama, and the Mode of Excess* (New Haven and London, 1976).
3. Ibid.
4. Bouissounouse, *Julie.*
5. Robert Darnton, *The Great Cat Massacre and Other Episodes in French Cultural History* (New York, 1984).
6. Milan Kundera, "Man Thinks, God Laughs," *New York Review of Books,* June 13, 1985.
7. Ibid.
8. Seznec, *Diderot et l'antiquité.*
9. Ibid.
10. Ibid. The discussion that follows and all quotes are from this source.
11. Quoted in ibid.
12. Quoted in Wildenstein, *Paintings of Fragonard.*
13. Ibid.
14. Georges Wildenstein, "L'Abbé de Saint-Non," *Gazette des Beaux-Arts* 54 (1959).
15. Beth S. Wright, "New (Stage) Light on Fragonard's Corésus," *Arts Magazine* 60, no. 10 (Summer 1986).
16. Seznec, *Diderot et l'antiquité.*
17. Marmontel, *Mémoires.*
18. Eunice Williams, *Drawings by Fragonard in North American Collections* (Washington, D.C., 1978).

CHAPTER 9

1. Sahut and Volle, *Diderot.*
2. Ibid.
3. Wildenstein, *Paintings of Fragonard.*
4. Quoted in ibid.
5. Quoted in ibid.
6. Mary D. Sheriff, "Invention, Resemblance, and Fragonard's Portraits de Fantaisie," *Art Bulletin* 69, no. 1 (March 1987).
7. Roger de Piles, *Cours de peinture par principes* (Paris, 1708).
8. Thomas Puttfarken, *Roger de Piles' Theory of Art* (New Haven and London, 1985).
9. English translation of 1743; quoted in ibid.
10. Ibid.
11. P. M. Gault de Saint-Germain, *Choix des productions de l'art les plus remarquables exposées dans le Salon de 1819;* quoted in Francis Haskell, *Rediscoveries in Art: Some Aspects of Taste, Fashion, and Collecting in England and France* (Ithaca, N.Y., 1976).
12. Quoted in Jack D. Flam, *Matisse on Art* (New York, 1978).
13. Ibid.
14. Quoted in Franco Venturi, *La Jeunesse de Diderot* (Paris, 1939).
15. Rousseau, "Letter to Franquières," in *Œuvres complètes.*
16. Rousseau, *Cinquième Reverie,* in *Œuvres complètes.*

17. Angelica Goodden, *Actio and Persuasion: Dramatic Performance in Eighteenth-Century France* (Oxford, 1986).
18. Georges Noverre, *Lettres sur la danse et sur les ballets* (Paris, 1760).

CHAPTER 10

1. Quoted in Wildenstein, *Paintings of Fragonard.*
2. J. Baril, *Dictionnaire de danse* (Paris, 1964).
3. Louise-Elisabeth Vigée-Lebrun, *Souvenirs de Madame Louise-Elisabeth Lebrun,* 3 vols. (Paris, 1835–37).
4. Ibid.
5. Goncourt, *L'Art du dix-huitième siècle.*
6. Baronne d'Oberkirch, *Mémoires de la Baronne d'Oberkirch* (1789) (Paris, 1970).
7. Laing, *François Boucher.*
8. Voltaire, "Le Mondain," in *Œuvres complètes,* ed. L. Moland, 52 vols. (Paris, 1877–85), vol. 10.
9. Noverre, *Lettres sur la danse.*
10. Ibid.
11. Ibid.
12. Cochin to Desfruches, Sept. 30, 1759; quoted in Sahut and Volle, *Diderot.*
13. Michel Gallet, *Claude-Nicolas Ledoux* (Paris, 1980).
14. Quoted in ibid.
15. Claude-Nicolas Ledoux, *L'Architecture* (1804) (Princeton, 1983).
16. Ibid.
17. Gallet, *Claude-Nicolas Ledoux.*
18. Wildenstein, *Paintings of Fragonard.*
19. Melchior Grimm, *Correspondance littéraire de Grimm,* ed. M. Tourneux, vol. 8 (Paris, 1831).
20. Goncourt, *L'Art du dix-huitième siècle.*
21. Grimm, *Correspondance littéraire.*
22. Lenoir, *Biographie universelle.*
23. Goncourt, *L'Art du dix-huitième siècle.*
24. Académie de France à Rome, *David et Rome* (Rome, 1981).

CHAPTER 11

1. Gallet, *Claude-Nicolas Ledoux.*
2. Louis Petit de Bachaumont et al., *Mémoires secrètes pour servir à l'histoire de la République des Lettres en France depuis 1762 jusqu'à nos jours* (London, 1784).
3. Ibid.
4. See Donald Posner, "The True Path of Fragonard's 'Progress of Love,'" *Burlington Magazine* 114, no. 2 (1972); *The Frick Collection: An Illustrated Catalogue,* vol. 2, *Paintings: French, Italian, and Spanish,* ed. M. Brunet and J. Pope (Princeton, 1968); Franklin M. Biebel, "Fragonard et Madame Du Barry," *Gazette des Beaux-Arts* 56 (Oct. 1960); and Edgar Munhall, "Fragonard's Studies for 'The Progress of Love,'" *Apollo* 93 (1971).
5. Fragonard file in the Frick Collection, New York.

6. Jean de Cayeux, "Le Pavillon de Madame Du Barry à Louveciennes et son architecte C. N. Ledoux," *La Revue de l'art,* June 1935; cited in Munhall, "Fragonard's Studies for 'The Progress of Love.' "

7. Louis de Carmontelle, *Jardin de Monceau près de Paris* (Paris, 1779).

8. René Girardin, *Promenade ou itinéraire des jardins d'Ermenonville* (Paris, 1788); and idem, *De la Composition des paysages* (Paris, 1788).

9. Denis Diderot, *Le Paradoxe sur le comédien* (Paris, 1830).

10. Diderot, *Rameau's Nephew and Other Works.*

11. Ibid.

CHAPTER 12

1. Jacques-Onésyme Bergeret de Grancourt, *Voyage en Italie 1773–74, avec les dessins de Fragonard,* ed. Jacques Wilhelm (Paris, 1948).

2. Ibid.

3. Ibid.

4. Ibid.

5. Goethe, *Italian Journey.*

6. Bergeret, *Voyage en Italie.*

7. Levey, *Rococo to Revolution.*

8. Otto Benesch, *Master Drawings in the Albertina* (Greenwich, Conn., n.d.).

9. Harold Joachim, *The Helen Regenstein Collection of European Drawings, Art Institute of Chicago* (Chicago, 1974).

10. Williams, *Drawings by Fragonard.*

11. Bergeret, *Voyage en Italie.*

CHAPTER 13

1. Quoted in Albert Bermel, ed., *The Genius of the French Theatre* (New York, 1961).

2. Quoted in Crow, *Painters and Public Life.*

3. Quoted in ibid.

4. Ibid.

5. D'Oberkirch, *Mémoires.*

6. Quoted in Austin Dobson, *Four Frenchwomen* (1893) (New York, 1972).

7. Quoted in Georges Wildenstein, "La Fête de Saint-Cloud et Fragonard," *Gazette des Beaux-Arts* 56 (1960).

8. *The Letters of Sir Joshua Reynolds,* ed. F. W. Hilles (London, 1929).

9. Wildenstein, "Fête de Saint-Cloud."

10. Cited by David Wakefield, *Fragonard* (London, 1976).

11. Sam Morgenstern, ed., *Composers on Music* (New York, 1956).

12. Ibid.

13. Ibid.

14. Eitner, *Neoclassicism and Romanticism,* vol. 1.

15. Quoted in Jean Starobinski, *The Invention of Liberty* (Geneva, 1964).

16. Williams, *Drawings by Fragonard.*

17. Goodden, *Actio and Persuasion.*

18. Starobinski, *Invention of Liberty;* see also idem, "Burying the Dead," *New York Review of Books,* Jan. 16, 1986.

19. Starobinski, *Invention of Liberty.*
20. Wakefield, *Fragonard.*
21. Letter to the author, April 1987.
22. Jacques Thuillier, *Fragonard* (Geneva, 1967).
23. D'Oberkirch, *Mémoires.*
24. Wakefield, *Fragonard.*
25. Wildenstein, *Paintings of Fragonard.*

CHAPTER 14

1. Wildenstein, *Paintings of Fragonard.*
2. Crow, *Painters and Public Life.*
3. Quoted in Aldis, *Madame Geoffrin.*
4. Louis-Philippe Ségur, *Mémoires, souvenirs, et anecdotes,* 3 vols. (Paris, 1827).
5. Ibid.
6. Mrs. Cradock, *Le Journal de Mme Cradock,* trans. Mrs. Odelphin Ballyquier (London, 1784).
7. Roger Vailland, *Laclos par lui-même* (Paris, n.d.).
8. Ibid.
9. Quoted in François Bluche, *La Vie quotidienne au temps de Louis XVI* (Paris, 1980).
10. D'Oberkirch, *Mémoires.*
11. Udolpho van de Sandt, "Le Salon de l'Académie de 1759 à 1781," in Sahut and Volle, *Diderot.*

CHAPTER 15

1. Casanova, *Memoirs.*
2. Michel de Montaigne, *The Complete Essays of Montaigne,* trans. Donald M. Frame (Stamford, Conn., 1957).
3. Quoted in Seznec, *Diderot et l'antiquité.*
4. David Hume, "Of the Standards of Taste" (1757), in *Essays: Moral, Political, and Literary* (London, 1898).
5. Miguel Cervantes, *Don Quixote* (New York, 1950).
6. Ibid.
7. Seznec in Mongan, Hofer, and Seznec, *Fragonard: Drawings for Ariosto.*
8. Benedetto Croce, *Philosophy, Poetry, History,* trans. Cecil Sprigge (Oxford, 1966).
9. Ibid.
10. Ibid.
11. Seznec in Mongan, Hofer, and Seznac, *Fragonard: Drawings for Ariosto.*
12. Ibid.
13. Ibid.

CHAPTER 16

1. Anita Brookner, *Greuze: The Rise and Fall of an Eighteenth-Century Phenomenon* (New York and London, 1972).
2. Ibid.

3. Wildenstein, *Paintings of Fragonard.*
4. Crow, *Painters and Public Life.*
5. Goncourt, *L'Art du dix-huitième siècle.*
6. Wildenstein, *Paintings of Fragonard.*
7. Goldoni, *Mémoires.*
8. D'Oberkirch, *Mémoires.*
9. Ibid.
10. Georges Vindry, "Fragonard," *Grasse expansions,* no. 1 (1972).
11. Wildenstein, *Paintings of Fragonard.*

CHAPTER 17

1. M. de La Girennerie, in Portalis, *Honoré Fragonard.*
2. Pierre Rosenberg, *The Age of Louis XV: French Painting 1710–1774* (Toledo, Ohio, 1975).
3. Seznec in Mongan, Hofer, and Seznec, *Fragonard: Drawings for Ariosto.*
4. Letter to the author, Aug. 28, 1985.
5. Quoted in Goncourt, *L'Art du dix-huitième siècle.*
6. *The Journal of Eugène Delacroix,* trans. Walter Pach (New York, 1937).
7. Andrew Forge, "Voilà mon atelier. A moi!" in *Aspects of Monet: A Symposium on the Artist's Life and Times,* ed. John Rewald and Francis Weitzenhoffer (New York, 1984).
8. Gérard de Nerval, *Selected Writings,* trans. Geoffrey Wagner (London, 1958).
9. Ibid.
10. Robert Rosenblum, *Transformations in Late Eighteenth-Century Art* (Princeton, 1967).
11. Jorge Luis Borges, in response to a question from the audience after a lecture at the School of Visual Arts, New York, November 1969.

Selected Bibliography

I have used the standard monographic sources—the Goncourt brothers, Roger Portalis, Louis Réau, and Georges Wildenstein—as well as studies by Jacques Thuillier, David Wakefield, and Jean-Jacques Lévêque for basic information. I have also benefited from the excellent catalog entries of Eunice Williams (*Drawings by Fragonard in North American Collections,* Washington, D.C., 1978) and Marianne Roland-Michel (*Artistes en voyage au XVIIIe siècle,* Paris, 1986). For information on the arts during the period, I have found works by Thomas E. Crow and Robert Darnton to be most helpful. The excellent exhibition catalog, *Diderot et l'art de Boucher à David* (Paris, October 1984–January 1985), is a good source of information. Two important books will be published in 1988: *Fragonard* by Jean-Pierre Cuzin, and the catalog by Pierre Rosenberg for the Fragonard exhibition at the Metropolitan Museum of Art, New York.

Below is a list of works cited in the text and a highly selective group of other helpful references.

Académie de France à Rome. *David et Rome.* Rome, 1981.

———. *Piranèse et les français.* Rome, 1978.

Adams, William Howard. *The French Garden: Fifteen Hundred to Eighteen Hundred.* New York, 1979.

Alembert, Jean le Rond d'. *Mélanges de littérature, d'histoire, et de philosophie.* Vol. 4. Amsterdam, 1759.

Aldis, Janet. *Madame Geoffrin: Her Salon and Her Times.* London, 1905.

Ananoff, Alexandre. *L'Œuvre dessiné de Jean-Honoré Fragonard.* 4 vols. Paris, 1961–70.

Baril, J. *Dictionnaire de danse.* Paris, 1964.

Beffara Papers. Bibliothèque de l'Hôtel de la Ville, Paris.

Benesch, Otto. *Master Drawings in the Albertina.* Greenwich, Conn., n.d.

Bergeret de Grancourt, Jacques-Onésyme. *Voyage en Italie 1773–74, avec les dessins de Fragonard.* Edited by Jacques Wilhelm. Paris, 1948.

Bermel, Albert, ed. *The Genius of the French Theatre.* New York, 1961.

Biebel, Franklin M. "Fragonard et Madame Du Barry." *Gazette des Beaux-Arts* 56 (Oct. 1960).

Bluche, François. *La Vie quotidienne au temps de Louis XVI*. Paris, 1980.

Blunt, Anthony. "Naples as Seen by French Travellers 1630–1780." In *The Artist and Writer in France: Essays in Honor of Jean Seznec*. Oxford, 1974.

Bouissounouse, Janine. *Julie*. New York, 1962.

Brookner, Anita. *Greuze: The Rise and Fall of an Eighteenth-Century Phenomenon*. New York and London, 1972.

Brooks, Peter. *The Melodramatic Imagination: Balzac, Henry James, Melodrama, and the Mode of Excess*. New Haven and London, 1976.

Carlson, Victor. *Hubert Robert Drawings and Watercolors*. Washington, D.C., 1978.

Carmontelle, Louis de. *Jardin de Monceau près de Paris*. Paris, 1779.

Casanova, Jacques. *The Memoirs of Jacques Casanova*, New York, 1929.

Cassirer, Ernst. *The Philosophy of the Enlightenment*. Translated by F. Koelin and J. Pettegrove. Princeton, 1951.

Cayeux, Jean de. "Le Pavillon de Madame Du Barry à Louveciennes et son architecte C. N. Ledoux." *La Revue de l'art,* June 1935.

Cazes, Georgette, and Bernard Cazes, eds. *D'Holbach portatif*. Paris, 1967.

Cervantes, Miguel. *Don Quixote*. New York, 1950.

Cobban, Alfred. *A History of Modern France*. Harmondsworth, Middlesex, England, 1957.

Cochin, Charles-Nicolas. *Voyage d'Italie*. Paris, 1758.

Collé, Charles. *Journal et mémoires de Charles Collé*. Edited by H. Bonhomme. Paris, 1868.

Correspondance des directeurs de l'Académie de France à Rome avec les surintendants des bâtiments. Edited by J. J. Guiffrey and Anatole de Montaiglon. Vol. 2. Paris, 1901.

Cradock, Mrs. *Le Journal de Mme Cradock*. Translated by Mrs. Odelphin Ballyquier. London, 1784.

Croce, Benedetto. *Philosophy, Poetry, History*. Translated by Cecil Sprigge. Oxford, 1966.

Crow, Thomas E. *Painters and Public Life in Eighteenth-Century Paris*. New Haven and London, 1985.

Darnton, Robert. *The Great Cat Massacre and Other Episodes in French Cultural History*. New York, 1984.

Diderot, Denis. *Rameau's Nephew and Other Works*. Translated by Jacques Barzun and Ralph H. Bowen. New York, 1956.

———. *Salons, 1759–1781*. Edited by Jean Adhémar and Jean Seznec. 3 vols. Oxford, 1957–67.

Diderot, Denis, Jean le Rond d'Alembert, et al. *Encyclopédie*. 1751–65. Pellet edition. Paris, 1777.

Dobson, Austin. *Four Frenchwomen*. 1893. New York, 1972.

Eitner, Lorenz. *Neoclassicism and Romanticism: 1750–1850*. 2 vols. Englewood Cliffs, N.J., 1970.

Flam, Jack D. *Matisse on Art*. New York, 1978.

Focillon, Henri. *Giovanni-Battista Piranesi, 1720–1778*. Paris, 1918.

Fontmichel, Hervé de. *Le Pays de Grasse*. Paris. 1963.

Forge, Andrew. "Voilà mon atelier. Á moi!" In *Aspects of Monet: A Symposium on the Artist's Life and Times*. Edited by John Rewald and Francis Weitzenhoffer. New York, 1984.

Francastel, Pierre. *Histoire de la peinture française*. Vol. 1. Paris, 1955.

The Frick Collection: An Illustrated Catalogue. Vol. 2. *Paintings: French, Italian, and Spanish*. Edited by M. Brunet and J. Pope. Princeton, 1968.

Galerie Cailleux. *Rome 1760–1770: Fragonard, Hubert Robert, et leurs amis*. Paris, 1983.

Gallet, Michel. *Claude-Nicolas Ledoux*. Paris, 1980.

Girardin, René, Marquis de. *De la Composition des paysages*. Paris, 1777.

———. *Promenade ou itineraire des jardins d'Ermenonville*. Paris, 1788.

Goethe, Johann Wolfgang von. *Italian Journey*. Edited by W. H. Auden and Elizabeth Mayer. New York, 1968.

Goldoni, Carlo. *Mémoires de M. Goldoni*. 1787. Edited by Paul de Roux. Paris, 1965.

Goncourt, Edmond and Jules de. *L'Art du dix-huitième siècle*. 1860. Translated by Robin Ironside. New York, 1948.

Goodden, Angelica. *Actio and Persuasion: Dramatic Performance in Eighteenth-Century France*. Oxford, 1986.

Grimm, Melchior, Baron de. *Correspondance littéraire de Grimm*. Edited by M. Tourneux. Vol. 8. Paris, 1831.

Guimbaud, Louis. *Saint-Non et Fragonard d'après des documents inédits*. Paris, 1928.

Haskell, Francis. *Rediscoveries in Art: Some Aspects of Taste, Fashion, and Collecting in England and France*. Ithaca, N.Y., 1976.

Haskell, Francis, and Nicholas Penny. *Taste and the Antique: The Lure of Classical Sculpture*. New Haven, 1981.

Hume, David. *Essays: Moral, Political, and Literary*. London, 1898.

Huyghe, René. "Fragonard." *Cahiers de Bordeaux* 3 (1956).

Joachim, Harold. *The Helen Regenstein Collection of European Drawings, Art Institute of Chicago*. Chicago, 1974.

The Journal of Eugène Delacroix. Translated by Walter Pach. New York, 1937.

Kundera, Milan. "Man Thinks, God Laughs." *New York Review of Books*, June 13, 1985.

Kunsthalle der Hypo-Kulturstiftung. *Albertina Wien, Zeichnungen 1450–1950*. Munich, 1986.

La Font de Saint-Yenne. *Réflexions sur quelques causes de l'état présent de la peinture en France*. The Hague, 1747.

Laing, Alastair, et al. *François Boucher: 1703–1770*. New York, 1986.

Ledoux, Claude-Nicolas. *L'Architecture*. 1804. Princeton, 1983.

Lenoir, Alexandre. *Biographie universelle ancienne et moderne*. Vol. 15. Paris, 1816.

The Letters of Sir Joshua Reynolds. Edited by F. W. Hilles. London, 1929.

Lévêque, Jean-Jacques. *Fragonard*. Paris, 1983.

Levey, Michael. *Rococo to Revolution*. New York and Toronto, 1966.

Mannlich, Christian de. *Mémoires*. Paris, 1949.

Marmontel, Jean-François. *Mémoires*. Edited by M. Tourneux. Paris, 1891.

Mercier, Louis. *Tableau de Paris*. Paris, 1781.

Miller, Naomi. *Heavenly Caves.* New York, 1982.

Mongan, Elizabeth, Philip Hofer, and Jean Seznec. *Fragonard: Drawings for Ariosto.* New York, 1945.

Montaigne, Michel de. *The Complete Essays of Montaigne.* Translated by Donald M. Frame. Stamford, Conn., 1957.

Montesquieu, Charles. *Voyage d'Italie.* Paris, 1728.

Morgenstern, Sam, ed. *Composers on Music.* New York, 1956.

Munhall, Edgar. "Fragonard's Studies for 'The Progress of Love.'" *Apollo* 93 (1971).

Nerval, Gérard de. *Selected Writings.* Translated by Geoffrey Wagner. London, 1958.

Nettl, Paul. *The Other Casanova: A Contribution to Eighteenth-Century Music and Manners.* New York, 1970.

Noverre, Georges. *Lettres sur la danse et sur les ballets.* Paris, 1760.

Oberkirch, Baronne d'. *Mémoires de la Baronne d'Oberkirch.* 1789. Paris, 1970.

Panofsky, Erwin. *Meaning in the Visual Arts.* New York, 1955.

Petit de Bachaumont, Louis, et al. *Mémoires secrètes pour servir à l'histoire de la République des Lettres en France depuis 1762 jusqu'à nos jours.* London, 1784.

Pierpont Morgan Library. *Drawings from the Collection of Mr. and Mrs. Eugene Victor Thaw.* New York, 1985.

Piles, Roger de. *Cours de peinture par principes.* Paris, 1708.

Portalis, Baron Roger. *Honoré Fragonard: Sa Vie at son œuvre.* Paris, 1889.

Posner, Donald. "The Swinging Women of Watteau and Fragonard." *Art Bulletin* 64, no. 1 (March 1982).

———. "The True Path of Fragonard's 'Progress of Love.'" *Burlington Magazine* 114, no. 2 (1972).

Puttfarken, Thomas. *Roger de Piles' Theory of Art.* New Haven and London, 1985.

Réau, Louis. *Fragonard: Sa Vie et son œuvre.* Brussels, 1956.

Restif de La Bretonne, Nicolas Edmé. *Le Paysan et la paysanne pervertis.* 1775. Translated by Allan Hull Walton. London, 1967.

———. *Les Nuits de Paris: A Selection.* Translated by Asher and Ellen Fertig. New York, 1964.

Riccomini, Eugenio. *Correggio and His Legacy.* Washington, D.C., 1984.

Roland-Michel, Marianne. *Artistes en voyage au XVIIIe siècle.* Paris, 1986.

Rosenberg, Pierre. *The Age of Louis XV: French Painting 1710–1774.* Toledo, Ohio, 1975.

Rosenblum, Robert. *Transformations in Late Eighteenth-Century Art.* Princeton, 1967.

Rousseau, Jean-Jacques. *Œuvres complètes.* Edited by Bernard Gagnebin and Marcel Raymond. 4 vols. Paris, 1959–69.

Sahut, Marie-Catherine, and Nathalie Volle, *Diderot et l'art de Boucher à David.* Paris, 1984.

Saisselin, Remy G. *Neo-Classicism: Style and Motif.* Cleveland, Ohio, 1964.

Sannazaro, Jacopo. *Arcadia.* 1502. Translated by Ralph Nash. Detroit, 1966.

Ségur, Louis-Philippe, Comte de. *Mémoires, souvenirs, et anecdotes.* 3 vols. Paris, 1827.

Seznec, Jean. *Essais sur Diderot et l'antiquité.* Oxford, 1957.

Sheriff, Mary D. "Invention, Resemblance, and Fragonard's Portraits de Fantaise." *Art Bulletin* 69, no. 1 (March 1987).

Solomon, Robert C. *History and Human Nature: A Philosophical Review of European Philosophy and Culture.* New York, 1979.

Starobinski, Jean. *The Invention of Liberty.* Geneva, 1964.

———. "Burying the Dead." *New York Review of Books,* Jan. 16, 1986.

Stendhal. *The Red and the Black.* Translated by C. K. Scott Moncrieff. New York, 1926.

Thuillier, Jacques. *Fragonard.* Geneva, 1967.

Thuillier, Jacques, and A. Châtelet. *La Peinture française de Le Nain à Fragonard.* Geneva, 1964.

Tivoli and Its Artistic Treasure. Rome, n.d.

Vailland, Roger. *Laclos par lui-même.* Paris, n.d.

Van Loo, Carle. *Œuvres complètes.* Paris, 1980.

Venturi, Franco, *La Jeunesse de Diderot.* Paris, 1939.

Vigée-Lebrun, Louise-Elisabeth. *Souvenirs de Madame Louise-Elisabeth Lebrun.* 3 vols. Paris, 1835–37.

Vindry, Georges. "Fragonard." *Grasse expansions,* no. 1 (1972).

Wakefield, David. *Fragonard.* London, 1976.

Wildenstein, Daniel. *L'opera completa di Fragonard.* Milan, 1972.

Wildenstein, Georges. *The Paintings of Fragonard.* London, 1960.

———. "L'Abbé de Saint-Non." *Gazette des Beaux-Arts* 54 (1959).

———. "La Fête de Saint-Cloud et Fragonard." *Gazette des Beaux-Arts* 56 (1960).

Williams, Eunice. *Drawings by Fragonard in North American Collections.* Washington, D.C., 1978.

Winckelmann, Johann Joachim. *Winckelmann: Writings on Art.* Edited by David Irwin. London, 1972.

Wright, Beth S. "New (Stage) Light on Fragonard's Corésus." *Arts Magazine* 60, no. 10 (Summer 1986).

Index